SEIZE *sur* VINGT

243 ELIZABETH STREET
NEW YORK NY 10012
212. 343. 0476

WWW.16SUR20.COM

Max Mara
MaxMara

kate spade
NEW YORK

new york · los angeles · boston

index A to Z

art, design, fashion, film,
and music in the indie era

edited by
Wendy Vogel and
Rachel Ward

First published in the United States in 2014
By Rizzoli International Publications, Inc.
300 Park Avenue South
New York, NY 10010
www.rizzoliusa.com

Creative Director: Richard Pandiscio
Designer: Mike Green / Pandiscio Co.
Editor: Wendy Vogel and Rachel Ward
Rizzoli Editor: Julie Schumacher
Production: Colin Hough-Trapp
Managing Editor: Anthony Petrillose

ISBN: 978-0-8478-4244-5
Library of Congress Catalog Control Number: 2013947774

Also, thank you to Kayleigh Jankowski, Leslie Kazanjian, Supriya Malik, Charles Miers, Ellen Nidy, and Lynn Scrabis

ACKNOWLEDGMENTS

This history of *index* magazine would not have been possible without the creative efforts and generous participation of its contributors. Our deep gratitude and admiration go to the photographers, writers, editors, designers, and interview subjects whose work and reflections appear here.

Many thanks also to the numerous former *index* staff members, interns, and contributors whose names are not included in this volume. Your talents and work are deeply felt.

We are most grateful to our collaborators on this project. Thanks to Julie Schumacher, Anthony Petrillose, and Charles Miers at Rizzoli International for your indispensable guidance and support on all aspects of this publication. For your creative vision and stunning design work, our humble thanks to Richard Pandiscio, Mike Green, and the entire team at Pandiscio Co.

For her editorial work and for initiating this project with Peter Halley in 2008, we extend our heartfelt appreciation to Rachel Ward.

The staff at Peter Halley's studio has provided crucial organizational, research, and photographic assistance at every step of this project. Very special thanks to Scott Dixon, Lauren Clay, Cara Jordan, Melissa Sachs, and Brett Riggle.

For their help in securing photographic permissions, we wish to thank the following people:

Alexis Hyde (Doug Aitken Studio); Whitney Carter (Carter & Citizen); Will Englehardt (Roe Ethridge Studio); Mico Livingston-Beale (Timothy Greenfield-Sanders Studio); Jamie Irving (Trish South Management); Simona Zemaityte (Sam Taylor-Johnson Studio); Meredith Bayse (Sharon Lockhart Studio); Augusta Joyce (Gladstone Gallery); Marc Alain (Ryan McGinley Studio); Maureen Hilbun (Estate of Shawn Mortensen); Julian Sambrano (Sheryl Nields Studio); Jose Luis G. Lopez, Jr. (Regen Projects); Heather Rasmussen (Catherine Opie Studio); Veronica Levitt (Marianne Boesky Gallery); Seth Goldfarb and Nikki Tappa (Terry Richardson Studio); Alina Grosman (Art Partner); Laura Steele (Stephen Shore Studio); Rachel Howe (Laurie Simmons Studio); Carmen Brunner and Frauke Nelißen (Wolfgang Tillmans Studio); Nathalie Amor, Georg Rulffes, and Sally Waterman (Juergen Teller Studio).

We must also acknowledge the efforts of Stephen Bender, Betsy Biscone (Richard Prince Studio), Cori Galpern and Cliff Fleiser (Tom Ford International), Erin J. Lefton, and Gene Parseghian for coordinating republication rights.

We are indebted to Donn Zaretsky for legal expertise, and to Gina Nanni and J.A. Forde at Company Agenda for research.

Finally, we extend our most profound gratitude to our family, friends, and expanded networks of colleagues for all that they have given to this project—inspiration, encouragement, intellectual stimulation, artistic exchange, critical feedback, and affection.

Wendy Vogel and Peter Halley

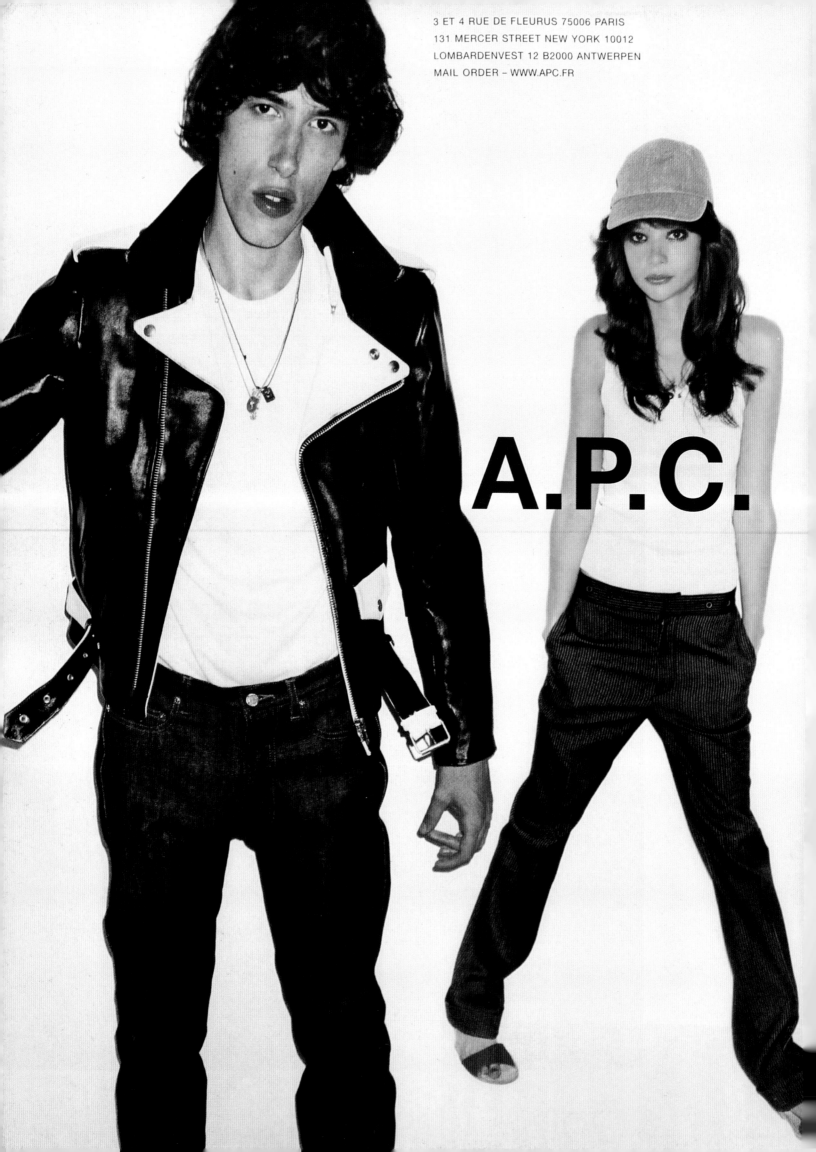

3 ET 4 RUE DE FLEURUS 75006 PARIS
131 MERCER STREET NEW YORK 10012
LOMBARDENVEST 12 B2000 ANTWERPEN
MAIL ORDER – WWW.APC.FR

A.P.C.

3 ET 4 RUE DE FLEURUS 75006 PARIS
131 MERCER STREET NEW YORK 10012
LOMBARDENVEST 12 B2000 ANTWERPEN
MAIL ORDER – WWW.APC.FR

embassy

5:PM until 4:AM Tribeca, NYC

steven·alan

60 WOOSTER ST.
212·334·6354

SHOWROOM
118 MERCER ST.
212·343·0352

330 E. 11 ST.
212·982·2881

•MEN'S STORE
558 BROOME ST.
212·625·2541

TRAVEL FURTHER

EXERCISE MORE

QUIT SMOKING

HAPPY RELATIONSHIPS

MEDITATE

GET NEW CLOTHES

HAPPY NEW YEAR 1999!

Dior

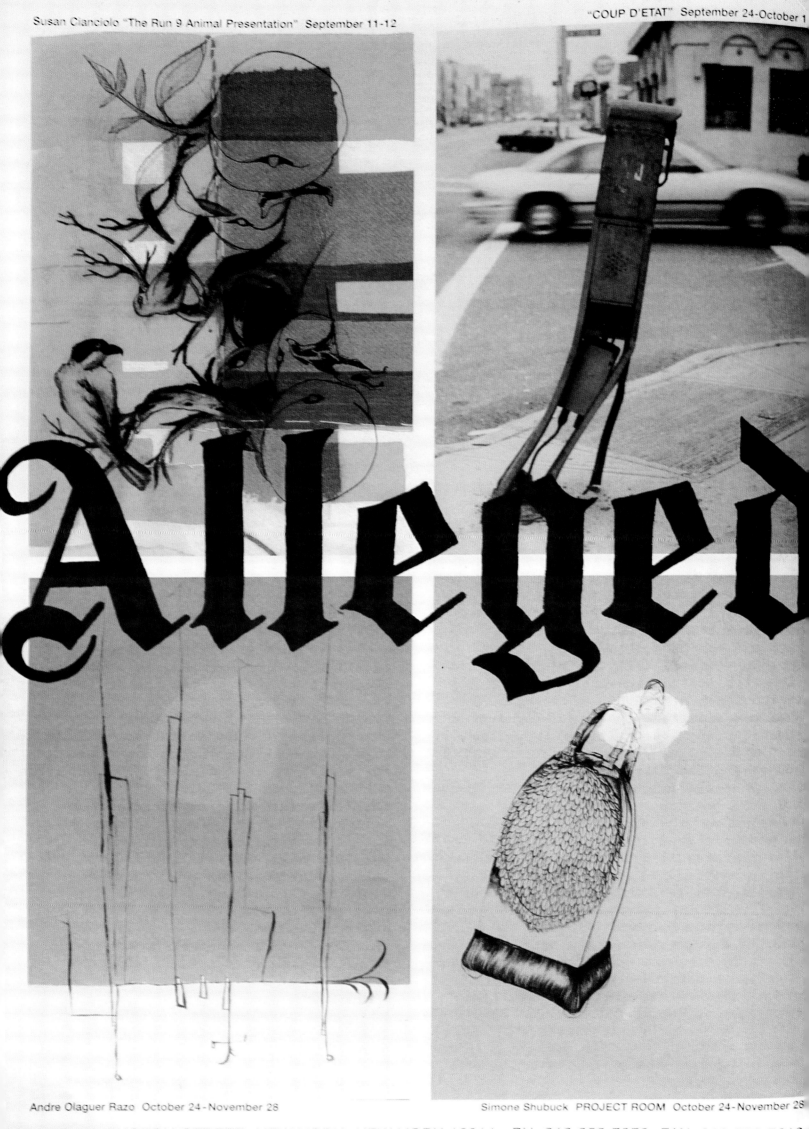

Susan Cianciolo "The Run 9 Animal Presentation" September 11-12

"COUP D'ETAT" September 24-October 1

Alleged

Andre Olaguer Razo October 24-November 28

Simone Shubuck PROJECT ROOM October 24-November 28

809 WASHINGTON STREET NEW YORK NEW YORK 10014 PH: 212 253 7278 FAX: 212 253 7610

Steven Alan *Store and Showroom* 103 Franklin Street New York NY 10013 Ph: 212-343-0692

MARC JACOBS

HEL T LANG

metallic shirts
photographed by Juergen Teller
Paris · New York N.Y. · S/S '04
WWW.HELMUTLANG.COM

B
Book

INDEXING THE INDIE GENERATION
by Wendy Vogel

Think back, way back, to the mid-'90s. Before the Internet forever changed alternative culture's distribution, "indie" described the aesthetics and the worldview of the creative vanguard. "Indie" was more than a style of music or movies: it represented a way of being in the world, ruled by opposition to the mainstream and profit-driven motives. Independent record labels, production companies, theaters, and mom-and-pop stores embraced "do-it-yourself" as their mantra. They considered selling out to larger corporate structures a deep ethical breach. Indie cultural cred was measured in mix tapes, zine collections, arthouse cinema references, and fashion looks Frankensteined together from thrift-store finds. Small independent magazines such as *index*, whose reputations grew by word-of-mouth enthusiasm, functioned as high-stakes cultural signifiers.

Founded in downtown New York by artist Peter Halley and curator Bob Nickas, *index* magazine quickly became a cultural bible celebrating the indie sensibility in art, design, fashion, film, literature, music, and photography. From the launch of its first issue in February 1996, the independent bimonthly contributed to the lo-fi, DIY zeitgeist. *index* sprang onto the scene with a fresh design concept borrowed heavily from broadsheets, mid-century conceptual art, and punk zines. Unlike the busy, dense, techno-utopian designs of its competitors, *index* drew readers in with its large-format layout, anti-glossy street photography, and stark typography. Most important, *index* celebrated the work of underground icons and emerging talents in long-format interviews, from the notorious director John Waters—affectionately dubbed "the Prince of Puke"—to then-new acts such as Daft Punk and Cat Power. Over its 51 issues that spanned a decade—the last appearing in November 2005—*index* would evolve from a black-and-white fanzine with long interviews and minimal advertising to a playfully designed, full-color publication where luxury advertisers, indie heroes, and obscure cult enthusiasts could happily mingle.

This book features the best of *index* magazine in a format that evokes the magazine's sensibility. Indexing 26 themes covered by the magazine in alphabetical chapters from A to Z—a riff on Bob Nickas's original tables of content, assembled like pages in a crossword dictionary—the book provides a lighthearted framework for a heterogeneous mix of smart, provocative content.

The unique mash-up of fandom and acute cultural commentary set *index* apart from many magazines of its era. Its fierce independence, visual acuity, and sharp curatorial discernment derived from its creators' vision. Peter Halley, a renowned painter whose writings on art and culture since the 1980s were highly regarded, was the publisher of the magazine throughout its run and offered his studio as a base of operations. Nickas, a curator of contemporary art firmly entrenched in New York's queer and punk scenes, served as editor for the magazine's first four years. Together, Halley and Nickas assembled a team of editors and designers that reflected a set of interests and positions that were more than the sum of its parts. Two of the most ambitious young hires at *index*'s start were Cory Reynolds and Ariana Speyer. After Nickas's departure in early 2000, they would respectively rise from the positions of managing editor and advertising director to become *index*'s successive editors in chief from 2000 to 2004.

In the mid-'90s, subcultures gained a new importance in the creative landscape. After the collapse of communism in 1989, capitalism spread across the globe, extending the reach of consumer culture and mass-media influence. During Mayor Rudy Giuliani's term from 1994 to 2001, New York City itself transformed from a place of financial and infrastructural hardship, where fragmented cultural diversity flourished, into a metropolis maximized for profit. During the transitional decade of the '90s, the AIDS crisis, women's and gay rights struggles, raging racial tensions, and endemic economic inequality generated debates about political and media representation that catalyzed wide-ranging movements from hip-hop to the AIDS activist collective ACT UP. As the contemporary-art boom ebbed, the issues of so-called "identity politics" quickly found expression in a new wave of contemporary art, from the explicitly queer, sexual content in Robert Mapplethorpe's classically composed black-and-white photographs to confrontational performance art like Karen Finley's. (The latter would become most famous as a member of the "NEA Four," a group of artists who battled the National Endowment for the Arts in the early '90s over the loss of individual artist grants.) Anti-corporate "slacker art" bled into pop culture, expressing the disenfranchised ennui of Generation X.

Meanwhile, activist energy and punk insouciance fused in musical and political movements such as the radical third-wave feminism of riot grrrl. Independent record labels such as Kill Rock Stars and Matador signed highly original bands such as Bikini Kill, Sleater-Kinney, Pavement, and the Jon Spencer Blues Explosion. Film production companies such as Killer Films made and distributed low-budget movies by emerging directors, such as like Todd Haynes's *Safe* (1995) and Mary Harron's *I Shot Andy Warhol* (1996). Anti-glossy fashion by designers such as Marc Jacobs and Jean Touitou of A.P.C. graced the pages of cutting edge magazines including *i-D* and *Purple*. Young, creative people channeled their feelings of marginalization

into the production of underground zines that anticipated today's diaristic blogs and social networking platforms.

index took its energy from this indie culture and blended it with Halley and Nickas's shared references. Andy Warhol's *Interview* magazine from the '70s was one such touchstone. Establishing it in 1969, Warhol headquartered the magazine at his downtown studio, the Factory. The pages featured intellectuals, celebrities, ingénues, classic Hollywood personalities, and debutantes in long-form Q&A interviews. Unexpected conversations between people such as cultural critic Susan Sontag and punk rocker Richard Hell regularly appeared. Hollywood actors and the quirky superstars of Warhol's films alike graced the magazine's covers, from Joe Dallesandro—of *Flesh and Heat*—to Bianca Jagger and Charlotte Rampling (who would all be interviewed again by *index*). The demimonde and the Old World, rich and poor, gay and straight—all mixed in *Interview*'s pages, just as they did at the Studio 54 disco in Midtown Manhattan.

Operating on a shoestring budget out of Halley's large Chelsea studio, *index* updated the *Interview* blueprint for a '90s audience. Where *Interview* was synonymous with disco, fashion by Halston, and high camp, *index* embraced punk and indie, anti-fashion aesthetics, and a queer sensibility. *index* avoided the turf wars of zine culture and the exhausted polemical writing of art magazines. It focused only on the people the editors and writers admired or even revered, ranging from then-teenage actresses such as Scarlett Johansson to veteran cultural luminaries such as writer J. G. Ballard and fashion arbiter Mr. Blackwell—two of many incredible interviews in the aptly named "Survival Guide" section.

Exceptionally long interviews, sometimes exceeding 3,000 words, conducted between friends or by people one or two degrees removed from the featured subject, formed the bulk of *index*'s content. The magazine usually interviewed people when they weren't promoting their latest film, book, or album. The simple but novel formula—conversations between friends outside the circus of self-promotion—led to intense conversations in which unanticipated insights often came to light. *index* then regularly tapped its interviewees to conduct interviews with their remarkable friends, heightening the magazine's in-the-know status while circumventing the stranglehold Hollywood agents and promoters had over their clients. In one notable chain of interviews, star photographer Juergen Teller interviewed Björk in 2001; Björk then interviewed fashion designer Alexander McQueen in 2002—and she dropped a reference to *index*'s interview with Rem Koolhaas from 2000 into her questions to McQueen. Through this associative web, *index* represented and crafted a community within its very pages.

index's issues of the '90s embraced a pared-down aesthetic that evoked '60s and '70s minimalist trends in design, film, and art. The design directly opposed the glossy, expensive creative direction of their corporate competitors. Laura Genninger designed the original black-and-white issues with large Courier fonts and a manuscript layout to mimic the typewriter Nickas used. In the second half of the magazine's life in the early 2000s, talented designers such as Stacy Wakefield and Faun Chapin would experiment with typography and a collaged aesthetic while maintaining a focus on full-page photographs that remained one of *index*'s hallmarks.

The debut issue of February 1996 already possessed the unique amalgam of content that would become *index*'s bread and butter, including long conversations with Wes Anderson and Owen Wilson, whose first film, *Bottle Rocket*, was about to debut in theaters, and Paul Miller—aka DJ Spooky—just before the release of his first full-length album. A secondary section, "Real Life," included the debut installments of the "Tour Diary" and "Survival Guide" features. The cult stoner metal band The Melvins—an obsession of Nickas—shared their tales from the road. "Survival Guide" profiled Quentin Crisp, a fearless, nearly 90-year-old gay British raconteur.

Along with Halley and Nickas, a core group of writers helped *index* take form. Many continued to write for the magazine throughout its ten-year run. Halley explains that his admiration for the "new journalism" of the '60s and '70s, exemplified by literary personalities such as Hunter S. Thompson and Joan Didion, encouraged him to foster strong, individual, journalistic voices. Representing different scenes, sexualities, genders, and generations, *index* established a cool but inclusive point of view so often missing from the indie rock culture largely coded as straight, white, and male. Rather than being monolithic, *index* embodied the "performativity" of gender and sexuality known as "queering"—a term that became popular in '90s cultural theory. Eschewing expectations and operating in the slippages of culture, *index* represented a point of view that was self-made, lively, and subject to change. Instead of ghettoizing anyone, *index* featured diverse cultural types, from indie band Sonic Youth to New Orleans soul great Allen Toussaint, from female pornographer Shane to Teresa Heinz Kerry, from the upstart Lower East Side designer Built by Wendy to Gucci's Tom Ford.

Nickas's witty and laser-sharp enthusiasms established the editorial direction for the magazine. Steve Lafreniere, a Chicago-to-New York transplant with wide-ranging cultural enthusiasms ranging from punk to drag; Amy Kellner, a young writer then circulating in the New York queer scene; and Toronto-based gay porn director Bruce LaBruce were among *index*'s earliest writers. A medical student by day and one of the Internet's first bloggers, Richard Wang wrote back-of-the-magazine columns on topics such as the supermodel-themed Fashion Café that anticipated

the hyperpersonal, alternately bitchy and sweet tone of today's social media. Writer Tina Lyons contributed riotous and poignant pieces from her diary, detailing everything from her battles with brain cancer to her affairs with mafiosi. *index* also looked to kindred magazines and their writers to define its stance. Mary Clarke and Christina Kelly, former staffers at the feminist teen magazine *Sassy*, pitched the idea for *index*'s very first cover interview with 17-year-old indie actress Alison Folland. As *index* would do, *Sassy* had cultivated a die-hard audience in the early '90s—Christina Kelly notoriously snagged the only cover interview with grunge übercouple Kurt Cobain and Courtney Love. Clarke and Kelly's columns on beauty and fashion possessed the trademark *index* wit.

From its start, *index* matched its lively interview content with a cutting-edge photographic perspective. Halley and Nickas set a high conceptual and visual bar when they asked German artist Wolfgang Tillmans to shoot the first year of covers in 1996. By the mid-'90s, Tillmans had established a unique practice as an artist working in photography and exploring new modes of distribution. His casual-seeming 35mm portraits of friends and celebrities were highly seductive without the artifice of studio lighting and styling. Tillmans's images appeared simultaneously in magazines such as i-D and in galleries. The photographer's flattening of hierarchies among his photographic subjects as well as between commercial photography and fine art mirrored Nickas and Halley's desire for inclusiveness.

Tillmans's portrait aesthetic influenced the direction of *index* throughout its run, though the magazine would go on to work with many other important photographers. Following Tillmans, Tina Barney shot five covers in 1997, including Warhol superstar Viva's teenage daughter Gaby Hoffmann. Timothy Greenfield-Sanders's large-format black-and-white portraits of celebrities were featured regularly. *index* would begin commissioning downtown denizen Terry Richardson in 1998 and crossover art-fashion photographer Juergen Teller in 2001. Teller imparted his trademark intimacy to portraits of celebrities such as Björk, while Richardson's roguish sense of humor and hard flash lighting illuminated stars such as Casey Affleck and Isabella Rossellini. One of *index*'s leading photographers, Leeta Harding, shot ten covers of icons from riot grrrl musician Kathleen Hanna to Scarlett Johansson, capturing her portrait subjects with a unique sense of poise. *index* made a special effort to support young photographers such as Ryan McGinley, whose images of nubile youths were indebted equally to punk and queer aesthetics, defined a new subcultural style at the century's turn. With the collaboration of Advertising Director Michael Bullock, *index* produced McGinley's first book of photographs in 2002. One year later, the twenty-five-year-old McGinley would be the youngest artist ever to be honored with a solo exhibition, "The Kids Are Alright" at the Whitney Museum of American Art.

The magazine enjoyed unique downtown cachet beyond its pages. *index* hosted exclusive parties for every issue, plus special events such as book launches, for contributing photographers Terry Richardson, Richard Kern, and Timothy Greenfield-Sanders. These see-and-be-seen soirees brought together figures such as Helmut Newton, Martha Stewart, Harmony Korine and Chloë Sevigny, Sonic Youth's Kim Gordon and Thurston Moore, and former Olympic skater Oksana Baiul. (This book's final chapter, Zeitgeist, showcases photos from these events.)

index's knack for discovering stars has continued even after the last print issue in 2005. In 2008, *indexmagazine.com* featured one of the first video interviews (since gone viral on YouTube) with budding singer-songwriter Lizzy Grant—known today as brooding pop star Lana Del Rey. *index* also captured writer-director Lena Dunham well before her *Tiny Furniture* film debut. An 11-year-old Dunham appeared in a photo (page 59 of this book) with Isaac Mizrahi, who was then photographed and interviewed by Dunham's mother, Laurie Simmons, for the January/February 1998 issue. In 2009, Dunham's offbeat web series *Delusional Downtown Divas* appeared on *indexmagazine.com*, laying the groundwork for Dunham's HBO hit *Girls*. Like *index*, *Girls* has become synonymous with a new generation—the irreverent, witty aesthetic of Brooklyn hipsterdom.

As '90s nostalgia peaks in fashion, in exhibitions such as the New Museum of Contemporary Art's 2013 survey show "NYC 1993: Experimental Jet Set, Trash and No Star," in histories such as Sara Marcus's *Girls to the Front: The True Story of the Riot Grrrl Revolution* (2010), and in Kara Jesella and Marisa Meltzer's 2007 "love letter" to *Sassy* magazine called *How Sassy Changed My Life*, this compendium from the pages of *index* looks back on the publication that became a primary text for Generation X culturati. This volume features the magazine's best photography alongside excerpts from *index*'s extensive interviews and articles. Complementing this re-published material are fresh reflections from contributors. An homage from contributing editor Bruce LaBruce, a collage of recollections by key contributors, and brand-new interviews with publisher Peter Halley and founding editor Bob Nickas all combine to tell the story of *index* in the words of its creators. From its brilliant Q&As to previously unpublished photo outtakes and party pictures, this book celebrates the quirk, grit, and intelligence of *index* magazine.

Of course, one volume can't sum up the fifty-one-issue run of *index*. The online archive of *index* includes the complete original interview text of over 150 feature stories, along with pictures and video extras. Visit *indexmagazine.com* for more interviews with some of the most enduring voices of the indie era.

MY LIFE INDEX

by Bruce LaBruce

I can remember vividly the first time I spied a copy of *index* sitting brazenly on the shelf of the Tower Records in Toronto. There it was, in its slightly oversized yet modest glory, an unlikely photo of Udo Kier washing his hands, eyes cast downward, gracing the cover. When, I thought to myself, was the last time you saw such an unusual cover on a pop-culture publication? I quickly snatched up the last copy and opened it to see who was responsible for this impertinent assault on magazine etiquette. As I scanned the table of contents, it all began to fall into place when I realized that the remarkable German photographer Wolfgang Tillmans, who had only recently shot me for the hip German music magazine *Spex*, had taken the cover photo. The publisher of the magazine was none other than Peter Halley, the abstract artist whose geometric paintings I already knew. I wasn't familiar with the editor, Bob Nickas, but I soon would be.

I didn't have to wait long. A mere six issues later I was being photographed for *index* by Toronto artist Alan Belcher and interviewed by Editor at Large Steve Lafreniere, whom I'd known since his wild Chicago days. Subsequently, I would become a frequent contributor to *index* as an interviewer, writer, photographer, and, eventually, contributing editor, providing me with an excuse to travel from my home base in Toronto to New York City at the drop of a hat to attend a glamorous *index* party or merely to hobnob off-hours with various members of the masthead. It was a heady

time, "just before the war with the Eskimos," when making love to Manhattan was still a consummation devoutly to be wished. Little did we know then that it was not just the fin de siècle, but also the end of a diverse and democratic era for a city where wealth and privilege once mattered less than character and a strong sense of style. But that's another story.

After I had been "indexed" myself, I felt compelled to drop into the magazine's office on the ninth floor of the West Chelsea Arts Building on West 26th Street, which doubled as Peter Halley's studio, to introduce myself

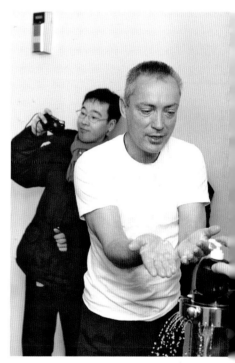

UDO KIER

in the flesh. Thus began the first in a series of lunches at *index* headquarters, where I would be invited every time I was in New York. The *index* staff and Peter's assistants would all sit around a long table and eat ordered-in food while we gossiped and griped about current events or brainstormed about future issues. Presiding over these uncatered affairs was none other than Editor Bob Nickas, the arch scribe and deft art curator who shepherded the first four years of the magazine. I was always impressed by his vast knowledge of things both popular

and esoteric and the nimbleness with which he navigated between the two. His bold, sometimes obtuse pronouncements often left everyone at the table scratching his or her head, but later that day you would finally figure out what he meant in a lightbulb moment and nod your head in silent agreement. Bob always had great ideas, like the *index* compilation CD, for which I recorded a homoerotic tribute to my cinematic idol, Jerry Lewis. Although it was rather out in left field, Bob didn't bat an eye.

Bob was always my great champion at *index*, supporting my crazy ideas and printing my verbose musings with just the right amount of editorial intervention. This orgy of advocacy culminated with his presentation to me—at an *index* party at the now-defunct club Idlewild—of the *index* Lifetime Achievement award, which, wrapped in a paper bag, he thrust at me while mumbling some aw-shucks sentiment. The dime-store award, an engraved mini-Oscar look-alike with the price tag still on, sits proudly on my bookshelf today.

My first assignment at *index* was a rather daunting one, even though it was my own idea: to interview and photograph the notorious fashion photographer Terry Richardson. I had recently met T-bone through our mutual friend Harmony Korine, whom I had met through my friend Gus Van Sant at the world premiere of *Kids* at the Sundance Film Festival in 1995. I mention this not only to name-drop, but also to give you an idea of how fluidly *index* operated on the principle of two or three degrees of separation. People were often drawn into the magazine not through publicists and promoters but rather through friends and acquaintances, which lent the magazine a more casual and less calculated appeal. The subjects of

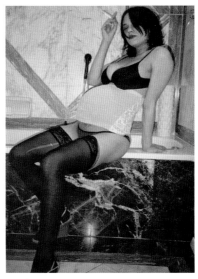

AISA ARGENTO

interviews, more often than not, didn't have specific products or projects to promote, so the focus was more on their lives, their personalities, and their core beliefs, unfiltered by the jaundiced agendas of agents and other proxies. It's increasingly rare to find this kind of unfettered access to artists, actors, and other creative types, which is why the demise of the printed *index*, after ten years of publication, was so unfortunate.

It was a heady time for Terry when I interviewed and photographed him back in 1998 during the week of his first big solo photography show at the Alleged Gallery, when it was still located in Soho. To give you an idea of how accelerated culture was in New York during this period, a year later Alleged would move to its Gansevoort Street location (where I would have my own show alongside artist Ed Templeton), and two years after that it would be gone, leaving in its wake the wasteland of gross celebrity excess and conspicuous consumption that is the new Meatpacking District. In fact, one of the extraordinary things about the *index* decade was its time period (1996 to 2005), spanning, as it did, the last vestiges of a more impudent and unruly New York, following its slow strangulation by the overzealous and authoritarian Mayor Giuliani, and bearing witness to the subsequent tribulations of 9/11 and its aftermath and finally the city's reincarnation as a playground for the rich and famous

that's been run through Woody Allen's proverbial "deflavorizing machine." The story arc of *index* magazine couldn't have been more perfectly realized by a professional scriptwriter. That is why it remains such an essential document of its time.

The sincere and straightforward approach of *index* often led to candid interviews in which subjects let down their guard, and Terry Richardson's interview was no exception. (I conducted similarly frank interviews for *index* over the years with the likes of Bijou Phillips and Asia Argento.) I photographed Terry and his wife at the time, the lovely supermodel Nikki Uberti, for the cover of *index*, nudging him perhaps toward his own subsequent stardom and ushering in his reign as the go-to photographer for *index* covers over the next five to seven years. A year after that cover, Terry and Nikki would fly to London for Nikki's appearance in my neo-Nazi porn epic *Skin Flick*, for which *index*, mercifully, can claim no credit. Perhaps even more controversially, two years later on assignment for *index* in Milan, I would photograph an eight-and-a-half-months pregnant Asia Argento naked and smoking a cigarette in a bathtub. I heard some vague rumblings at the time, some accusations of exploitation, but if people knew how naturally and spontaneously these collaborative photographs materialized, they wouldn't be so quick to judge. For their part, the kids at *index* never flinched.

It was around that time that I started dragging one Ryan McGinley into the *index* studios. Ryan was a fresh-faced photog I had met when he was a student at Parsons School of Design and whom I had been introducing to a few art-collector acquaintances. He soon became an *index* protégé, the magazine eventually publishing its first and only book of photographs by the ambitious young artist who would go on to become a superstar photographer in his own right.

As an ace reporter for *index* I had the opportunity to visit the sets of some of my favorite filmmakers: Harmony Korine's *Julien Donkey-Boy* in Queens, New York; Gus Van Sant's never-released *Easter*, based on a short story by Harmony, in Mayfield, Kentucky; and John Waters's *Cecil B. Demented* in Baltimore, Maryland. In the former two instances, I was literally the only member of the "press" (I never felt like a real reporter) allowed onto the set—such was the access that *index* afforded. In the last instance, Melanie Griffith yelled at me, and being on assignment for *index* didn't help much at all. Each excursion was a little adventure unto itself, and it gave me the rare opportunity to see my friends in action behind the camera. The cinematic assignments were always my favorites, including a gig photographing a cantankerous yet compelling Joe Dallesandro in Los Angeles, and a memorable two-hour-plus phone interview with cinematic genius Paul Verhoeven.

My *index* years came to a close with the magazine itself when I interviewed and photographed the great Eugene Hütz of Gogol Bordello fame for a cover story in the very last issue. Just one issue short of its tenth anniversary, this *index* compilation rounds out a heady decade in the history of publishing, of which my exploits were only a small sample. When you factor in the adventures of everyone involved, it adds up to a potent index of the times.

WORDS FROM OUR CONTRIBUTORS

Culled from interviews conducted by Rachel Ward, Amoreen Armetta, and Wendy Vogel between 2008 and 2013 with editors, writers, photographers, and designers that formed *index*'s inner circle.

STEVE LAFRENIERE, Contributing Editor & Writer (1996–2005)
I'd written for magazines for a long time, and I was about to move from Chicago to New York in 1997, when I got a call from a friend there asking me if I'd like to interview Bruce LaBruce for a new magazine called *index*. A few days later I was on the phone taping the interview, and a few days after that I'd pretty much forgotten about it. That is, until the check from *index* arrived in the mail with a copy of the issue.

I'd figured it would be like the other arty rags of the day, say, *BOMB* crossed with *zing*. Instead I was startled to find that *index* was every idea I'd ever had for a dream zine rolled into one. Oversized, beautifully toned black and white, Courier typeface à la '70s *Interview*, and layout style up the jaxxy. They used photographers like Tina Barney and Wolfgang Tillmans to shoot the editorial, and the list of interviews made the jaw drop. Besides my LaBruce interview, there was the mysterious fashion/art project Bernadette Corporation, Viva's actress daughter Gaby Hoffmann, '60s soul and funk diva Lyn Collins, MoMA Trustee/design guru Barbara Jakobson, gospel yeh-yeh rockers The Make-Up, and David Sedaris. Plus a section in the back called "Scene and Herd" with terrific little bits on odd subjects like the legendary 14th Street coffee shop, The Donut Pub, playing slots at the Mohegan Sun casino in Connecticut, and Keith Mayerson's new comic based on a Dennis Cooper story. My God, when I got to New York, these *index* people were going to be my new best friends!

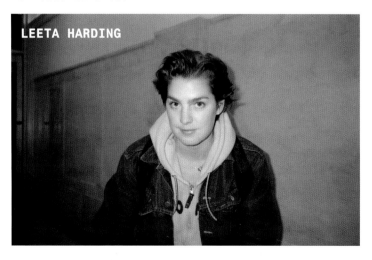
LEETA HARDING

LEETA HARDING, Photographer (2000–2005) *index* was a forerunner to independent magazine culture in America when it came out in 1996. Not a lot of magazines were doing what Peter Halley and Bob Nickas were doing—running un-retouched photography with clean, uncluttered text. That appealed to me as a photographer. I loved its zine-like quality. *index* described what was happening in culture, art, design, and fashion in New York before other magazines. It was straight-from-the-hip reporting that felt genuine and real.

The great thing about shooting for *index* was having a voice. Peter gave young photographers, artists, designers, and musicians a unique opportunity to be published. It was brilliant and timely, the antithesis of slick and glossy. In the '90s, New York needed it, because Europe already had magazines like *i-D*, *The Face*, and *Purple*.

MICHAEL BULLOCK, Advertising Director (2000–2005)
Before I came to work at *index*, Bob Nickas was filling the pages with all types of amazing people: freaks, outsiders, hustlers, artists, and punks. If two teenagers in a basement in Detroit were making interesting music, Bob somehow knew about it. His editing was never the typical "Who's hot right now?" approach. He is a curator and edited as such, focusing on who was moving culture forward.

For obvious reasons (artist-owned, office in the studio), *index* was often compared to the early days of Andy Warhol's *Interview*. Peter Halley may have consciously followed that example, but to me *index* was much more an evolution of *Interview*. In the early '00s, mainstream magazines in general had pushed Warhol's holy conception of celebrity and glamour to its absolute end point. *index* took the concept back to its roots, stripping it of all empty glamour clichés and making the new cultural luxury an un-Photoshopped reality.

RICHARD KERN, Photographer (2002–2005) *index* wouldn't say, "Go shoot Tom Cruise." I shot people like Jennifer Coolidge for them, which was way cooler. I don't want to say she is not a major star—she is a big star—but they focused on people who were kind of quirky. Even though it was an independent mag, it had a big reputation. People who wouldn't normally say yes would say yes to *index*.

There isn't really a magazine like that anymore in New York, or in the US, actually. It was a good blend of content. Plus, as soon as I started shooting for it, people overseas, in Europe, who were huge fans of the magazine, began contacting me. It became an introduction to a lot of the galleries I work with over there.

LAURA GENNINGER, Designer (1996–1999) *index* offered a relationship with an exceptional editor and an adventurous publisher, and it offered everyone who worked on it an open platform to create a new magazine from the ground up. At the beginning it was hard work because of its obscurity and low budget, but it was one of the few independent magazines around, and that seemed to make any sacrifice worth it.

For an art director, it's a great privilege to design a magazine masthead or logotype and to create an original design format and grid. I became responsible for the identity of *index*, its approach to typography and photography, which was unlike that of any magazine on the newsstand at the time. It was an oversized magazine format and presented unusual possibilities.

The main text was large to match Bob's typewriter. It did not try to be *Vogue*, *The New Yorker*, or *The Face*. For art direction and editing, I looked at film and to realist documentary photography and would likely print the unexpected picture—a photographic style that *index* became known for. The art direction was specific and decisive. There were no forced ideas or heavy-handed concepts, and the assignments were made with the photographers and artists we collaborated with. Almost everyone on the masthead, other than myself, was new to magazine design and publishing. Since I already had years of experience, this novelty was very refreshing, because it made new ideas and unexpected editorial decisions possible, and it was all done with great expectations.

I designed *index* to look and read like a raw film transcript or a Fluxus manuscript—it also referenced Andy's first issues of *Interview* that were printed on a newspaper press. The look was lo-fi and real. Finally, by 1999, our budgets moved us into four-color printing, which exposed the contributing photographers' work even better. In the '90s, *index* was underground, noncommercial, not timed for media but ahead of time, a curious print for art directors to ponder, existing totally on its own. *index* evolved, and by 2000 it was known for being downtown and cool. In 2002, it gained increasing popularity and was perhaps considered the "of-the-moment" downtown cool magazine.

STACY WAKEFIELD FORTE, Designer (2001–2003) I'd been at a few different magazines before starting at *index* in the summer of 2001. I'd worked my way up from designer to assistant art director. The editors at *index* made me question all the rules I'd learned. I pointed out that magazines have only one or two fonts they use for feature headlines and a limited color palette, so their look is consistent and branded. No one at *index* saw the point. I was encouraged to forget all that. If we ended up sticking to any standard magazine conventions, it was because we agreed that we loved them, not because we had to.

LEETA HARDING In 1996, I went to a book launch for Wolfgang Tillmans's book *Burg*, published by Taschen, at the defunct art book shop Art Market located in SoHo. That was where I first saw *index*— it was the second issue with the Udo Kier cover. Great, great cover. I started talking to Wolfgang, and he said, "You should take your work to Peter Halley at *index*." So Wolfgang was vicariously responsible for my run at *index*. I'm very grateful to him for that.

NINA ANDERSSON, Photographer (2003–2005) I always read *index* and thought it was the best magazine. I dropped my book at *index* with Ariana Speyer in 2002 and started to shoot soon after that. I *loved* it so much—it was my first photo job ever!

ALEX HOERNER, Photographer (2002–2005) I was assisting Terry Richardson, and he called Cory Reynolds at *index*. I went over to the studio to meet them. I was living in LA, and I started getting great gigs from them. They were so supportive. It was magical, the quality of the people.

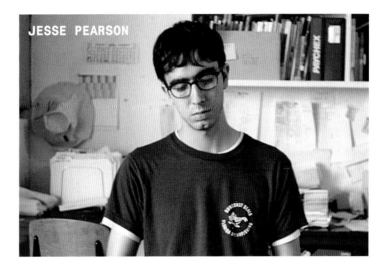

JESSE PEARSON

JESSE PEARSON, Associate Editor (1999–2002) The first time I ever saw *index* was at a Borders in the suburbs in South Jersey, when I was at home for a vacation from college in 1998. I think I bought it because it had David Sedaris inside, plus an article about The Make-Up, a band I really liked. *index* stood out big-time from everything else on the shelf. I fucking loved it. It was like a big punk zine but fancy and smart. I was still a poetry major—yeah, I know—at a small hippie school in New England, but I didn't want to spend another summer serving subpoenas all around New Jersey, which had been my summer job three years running. So, totally on a whim, I wrote to the *index* Email address—this was back when the whole office shared this one Email, phcell@pipeline.com. Cory Reynolds wrote back and said to come on in for an interview. I took the train to the city, found the office, and Cory and Ariana Speyer sat me down and asked me stuff. I guess I was worthy of taking out the trash, because they told me I could be an intern for that summer. This was 1999. That fall, I was hired. I was *index*'s Web Editor—which I sucked at; then for a while I was Editorial Assistant (I think), and then I was one of three

Editors, along with Ariana and the great Steve Lafreniere. Sometimes it seems that everything I do now, and a lot of my friendships, stem from working for *index*. It's pretty crazy. My life in New York started then and there.

AMY KELLNER, Associate Editor (1996–2001) *index* was my first real job, and I was psyched. They had Mary Clarke and Christina Kelly from *Sassy* writing for them! They had Wolfgang Tillmans doing the covers, and interviews with Will Oldham and the chick who designed X-Girl! The Courier font, the minimal layout—my little fresh-out-of-college mind was blown.

I started as an intern in the summer of 1996, around the time of the third issue, and it was just four people working in the corner of Peter's huge white studio with a gorgeous view of the sunset. I thought everyone was so amazingly cool. Peter was terrifying, Bob was hilarious, Cory was the soothing voice of reason when everyone else was going ape-shit, and Laura was the embodiment of everything that was stylish circa the late-'90s. After interning for about two months, I was hired as an Editorial Assistant. I think I got the job because I got the office a Pitney-Bowes postage machine. Before that, we would just take all the magazines to the post office and have them do it, and they were getting really pissed off.

RICHARD WANG, Contributing Editor & Columnist (1996–2005) I started writing for *index* in their second issue. I was in medical school at the time and had exchanged Emails with several editors of the recently defunct *Sassy* magazine. One of them was Mary Clarke, who is one of the original *index* writers. She referred me to Bob Nickas, who took me out to lunch.

I remember in this one episode of *90210* they asked this girl Amanda at a slumber party if she ate on dates, and she answered, "No, but I always order the most expensive dish on the menu . . . to let them know I'm worth it." So I used this advice and ordered a crab cake entrée, and it worked!

MICHAEL BULLOCK When I went in for my first interview at *index*, editors Cory Reynolds and Ariana Speyer wasted no time telling me that my salary would be small but that the interesting part of working there was that I would meet, work with, and perhaps even become friends with my cultural heroes. They could not have been more right. Only two years earlier, in college, I discovered Bruce LaBruce's groundbreaking film *Hustler White*—a film that literally blew my small suburban mind and in one swoop destroyed all my preconceived notions of what it meant to be gay. Bruce had, of course, been featured in *index* and had since become a contributor. The notion of meeting and working with Bruce was unbelievably exciting.

TINA LYONS, Columnist (1996–2002) My whole experience with *index* took place after I'd already left the city. I was living in the Hamptons, and

in the winter it got very *Grey Gardens*. *index* was my lifeline to New York, to Manhattan. I don't remember if it was Peter or Bob who first approached me. But I believe I was the first person asked. I used to send Peter faxes when I worked at a gallery. He thought my faxes were so charming that we were talking about doing a book of the faxes. This was 1989 or '90. He liked my conversational writing style, which is the only style I know.

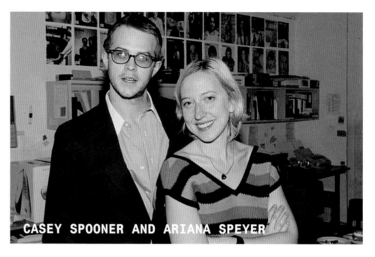

CASEY SPOONER AND ARIANA SPEYER

ARIANA SPEYER, Advertising Director & Associate Publisher (1997–2002); Editor in Chief (2002–2005) *index* was a place of extremes: the newest, greenest photographers—I remember when we assigned Ryan McGinley to take his first pictures for us of a British band called Baxendale (Amy Kellner may have been their only fan)—next to masters like Helmut Newton; an expansive vision on a shoestring budget; a big, oversized magazine produced by a tiny staff; a place where you could enter as an advertising grunt and leave as the Editor in Chief.

RICHARD WANG What I loved most about writing for *index* was that it allowed an untrained writer such as myself to have a little column in the back of the magazine. I don't think anyone else would've hired me. I once was asked by Jane Pratt to submit a writing sample to *Sassy* and then never heard back, but *index* basically allowed me to write about whatever I wanted.

AMY KELLNER I'd never written anything before, but Bob liked my music taste and suggested I write something about bands I was into. So I wrote about the No-Neck Blues Band (very serious art hippies) and The Scissor Girls (no wave girl trio from Chicago). It was really pretentious. But eventually I got to interview some of my favorite bands and people: Royal Trux, Cat Power, Eileen Myles, some riot grrrl bands, and other very dated '90s things. But it was all so exciting and glamorous. One time I got a fax from Thurston Moore and thought, "This is it. This is the pinnacle of my coolness."

TINA LYONS For me, it was what I always wanted a magazine to be. It was smart without being snarky. It sort of functioned as a post-new wave *The New Yorker*. Peter didn't go into it to make it a

charity or a sideline project. He really wanted it to be viable the whole way through, but the focus wasn't commerce.

ARIANA SPEYER Mostly I remember the passion *index* would incite in its tiny group of readers—usually very cool and collected folks—because they were finally reading about people they wanted to read about, whom represented them, whom they admired, that they wanted to be, but not because of their clothes or hair or wealth (well, sometimes maybe wealth . . .) While *index* has many imitators, and its style has been watered down in countless derivations, there's still nothing that compares.

LAURA GENNINGER The exposure of great and unusual people, places, and ideas that were not necessarily aligned with a greater plan, the media, the web, or Twitter—there was always an element of surprise, because the content relied heavily on intuition and relationships with the contributors.

ARIANA SPEYER The freedom of operating on the fringe, with so little interference between an idea and its execution, the pleasure of not knowing how "real" magazines did it—a.k.a. total ignorance—and therefore having to make it up as we went along, was fantastic. The camaraderie and being in the trenches with an uncannily talented group of people who would generally stop at nothing to get the job done was its own reward. It's the yardstick against which I've judged every job since.

CORY REYNOLDS, Managing Editor (1996—2000); Editor in Chief (2000—2002) Certainly there were glamorous moments, inspired gestures, ideas, and connections coming from all over the place, all the time. Feuds, fiends, melodrama, experimental music, art, writing, sex, and lots of very, very late nights. I don't know which memories are the truest, but the most intimate are the ones that happened behind the scenes, when those of us who actually made the magazine were together, exposing the best and the worst of who we were then.

AMY KELLNER Other fond memories: Having a drug-delivery service called "Food Chain" come to the office with a Tupperware container full of every drug, and we'd all joyfully pick through it together. Having a "professional magazine advisor" come in and tell us not to put black people on the cover—we didn't listen to him. Getting arrested for wheat-pasting posters of the magazine cover in SoHo—the report said I was arrested for "graffiti," which made me feel real bad-ass. And, of course, plenty o' melodrama. Bob still loves to tell people how I supposedly tried to throw a computer out the window, which is entirely not true! I did kick a door, though.

CORY REYNOLDS I can still see Amy Kellner as she kicked the studio's heavy steel door out with her little sneaker, screaming pure outrage for some editorial slight, on the day she quit for the last time. And tall, gentle Stephen Sprott, hiding

quietly in the back every time Peter would start screaming that an assistant had fucked something up. And Jesse, dragging himself into the office morning after morning and claiming food poisoning, family problems, or a fight with his girlfriend, when everyone knew he'd been out all night with Dash Snow and Ryan McGinley. These were some very strong personalities, to say nothing of the cast of thousands who were always coming in and out of the studio. Mark Borthwick with his weird poems and luminous slides. Steve Lafreniere with his beautiful young friends, always very soon to become famous. Elizabeth Peyton, David and Amy Sedaris, Tina Lyons, Ryan McGinley, Vaginal Davis, Bruce LaBruce, Bernadette Corporation, Wolfgang Tillmans, Fischerspooner, Momus, John Waters I'll always love Udo Kier, the Courier typeface, Wallabees, Juergen Teller, Eileen Myles, Chan Marshall, cinéma vérité, and 50-pound newsprint because of *index*.

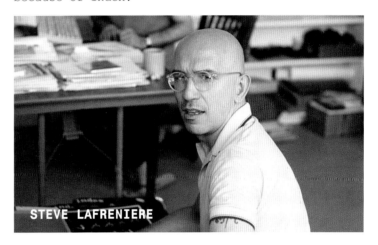

STEVE LAFRENIERE

STEVE LAFRENIERE I hung out extracurricularly with Bob Nickas, Associate Editor Amy Kellner, and her downtown pals like Meredith Danluck and wee Ryan McGinley.

One night, Bob asked me to list on a napkin five people I'd kill to interview. I forget what I wrote, but I know that after that I was pretty much given carte blanche. I'd drunkenly passed the taste test, and over the next seven years I was able to prod the interesting likes of John Peel, Linda Thompson, Elizabeth Peyton, Autechre, David and Amy Sedaris—together!—Lili Taylor, Kahimi Karie, Fischerspooner, Monica Lynch, Slava Mogutin, Catherine O'Hara, Momus, Robert Indiana, Jerry Hall, and loads of others. Even as younger editors like Cory Reynolds and Ariana Speyer succeeded the great Nickas, my little Sanyo tape recorder kept humming.

JESSE PEARSON I got the magazine bug from working under Bob Nickas, and I went on to be the editor in chief of *Vice* magazine for eight years. I quit that job in 2010, and now I have my own fully independent magazine. It's called *Apology*. And I still dig out my *index* archives when I'm feeling like I need some inspiration. Bob was a mentor to me in a lot of ways—especially how he can transmit enthusiasm and humor and intelligence in just a couple of sentences. He is a magician. I'm really happy that we're still friends.

CORY REYNOLDS More than anyone else, there was Peter—volatile, demanding, and perpetually swamped, but brilliant, generous, and always struggling to find the money to pay all these crazy people. I remember when he sold his treasured Warhol *Electric Chair* to keep *index* afloat. That was one of several artworks that went to finance the magazine.

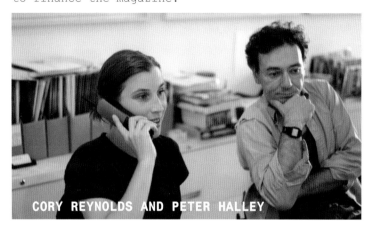

CORY REYNOLDS AND PETER HALLEY

ARIANA SPEYER Being editor in chief of a magazine published by Peter Halley was a mixed blessing, as those who came before me can attest. No one else could tear you down and build you up so dramatically, sometimes in the same day. But the fact is, he funded a losing proposition for way longer than most people would have tolerated, bleeding large amounts of money, and he did it for mostly selfless reasons. The world is a better place for *index* having lived, and Peter can largely take the credit for that.

BRIAN BERMAN, Photographer (2000-2002) Basically *index* magazine was the first magazine I got work from. I dropped off my book, and then Cory Reynolds called and said Peter wanted to meet with me to "talk about stuff." It meant a lot to have an artist such as Peter endorse me, not only as a photographer, but as an artist.

LEETA HARDING What I loved about the magazine as well, as was certainly Peter's intention, was that he gave people a voice, young people. So writers who weren't getting published in mainstream magazines were getting published in *index*.

JESSE PEARSON Peter Halley consented to hire me when he totally didn't need to. He's an intense guy. He's very smart, and you can sort of feel that beaming off of him. He's also a really generous person. He paid all of our salaries and gave all these freaks a forum. He hated when I started freelancing for *Vice*, and he told me I couldn't, but I kept doing it, just under fake names. Then I guess I either got fired or semi-quit, because I was gradually becoming addicted to heroin back then—which I occasionally bought with stolen petty cash. Sorry about that, guys—especially Cory, who was really nice about my obvious drug use even though she should have just put my head through a window.

STACY WAKEFIELD At design meetings where we had huge piles of pages to get through, Peter would invariably get caught on the color of a headline. Should it have 3% more cyan or 4% less magenta? He'd take his glasses off and hunch over my process color manual and contemplate every possibility and its repercussions while his cell phone rattled on the table and Cory and Jesse and Ariana looked at the clock and sighed. The details of design seemed like an escape for Peter, so as hectic as his schedule was, he always had great attention for my work, which was wonderful for me. I learned a lot about color from him.

ARIANA SPEYER I remember when the tape of Morrissey—who agreed to be interviewed by James Murphy and Jim Goldsworthy of DFA in Oxfordshire, where he was recording a new album—turned out to be barely audible. Managing Editor Ella Christopherson had to patiently—and sometimes not-so-patiently—listen and re-listen for hours to make anything out. There was Amy Sedaris editing her own Dada-esque interview with herself—Amy's idea, in which she calls herself a whore and talks to a dustpan—an editor's dream. Eileen Myles interviewing a cagey Daniel Day-Lewis and bonding with him about poetry, of course. Fritz Haeg being interviewed in his geodesic dome-home and trying to control the questions, until I told him to relax and let me handle it. Tom Ford agreeing to pose in a faux voting booth, which had to be remade a few times to Peter's specifications, for our September 2004 Politics issue, and Features Editor Zoë Bruns miraculously producing the LA shoot from New York at the last minute. Casey Spooner, confiding that he had always dreamed of being on the cover of a magazine by the time he was 30, could hardly believe that we had made it a reality.

LEETA HARDING My first cover was Elizabeth Peyton, who at that time wasn't really well known. She was showing with Gavin Brown. I arrived at Elizabeth's apartment early one morning. She was fresh out of the shower, hair wet, and her skin was all dewy. I set up pillows on the floor in her living room and asked her to lie down and thought, *That's it. This should be the cover. I think it's time to put another woman artist on the cover of* index. I only shot three or four rolls of film. Total cost: $40. The week my cover hit the stands, one of her paintings sold for half a million dollars at Sotheby's.

RICHARD KERN A. M. Homes was my first job with *index*. I got to the shoot, and I had left the main piece of my equipment at home, so I had to wing it. I was so embarrassed that I'd gone on my first job and fucked it up. But I didn't fuck it up. It turned out great.

LEETA HARDING The highlight of my career was meeting Helmut Newton. It was two years before he died, and initially he declined to be photographed and interviewed for *index*. Peter Halley and I were invited to lunch by Andrea Caratsch at Helmut's favorite restaurant, the Kronenhalle in Zurich. We brought along the tape recorder. When I asked him, "What's your favorite magazine?" he said

"*Housewives in Bondage*," and that was it! We were off and running. His voice and manner of speaking were mischievous and fun. I felt in awe, sitting across from him. At the end of our interview, I politely asked if I could take his portrait, not knowing at all that it would be our next cover. Helmut protested, "No. I look terrible. My hair isn't great today." I reassured him. It was the only time I really begged for a photo. After I'd only shot four frames, he waved his hand "enough." Back in New York at my lab, I nervously flipped through the snapshots. By the third I said, "Oh, my God, I got a cover." That's the way it happened sometimes: good luck and timing.

AMY KELLNER It's funny to think about what a ramshackle little operation *index* started as. How did we do anything without Email? I remember getting articles from contributors by fax and having to retype them. We also didn't have an advertising or distribution person yet, so I would lug boxes around town to cool stores, ask them to carry the magazine, and then ask them to buy ads. I got an ad for $50 from Adult Crash, a great, now-defunct record store on Avenue A, and one from a clothing store called Label in exchange for a cute purse.

ARIANA SPEYER The earliest advertisers—people who owned small stores in the newly coined Nolita and on the Lower East Side—thought *index* represented their worldview and wanted to be next to Sonic Youth and Parker Posey. They supported the magazine when no one else would: Wang, Spooly D's, TG-170, Cherry, Timtoum, Valerie's. André Balazs, after being plied with a delicious Indian dinner cooked by our friend Leslie Samuels, agreed to stock the rooms in his hotels with *index*—a major coup.

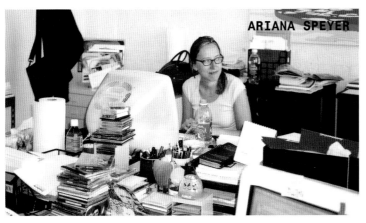

ARIANA SPEYER

MICHAEL BULLOCK The thought of becoming an ad salesman never would have crossed my mind in a million years, but for *index* it was a different story. *index*'s small structure allowed me to be involved at every level: editorial decisions, writing, planning events, and, lastly, selling advertising. Knowing that by selling ads I was supporting artists and ideas that I admired allowed me to take on sales with conviction. About the time I started, the fashion world was getting into bed with the art world, and *index* benefited. Tom Ford was the first to act on the trend. He collected Peter's paintings, but *index* had no

Gucci ads. This was my potential break into the fashion system. Gucci said yes, quickly followed by Marc Jacobs, Comme des Garçons, Jil Sander, Dior Homme, Yves Saint Laurent, Helmut Lang, and APC. The ironic thing about my job was that the culture *index* championed was almost diametrically opposed to consumer culture.

ARIANA SPEYER The short-lived Japanese version of the magazine was improbably published by a mysterious Japanese clothing importer/exporter who liked to party.

SHAWN MORTENSEN, Photographer (2004–2005) I think that *index* was a magazine that other magazine writers would read for story ideas, and it was definitely a sign of the changing times when *index* decided to close. *index* was really at the cusp of culture, so when they decided to close at the ten-year mark, it really seemed to encapsulate an era.

Shawn was interviewed in 2008.
He passed away in 2009.

JESSE PEARSON *index* has been ripped off a lot. The chatty, sweet, casual tone that was an *index* trademark is everywhere now. I think that voice was in large part due to Richard Wang and Amy Kellner. And the original clean and stark design that the magazine used in its first years got aped so much that it became a cliché in the indie magazine world.

STEVE LAFRENIERE I'm glad this best-of-*index* collection is being published, so that kids know where the look and feel of so many current mags came from. But I'd also advise them to hit eBay, track down the original issues, and read not only the interviews but anything by Richard Wang, David Savage, Christina Kelly, Mary Clarke, Bruce Hainley, Carole Nicksin, Ian Svenonius, Pat Sullivan, and the great Tina Lyons. It is recent history in the making and the best guide I know to how it should be correctly recorded.

JESSE PEARSON This might sound fogeyish, but I wish that every new kid who moves to New York to be an editor, a writer, or a photographer could each get a full run of the first couple of years of *index*— those big, cumbersome, amazing issues. I bet it would cause a lot of blogs to shut down and a lot of print zines to start up. We all know that print is just *inarguably* better than web because you can hold it in your hands. The web is important, and to ignore it is silly, but print is alive in a way that the Internet can never be.

All images courtesy of *index* magazine archive.

index

2 / 96

C
Covers

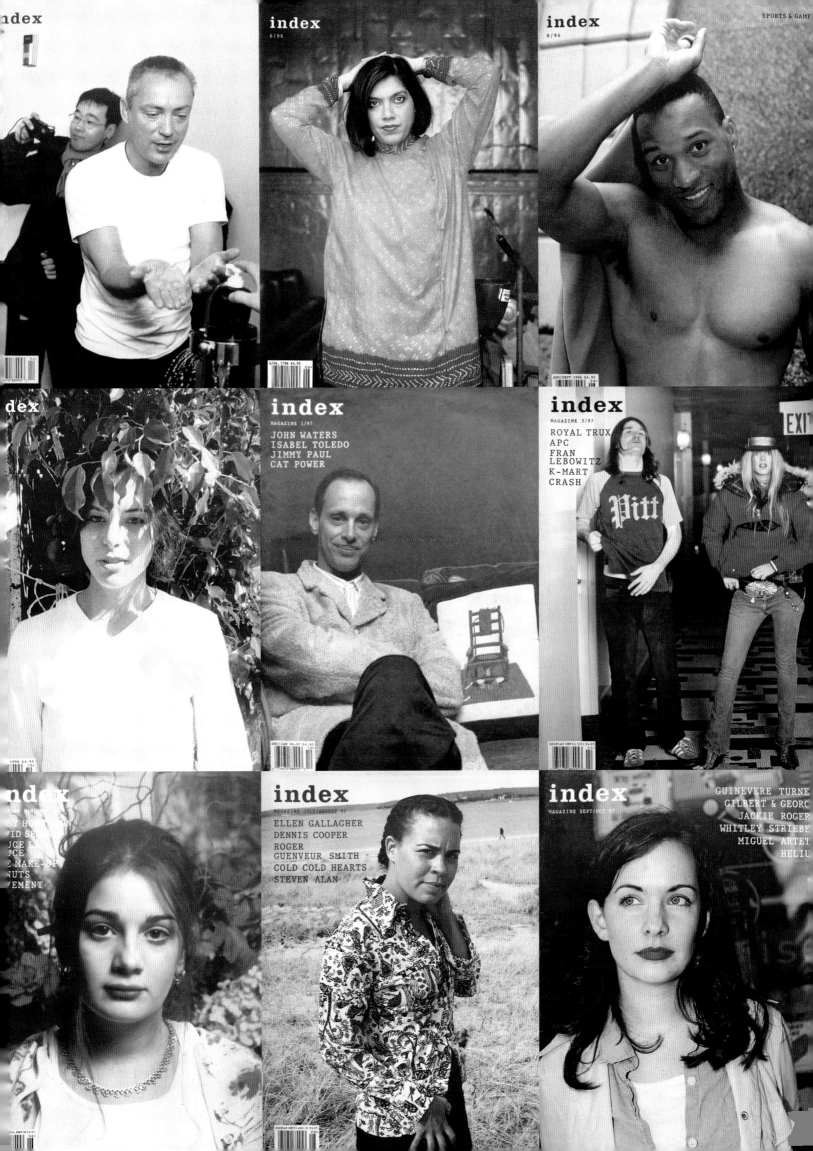

index

index
6/96

index
8/96
SPORTS & GAME

index
MAGAZINE 1/97
JOHN WATERS
ISABEL TOLEDO
JIMMY PAUL
CAT POWER

index
MAGAZINE 3/97
ROYAL TRUX
APC
FRAN
LEBOWITZ
K-MART
CRASH

index

index
MAGAZINE JULY/AUGUST 97
ELLEN GALLAGHER
DENNIS COOPER
ROGER
GUENVEUR SMITH
COLD COLD HEARTS
STEVEN ALAN

index
MAGAZINE SEPT/OCT 97
GUINEVERE TURNER
GILBERT & GEORGE
JACKIE ROGERS
WHITLEY STRIEBER
MIGUEL ARTETA
HELIUM

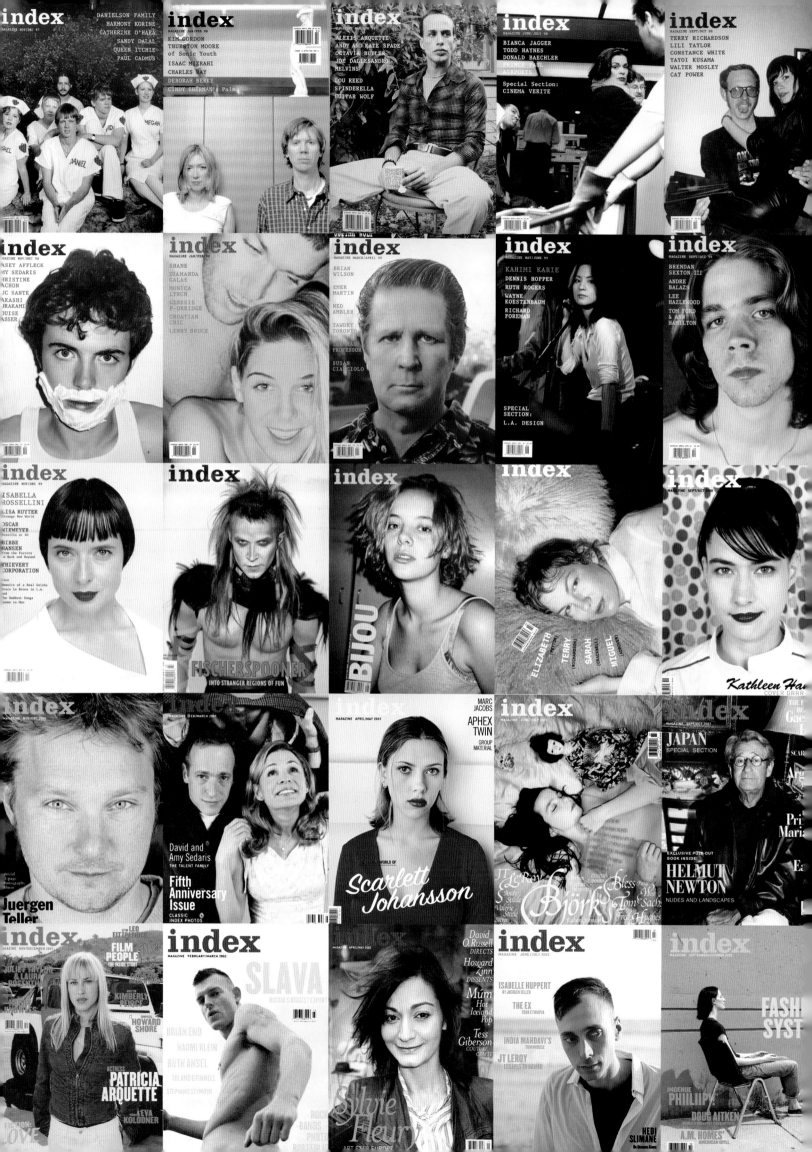

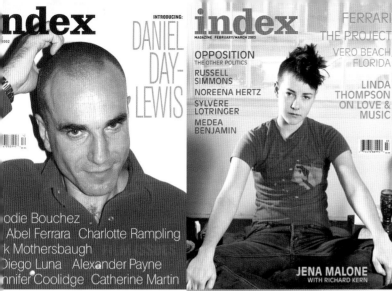

index

INTRODUCING:

DANIEL DAY-LEWIS

odie Bouchez

Abel Ferrara Charlotte Rampling

k Mothersbaugh

Diego Luna Alexander Payne

nnifer Coolidge Catherine Martin

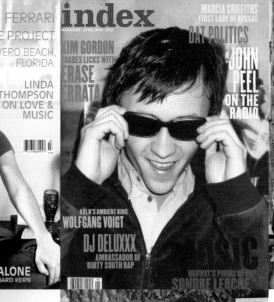

index

MAGAZINE FEBRUARY/MARCH 2003

OPPOSITION
THE OTHER POLITICS
RUSSELL SIMMONS
NOREENA HERTZ
SYLVÈRE LOTRINGER
MEDEA BENJAMIN

FERRARI
THE PROJECT
VERO BEACH, FLORIDA

LINDA THOMPSON
ON LOVE & MUSIC

JENA MALONE WITH RICHARD KERN

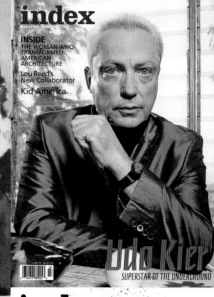

index

MAGAZINE APRIL/MAY 2003

MARCIA GRIFFITHS
FIRST LADY OF REGGAE

DAT POLITICS

KIM GORDON
TRADES LICKS WITH
ERASE ERRATA

JOHN PEEL
ON THE RADIO

KÖLN'S AMBIENT KING
WOLFGANG VOIGT

DJ DELUXXX
AMBASSADOR OF
DIRTY SOUTH RAP

NORWAY'S PRINCE OF POP
SONDRE LERCHE

index

INSIDE
THE WOMAN WHO
TRANSFORMED
AMERICAN
ARCHITECTURE

Lou Reed's
New Collaborator

Kid America

Udo Kier
SUPERSTAR OF THE UNDERGROUND

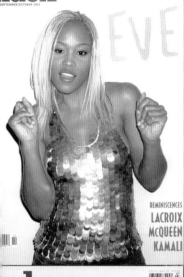

index

SEPTEMBER/OCTOBER 2003

EVE

REMINISCENCES
LACROIX
MCQUEEN
KAMALI

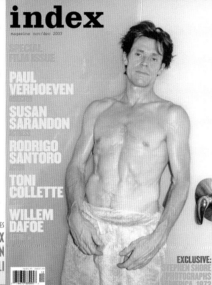

index

magazine nov/dec 2003

SPECIAL FILM ISSUE

PAUL VERHOEVEN

SUSAN SARANDON

RODRIGO SANTORO

TONI COLLETTE

WILLEM DAFOE

EXCLUSIVE:
STEPHEN SHORE
PHOTOGRAPHS
CIRCA 1972

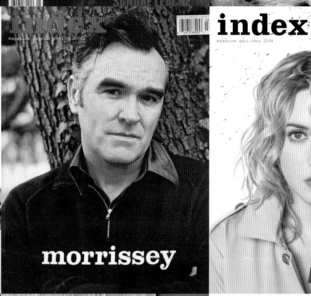

index

magazine february/march 2004

morrissey

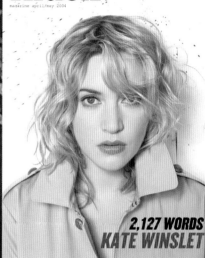

index

magazine april/may 2004

2,127 WORDS
KATE WINSLET

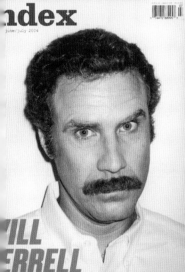

index

june/july 2004

WILL FERRELL

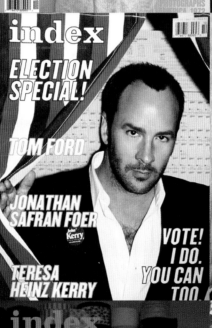

index

ELECTION SPECIAL!

TOM FORD

JONATHAN SAFRAN FOER

TERESA HEINZ KERRY

**VOTE!
I DO.
YOU CAN
TOO.**

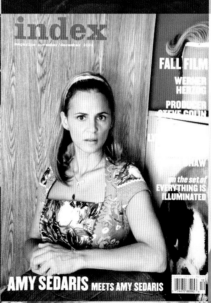

index

magazine nov/december 2004

FALL FILM

WERNER HERZOG

PRODUCER
STEVE GOLIN

on the set of
EVERYTHING IS ILLUMINATED

AMY SEDARIS MEETS AMY SEDARIS

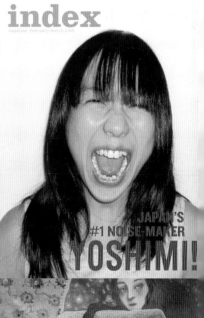

index

magazine february/march 2005

**JAPAN'S
#1 NOISE-MAKER
YOSHIMI!**

index

TOGRAPHER
ARD PRINCE

SAGE
IA BALDRIGE

OD COUPLE
R & ROLF

SMOKY CHANTEUSE

RK LORD
RANK

E SILL

**RISPIN
OVER**

IS WHAT IS IT?

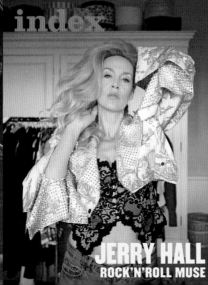

index

JERRY HALL
ROCK'N'ROLL MUSE

index

magazine september/october 200

stephen malkmus

from pavement
poet to portland
pop

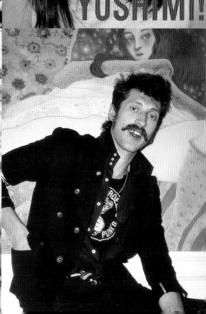

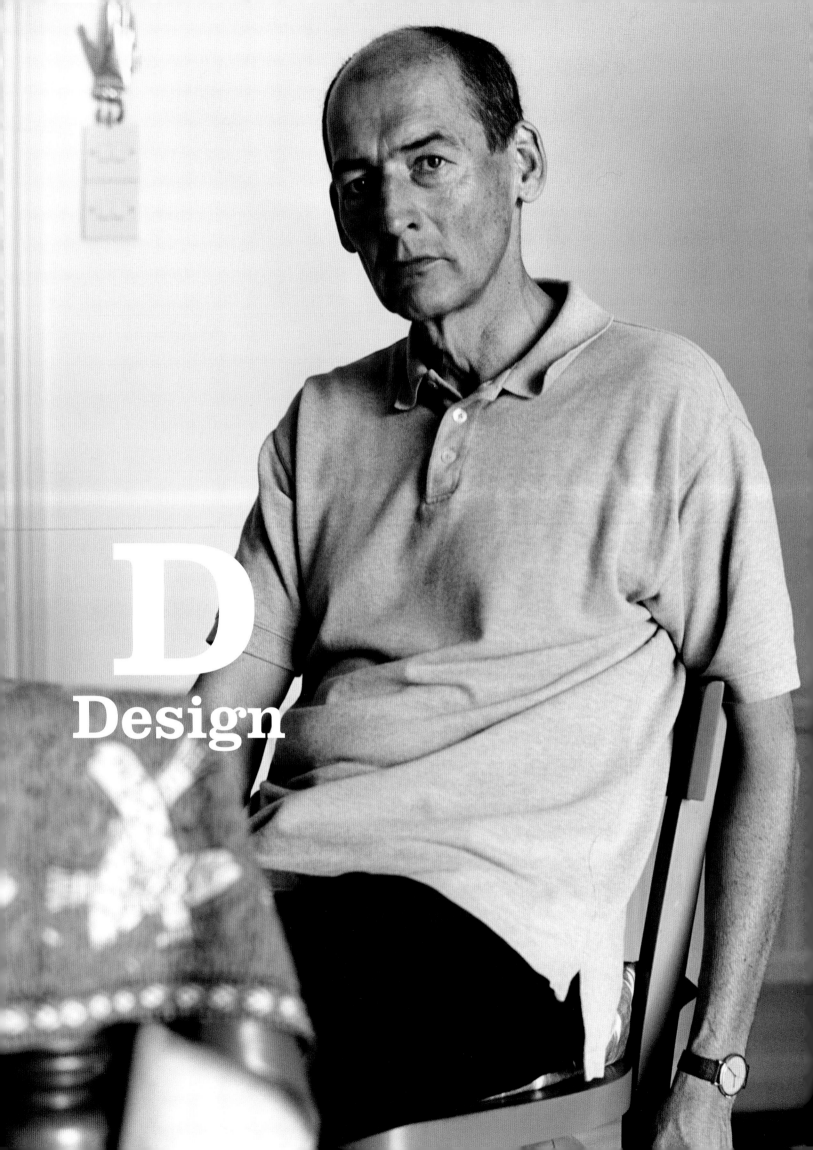

D
Design

REM KOOLHAAS
with Jennifer Sigler

**Photographed in Rotterdam by Wolfgang Tillmans
September/October 2000**

JEN: Let's talk about something besides architecture.

REM: Do you know that in the past week I've been swimming in Lagos, in Milan, in Switzerland, in Rotterdam, in London, in Los Angeles, and in Las Vegas?

JEN: Incredible. In one week?

REM: Yes. That means seven cultures, seven typologies of bodies, seven typologies of movement, seven typologies of exhibitions, of introversion, of hygiene, seven typologies of smell. Taste is almost as important. The water feels like a very thin soup, like gruel, and with some training you can taste who has been swimming there. In Holland, they rotate swimmers in a very ideological, politically correct way—old people, retarded people, Turkish people. I have a sense that I can tell the whole prehistory of the water.

JEN: Why do you swim?

REM: It's about the relationship between your ideas and your body. It both evacuates and charges. You can influence your mind by being serious about your body—by knowing it very well.

JEN: You also run. When did you start running?

REM: '74. In America. I was the typical European. That means either you're perfect or not. But you're not perfectible. In Europe, the authentic is foremost, and anything related to sports is suspect. So, I was thirty and in America, and I discovered for the first time the virtues and pleasures of synthetic materials instead of cotton. Sports, for me, are about artificiality.

JEN: I heard that during the construction of the Netherlands Dance Theater in The Hague, you were trying to find a fabric the texture of American women's underwear. Nobody could imagine what you wanted.

REM: They didn't know! Anyway, it became incredibly exciting to overcome the European taboo. And running became interesting.

JEN: Were you trying to get in shape or did you just enjoy it?

REM: I enjoyed the intellectual side of it. I enjoyed it as an alternative to letting nature take its course.

JEN: In New York, you ran in Central Park?

REM: Yes. Around the reservoir, and Jackie Kennedy was there, and sometimes you were trailing Jackie, and you would pass her and smell her . . .

JEN: Jackie was also running?

REM: Yes. There are so many people I know as a kind of afterimage of their smell. Seriously. An afterburn. You might not know who they are, but you know them incredibly well, because you know how they move and how they smell.

JEN: That must be why you make people nervous. You take in everything. People feel that.

REM: I can't ever be oblivious. I wrote a sentence today: "The tyranny of the oblivious . . . " My whole life has been about envying the tyranny of the oblivious. And feeling the vulnerability of the recorder.

JEN: Of the what?

REM: Of those who record.

JEN: You call yourself a recorder?

REM: The thing is that I have a really intense, almost compulsive need to record. But it doesn't end there, because what I record is somehow transformed into a creative thing. There is a continuity. Recording is the beginning of a conceptual production. I am somehow collapsing the two—recording and producing—into a single event.

JEN: In that sense you're still a journalist. You study a situation and then report it. The Harvard Project on the City—including your studies of shopping and of Lagos, Nigeria—seems to be a form of journalism.

REM: Well, shopping led to my writing *Junkspace*, which goes beyond journalism.

JEN: Why did you want to study shopping?

REM: I did the family shopping—in Indonesia, when I was eight—in a chauffeur-driven car. That was my first experience with shopping. Markets. That is why the Western experience of shopping is a disappointment. All goods are put in their places—in compartments; there is no surprise. Shopping is based on certainties of what you get where. It's so sedate.

JEN: What made the Asian markets so alive?

REM: In Asian and African shopping, every transaction is also social, really charged. It's happening in the free air. That kind of condition is the urban realm. Here, what used to be free—namely, the city—has become private. You have to pay for it. There, it's still free. That's why we did the shopping book—to document, analyze, and interpret what was happening.

JEN: Wasn't there a time in the Western world that shopping had that energy?

REM: In the shopping book we have reconstructed the transformation of shopping with these genealogical trees that document it almost step by step. The whole Harvard Project is about modernization—"Annals of Modernization" could be its subtitle. When air-conditioning, escalators, and advertising appeared, shopping expanded its scale but also limited its spontaneity. And it became much more predictable, almost scientific. What had once been the most surprising became the most manipulated. When shopping was still connected to the street, it was also an intensification and articulation of the street. Now it has become utterly independent—contained, controlled, surveyed. You could say the shopping project is also about nostalgia for a pre-modern condition.

JEN: But are any of those qualities things that you can

REM: Resurrect?

JEN: Yeah—would you have the ambition or interest to try to do that?

REM: I don't think you can actually do the same thing again. It's about the numbers of vendors, the scale of the operation. That is the ambiguity of this moment: on the one hand, the possibilities are becoming limitless, but at the same time, the choices are becoming more coherent—they form a single pattern, address a single group, and are becoming more exclusive.

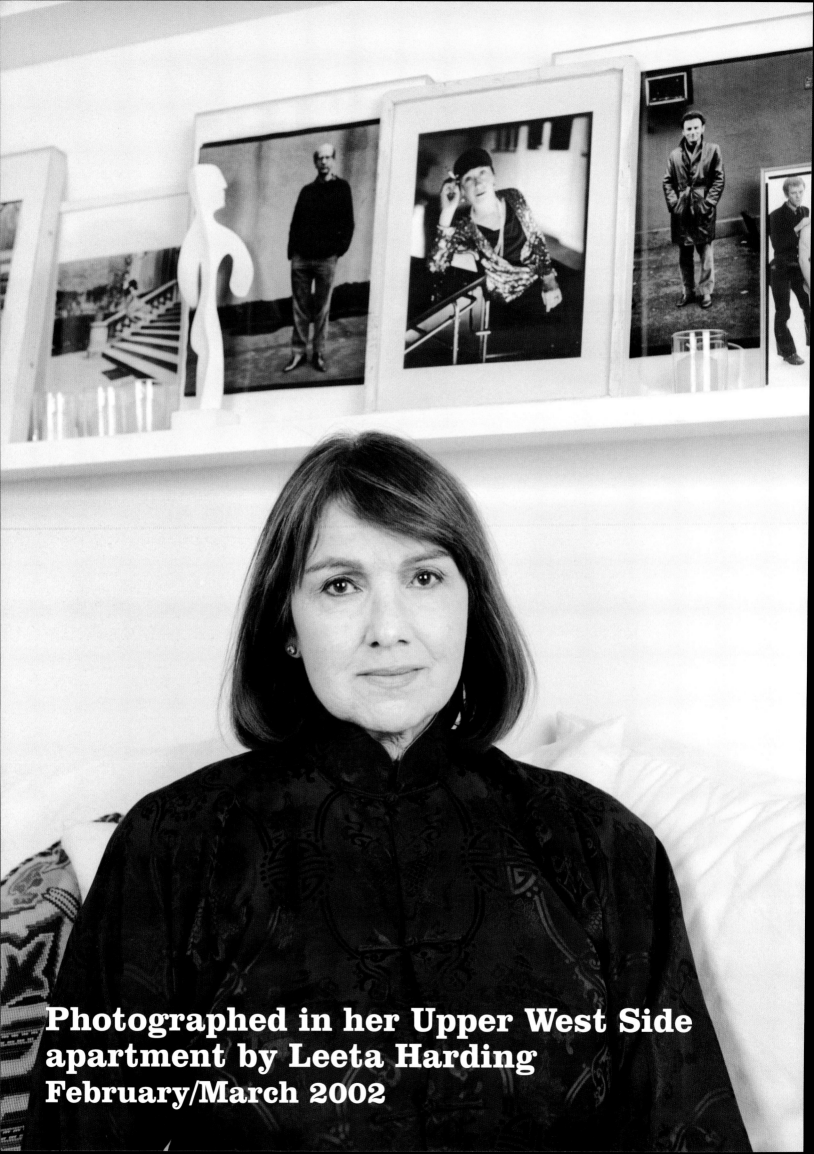

Photographed in her Upper West Side apartment by Leeta Harding February/March 2002

Photograph of *Harper's Bazaar*, April 1965 (right)

RUTH ANSEL
with Leeta Harding

Every decade has a few magazines that seem to reflect its cultural essence. During the experimental '60s, *Harper's Bazaar* redefined the fashion magazine. In the unsettled '70s, the *New York Times Magazine* brought the rough-and-tumble world of the Nixon era into focus. And in the opulent '80s, Vanity Fair pioneered the glamorization of the media. It just so happens that one woman, Ruth Ansel, was the art director for each of these magazines in their heyday.

RUTH: Movies were my touchstone. The excitement of the images, the sense of escape, and the new iconography were what moved me. As I got out into the world, the closest thing to movies that I could envision making a living at was in magazines. My choice was *Harper's Bazaar*, because it had great beauty. I knew nothing of Alexey Brodovitch, who had art-directed the magazine so brilliantly for twenty-five years before Marvin Israel. And I only knew Dick Avedon because of *Funny Face*. At the time my heroes were Picasso, Matisse, and the artists who were emerging in the '60s. I didn't think of graphic designers or photographers as heroes—I thought, "So what, nice work, but so what?"

LEETA: As an art director, what are your main concerns?
RUTH: It's all about casting, casting, casting—finding the right photographer for the right assignment at the right time. In that sense, a good art director is almost silent.

LEETA: Like certain film directors.
RUTH: Yes. There are two important facets to the job. First, you have to juggle the major talents who are already on board. And second, you're always looking for up-and-comers to complement what you already have. At *Harper's Bazaar*, for example, I never wanted two Avedons once I had Avedon, or two Hiros once I had Hiro. Bob Richardson was totally different from any other photographer when he appeared in the early '60s, so I helped bring him along.

LEETA: Your former boss at *Bazaar*, Marvin Israel, once said that art direction is like theater: "When it works, it's like putting on a play—there's this great feeling of union."
RUTH: He was a great artist himself. He liked the fact that I didn't come from a graphic-design background—that I had a fresh eye. I've always respected him for giving me the chance. And there was also Bea Feitler, this mad, wonderful, eccentric, Brazilian girl whom Marvin had taught too. It was just the three of us.

LEETA: What a unique opportunity.
RUTH: Yeah. I learned it all on the job, I really did, and I was in pretty rigorous company. These people were not kidding around with their level of talent. I had no idea that I was working at the tail end of a great era—that Diana Vreeland was one of the greats of all time who could never be replaced. I had been touched by the brilliance of all these people.

LEETA: What was the reason Vreeland left for *Vogue* in 1962?
RUTH: The story is really a blot against the Hearst Corporation. Nobody got paid much in those days—in most cases they still don't—so a lot of the ladies who worked in fashion were from rich families. They could afford to work for nothing, and their contacts made the magazine, because they were the beautiful people. Vreeland, who needed to work, was never paid enough. When she was offered the job at *Vogue*, Hearst Corporation wouldn't match the salary—and it was a measly sum. They lost her on account of that stupidity.

LEETA: You became co-art director with Bea Feitler in 1963. You must have been in your mid-20s.
RUTH: And we were women! When Marvin was fired, there must have been a hell of a lot of talk about, "Who shall we get? Who's going to replace Marvin?" It was a big deal—*Harper's Bazaar* was a high-end fashion magazine. The decision was made to give "the girls" the chance to be co-art directors.

LEETA: Did you feel overwhelmed?
RUTH: To be quite honest, I was blissfully ignorant of the legacy.

LEETA: Do you remember your first issue?
RUTH: I really don't. The issue that I worked the hardest on, and the one that reflected most of who I was at the time, was the '65 Avedon issue. It celebrated the explosion of pop art, rock music, The Beatles, and youth.

LEETA: And Space Age technology?
RUTH: That's right. It was this incredible moment in the early '60s, and Dick Avedon was out there sniffing around. He understood what was happening in politics and the new youth culture. He knew that our editor, Nancy White, was not savvy enough to pull it off. His success as a photographer gave him great power, so he persuaded Nancy to let him take over the issue as guest editor, which was a wonderful idea.

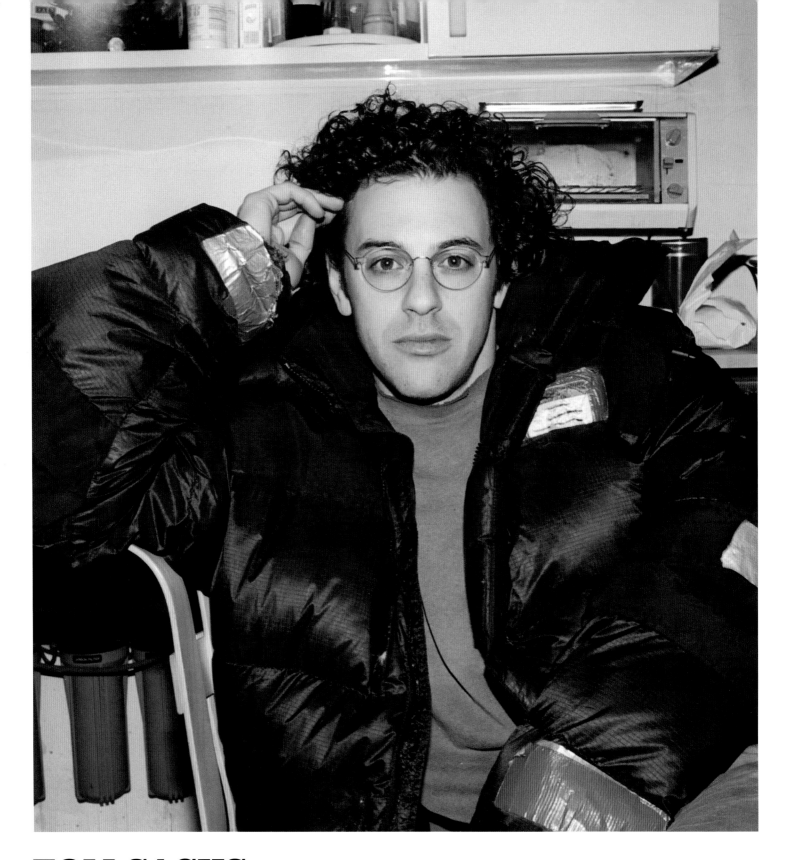

TOM SACHS

Photograph by Leeta Harding
June/July 2001

Someone said to me, "Don't you make anything
that isn't about killing and destruction?"
And I said, "Well, I just made a model of
every object in my Hello Kitty collection—
one hundred and fifty pieces."

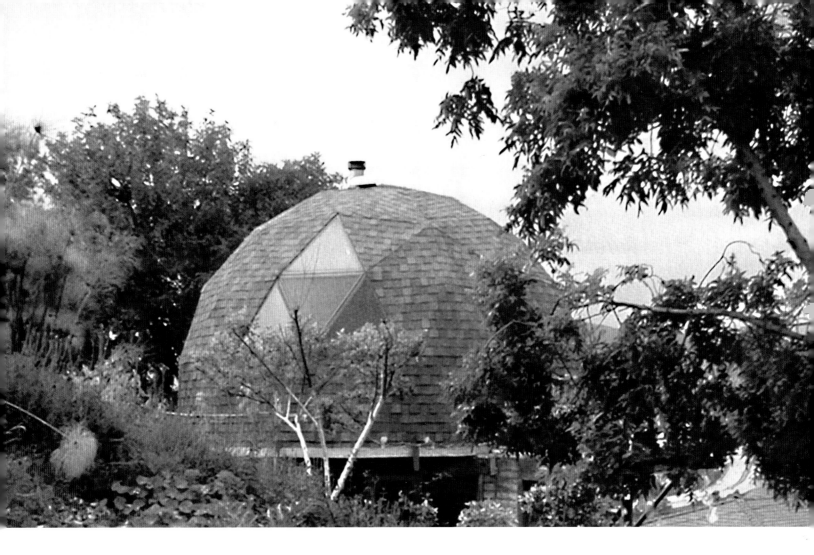

Architect FRITZ HAEG'S geodesic dome in Los Angeles.
September/October 2005

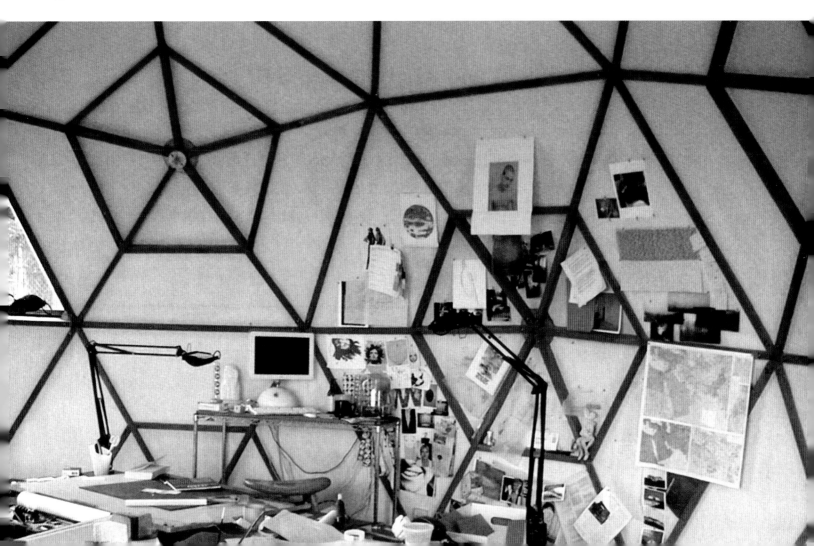

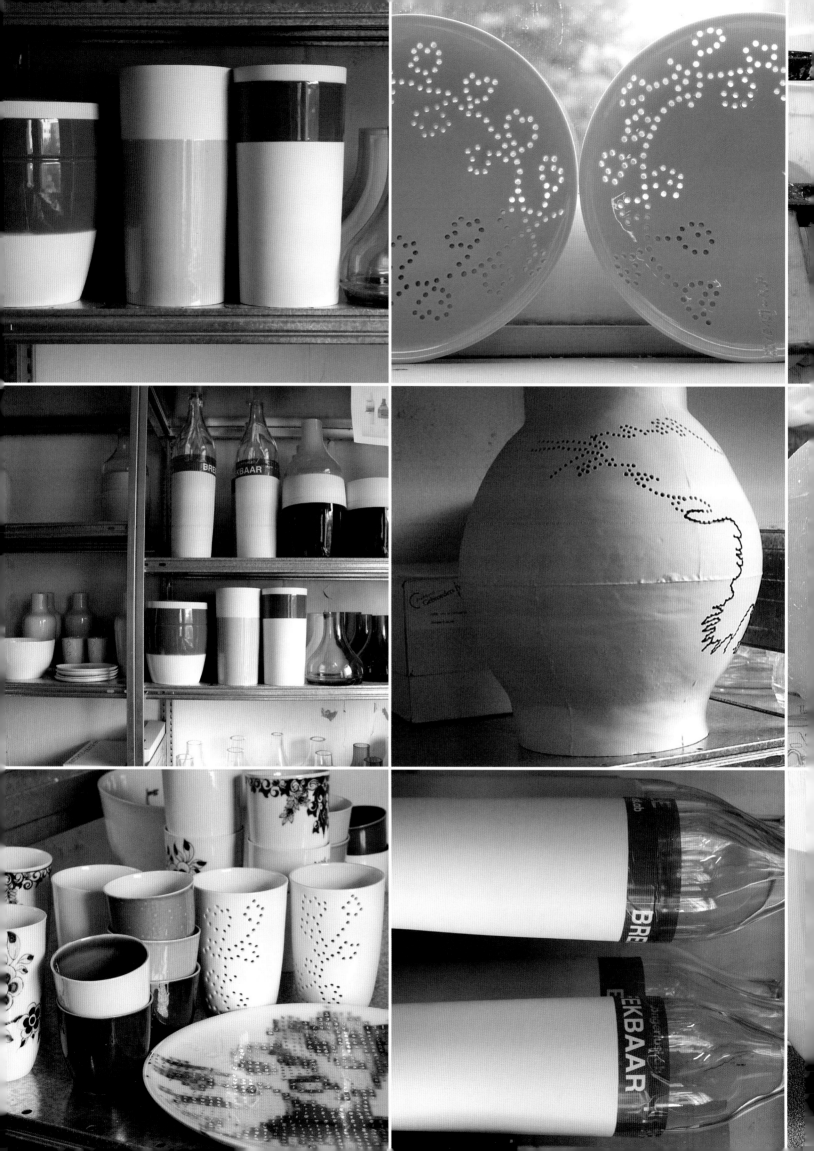

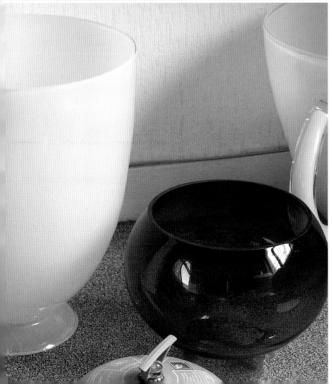

HELLA JONGERIUS
with Andrew Goetz

Photographs by Beat Streuli
September/October 2003

ANDREW: You work with materials that are widely used, but you find surprising applications for them. Polyurethane is usually thought of as an industrial coating, but you employ it for your vases and bath mats. How do these ideas come to you?

HELLA: I find them everywhere. I'll see something in a sports shop, make a note, and call up later to find out what material it's made from and how that material is manufactured. I'm like a child in a toy store. I am always drawn to materials that I'm not familiar with. For example, now I know a lot about porcelain, but it's not much fun for me to use. It feels too much like work.

ANDREW: So there is an evolution. You get tired of one material . . .

HELLA: And I move on to another.

MATALI CRASSET
Photographed in Paris by Elke Hesser
June/July 2005

The French designer remarked on designing furniture, "I'm not driven by aesthetics—it's more a matter of logic and methodology."

GAETANO PESCE
Photograph by Juliana Sohn
September/October 2001

I think that before everything else,
the intellectual has to be a traitor.

CASEY SPOONER
Photographed by Terry Richardson
February/March 2000

It'll be interesting when DJs start
playing our music, because a certain
crowd is just going to relate to
us musically. The only problem with
that is a year from now Fischerspooner
might not be doing music anymore.

E
Electro

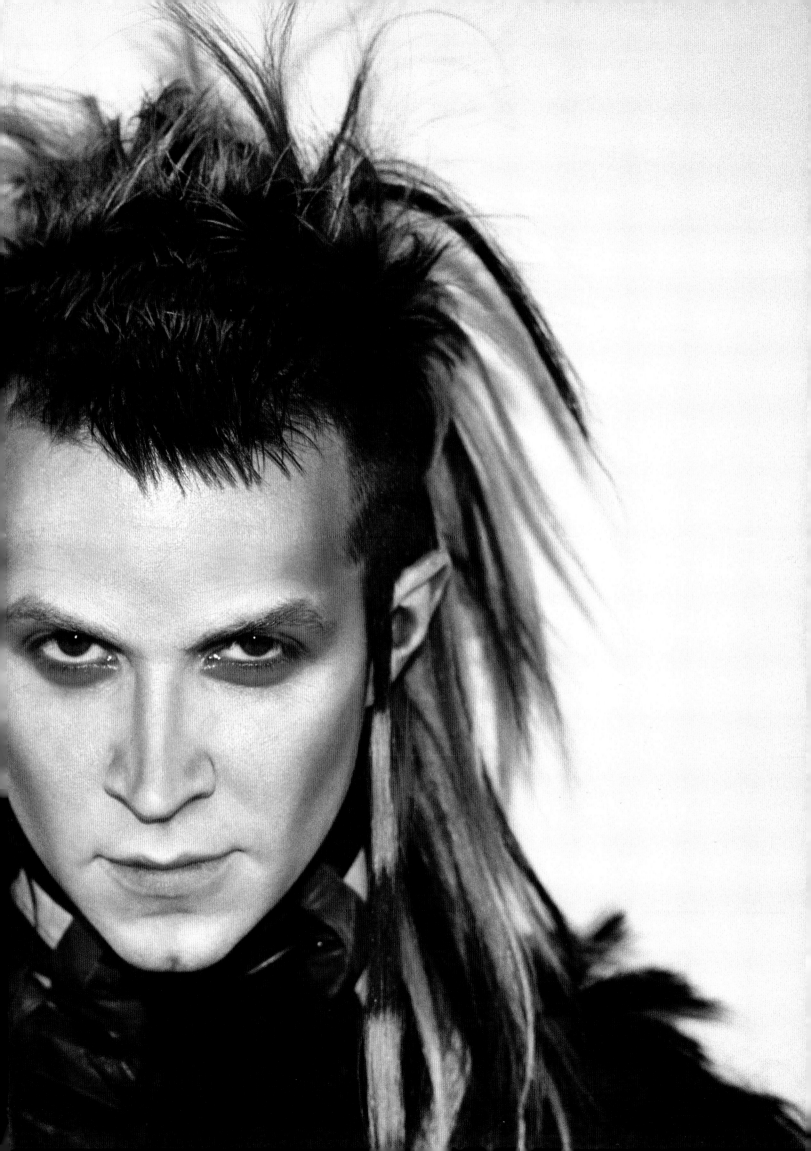

SWEET THUNDER at Starbucks

By Steve Lafreniere
November/December 1998

A few Thursdays ago, I invited my friend Hugs over for dinner. He wanted to come, he said, but had to get back to the city by 9:30 to see a band. "You should go with me. I think you'd like them. They're, like, glam rock. At Starbucks." Not grasping this last detail, I said, "Maybe. Where're they playing?" He laughed, "Starbucks . . . I know, right?"

Indeed, at the Astor Place outlet later that night, the ungraspable was in full swing. Arriving late, we were amazed to find a hundred or so cafinos and youthquakers packed at the counters and spilling out onto the sidewalk. In one corner of the store had been erected a teensy stage, currently upon which a man in a Lydia Lunch wig was pulling off his trousers. A backing track of Casio-ey techno was ching-chonging over the sound system, and for a second I thought we'd gotten there between acts. But then, stripped to his engine-red jockeys, the fellow roared to life. Berserking around the stage in a distraught approximation of '80s robo-goth, he began screaming over the music: "Ogi! Ogi! Ogi! Ogi! Ogi! Baby New Yooork!" Hugs leaned over. "Casey's doing Mono Trona's act for her. She's this Korean performer. She had to cancel." Many in the crowd chanted along cheerfully. A woman next to me, a devotee of either Mono Trona or her interpreter, was responding with High-Sierra hoots, prompting a man near the front into fits of shimmying while marching in place—probably the only time I've seen a Nolita-type in Sandy Dalal slacks thusly moved. After a couple more numbers, performed as much to surprised passersby outside, the window as to the audience inside, "Mono" was off, to strong applause. "How is this happening?" I wondered, and bought a Frappucino™.

Next up for consideration was a puppet act titled "Mister Manchild and Spoons." Costumed as a kiddie-show host, replete with construction-paper crown, Mister Manchild posed casually at a Fairlight keyboard and grilled his floppy canine about his day. Spoons answered in the requisite cross-eyed manner of hand puppets everywhere, and I thought maybe the act was going to tank, when, for no discernible reason, Donovan walked onstage and began singing "Mellow Yellow." Well, another approximation. But for the wonderstruck/confused Starbucks mob, it was "Yay! Donovan!" As he joyously kicked up his caftan and sang, Spoons shrieked with glee, and I couldn't help but notice through the caramel glow of absurdity a yup chick rocking out by the door, tapping a cell against her cup in time. Lovely. Really. Although with the sudden appearance of another puppet named The Ghost of Darby Crash, sprouting hypodermics from each arm, I realized how dizzy with incongruity things were becoming.

While the audience giggled and whooped it up, I worked my way back to the counter and there eavesdropped on a Starbucks worker explaining to someone, "It's just another way to bring in business, really. On Wednesdays we're going to have drum 'n' bass." Well, I reasoned, here's the future. But then . . . it actually would be sort of great seeing DJ Soul Slinger here. Or at Krispy Kreme Doughnuts, for that matter. My caffeinated mind whirred: Karen Finley at Au Bon Pain; Thurston Moore at the Sixth Avenue Taco Bell; the Toilet Böys knocking 'em flat at Boston Market. Hell, they could even put on Wigstock at that big Red Lobster in Midtown.

The entrance of the evening's stars cut short my reverie. At the mercy of a malfunctioning backing tape, Sweet Thunder nonetheless marshaled themselves glamorously and teetered into their set. Mock rock-operatic and "futuristic" in frippery not seen since Jobriath's last gig on *Don Kirshner's Rock Concert*, I guess you could say Sweet Thunder were the antithesis of their burnished-wood surroundings. But marching upstage and back in twos and threes, immense glitter collars flapping aloft, somehow theirs was a show with an anodyne effect. Maybe it was the song lyrics themselves, which, though obscure ("Panorama! / Cyclorama! / Paint and canvas! / Are simply not enough!"), had a threateningly mystical quality, as if they'd been mopped from some beautiful antique musical for machine elves. It wasn't until later that I was told all their songs are about Niagara Falls, a conceptual trope they find endlessly rich with metaphor. Wow. They were really great.

If you call the manager of Starbucks and praise this new twist in product branding, he will graciously acknowledge your thanks before making you aware of the 100 Starbucks stores expected in Manhattan by the end of the year, of the company's sponsorship of the Lilith Fair festival, and maybe even of the Tiazzi™, "our latest menu-board entry." And it's at that moment that you will maybe muse on how strange fun has become.

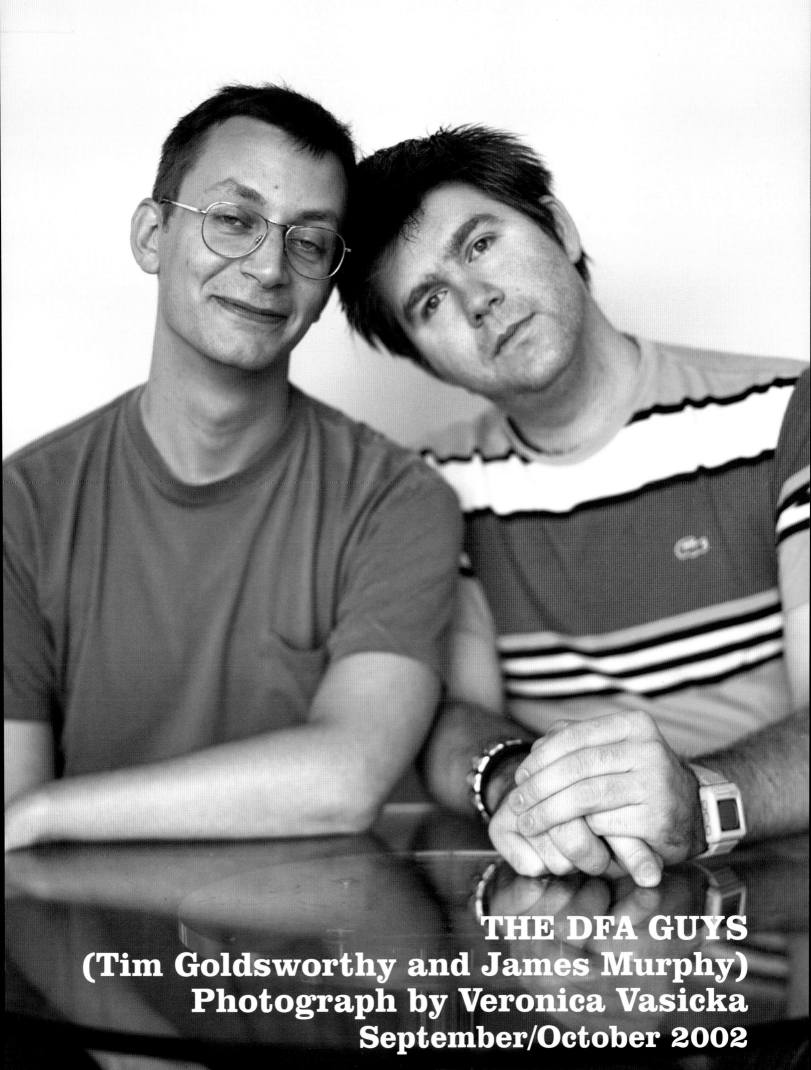

THE DFA GUYS
(Tim Goldsworthy and James Murphy)
Photograph by Veronica Vasicka
September/October 2002

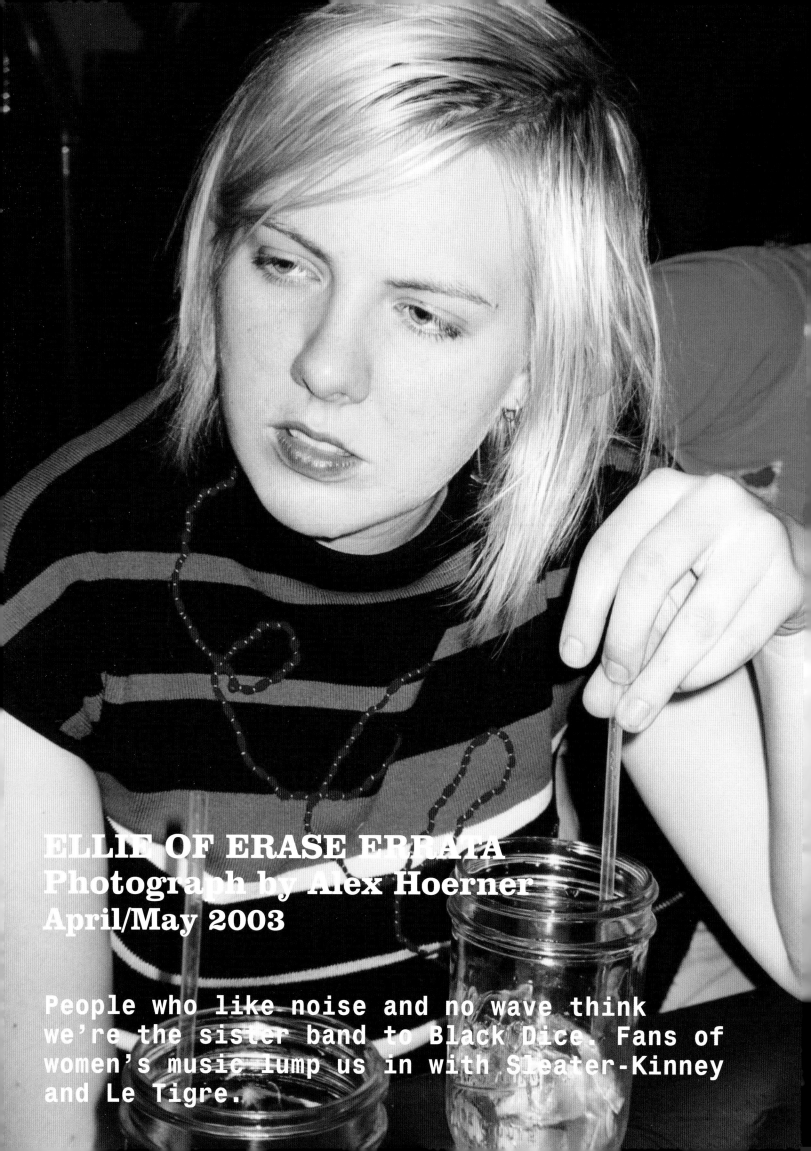

ELLIE OF ERASE ERRATA
Photograph by Alex Hoerner
April/May 2003

People who like noise and no wave think
we're the sister band to Black Dice. Fans of
women's music lump us in with Sleater-Kinney
and Le Tigre.

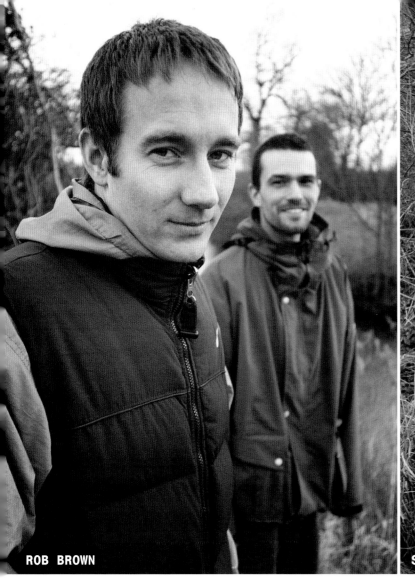

ROB BROWN

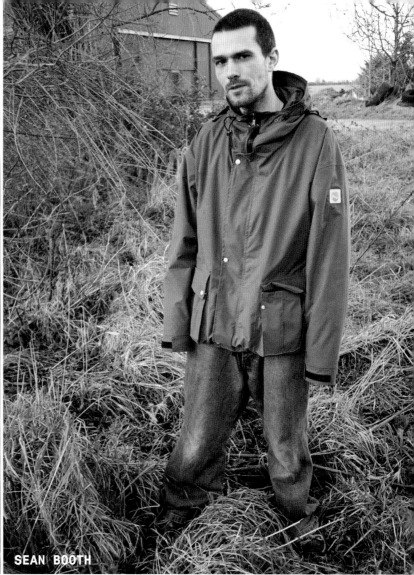

SEAN BOOTH

AUTECHRE
Rob Brown and
Sean Booth with
Steve Lafreniere

Photographs by Juergen Teller
April/May 2000

ROB: Music was the hub of the whole collection of things that were about when we were twelve, thirteen years old.

SEAN: Hip-hop was something we could make at age twelve. All you had to do was find a good record, nick a bit of it, loop it over, Scotch over it, and then you had a track. We'd been messing around with tape recorders and Walkmans and butchering stuff, so it was that kind of spray-can mentality: taking prefabricated things and really expressing yourself within a short amount of time. Using things that had taken an awful lot of planning, flipping them and doing something that's totally fresh. Not anything the maker had intended it to be used for, but actually turning it into a tool.

STEVE: Where did the obsession with complex polyrhythms come from?

SEAN: Well, in the beginning, when you would see someone scratching, it was, "Fuckin' hell, check that out." Rather than just playing records backward or slowly, you could go "chka-chka-chka-chka." I think there's more rhythm in scratching than there's been in any kind of dance music that's come before or since.

STEVE: It's not really been looked into very critically.

SEAN: You can get ahold of time and absolutely fuck it over, turn it inside out. You're actually, literally, folding time.

ROB: And the format, being analog, goes quite deep with the different pitches. You can get a massive dynamic range across the rhythmic spectrum.

SEAN: When I was first getting spun out by music, it was things like K-Rob, Kraftwerk's Tour de France, "Hip Hop, Be Bop" by Man Parrish—all Man Parrish, actually—and stuff like the Jonzun Crew. They were so loose, but so fucking anally tight as well. All that music back then had so much flow to it.

STEVE: Did you have to really seek this stuff out?

SEAN: No. Every kid we knew was into breaking and funk. It was massive over here in the UK.

ROB: Even shopping centers would be a hub. There was space, a floor, and a solid roof. You could go there at any time of the day, and it was usually lit up.

STEVE: So you were mall rats . . .

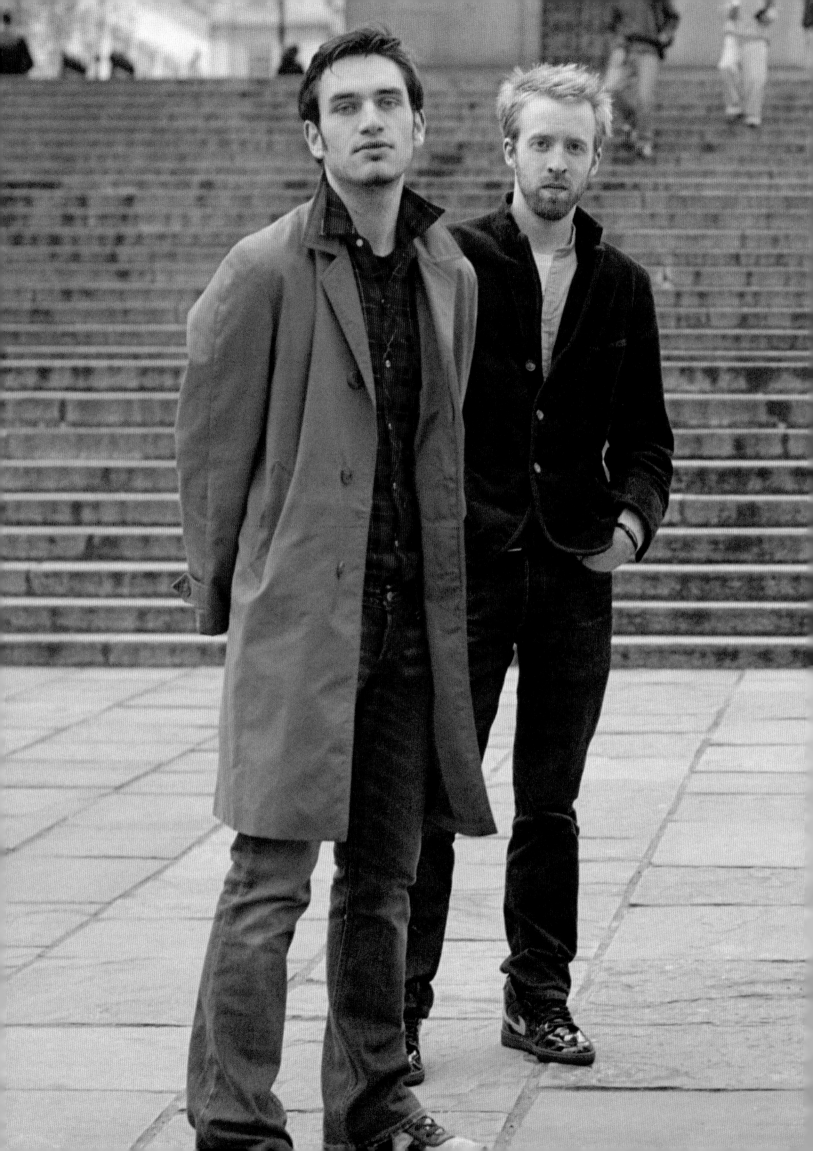

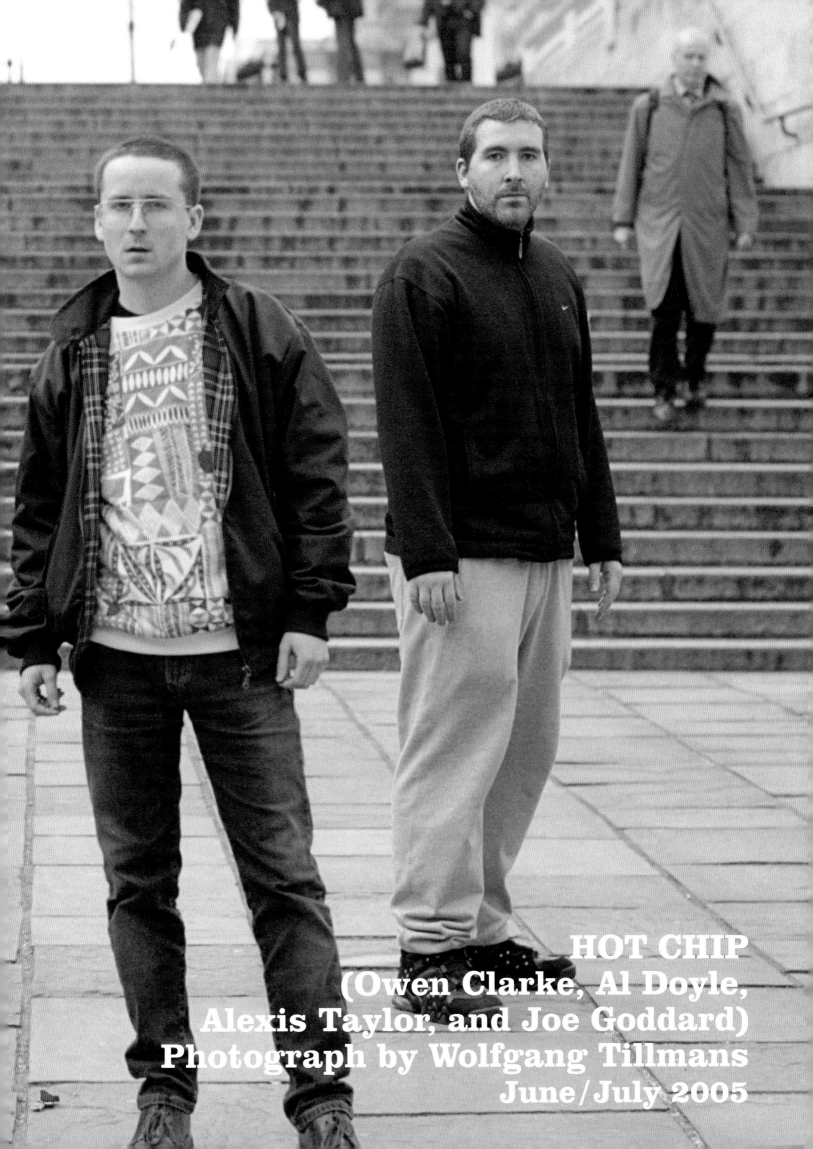

HOT CHIP
(Owen Clarke, Al Doyle,
Alexis Taylor, and Joe Goddard)
Photograph by Wolfgang Tillmans
June/July 2005

APHEX TWIN (Richard D. James) with Meredith Danluck

Photograph by Wolfgang Tillmans
April/May 2001

MEREDITH: You must have thousands and thousands of tracks. How do you choose which ones you want to release?

RICHARD: I'm not into releasing every track I've done. Some are sort of personal; some are written for specific people. You wouldn't want anyone else to get those. They're like my little babies. Others, I really don't care about at all.

MEREDITH: Would you ever want to do an over-the-top, chart-busting pop song?

RICHARD: How do you know I haven't? [Laughs.] I've done loads of secret things. There are quite a few that no one has come close to guessing. But then, a lot of people think everything electronic is mine. I get credited for so many things, it's incredible. I'm practically everyone, I reckon—everyone and nobody.

MEREDITH: Well, people expect you to do such varied things. You're the opposite of someone like Squarepusher, for example. His work is so distinctive that any track I've ever heard, including the unreleased stuff you were playing off your computer, is instantly recognizable, whereas most of your stuff is radically different from track to track.

RICHARD: It's funny, with pop music there's usually no doubt whether you're hearing a certain singer or not. But with a lot of electronic artists, you'll be like, "This artist is really amazing, they're the best in the world, but is this track by them?"

MEREDITH: I see a mask of your face on the wall. It's from one of the Chris Cunningham videos, right?

RICHARD: Yeah, it's from "Come to Daddy."

MEREDITH: Freaky!

RICHARD: Quite disturbing, isn't it? My girlfriend and I have scared each other so many times with that fucking thing. I'll wear it to bed and put the covers over myself, then sort of cuddle up to her and wait for her to turn around. Once she went to stroke my face, and I had it on! [Laughs.] Then she did the exact same thing to me three months later.

MEREDITH: What's it made of?

RICHARD: Silicone. They cast my face, but it didn't look anything like me—it looked like I was taking a dump. So they had to sculpt it from photos instead. Quite well done, except they didn't give me any eyebrows. And they're not my teeth. All the masks are different. The black ones are really lush—they were for the "Windowlicker" video.

MEREDITH: Both of those Chris Cunningham videos are amazing. They really connect with your music.

RICHARD: It's funny, sometimes people refer to those as "my videos." It's my music, but they're not my videos. I didn't make them.

MEREDITH: Both "Windowlicker" and "Come to Daddy" poke fun at certain genres. "Come to Daddy" seems like it's saying, "Black metal rules, but this is how it should be done!" And "Windowlicker" is, like, "R&B, I love you dearly, but have you no shame?"

RICHARD: I've worked in so many genres, though. People always think that I consciously manufacture those ideas. I'm always envious of people who do only one thing—I think that would be quite relaxing. But I definitely wouldn't want to make the same sort of music all the time. I'd go mad. "Come to Daddy" came about while I was just hanging around my house, getting pissed, and doing this crappy death-metal jingle. Then it got marketed, and a video was made, and this little idea that I had—which started as a joke—turned into something huge. It wasn't right at all.

MEREDITH: You're not into the whole showbiz thing.

RICHARD: Well, I'm not into the big media effort. It was good for a while, but I'll never do it again. I might make other videos, but I'll never make another that gets into the mainstream.

MEREDITH: Those tracks got into the mainstream?

RICHARD: Pretty much. "Windowlicker" was going to go, well, massive—not in America, but over here. It got to about 16 in the charts, and it was on the way to the top. I had to withdraw the record for a week, just so it would drop out again.

MEREDITH: Why would you do that?

RICHARD: I think it's bad to be really well known, because you end up in people's faces whether they like you or not. That's a really horrible thought. The shittiest thing about famous people is that they just assume everyone wants to listen to them or look at them all the time.

MEREDITH: That's the beauty of the Internet, I guess. You can choose your own content instead being bombarded with the crap that's been chosen for you.

RICHARD: All media will be like that sooner or later. People will have to engage their brains and decide what they want to listen to or see. At the moment, most people don't do that. They just turn on the TV and are quite happy to be fed whatever is being transmitted. In America, you have more choices, though there's not actually any content. But in Britain, there are still only five channels.

MEREDITH: And even that's a fairly recent development.

RICHARD: Right. Until I was a teenager, there were only three channels. It was brilliant, because everyone watched the same programs. So if you know someone's age, you also know which programs they saw millions of times, just sitting there watching TV with their parents.

MEREDITH: Watching television used to be more of an event. People would watch while on the phone with a friend.

RICHARD: People still do that—they just do it on mobiles. I know, because I've got a mobile scanner, and I listen in on conversations. Late at night, loads of couples phone each other up and watch films together. If you listen for more than fifteen minutes, you always get something spicy.

F
Fashion

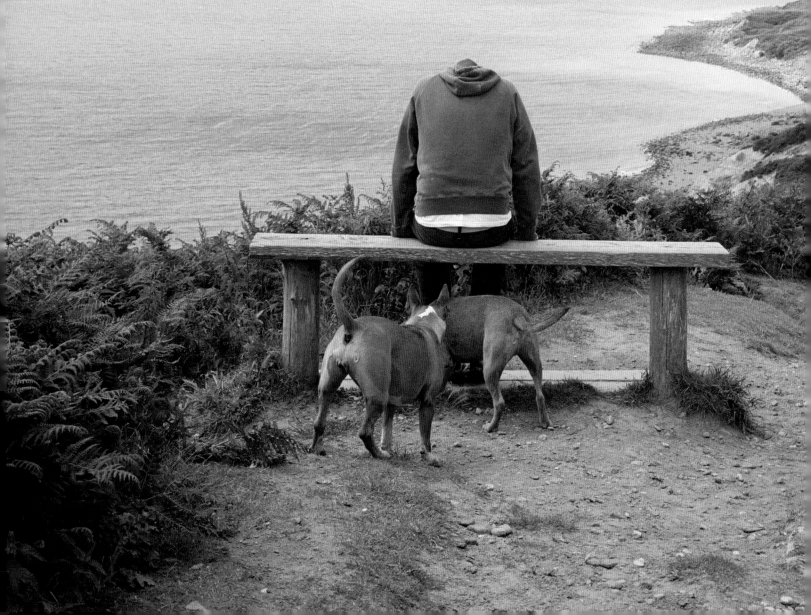

ALEXANDER MCQUEEN
with Björk

Photograph by
Sam Taylor-Wood
September/October 2003

BJÖRK: When I was thinking about you, for some reason I remembered an interview I'd read with this one architect. He talked about something he called the "tyranny of the oblivious." He thinks there are two types of creative people: the people who gather ideas and the people who fall into a state of oblivion and create something out of nothing. He sees himself as a gatherer, and he can't stand the second group. His theory is that the people who collect ideas feel really threatened by those who create from nothing. That's what he means by the "tyranny of the oblivious." Which group do you think you are in?

ALEXANDER: I would be the dreamer. I get my ideas out of my dreams. Does that make me a tyrant?

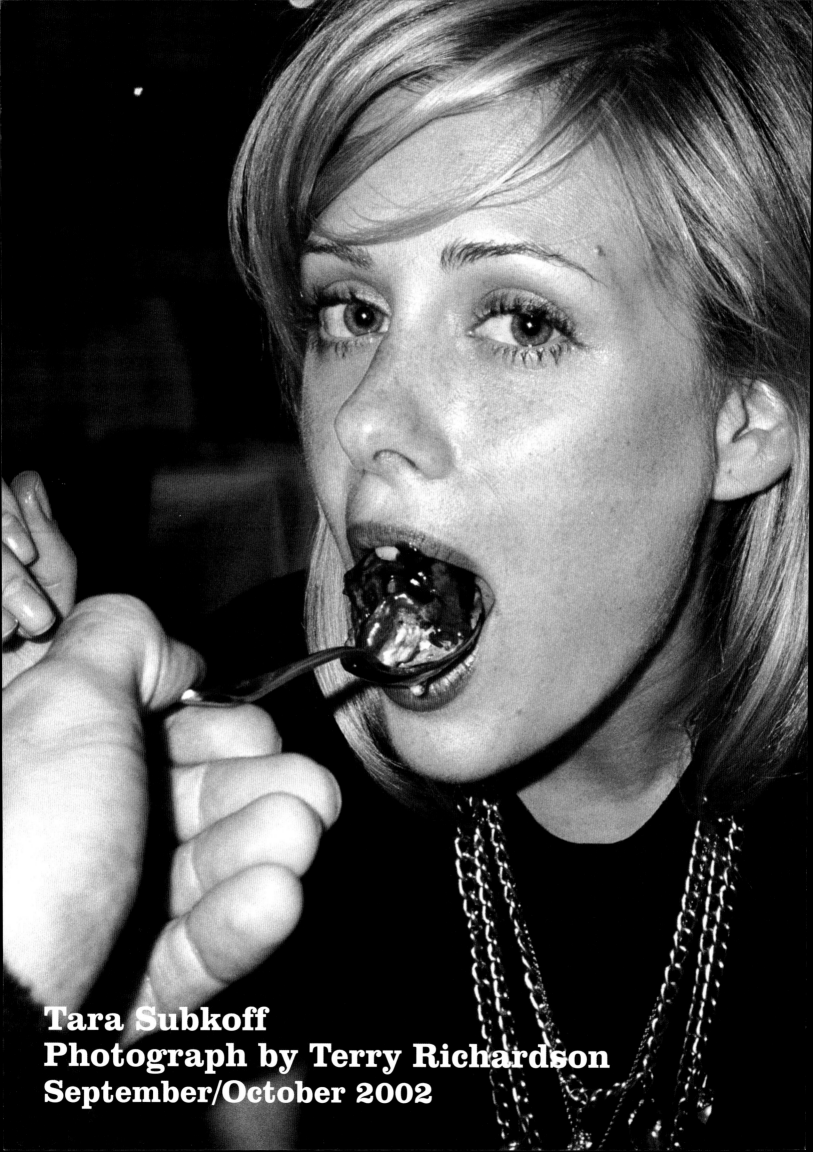

Tara Subkoff
Photograph by Terry Richardson
September/October 2002

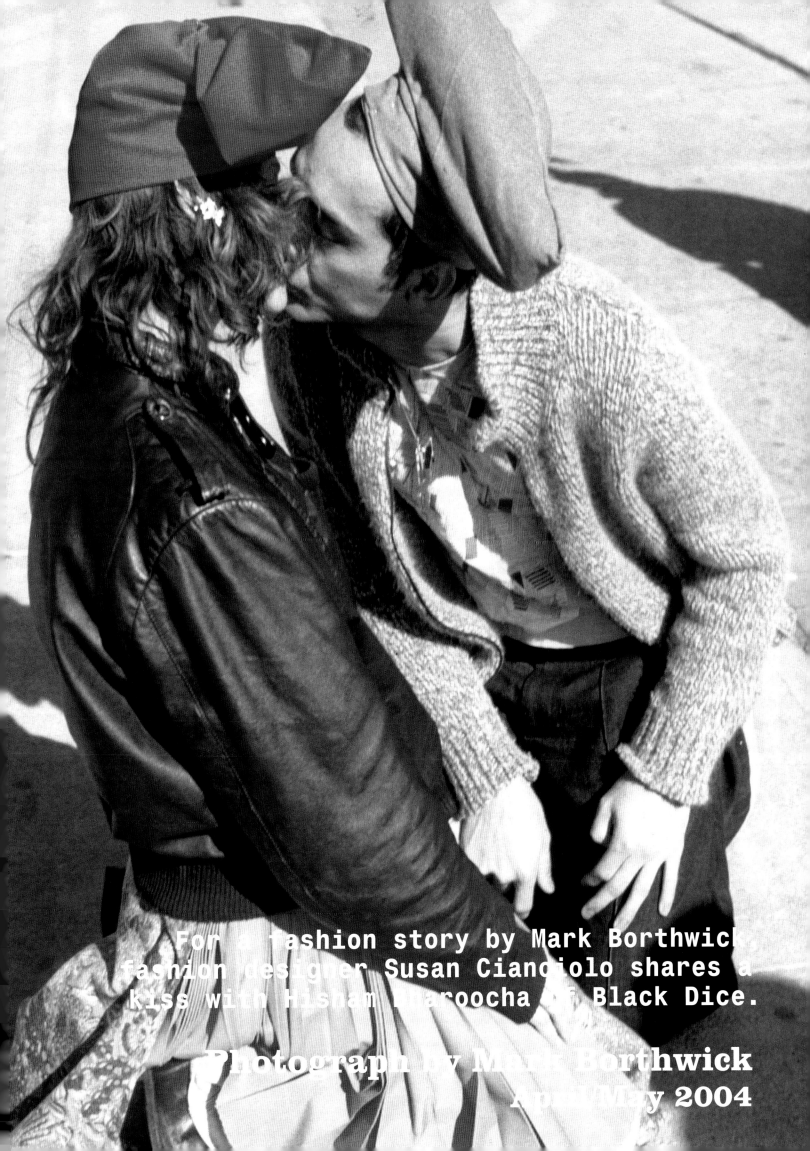

For a fashion story by Mark Borthwick, fashion designer Susan Cianciolo shares a kiss with Hisham Bharoocha of Black Dice.

Photograph by Mark Borthwick
April/May 2004

BRUCE: How did you get photographed in drag by Nan Goldin?

JIMMY: Jack Pierson and I were roommates, so I was hanging around with this Boston crowd. People would talk to me about Nan Goldin. Everybody loved her and worshipped her work. She was a notorious junkie, and she was always a "big thing." I was working as an assistant at Oribe. I had a really big ego as a drag queen, but as a hairdresser I did not seem to exist the same way. Drag put me on an emotional roller coaster: I would go into full fantasy and wouldn't be prepared for the big letdown when I didn't get the same attention. So I made a decision: I cut out drag to concentrate on hairdressing. Around the same time, I met a guy. We were boyfriends for three years. He hated

been photographed by Nan before, so I didn't really realize what might go on. I thought she was taking snapshots. Tabboo! and I were putting our makeup on in the same mirror. There's a famous photograph by Diane Arbus of these two transvestites backstage, their shirts off, their wigs off. All of sudden Tabboo! and I had our shirts off and our wigs off, our makeup on. Nan said, "This is the best picture I've ever taken in my life." We were like, "Wow, great," not thinking anything of it. When you're in drag, it's *Fantasia*. Little did I know that one day the pictures would be great.

BRUCE: Let's shift gears a bit. You are in great demand for photo shoots. How did you start to really understand how hair works, especially when photographed?

JIMMY PAUL with Bruce Hainley February 1997

that I did drag. I would not even consider doing drag while I was with him, but the salon was going well, and my freelance career was starting to click. And I met Nan.

BRUCE: So if you weren't doing drag when you met her, how did that photo happen?

JIMMY: I broke up with the guy who hated drag. Lady Bunny called me and asked, "Do you want to be on this float we're doing for Gay Pride Day?" On the spur of the moment, I said yes. I went out and bought all new stuff, new high heels. I had some wigs, but I bought an outfit. I invited Nan to come over. I lived near where the float was going to meet, so Tabboo! and Miss Demeanor, friends of mine, also came over to get ready at my little apartment. Nan brought her camera. I had never

JIMMY: Steven Klein was the first photographer I ever worked with who was a perfectionist; he cared about the hair. In any fashion photograph, even though you might do something with clothes, the hair is a really big part. It determines the way a girl looks. Not to say that a girl in a hat can't be fantastic, that a girl with slicked-back hair can't be fantastic. But bad hair can ruin a photograph. I should also mention fashion stylists Victoria Bartlett and Joe McKenna, from whom I learned a great deal. The fashion stylist is probably the most unsung person on a fashion shoot. Grunge was a big help for me—I got grunge. A lot of hairdressers didn't. Danilo said I was one of the first queens to do rock drag. Rock fashion has been a huge influence on my aesthetic. My career began to kick-start because I got grunge: using grease in hair.

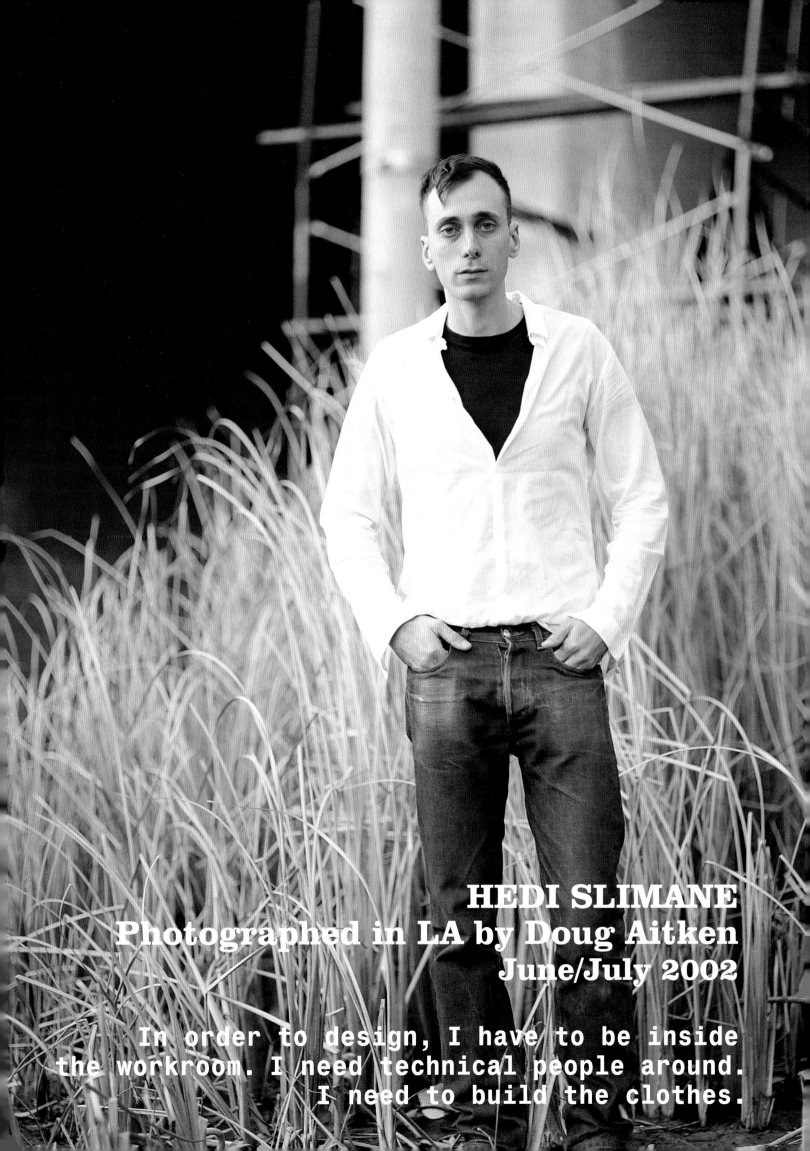

HEDI SLIMANE
Photographed in LA by Doug Aitken
June/July 2002

In order to design, I have to be inside
the workroom. I need technical people around.
I need to build the clothes.

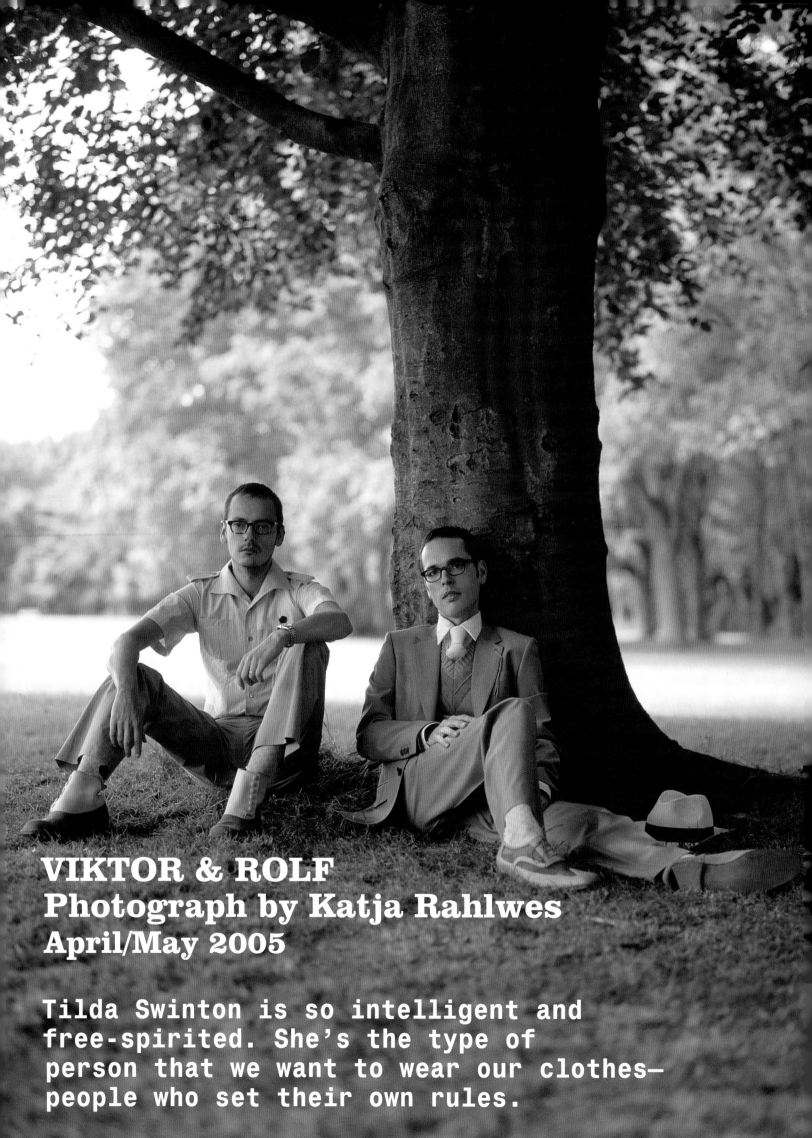

VIKTOR & ROLF
Photograph by Katja Rahlwes
April/May 2005

Tilda Swinton is so intelligent and free-spirited. She's the type of person that we want to wear our clothes— people who set their own rules.

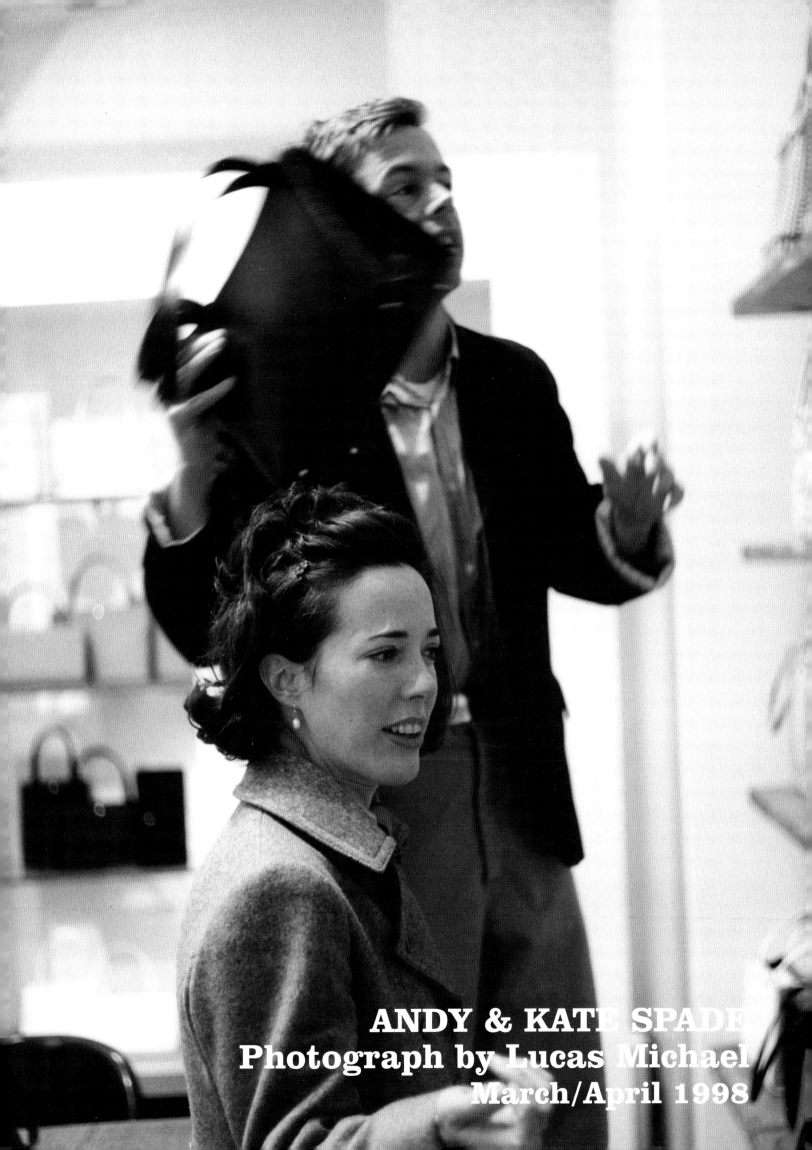

ANDY & KATE SPADE
Photograph by Lucas Michael
March/April 1998

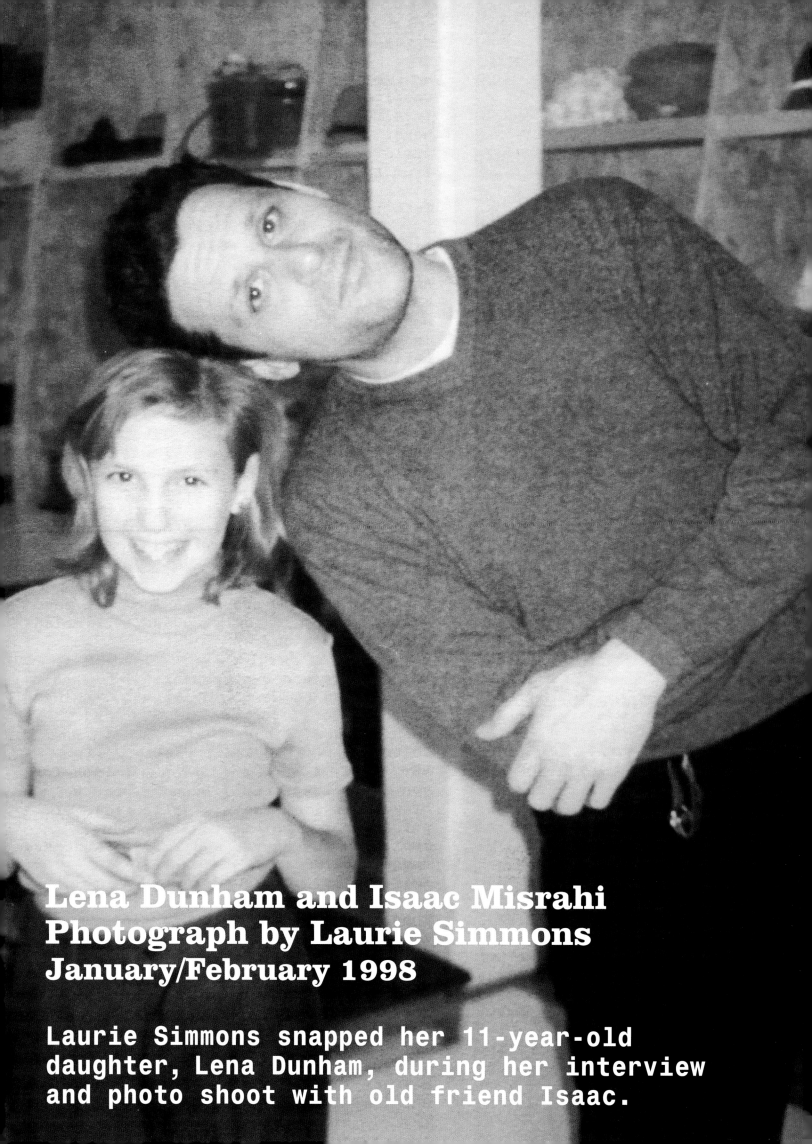

Lena Dunham and Isaac Misrahi
Photograph by Laurie Simmons
January/February 1998

Laurie Simmons snapped her 11-year-old daughter, Lena Dunham, during her interview and photo shoot with old friend Isaac.

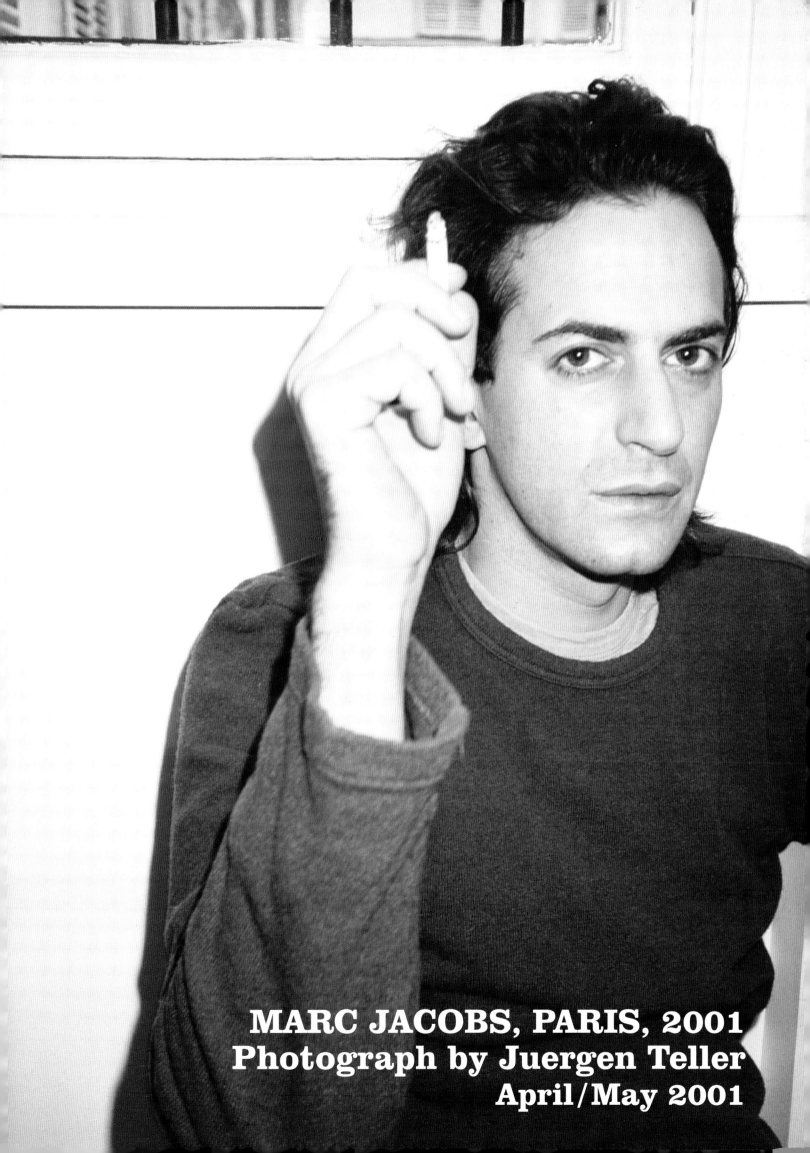

MARC JACOBS, PARIS, 2001
Photograph by Juergen Teller
April/May 2001

G
Global

BIANCA JAGGER
with Peter Halley
and Bob Nickas

Photograph by Wolfgang Tillmans
June / July 1998

Photographed leaving for India from New York's John F. Kennedy Airport. Bianca Jagger has used her fame and international connections to become a human rights ambassador. She talked with *index* about her recent work in the former Yugoslavia and Latin America.

BOB: Do you think that part of your job is to put a human face on what seems to be some remote problem that's really someone else's problem? To make people see it in human terms?

BIANCA: I want to be a voice for those who are denied access to speak out about their plight and their suffering. I denounce the injustice I have witnessed in Guatemala and Brazil where indigenous people are being killed by big powerful ranch owners, death squads, government forces, or big powerful oil companies. I speak on behalf of the women from Srebrenica, Bosnia who were betrayed by the U.N. and the international community. They are denied access to speak about the atrocities they suffered. I continue to ask on their behalf why after two and a half years the war criminals have not been apprehended or brought to trial? So yes, in a way, I serve as an instrument to give a human face to some of those issues and to speak for some of those forgotten people who have no voice.

PETER: As you look into the next century, what are some of the changes that you see between peoples and governments, and between different governments, that might lessen some of the tragedies we're talking about today?

BIANCA: I don't know if the tragedies will lessen. When I looked at the recent visit of President Jiang Zemin from China, and see the position that President Clinton took vis-à-vis China, for the President, the most important issue was economic trade, not human rights. He viewed human rights as a commodity, and he traded it in so easily. To answer your question, I don't see a great commitment from the leaders of the superpowers to make the world a better place. I only hear a lot of pretty hollow speeches.

PETER: Well, let me ask you something specific, because every time I go and buy a pair of sneakers or anything else, it says "Made in China." And I know that the people who make these things are getting three dollars a week and working in terrible conditions. What would you say to me about something like that?

BIANCA: A lot of people today don't understand the consequences of free trade. It sounds so good. For example, "Fast Track," which President Clinton is promoting. Fast Track pretends to bring work and prosperity to Third World countries. Multinationals from the United States will invest their capital and bring employment in poor countries. But what is the real truth about Fast Track and NAFTA? The real truth is that multinational companies will go to countries in the Third World, particularly Latin America, and they will have very cheap labor. Often, they will subcontract companies that hire child labor, and since child labor usually pays less than what adults earn, that drives down wages, making it tougher for adults to hang on to wages, jobs and unions. So these companies will leave the United States and the workers they employed in this country—where they have to abide by labor laws and environmental laws. Instead, they will go and destroy the environment and abuse the workers of the Third World. That's free trade. I am for free trade, if it is fair. If they negotiate labor laws that protect the workers. If they negotiate and enforce environmental laws. But if multinationals just go to Mexico and Latin America and other Third World countries to exploit the people, I view that as the neo-colonialism of the twenty-first century—another form of oppression.

PETER: How can our governments cooperate to actually make international agreements about the environment?

BIANCA: Well, it's probably through NGOs. They have developed in the last decade what we call "civil society"—non-governmental organizations that worked on human rights issues, environmental issues and civil rights issues. And in the Third World, this concept is coming along. Before, the World Bank, the Inter-America Development Bank, and other financial bodies would give loans only to governments, but now they're beginning to understand that they need to work with civil society, with non-governmental organizations.

BOB: In what direction do you see yourself going over the coming years?

BIANCA: I don't know yet. For now, I'm going to pursue my work on human rights issues around the world. And it might well be that someday I decide to opt for a political career, but I haven't made up my mind. I think that since too often politicians make unsavory compromises, I'm not sure that is what I want to do. I just continue to work day by day. I have to be very careful because I have overwhelming numbers of requests to get involved with issues all over the world. So I have to choose carefully the ones for which I can be the most effective.

PETER: Actually, one of the reasons I wanted to interview you is I think I've met you three times, and I don't think you've ever said a word about yourself, but you always ask questions about whatever is going on around you.

BIANCA: Well, I don't like to talk about myself…

Summer in Salzburg photographed by Leeta Harding, June/July 2001

MY WEEK IN LONDON BY RICHARD WANG
SEPTEMBER/OCTOBER 1997

People say that the gross thing about London is the food, but I can tell you that the food is actually OK. It's really the *girls* in London who are gross. Unstylish, horsey girls abound. To make it even more obvious, the girls pair themselves with all the superhot English guys! It is a total peacock/peahen situation over there. The main thing about English guys is that while they are not really dropdead gorgeous, they make up for it by paying more attention to their clothes . . . and London is definitely a city that's all about men's fashion. If you are into seeing lots of well-clad boys parading around with ugly girls and saying to yourself, "He could do better . . . with *me*!" then this is your kinda town. I *love* London!

I met a few guys while in London, and they were cute plus gentlemanly, which is a rad combination to have. At this one pub, me and my friend Judy befriended the gay-mafia contingent of MTV Europe. One guy whose name I don't remember was nicknamed "Posh Spice" after Victoria, the posh Spice Girl. I asked him if he thought English girls were ugly too, and he said no. Then I asked him if he knew any good places to pick up some Fergie tea sets, and he laughed! He said that Fergie is totally disliked, and that nobody would make a Fergie tea set. I was shocked, cuz Fergie is one of my heroes, and, duh . . . she's like on TV and stuff so *obviously* she is popular. So, after the Fergie dis, I lost interest in Posh Spice and turned to his friend Owen.

Everyone kept calling Owen "Owing," by the way. That's how they talk there! Owen was devastatingly charming, with his boyish good looks, crisp white dress shirt, and a seemingly endless supply of brown-filtered Marlboro Lights, which he'd light for me one by one, like I was the Duchess of York. I thought for sure this was the sign that Owen was gonna be my number one London boyfriend of all time, so when he got up to go to the bathroom, I asked Posh to dish the deets on my new boyfriend. Posh laughed again, and told me Owen was straight! I *hate* London!

After that whole incident, I spent a lot of time at home watching BBC instead of going out, and, lemme tell you, British TV is great! First off, the commercials are maybe a zillion times more stylish, and many of them use drum 'n' bass soundtracks, which I thought was very progressive. I mean, even normal products like Popsicles and soda were all of a sudden very hip to me, and I had to have some Fanta and Lucozade right away. Another good thing about the TV there is that they can say bad words and show boobs, and lesbians are kissing all the time, and its no big whoop.

It is kinda sad that I stayed inside the whole time. Don't laugh at me! But, see, I think it eventually paid off, cuz on the train ride back to Gatwick airport, I saw balls! Yep. See, all the good karma I accumulated by watching tv all week made it so I would end up riding the train with a whole team of Scottish rugby players. In kilts! They had loads of beers in their backpacks and were into sharing with me. Also they were super loud and obnoxious, but in a good way, cuz I was sitting with the one who is, like, their loudmouth leader and his smaller witty sidekick. They had all dyed their hair blond too. Well, there isn't anything I like better than a team of drunk blond 20-year-old Scottish rugby players in kilts. And to top it all off for my grand finale, they their flashed balls, answering my question of "Do you wear underwear?"

It was with a little apprehension that I accepted an invitation to Out in Africa—a gay and lesbian film festival that travels from Cape Town to Johannesburg to Pretoria—particularly since one of the movies I would be showing was a porno about neo-Nazi skinheads who rape a black fag. Feeling a bit reckless and devil-may-care, I decided to venture forth with my Aryan fare. Although I wasn't sure if I'd be coming back, except, maybe, in a box.

Actually, it was all very civilized. The festival itself was a decidedly white, bourgeois affair held in the plush theatres of upscale malls that wouldn't look out of place in Toronto. The screenings were attended mostly by moneyed homosexuals whose style and demeanor were indicative of the new "clone-ialization" (as I and a kindred wag dubbed it) that has overtaken the world's capitals. It's alarming how white Western homosexuals with their disposable incomes and matching luggage are exporting, with the zeal of Christian missionaries, their culture and style to such far-off cities as Johannesburg. Here, a Chelsea-like gay ghetto called the Heartland has sprung up almost overnight.

IN SOUTH AFRICA BY BRUCE LABRUCE
JUNE 2000

The opening of the film festival was particularly memorable. A skinny white Leigh Bowery-style drag queen in a mask—who looked like a burn victim from the Folies Bergère—got up on a small platform and proceeded to pull Ben Wa balls out of his ass, evacuated a brown liquid from the same source into a glass decanter, and drank it. He was directly followed by the Assistant Minister of Defense, a handsome young black man who presented what amounted to an army recruiting speech to the gay crowd. The juxtaposition of the two presenters wrecked my beads, but no one else seemed to bat an eye.

I was dreading that a tour of Soweto arranged by the festival would be exploitative and patronizing, but, fortunately, our guide, Nelson, a jolly chap who was born and raised in the townships, provided us with an experience that was both uplifting and heartbreaking. During his nonstop routine, for example, he defended Winnie Mandela as a hero of the struggle against apartheid but admitted she's a bit "hectic" (a popular Johannesburg word, and for good reason). The stories I heard about her feud with a former close friend, a gay Methodist priest, over a 14-year-old black boy named Stompie (slang for cigarette butt—so named because smoking supposedly stunted his growth) would tend to verify her as the Imelda of South Africa. After she denounced the priest for molesting the boy and called homosexuality an evil import, Stompie ended up murdered, reputedly for being a police informant. Along with her "Football Squad," the boy had been living under her roof at the time, leaving much conjecture about her involvement but no clear answers. In a country in which police corruption is easily as common as crime, the truth in such scenarios remains hopelessly murky.

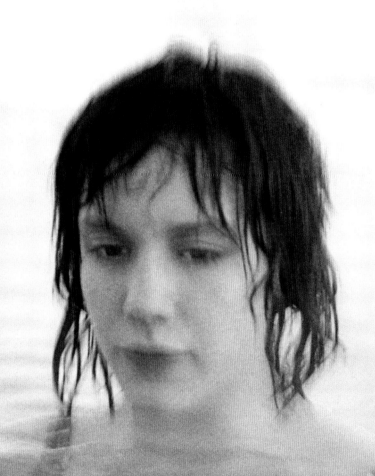

KRISTÍN ANNA VALTÝSDÓTTIR OF THE BAND MÚM
Photograph by Ryan McGinley
April/May 2002

Our new record comes from an imaginary place—
maybe there's a valley, a swimming pool, some
hills, a tunnel—it's not clear what goes on there.

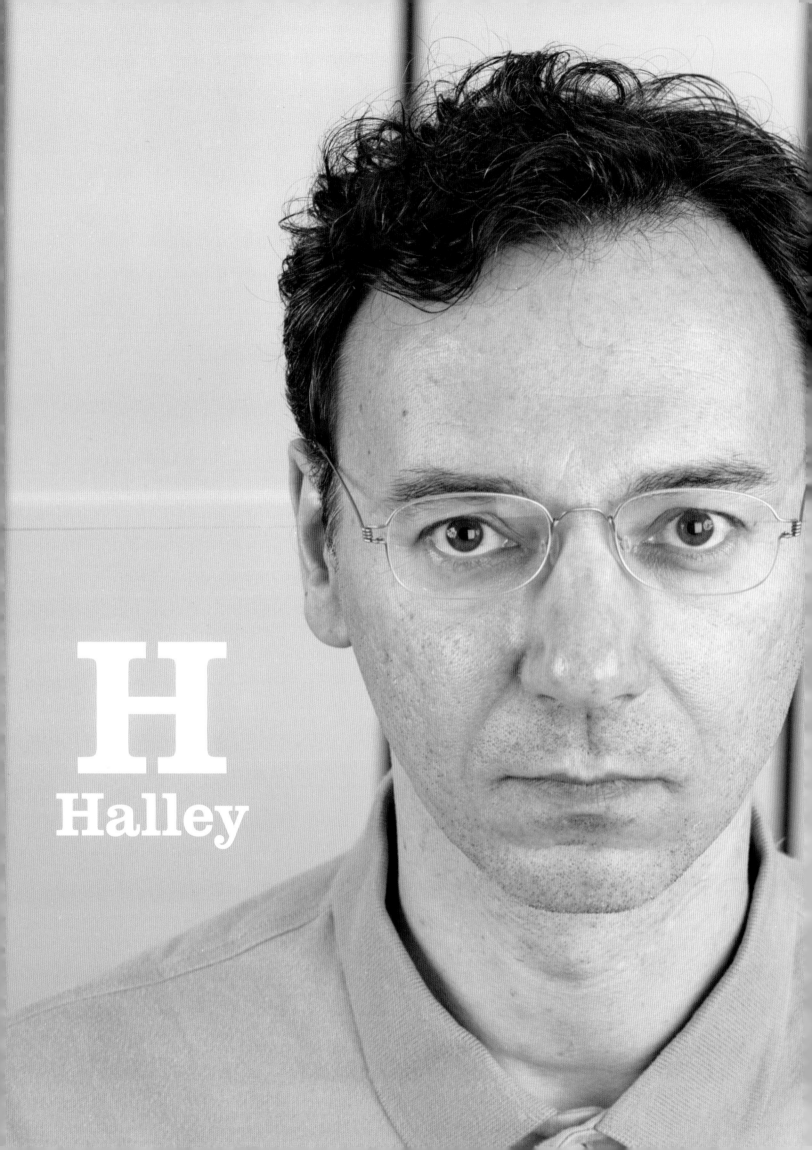

H
Halley

INTERVIEW
Peter Halley
with Rachel Ward,
September 2008

Photograph by
Leeta Harding, 2000

I've always been a magazine
person. I had a great-aunt
and a great-uncle who
published magazines in the
1940s, and I think there's
some trace of that in my
enthusiasm for publishing.
When I was a senior in high
school, at the same time
I was starting to paint, I
was the programming
director for the school
radio station. I even
worked at WNYC one summer
as a radio engineer. I
consider working in media
as a course not taken in
my life.

When I lived in New Orleans
for six years in the '70s,
I was very much out of
the New York mainstream.
I remember picking up
Interview magazine at a
newsstand on Canal Street

and how much I enjoyed its downtown, queer point of view. I was also a big fan of *W* magazine. Later on, I found *W* an interesting model for *index* because they hired a whole crew of very young people who became very tight-knit. They were forming the content out of their personal interests, from a very subjective position of "If we think it's cool, other people will think it's cool too."

After the art boom of the '80s, the early '90s were a depressing period in New York because the contemporary-art world sort of fell apart. I talked to various people at the time about the idea of starting a small school along the lines of the Whitney Independent Study Program, but I never found a willing collaborator. And then sometime in 1995, I began to talk to the curator Bob Nickas about collaborating, and it turned into the idea of starting a magazine.

Bob and I shared an interest in things beyond the art world and a desire to start a publication that dealt with various areas of culture. We were members of the first generation to really be influenced by Warhol during the '80s. So we certainly had in mind Warhol's *Interview* magazine from the '70s, with those long interviews and unexpected people and the humor of doing things that were a little bit provocative.

We started in the mid-'90s, when the word "indie" was really coming into its own. There was indie music, like the Butthole Surfers, and even the whole slacker scene, which was paralleled by Europe's squatter scene. It was also the golden age of indie movies produced by companies like Killer Films. I think Bob's strongest ideology is indie. He has this kind of creative integrity and desire to be oppositional or to stand apart from the mainstream.

index was symptomatic of indie culture as well as covering it, because, in fact, what we were doing was similar to what some of the directors and the musicians were doing. That also meant carving out our own way of marketing. The biggest problems with running an independent magazine are subscriptions and circulation. You're competing against corporations that have far more resources to spend on those things. My job at *index* was first and foremost as the publisher—who also provided the funds to get the magazine started. Subsequently I learned that there was such a thing as a business plan. That took me about two years to figure out. [Laughs.] We didn't have a business plan. Our plan was, if we will publish it, people will buy it. It was a very poor road map, but I had read Andy Warhol's diaries several times, and I would always think about Warhol's approach to getting advertising—meeting someone at a party, trying to get them interested, and developing a personal connection. But gradually we did begin to develop really healthy advertising revenue, first through the efforts of Ariana Speyer and then Michael Bullock. By the end, our ad revenue was really great. More and more mainstream advertisers were willing and able to work with us.

We started *index* with a very small budget. Bob wasn't even intending to work on it full-time, so one thing that was really built into *index* from the start was sustainability. Come hell or high water, we could put this thing out for a few thousand dollars.

As an artist, I'd met all these highly successful businesspeople who collected my work. I wanted to take on the role of doing something that wasn't making art; I wanted to participate in a business enterprise, running a magazine. Could we make as much money as we spent? Could we grow the magazine? Could we make it more influential? Could we make it more visible, sell more copies, get more ads?

As it says in our first press release, we didn't want to cover people during their typical publicity blitzes, when they had a movie or book or show coming out. I think that allowed people to speak in a more leisurely fashion. Most of the interviewers were either a friend of the interviewee or one or two steps removed, which encouraged a relaxed, cocktail-party atmosphere.

We only covered people we liked. We didn't want to be critical. We wanted to do long interviews with interviewers the person would be comfortable talking to, and we wanted that person to really tell us what was on his or her mind. For instance, in the first issue I interviewed Eduardo Machado, a brilliant Cuban-American playwright. We were really sitting down and talking as friends.

The covers were a combination of excitement and dread. Because we didn't have much money, we would do a shoot, and we had to work with whatever we got and hope that we got a good cover out of it. Working with Wolfgang Tillmans was always extremely exciting. He wouldn't give us a choice of what to use. He would send us a single print, and we had enough respect for him that we would run whatever he sent us.

Wolfgang shot our first year of covers, and his aesthetic was crucial to the whole magazine. At the time, the typical magazine portrait would be photographed in a studio. But Wolfgang only used a 35mm handheld camera, no artificial lighting. Throughout his career he has only shot people who interested him, in their native environments. Our roster of photographers grew out of Wolfgang's aesthetic. Because we didn't have any money to send photographers all over the world, we also tended to develop an international network of photographers. So we had contributors in LA, in New York, and a half-dozen people in Europe. At the same time, interesting people started coming to us—in fact, Juergen Teller approached us. At that time, he already had a very established career, and it was a thrill that he thought he would like to see his photography in *index*.

Shortly after Bob left the magazine, Leeta Harding photographed Kathleen Hanna, who I thought was just a fantastic person. That was a powerful headshot of this very confident, assertive artist. A little later we put Scarlett Johansson on the cover. Leeta shot her too. It was Scarlett Johansson's first magazine cover ever. She wasn't our first choice for a cover, but she turned out to be so big. Pictures by Terry Richardson were always fantastic too. He really had a knack for creating an immediate, strong, gestalt image, such as the cover of Casey Affleck.

We once all went to Cornwall in the UK to interview and photograph Juergen Teller, who was spending the summer there—he and his family had this little cottage. We drove all the way there from Heathrow, walked around with him, took pictures, and then sat down for an interview. Juergen's a very interesting guy. Another one of my favorite subjects was Udo Kier, who is just the most brilliant actor. Bob, Wolfgang, and I interviewed him together. He has worked with almost every important director of the last forty years—Rainer Werner Fassbinder, Warhol, Lars von Trier. He was in Gus Van Sant's *My Own Private Idaho*.

There were also some interview misses. A whole slew of people on staff were obsessed with interviewing Bill Murray, and that was before he really had his comeback. [Laughs.] The other person we really wanted to interview was Bill Clinton, especially after he was no longer president. But we came close—we talked to Donna Brazile, who was Al Gore's campaign manager in 2000, and we interviewed Teresa Heinz Kerry during the 2004 election.

I once read an interview with Michel Foucault, who said, "I'm giving up philosophy, and I'm going to become a journalist." And at some point, Rem Koolhaas—Foucault and Koolhaas are two of my big heroes—also said, "I'm giving up architecture, and I'm going to become a journalist." [Laughs.] Being a journalist in this society is like having the keys to the kingdom. I mean, you can call up people and get to meet them by saying, "I'm doing an interview."

Gradually *index* was able to interview people who ordinarily wouldn't agree to be interviewed. I think the first celebrity to take the plunge was Isabella Rossellini in 1999. She had a new book out, and she agreed to be on our cover. Around the same time, we also featured Bianca Jagger, whom I knew socially. Later on, Zoë Bruns came to work for us. She found a way to get hold of Daniel Day-Lewis just after the filming of *Gangs of New York*, and that was a great coup.

I always thought that *index* became a kind of trade paper for New York editors, creative directors, and PR people who were trying to follow what was going on. That's one reason it became attractive to well-known people, especially some of the more interesting ones, to be covered by us.

We would have parties for every issue, and all these amazing people would attend. Being a little bit the nerdy artist, I would always end up talking to the photographers. So my experience was more or less being huddled with Mark Borthwick, Leeta Harding, Nina Andersson, or Juergen or Terry if they were there. That was sort of my crowd. It was a learning experience for me. I've always been a photography fan, going all the way back to my twenties. I'm interested in photography because I can't do photography—I have no photographic eye. So I like talking to photographers because I can't do photography, and to architects because I can't do architecture.

My natural inclination as an artist, or even a businessperson, was to put back whatever revenue we got into producing the magazine. So after a couple of years we started publishing in color, and then with more expensive paper stock, and then spending more on editorial, so we were always hovering around the break-even mark.

We never had any outside investors. You might call this the difference between indie culture and commercial ventures. One person makes a movie because he wants to make as much money as possible. The other person makes a movie because she has a vision and hopes to make money. So *index* was definitely the second kind of enterprise.

The magazine closed at the end of 2005 because of my changing priorities. I took a job as Director of Graduate Studies in painting at Yale in 2002, on top of publishing *index*. I tried to find a new publisher, but I couldn't find anyone who could really run the magazine day-to-day. It's a demanding job. I also needed to find a new editor. Faced with both those vacancies, I decided it was time to shut the magazine down. It lasted almost exactly ten years.

WAYNE KOESTENBAUM with Peter Halley
May/June 1999

Photograph by
Timothy Greenfield-Sanders, 1998

PETER: After I read your book *The Queen's Throat*, your study of the opera diva, it struck me that, as a writer, you have transformed yourself into the diva you are fixated on.

WAYNE: I wish. And I'm not being modest, but I guess . . . I don't know how to put this, exactly, without it seeming like a personals ad. But I would not say that I've received enough propositions in my life on some basic level.

PETER: As an artist?

WAYNE: As an artist, even as a body. I could use a few more star fuckers in my life who considered me the star. Let's just say that's not been my experience. Or at least it's not been my perception. And I think I would be pretty aware. Put it this way. That would itself be a really interesting project, to work on that.

PETER: That would be really great.

WAYNE: In my poem "Four Lemon Drops" I said that I always feel like there are all these people in the room with me at this moment. I'm quite sensitive to what I think of as psychic invasion, what I refer to as negative capability. I often feel kind of boundaryless. Keats said this in his negative-capability letter, and I used it in my book on Jackie Kennedy Onassis to describe my relationship to her. When I'm in a room with other people, I do feel that their identities press in on me so that I don't even exist, and sometimes I really love that annihilation. But it also drives me crazy, which is why I'm quite a loner and why poetry is so important to me. It's an entirely solitary process of self-consolidation. But, with the star-fucking theme—in my solitude I often say, and this is a quote from the poem: "I wish off the bat I could name 300 people who know me." And I could say: I wish I could name 300 people who want to sleep with me right now. Or 300 people who think I'm a great writer. Or 300 people who have fantasies about me. You know what I mean? I do have this collector in me. I love assembling imaginary constituencies.

PETER: I'm nostalgic for the era in which intellectuals were glamorous, especially the 1950s.

WAYNE: Well, there are the glamorous artists.

PETER: That's different somehow.

WAYNE: Look at Jackson Pollock. I mean, there were very sexy pictures of him. He's not my type at all. He looks far older than he was. He could have been so much better-looking. I mean, his body . . . he didn't take care of himself, terrible bags under his eyes. He should have just shaved his head. But it's an extremely sexy thing in that barn out there in The Springs, with Lee Krasner on the stool. I go for that. And I think Warhol was incredibly glamorous. I mean . . . duh. But even in the most specifically sexual way—just the quality of his skin in the '60s, the kind of fleshiness, doughiness.

PETER: Yeah, people don't usually talk about him as sexy. But he had really great lips. And he was very photogenic.

WAYNE: He was incredibly photogenic.

PETER: And he had nice eyes.

WAYNE: He knew how to wear pants. I have a feeling he had a good butt. I just have that feeling from the way the pants fit in some of the early photographs, that he's a little pudgy but that he rounds out that region. I think he was sexually very desirable. And I think that a lot of people were having sex with him, and not enough of that has been put on record.

PETER: Is your major project right now your book on Andy Warhol?

WAYNE: Yes.

PETER: That's almost as much of a challenge as a book on Jackie.

WAYNE: More.

PETER: Because . . .

WAYNE: Because smart people have things invested in Warhol, and smart people have nothing invested in Jackie. The problem with writing about Jackie was that I was writing it as a smart person, and it's not a smart subject. Though I think it is. But Warhol—except for people who are incredibly reactionary and just blind, deaf, and dumb—his name and work summon a huge range of the most important issues of cultural theory.

PETER: How are you approaching it?

WAYNE: It's still at the research stage. But it's due in a year, so it's going to have to speed up.

PETER: What relationship do you feel with Roland Barthes?

WAYNE: Deep. Though it's a little bit jaded now. Roland Barthes envied the novel. And he approached his work through what he calls the novelistic way, which is writing essays as if they were novels. And I see in his work an incredible over-intellectualizing. This is kind of obvious. It's his temperament, and it's his mandate. In one of his books, *Roland Barthes by Roland Barthes*, he makes a list of things . . . he calls them *anamneses*, moments of narrative or visual interest that he says have no meaning. He just lists them, three pages of them, and they have incredible meaning. Each of them is luminous and speaks volumes. And his immediate dismissal of their possible meaning is like a denial that there's an unconscious, a denial that he has an unconscious or that he might be able to wander with one of them in an unscripted direction. And all his life, the reigning intellectual paradigm was Marxist, but he was a hedonist and an aesthete. You can feel, through the first three-quarters of his work, the struggle to justify bourgeois pleasure, which is basically what he has. And then he relaxes a little bit about that.

PETER: How?

WAYNE: He has a much less dogmatic relation to his

own pleasures, and he doesn't need to do what he did in *Mythologies*, which is to explicate a cultural site for the pleasure of explication and then at the end show how we're just being mystified . . . how somehow this cultural site produces false consciousness. After a while, he doesn't need to condemn things as much.

PETER: Did he always end up with false consciousness?

WAYNE: In the *Mythologies* essays, in every one, he says, "And this is the pleasure of this, and this is the pleasure of that," and then it ends with a mention about Algeria, the war in Algeria.

PETER: [Laughs.] I noticed that. *Jackie Under My Skin* can be said to start from Roland Barthes . . .

WAYNE: It's technically entirely indebted to Roland Barthes, yeah.

PETER: Each chapter has a title referring to different aspects of Jackie: Jackie's Death, Jackie's Hairdos, Jackie's Wealth, Silent Jackie, Jackie versus Liz, Passé Jackie, Jackie as Dandy . . . it's a beautiful organization. Given what you've said about your debt to Barthes, where Barthes is lacking, how did you choose your categories for Jackie?

WAYNE: I think I was simply trying to be organized. I didn't have any other recourse. I now look at it, and I say: That's just pure Roland Barthes.

PETER: Oh, I don't think it is. It's a trope taken from Barthes.

WAYNE: One of the documents that I'm most enamored of in my private archive, as I keep every piece of paper I've ever written, is the list. It's the most obsessive page. I was literally writing in circles around the page—trying to keep sane about Jackie by separating her image into logical categories—because her simultaneity so numbed discourse and prevented consecutive speaking. Throughout the book I talk about her silencing capacity: that she was silent and that she silences those who wish to speak of her. You want to say everything at once, which has always been my desire and my impulse, but you can't—you'll explode. You have to break it down. And that was simply how I thought of it.

PETER: Writing about Jackie and also about the opera diva, you approach the subjects as a gay writer, but, on the other hand, both books seem really feminist.

WAYNE: Right, right.

PETER: In a way they're guidelines for feminist power. And I think they can be taken very seriously that way. Especially in *Jackie*—Jackie's inauguration versus Jack's inauguration. In *The Queen's Throat*, you talk about the power of the diva earlier in the century, when it was more intensely a man's world. You state in quite a bit of detail how this kind of female power can be constituted, what its rules are, and how it can be effective.

WAYNE: Well, I definitely think women should rule the world. I don't even know if this counts as feminism. It might even be seen as somehow weirdly anti-feminist because of its essentialism or whatever. But I never feel that you can go wrong by moving toward the women, in whatever way possible. It's always been my impulse to pay attention to the women. They're more interesting. [Laughs.] . . . like women vibrate for me. Now I'm sounding like Anna Wintour. I guess I've always

been a little repulsed by some of the traditional aesthetics of male power. I hate bullies. I hate bossy men. I hate men who talk too loud. I hate big men. I hate Washington men. I mean, who doesn't these days? But I hate that whole way of being. And I think a lot about Adrienne Rich, the feminist poet—a very important figure to me. And I always think of how would she look at this. And I know she would hate my work. I'm sure she would hate my work, because of its somewhat retardataire objectification . . . I do fetishize women.

PETER: How would you summarize how Jackie is most powerful?

WAYNE: In the realm of the visual, she enacted a sort of transfer of power. She summoned interest. She reorganized space visually. Semiotically, she suggested shadow readings of events, like the inauguration. She suggested a way in which appearances could be a valuable realm, could be a realm in which the work gets done—you know, the empire of signs.

MARIUCCIA CASADIO
with Peter Halley

**Photographed in Milan by Don Cunningham
June/July 2001**

PETER: At *Vogue Italia*, your work on the page layouts always feels very spontaneous.

MARIUCCIA: Oh, yeah, and it's really fun every time. I feel no inhibitions when I work with our art director, Luca Stoppini. We never worry about doing something embarrassing. We put all the work in front of us—the pictures and illustrations—then we experiment and try different things out.

PETER: I've heard that you even let photographers come to design meetings.

MARIUCCIA: That's true.

PETER: Does it lead to any fights? [Laughs.]

MARIUCCIA: Not really fights—more like exchanges. From what I've observed, a photographer, in his best pictures, must forget what he knows about himself and about photography.

PETER: Oh, that's so wise.

MARIUCCIA: If you accept all of their conditions for how the pictures should be laid out, 80 percent of the work will turn out boring. In general, I think that we all have ideas that we hesitate to use in our lives because they're too extreme. Those are the best ideas to foster.

PETER: How have all the graphics programs like Photoshop changed the way you design the magazine?

MARIUCCIA: Quite radically. They give us more options in creating a page. When I started doing this, we were cutting things with scissors, enlarging photocopies . . .

PETER: It'd take two hours to make one change. Now it's easier to experiment.

MARIUCCIA: It's much more exciting. It's even a little bit dangerous. We can take a little body and turn it into a large body, or turn horrible skin into beautiful skin. Everything can be changed into something else. I try to be careful with it, because I'm interested in showing things as they are, but fashion is often about showing things the way they look best.

PETER: Is there anything you're seeing lately that has especially fired your imagination?

MARIUCCIA: What I like about this moment is the way that art, fashion, and design are connecting. I feel that these languages communicate more intensely than ever before. Everything seems very present and active.

PETER: As a magazine person, what do you think of the web?

MARIUCCIA: There isn't much there in terms of aesthetic quality. And I like print. In my view, the Internet exists only to inform. I would say that the two languages—computer and paper—have very different qualities. I like the fact that paper really hasn't been superceded by the Internet.

PETER: That's a good thing for both of us. [laughs]

MARIUCCIA: An important difference between print and the Internet is the speed at which things can be produced. I like magazines because the more you slow down, the more you can amplify the subject.

PETER: How do you see fashion influencing art in recent years?

MARIUCCIA: *Vogue* has been referenced so many times by people like Vanessa Beecroft, Sylvie Fleury, and Elizabeth Peyton. And that's so vital, I don't even want to question it. Before that, there was Luigi Ontani, Joseph Beuys, James Lee Byars, Gilbert and George. They were all very important.

PETER: You're forgetting one person—Andy Warhol.

MARIUCCIA: Warhol, yeah. Keith Haring as well. Photography is also an important part of the equation. At some point, the portrait of the artist became more important than the artist's work itself.

PETER: Who or what in fashion has had an influence on today's artists, in your opinion?

MARIUCCIA: I immediately think of Leigh Bowery. He was a designer and stylist, very involved in the club scene, who lived in London. Malcolm McLaren also comes to mind, as well as Gucci, John Galliano, Prada . . .

PETER: I really admire Prada. The craftsmanship is incredible.

MARIUCCIA: At Prada, they really make their work as if it were art.

PETER: Do you think that artists are interested in the way fashion creates such perfect images?

MARIUCCIA: That's a possibility. But in a more general sense, fashion gave art a great deal of information about how to communicate.

PETER: You visit New York quite often. Is there anything here that's excited you in recent months?

MARIUCCIA: The birth of new hotels, like the Hudson, is very exciting. I like the playground quality of it. It's like they've re-created a work by Rirkrit Tiravanija. It's an ideal place to socialize and have meetings, as well as to eat and sleep.

PETER: Starck is so great—the Hudson is sort of a kaleidoscope of historical memory and contemporary technology.

MARIUCCIA: Right. The Plexiglas and the fluorescent colors combined with the bricks and the plants . . . it's like a wired cottage. The lesson is, we've got the freedom—with something like Photoshop, for example—to deform and clean and enlarge. But we need a background, a memory, as well.

PETER: You've talked a little about communication and connectedness. I think of the last few years as a great period of internationalism. We seem to be more aware of things going on all over the world.

MARIUCCIA: Absolutely. And I think that the more conscious you are of the periphery, of places outside of the cultural centers, the more international you become. Provincial places have been very active recently, which has made for a very cosmopolitan fashion world. To be aware of the provinces is probably the best way to be international.

BRIAN ENO
with Peter Halley

**Photographed in London by Leeta Harding
June/July 2001**

PETER: Do you still feel connected to the world of mainstream music?

BRIAN: One often used to hear high-art people saying that pop music was so boring and formulaic. I never thought that was true. All that formula and repetition is like a great big vehicle for carrying the moment of difference—the tiny point where something happens that didn't happen before.

PETER: The best thing about music is that, in contrast to art, it's available to a large audience at a low price.

BRIAN: What I value more than anything else about the music business is its distribution system. I like the idea of saying, "Here's this incredibly well organized, powerful, and pervasive machine— I want to be part of it." If something I do gets criticized, I would never say, "They didn't understand me," or, "What I did was too good for them." I would assume there was something wrong with what I was doing.

PETER: Well, not necessarily wrong. There's nothing wrong with appealing to a very small audience.

BRIAN: I do a lot of things that I know won't interest thousands of people, but I release them for the hundreds who will be interested. Sometimes I'm wrong, and it turns out that quite a lot of people actually do like them. Or, on the other hand, nobody does. [Laughs.]

PETER: I really don't think the artist can tell.

BRIAN: I've often thought that there are two varieties of artists. There's the fussy type, which I tend to be, who always censor themselves, and then there are people like Miles Davis and Prince who just say, "Look, if it came from me, it's probably good."

PETER: But you have such a huge body of work.

BRIAN: I'd probably have about four times more if I hadn't censored so much.

PETER: Jasper Johns is famous for holding on to his work.

BRIAN: A few years ago I was interested in what was happening to the act of curating. I'd seen a few shows in Europe, where the name of the curator was bigger on the poster than the names of the artists. It's like saying, "Here's somebody who can draw an interesting line through our culture. He can connect a few things you'll probably find worth taking seriously."

PETER: As an artist, I'm not sure how much I like that trend. In Europe, most of the exhibitions tend to be poetic in their conception. I get a big kick out of all the titles, like "The Cooked and The Raw." And the way exhibitions are curated is not systematic at all.

BRIAN: It's very much a creative act rather than an academic act. We've dropped the pretense that what these people are doing is assembling the most important things on some previously agreed-upon scale. I think this is the way that ordinary people make their own culture. You own these records, you like those films, you've got these reproductions on your wall.

PETER: Culture has become like tourism. Instead of visiting London, you put on an Oasis record, or you go see _Sensation_ at the Brooklyn Museum.

BRIAN: Cuban music is a good example of that. How many people, Americans especially, have been to Cuba? Very few. But somehow that culture has come to represent sexy, sophisticated life. And it's all based on four records!

PETER: This gets us into the idea of importing the exotic while ignoring the local reality.

BRIAN: When David Byrne and I released _My Life in the Bush of Ghosts_, I felt that there were so many things wrong with it. I had just started to get what rhythm was about. I had just become aware that there were people who did it a whole lot better than I did. _The Village Voice_ reviewed it, and the only other review on the page was of a record by a black punk group from Harlem. They had appropriated all the clichés of punk music and were praised roundly, while we were condemned as being neocolonialists.

PETER: _My Life in the Bush of Ghosts_ struck me as being the opposite of neocolonial. There were things like Islamic Maqam singing on it, but it was right after the Iran hostage crisis, and it was like, "There are all these people out there, and their worldview is not the same as ours in the West. And we should listen." At the same time, the album referenced this new American landscape that not only included technology, but also right-wing preachers.

BRIAN: As an English person living in America in the early '80s, I was much more receptive than a native would have been. I didn't have many friends there, so I would just listen to the radio. There were complete lunatics on the airwaves—people whose views seemed so objectionable. I started recording them just because I wanted to show my friends in England what people in America were listening to.

PETER: I also used to tape things off the radio at that time. Maybe that's why I responded to that record so immediately. We probably weren't the only ones recording off the radio, but you were able to make a work of art out of it.

BRIAN: I already saw it as art, so I only needed to put a little context around it, and it was dynamite. It was like discovering a totally exotic culture where I never expected one. I'd just been to Thailand before moving to America, and it was far less foreign to me than New York turned out to be.

PETER: Your trajectory from the early '70s to the mid-'80s seemed to encompass all the things that would be called postmodernism in the '80s. You went from an exploration of sexual personae, to skepticism about the emotional authenticity of pop music, to experiments that later became known as ambient music, and then an involvement with world music. You covered it all.

BRIAN: Things always look much more calculated in retrospect. I agree that you can draw a line through the things that I did, but at the time they all seemed chaotic to me. I just kept thinking, "When am I going to find out what I actually do?" I still think that, actually.

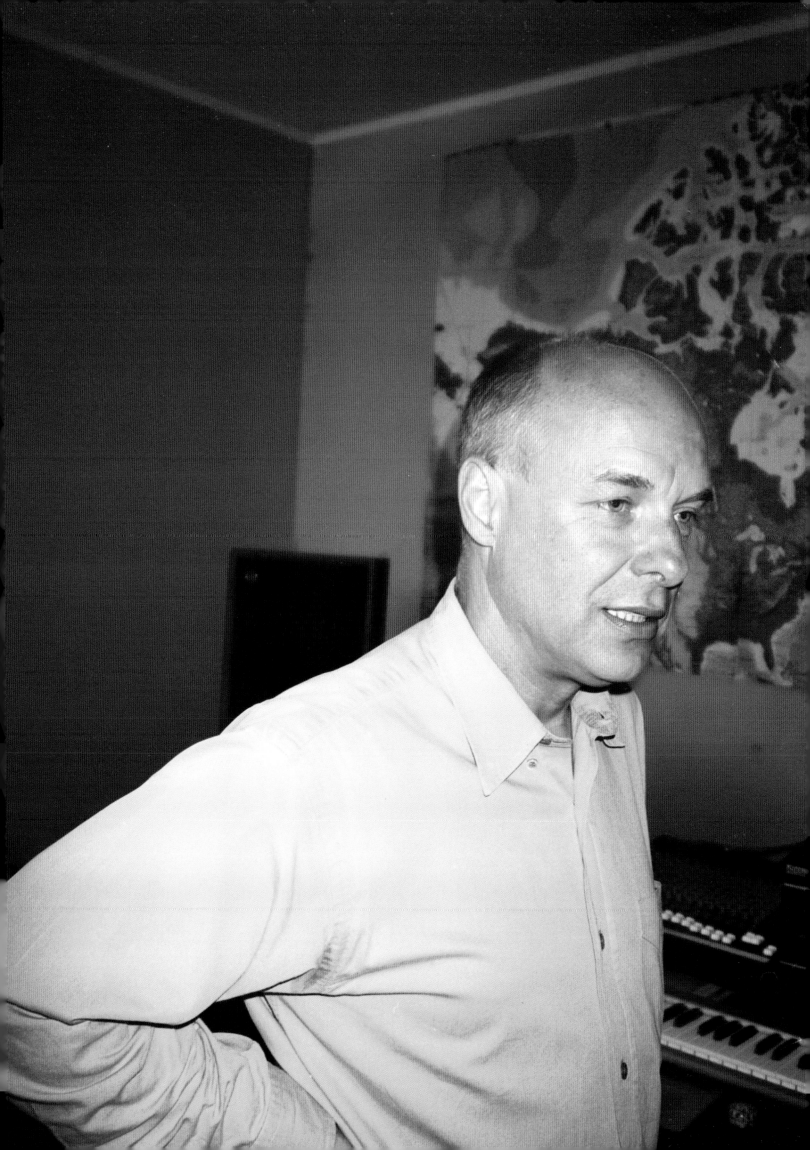

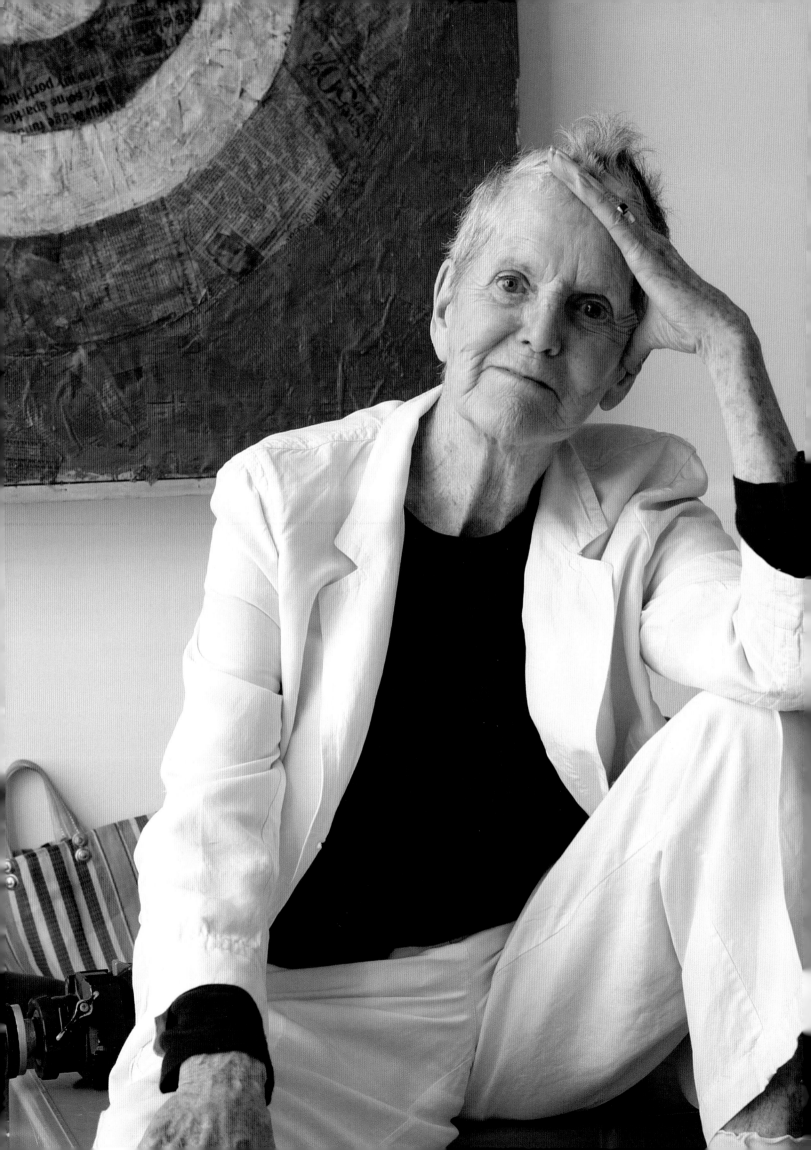

STURTEVANT
with Peter Halley

Photographed in Paris by Elke Hesser
September/October 2005

PETER: Would you go back to the work you were making in the mid-'60s and describe how you came to those decisions?

STURTEVANT: Well, that work was a result of very long-term thinking. It was not something that just popped into my head, that's for sure. See, in the '60s, there was the big bang of Pop Art. But Pop only dealt with the surface. I started asking questions about what lay *beneath* the surface. What is the understructure of art? What is the silent power of art?

PETER: How did you translate that concern into making, say, your *Johns Flag*?

STURTEVANT: If you use a source-work as a catalyst, you throw out representation. And once you do that, you can start talking about the understructure. It seemed too simple at first. But it's always the simple things that work.

PETER: Going back to that *Johns Flag*, how, specifically, does the work enable the viewer to think about the understructure?

STURTEVANT: Technique is crucial. It has to look like a Jasper Johns flag so that when you see it, you say, "Oh that's a Johns flag," even though there's no force there to make it exactly like the Johns. Quite the opposite—the characteristic force is lacking. So when you realize it's not a Johns, you're either jolted into immediately rejecting it, or the work stays with you like a bad buzz in your head. You have to start thinking, "What is going on here?"

PETER: There was intense controversy about your work in the mid-'60s.

STURTEVANT: You know, five or six years ago I was in a seminar with some young students, and I was talking about how my work had engendered this horrendous hostility. They had no idea what I was talking about. It's very far away for young artists.

PETER: But, if a young artist today made a painting, and then walked into an art gallery and saw a painting that was almost identical, I think he or she would react quite strongly.

STURTEVANT: I'm not so sure about that. It finally took the appropriation artists to give me a negative definition of my work.

PETER: And appropriation started in the early '80s, almost twenty years later.

STURTEVANT: It really did push the work forward. Before then, there were no references. Most art dealers and critics had severe blocks against understanding the work. Then, some people would just try to trap me in conversation. I used to say things like, "You're too fucking dumb. I'm not going to talk to you." And that took care of that. I was a very bad girl then, eh?

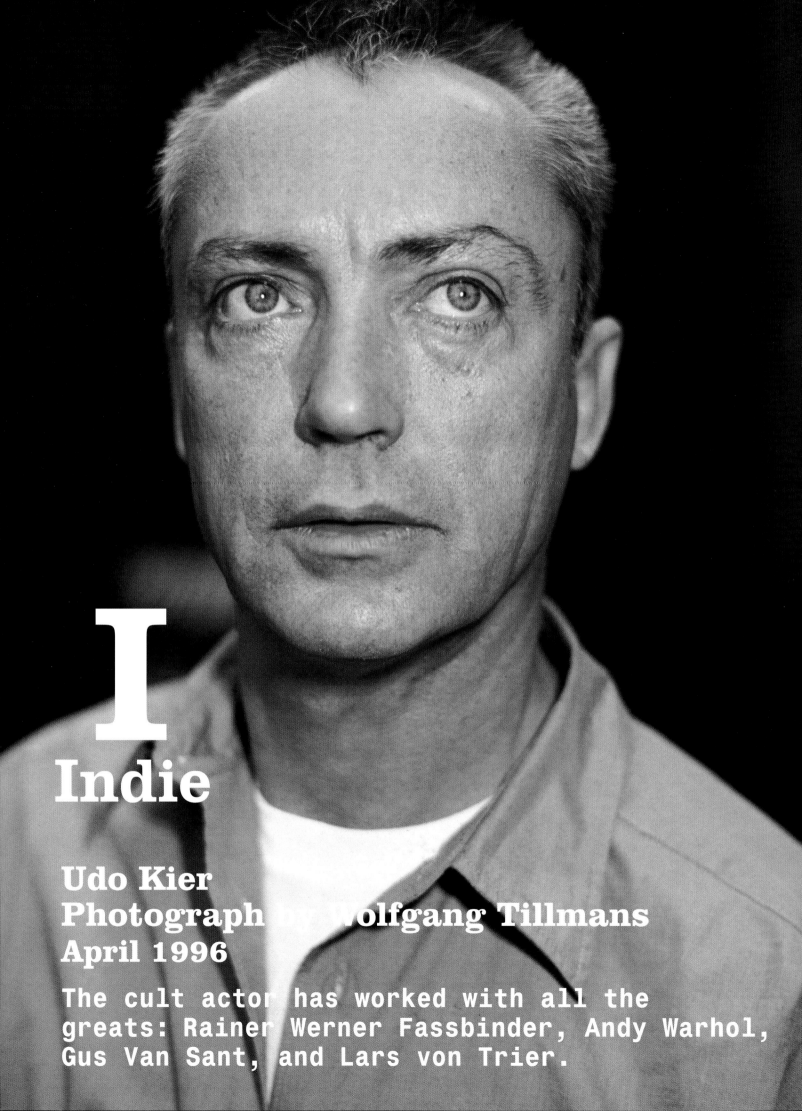

I

Indie

Udo Kier
Photograph by Wolfgang Tillmans
April 1996

The cult actor has worked with all the greats: Rainer Werner Fassbinder, Andy Warhol, Gus Van Sant, and Lars von Trier.

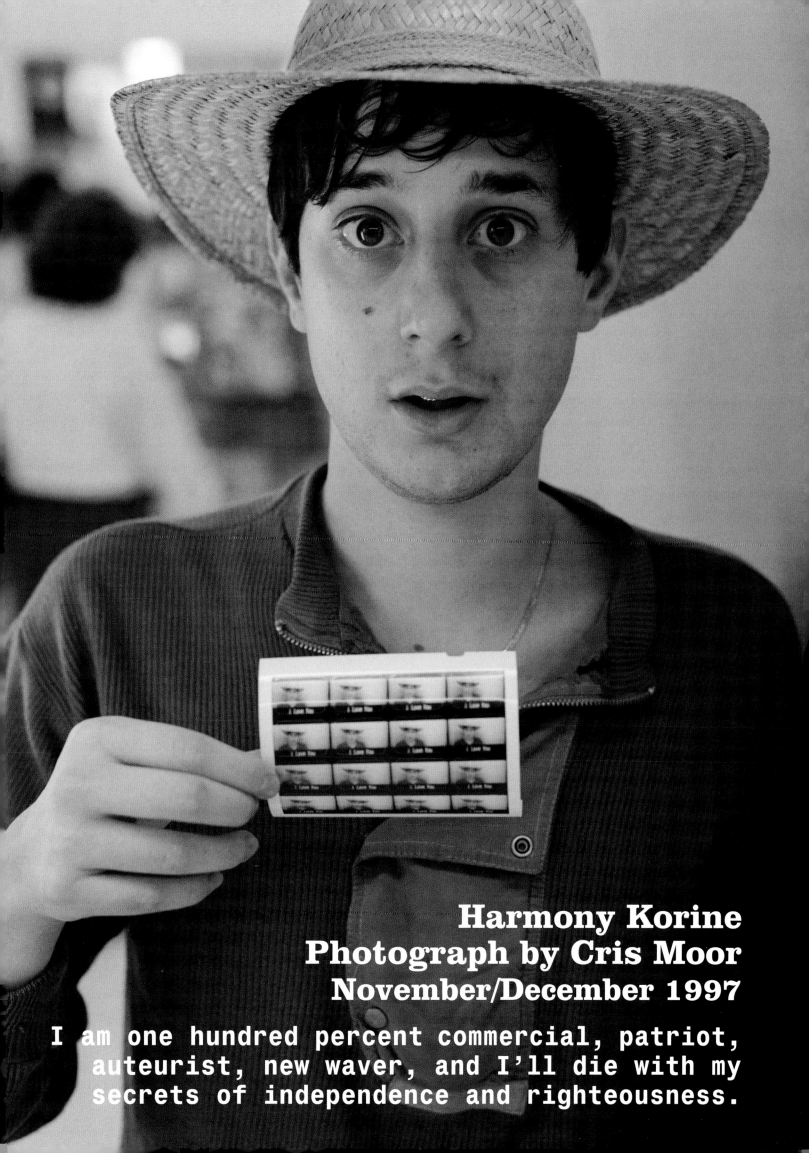

Harmony Korine
Photograph by Cris Moor
November/December 1997

I am one hundred percent commercial, patriot, auteurist, new waver, and I'll die with my secrets of independence and righteousness.

KATHLEEN HANNA with Laurie Weeks

Photograph by Leeta Harding
September/October 2000

LAURIE: How did Le Tigre come into being?

KATHLEEN: Johanna Fateman and I had been in a band called The Troublemakers, named after G. B. Jones' movie. Sadie Benning and I met when I saw one of her PixelVision videos.

LAURIE: You and Sadie seem made for each other.

KATHLEEN: She used a Bikini Kill song in that video, which just gave me shivers up my spine, because I was, like, "Finally somebody's doing something really cool with something I've been a part of, as opposed to just ripping it off and making fun of it." Then she just started writing me these letters . . .

LAURIE: That's so cool and open, to put herself out there like that.

KATHLEEN: Yeah, and I started writing back, and one thing led to another. She got a gig doing a short thing for *MTV*, and she needed somebody to do music for it. I lied and said, "Oh, yeah, I play guitar," and I totally didn't know what I was doing. So I locked myself in a room with a four-track and a guitar I didn't know how to play, and I sat there for an hour trying to tune it, and when I finally did, I was just crying. But it was really cool, because nobody else would have hired me for something like that, and I needed the money, and it was really fun working with her. Then, when I did the *Julie Ruin* project, I asked her to work on a video with me. So we went to Chicago and made *Aerobicide*.

LAURIE: And how did you originally get together with Johanna Fateman?

KATHLEEN: She's a painter and writer, and she did a bunch of really great zines. I met her through this zine called *SNARLA*. At one point, I really needed to get out of Olympia, so I moved to Portland for about a year. This was when I was still in Bikini Kill. So I found out where Johanna worked, and I hung out there, trying to meet her. After talking to her for about ten minutes, I was, like, "Can I move into your house?"

LAURIE: No shit?

KATHLEEN: Yeah. I needed a place to live, and she was, like, "A room's opening up soon," so I just sort of bided my time until then. And she was really, really cool to me, and we did a band together and did all kinds of weird shit. We built a stage in our basement and had shows at our house. Then Johanna went to New York and started art school and writing zines about art, and it was really freeing. I'd had this thing about, "Oh, it's so fucked up to be an artist, and I should be an activist, because how's art actually going to change material conditions?"

LAURIE: Well, your art is your activism.

KATHLEEN: Yeah. And it's always really hard, you know? With Le Tigre, one of the things that really helped me was being excited about Mr. Lady, our record label. Tammy Rae Carland runs it. She started Mr. Lady with her girlfriend, Kaia, who's in The Butchies. One of the first things they did was the *New Women's Music Sampler*, and in the liner notes Tammy talks about the whole lie that things are "post-gay, post-feminist, post-riot grrrl, post-race, post-poor, post-oppressed."

LAURIE: Post-depressed!

KATHLEEN: Post-oppressed. I wish it was post-depressed! But there's this other sentence, "We refuse to allow our writing, songs, art, activism, and political histories to be suppressed or stolen . . . we refuse to be embarrassed about the mistakes and faults, and we move forward." That inspired me, because I realized I didn't have to be either/or. I don't have to be involved in something or be totally the opposite of it. We can take the mistakes and learn from them.

LAURIE: Was it hard to put that into action?

KATHLEEN: Well, that's what Le Tigre was for me. I was, like, "Okay, I'm going to get these people who I've always wanted to seriously collaborate with and make something happen." When we started working together, I got really interested in writing something . . . I don't believe in positive and negative, but I did want to make something really hopeful. So I thought about how there are all these really great artists, and I keep their stuff around me all the time. And I wanted to make a song about it. And the "old me" was, like, you can't make a song like "Hot Topic," where you list all these people you find inspiring. You're going to leave someone out! But then I thought, "This is a snapshot of this moment and who we're talking about today." So the three of us sat down and wrote out these lists and figured out who rhymed and who fit and who made us feel like we could do anything.

LAURIE: What are you getting into now with Le Tigre?

KATHLEEN: We're going to do all these collaborations. We really want to work with Anna Joy Springer, because I love her singing. And we want to do this record that takes the "Hot Topic" theme to the next level. Instead of talking about people, we make tracks and do collaborations with them, because with electronic music it's so much easier.

LAURIE: I think the fact that you can dance to Le Tigre is such a subversive thing.

KATHLEEN: Well, pop music is a structure, and I'm going to use the structure and make something else happen with it. Sort of like Style Council. A lot of their songs are political, but they're so soothing and pleasant that you can miss it. What they're counting on is that people will listen to it over and over and read the lyric sheets, so it can be both beautiful and political. You don't have to make a choice. You don't have to be in a punk band screaming political lyrics that nobody really wants to dance to—you know what I mean? A lot of rap music is about pleasure and politics all at once. I want to make something that's totally pleasurable and political too.

PARKER POSEY
with Christina Kelly

Photograph by Wolfgang Tillmans
November 1996

CHRISTINA: What was Laurel, Mississippi, like?
PARKER: Population, like, 2,000. I'm glad I'm from there, but I think the South is just wacko and crazy. There's good storytelling, good characters. Nothing to do, but, you know, the hypocrisy everywhere. Forty-one Baptist churches in my hometown, one Catholic church.

CHRISTINA: Were you Catholic?
PARKER: Yeah, they thought Catholics were like alcoholics 'cause they serve wine in Mass. And the Jews were all shot or killed. I mean, where are they? So they preach all this, you know, love your brother, yet, literally, over the tracks, poor people are getting shot. We're talking, like, Carson McCullers.

CHRISTINA: I just finished reading *The Heart Is a Lonely Hunter*, and that's immediately what I started thinking about when you were talking about the South. How did people react when you went away?
PARKER: They didn't know what I was doing. They just thought I was weird. But then I got on the soap opera, and, you know, wheee! It was the greatest thing that could happen to my hometown. My family just loved it.

CHRISTINA: What were you like as a kid?
PARKER: I'm so boring. You're, like, "Yeah, how much longer do I have to interview Parker? She's such a bore." Oh, I don't know. I leave that between me and my shrink. No, I'm teasing. I was sick a lot, actually. Allergies.

CHRISTINA: Really?
PARKER: And I was a dreamer. I was kind of strange. I was very absentminded. My parents thought I had a learning disability, because my grades weren't as good as my brother's. Plus I was three months premature. The doctors told my parents that their children could very possibly be retarded and to hold them back a year in school. So my parents were on the lookout to see if their kids turned out to be mental cases. And I did, and my brother didn't.

CHRISTINA: What was your favorite role?
PARKER: They're all fun—you know what I mean? I'm not out to play the retarded girl, like Jodie Foster in *Nell*, which everyone thinks is so good. Forrest Gump. Tom Hanks is incredible in that, but it's ironic. We all like to look at people who are deaf and dumb heroes. I don't know where that thought came from.

CHRISTINA: Maybe because you were saying that . . .
PARKER: My parents thought I was retarded. That's it.

CHRISTINA: How long did it take for you to write your script for *Dumb in Love*?
PARKER: I wrote it in the cycle of my period. I started on my period and finished on my next period. It was two years ago in May. I just think people need to see people act passionately, and not just in the sheets. They should be more passionate about their ideas, more passionate about what they believe in. Especially men, you know? I think male actors are just trying to be macho or trying to be John Wayne, Jack Nicholson, Mickey Rourke, De Niro, Pacino. They're all short, by the way.

CHRISTINA: So you were saying people need to see passion that's not between the sheets. How do you feel about doing sex scenes?
PARKER: Sex scenes are scenes that imitate sex scenes in other movies.

CHRISTINA: As opposed to actual sex?
PARKER: Uh huh. Here's my theory, if you really want to hear it. I think that in the past 15 years the women have gone to work and left the men, and the baby boomers who are now in Hollywood and control a lot of the money are upset that the wives have gone, that mommy's gone off to work. So there are all these scripts where the women, if they're working, are prostitutes or lawyers with an angry streak who'll kill you. It's a reaction to women leaving their men and men being angry about it and saying it on some subconscious level.

CHRISTINA: Why do you think so much attention is given to actors?
PARKER: Looking perfect and looking young and looking beautiful and having wealth—I think people just want that. So they want to see that or dream about it. Or they want to be movie stars. I want to be a rock star. Really. I'm not ashamed. I want to get onstage and sing. And I can't, but I want to. It's all fantasy, you know?

CHRISTINA: How do you feel about being the object of fantasy?
PARKER: I don't feel like I am.

CHRISTINA: How about the prospect of that?
PARKER: I guess I feel bad when people look at me like I have everything and it's like they hate you.

CHRISTINA: Or they love you.
PARKER: They're fans. They couldn't really love you, because they don't know you. So either they are a fan or they are repulsed by you. I've done interviews where the person just looks at me with this look of, "I know who you are and what you're about." And no one can know that. The flip side of that is, it's kinda neat to have an image.

CHRISTINA: What do you think your image is?
PARKER: A party girl, I guess. My image is totally out of control. But it's fun to be something, have that, and you don't have to be real. It's, like, comedians. They go on, and they're doing all these jokes. I would be like that if I were more awake.

CHRISTINA: Does that protect you from being real?
PARKER: It protects you from having people suck you out of yourself. You've got to take care of yourself. You can't give that all away. It's why some actors do drugs. Like heroin—I've never done it, even by accident. So I don't know what it's like. But it's the feeling of being alone with yourself. You lose it if you give too much of yourself, if you let people take from you. I would like to get really big and huge so I could go to outer space. I would like to be the first actress in space.

JOHN WATERS
with Peter Halley
and Bob Nickas

Photograph by Wolfgang Tillmans
February 1997

BOB: You probably didn't like our Sports & Games issue.
JOHN: I liked all your other issues. I just hate sports, so how could I like that?
BOB: Our new issue has an interview with Gus Van Sant.
JOHN: I love Gus. He's been in Baltimore.
PETER: Can you put your finger on what it is you hate about sports?
JOHN: Basically I hate it because I hate the idea that men assume other men have an interest in it. When you get into a cab in a strange city, and the driver talks about a football game, I think, How dare you say that to me? Would I get into a car and say, "Wasn't Fassbinder's last movie great?" No, I would never do that. So why do you think I'm interested in that? Also, my father, who I get along with great—I love my father, but when I was a child, he felt it was his duty to take me to sporting events. And it was torture for me. I remember sitting there the whole time trying to imagine what would happen if the stands collapsed and every person there died. And I pictured thousands of ambulances coming in. That's how I'd sit there, imagining destruction and death, with my father. So, I hated it always. [Intercom buzzes.] Who is it? [Silence.] Just delinquents.
BOB: Tomorrow's stars today.

JOHN: I doubt it.
PETER: When do you write?
JOHN: I write every day, Monday through Friday. I get up at six. I write from 7:30 to 12:00 every single day, with Bic pens, legal pads, Scotch tape, and scissors. I've written 13 movies and four books. I'm writing my movie right now in the same way.
PETER: That's incredible.
JOHN: All writers write every day. You can't get it done if you don't.
PETER: But as a director, it's unusual for you to be such a writer. Or are there others . . . ?
JOHN: Well, who has the best career in the world? The most enviable career is Woody Allen's.
PETER: And he writes them.
JOHN: He writes every one of them. And nobody says to Woody Allen, "I don't like this scene—how about this?" He doesn't take notes from studio executives, I promise you.
PETER: I've got to say, I like his work, but it is an unusual example of somebody growing up on film as a director.
JOHN: I think it's the most stunning American career there is. I think Scorcese is the best American director, and Woody Allen has the most enviable career.
PETER: And why does everybody say Scorsese is the best American director?
JOHN: To me, he just makes the best movies. He has more film knowledge than probably any human in the country.
PETER: More than you?
JOHN: Oh, way more. He has an obsessiveness about movies that makes me look like an amateur. I think he's incredibly intelligent, driven, and makes incredibly wonderful, well-directed movies.
PETER: I know you have a place in New York now. I have this theory that people can't write in New York because it's so hectic.
JOHN: I can.
PETER: You can?
JOHN: I write in Baltimore and New York. I write in both places equally well. Whichever apartment it is, I keep the same hours. It makes not one bit of difference to me.
PETER: And do you like going to Los Angeles?
JOHN: Let's put it this way: I have friends I adore in LA.
PETER: Work friends?
JOHN: No, real friends. Then I have work friends. But I get out of there as quickly as I can. Because what little power I have there would evaporate if they saw me at parties. I'm there for one week. It's either, they're going to go for it or not. If they see me all the time, I won't even have that.
BOB: It makes them want you more. I mean, if you're always around . . .
JOHN: . . . they get used to you.
PETER: I happen to like a lot of movies that were the director's first movie. But a lot of directors only seem to be able to make that one movie, and then they fall apart.
JOHN: Well, you know what Alfred Hitchcock always said, "Self-imitation is style."
BOB: There's obsession again . . .

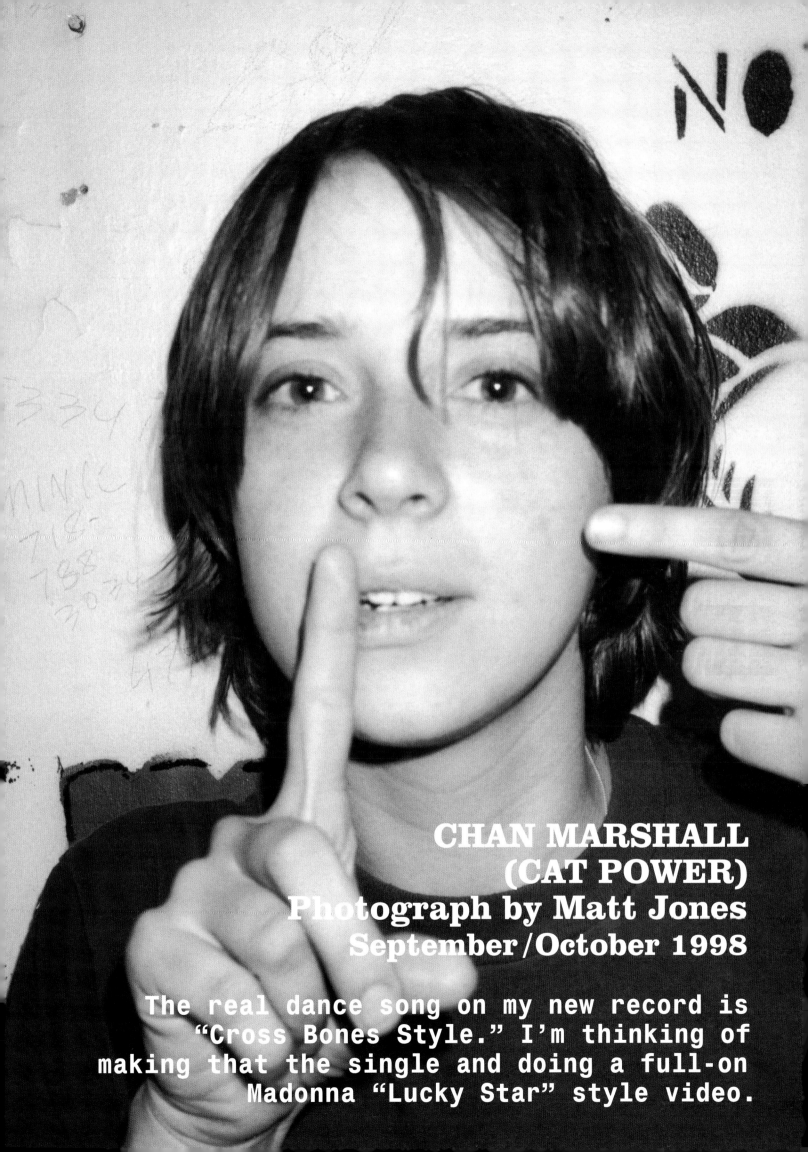

**CHAN MARSHALL
(CAT POWER)
Photograph by Matt Jones
September/October 1998**

The real dance song on my new record is "Cross Bones Style." I'm thinking of making that the single and doing a full-on Madonna "Lucky Star" style video.

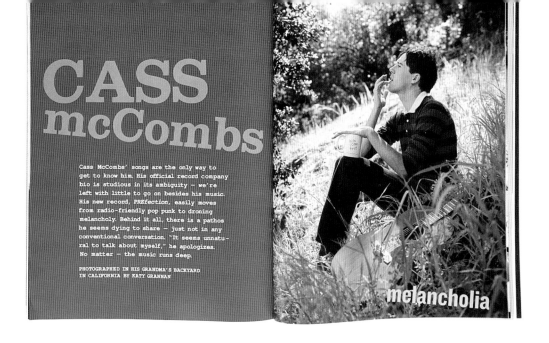

CASS mcCombs

Cass McCombs' songs are the only way to get to know him. His official record company bio is studious in its ambiguity — we're left with little to go on besides his music. His new record, *PREfection*, easily moves from radio-friendly pop punk to droning melancholy. Behind it all, there is a pathos he seems dying to share — just not in any conventional conversation. "It seems unnatural to talk about myself," he apologizes. No matter — the music runs deep.

PHOTOGRAPHED IN HIS GRANDMA'S BACKYARD IN CALIFORNIA BY KATY GRANNAN

melancholia

need ne

...ILADELPHIA BY ALE...

SUMMER TOUR:

Photographs by Katy Grannan, Alex Hoerner, Susanna Howe (top row), Nick Haymes, Marcelo Gomes,

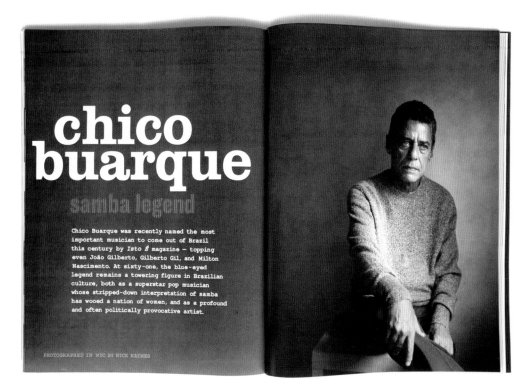

chico buarque
samba legend

Chico Buarque was recently named the most important musician to come out of Brazil this century by Isto É magazine — topping even João Gilberto, Gilberto Gil, and Milton Nascimento. At sixty-one, the blue-eyed legend remains a towering figure in Brazilian culture, both as a superstar pop musician whose stripped-down interpretation of samba has wooed a nation of women, and as a profound and often politically provocative artist.

PHOTOGRAPHED IN NYC BY NICK HAYMES

dreampop

la li puna

PHOTOGRAPHED IN TRENTON, NYC BY MARCELO GOMES

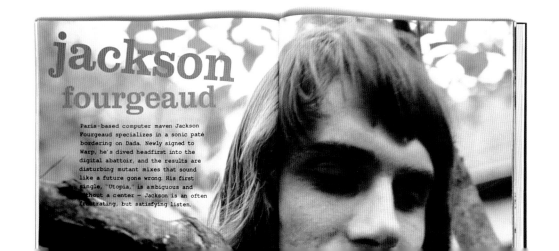

jackson
fourgeaud

Paris-based computer maven Jackson Fourgeaud specializes in a sonic paté bordering on Dada. Newly signed to Warp, he's dived headfirst into the digital abattoir, and the results are disturbing mutant mixes that sound like a future gone wrong. His first single, "Utopia," is ambiguous and without a center — Jackson is an often frustrating, but satisfying listen.

melodic synth

ody

Her third sonic manifesto *Where's Black Body?*, deliciously extraordinary... New Body wind through multiple... free-form arty explorations, art-damaged... slipping alt-rock mockery. "I give a nod to... their scooters," vibes singer Jeff... to... stoned Jonathan Richman. "They keep it on..."

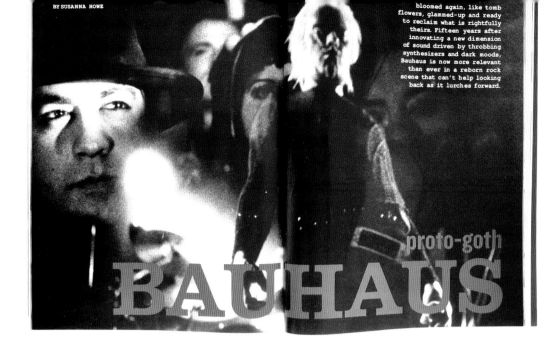

BY SUSANNA HOWE

bloomed again, like tomb flowers, glammed-up and ready to reclaim what is rightfully theirs. Fifteen years after innovating a new dimension of sound driven by throbbing synthesizers and dark moods, Bauhaus is now more relevant than ever in a reborn rock scene that can't help looking back as it lurches forward.

proto-goth

BAUHAUS

UNE / JULY 2005

Leeta Harding (middle row), Vanina Sorrenti, Katja Rahlwes, Valerie Stahl von Stromberg (bottom row)

...ali Puna are a study in dynamics. Keyboard melodies wrestle with muscular guitars and drums, as their songs teeter between lush pop and wall-of-sound rock. Fronted by vocalist/keyboardist Valerie Trebeljahr, a Portuguese-educated German national of Asian descent, the Munich-based ensemble has accomplished what so many have failed to do – finding the human voice in what has largely become an electronic medium. A double CD of new songs and remixes, *I Thought I Was Over That*, is out this summer.

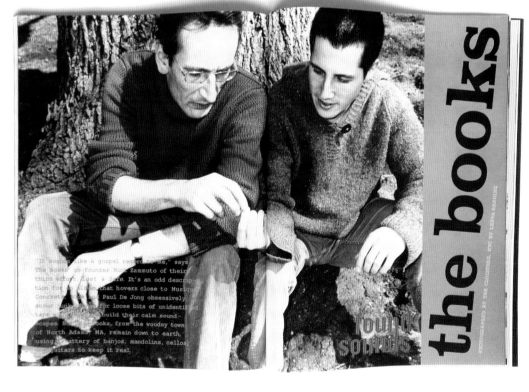

the books

PHOTOGRAPHED AT THE CLOISTERS, NYC BY LEETA HARDING

"It sounds like a gospel record to me," says The Books co-founder Nick Zammuto of their third effort, *Lost & Safe*. It's an odd description for a duo that hovers close to Musique Concrète... Paul De Jong obsessively scour... for loose bits of unidentified... build their calm sound... Books, from the woodsy town of North Adams, MA, remain down to earth, using a battery of banjos, mandolins, cellos, guitars to keep it real.

cyann

Gingerly sculpting minimalist folk and seasonal moods (their first album was titled *Spring*, their second, *Happy Like an Autumn Tree*), and painting their songs with ear-tickling radio waves, French quartet Cyann&Ben have concocted a melodic oeuvre as otherworldly as it is human. One can only wonder what textures they'll summon for their next venture, which they're recording right now.

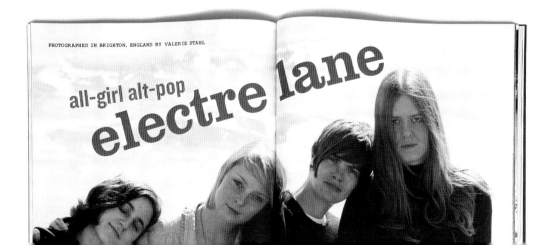

PHOTOGRAPHED IN BRIGHTON, ENGLAND BY VALERIE STAHL

all-girl alt-pop
electre lane

JACQUI MILLAR
Photograph by Mark Borthwick
November/December 1999

Technoenthusiast and PR director for tomandandy, a multimedia music company, Jacqui explained, "I think technicians are the new gods. Like, it went from bands to DJs, and now it's software."

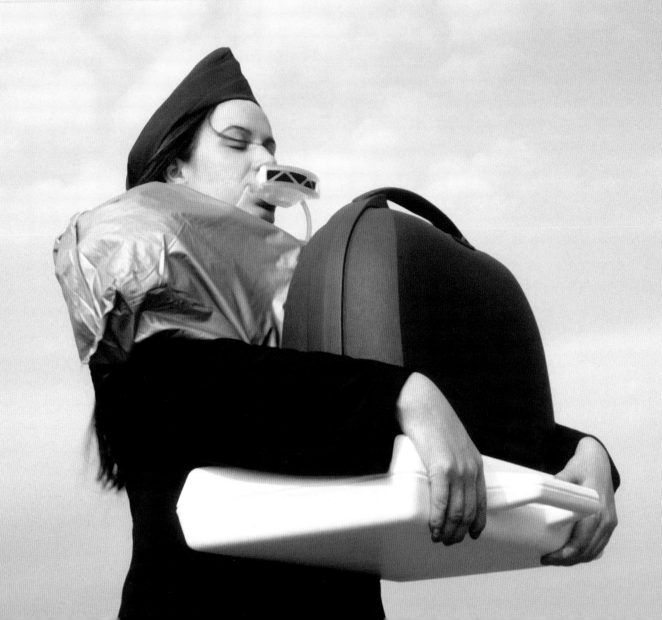

TOUR DIARY: THE MELVINS
FEBRUARY 1996

CHARLESTON, SOUTH CAROLINA

We're playing at the Music Farm. We haven't played there in eight years. Last time we played there, it was with a heavy-metal cover band called Fatal. Needless to say, the show was very fatal. There were all these totally mohawked punks who were there to see RKL—that's Rich Kids on LSD. They're still around. I saw them a few months ago, and they're playing the same songs they were eight years ago. So the club was packed with these punks and jock redneck guys who were there to see Fatal. We were hated with a passion. A huge riot broke out, because the two audiences didn't get along. The jocks started beating up the punks and vice versa. We had to call the cops and get our gear out of there, because they wanted to murder us. So we'll see how much things have changed in the good ol' South.

Charleston is right next to Pork & Beans, South Carolina. We checked that out, and then we actually went to Mayberry. It's wild. They actually have Floyd's Barber Shop and the sheriff's office. They sell tons of Mayberry, USA stuff. I actually bought a Gomer Pyle hat, so when we do "Joan of Arc" tonight I'll be sporting it when I do the Gomer Pyle beginning. We're thinking about starting a cover band called Ronnie James Devo. We're going to do Dio songs Devo-style and Devo songs Dio-style. It's gonna be great. "Whip it gooooood—Yeah!"

We just got a new shipment of T-shirts the other day. But we got 18 dozen Material Issue T-shirts. They sold like hotcakes! I suppose Material Issue, wherever they are, are having a hard time selling ours. But our shirts are really cool. They have an upside-down cross with a happy face in the middle. Then there are four circles; inside one is a peace sign, in one there's a pot leaf, then a gun, and a Magic 8 Ball. On the back is a skull, and it says STONER WITCH. So we have all our bases covered with the teen themes—Satanism, heavy metal, we've got the stoners, we've got the hippies. It represents good and evil. The Magic 8 Ball represents religion, spiritual guidance. The spiritual guidance on our record was provided by the Magic 8 Ball. We said, "Is this mix done?" And the 8 Ball would say, "No." or "Reply hazy: ask again later."

Over the years, working with filmmakers such as Mary Harron, Todd Haynes, and Larry Clark, Vachon has re-cast the usually anonymous role of producer into one as creative and uncompromising as the director's. With films to her credit such as *I Shot Andy Warhol* and *Velvet Goldmine*, it's not so far-fetched to suggest that today Vachon is to independent film what Cubby Broccoli was to the James Bond series and Dino De Laurentiis was to the mega-disaster flick.

MARY: Killer Films has hit upon so many touchy subjects that are in the press. How do you negotiate between what's pure sensationalism and what's a good story?

CHRISTINE: I think it's just a gut feeling. A story doesn't appeal to me because it deals with grisly subject matter. It appeals to me because it's well told or because it feels like it's hitting some button that I haven't seen hit before.

MARY: What are some of the projects you're working on now?

CHRISTINE: *Crime and Punishment in High School*, which is exactly that, and the film about Brandon Teena, a Nebraska trans teenager who was raped and murdered. The working title is *Take It Like a Man*.

MARY: It would be such a shame if a movie dealing with extreme transphobia and hate crimes only got an art-house release.

if you're making a film for $50,000 or $50 million.

MARY: What's the biggest budget you've had to work with?

CHRISTINE: *Velvet Goldmine*, which was under ten. The good part is, when you're making a movie that's under ten, there's a sense from the cast and the crew that they're there because they want to be.

MARY: Do you see yourself going toward bigger-budget movies?

CHRISTINE: It totally depends on the film. You know, my sense is always that the budget has to have some correlation to the film's potential audience. It has to. If I come across a script that one of my directors wants to make that is big-budget in nature and in appeal, then we'll make a big-budget film. Maybe Todd Haynes will decide he wants to make *Lethal Weapon V*, but with a Haynesian twist. Then we'll make it.

MARY: Well, what about kids today? So often it seems people are bringing a greater sense of entitlement to what they're doing.

CHRISTINE: Absolutely. There's a sense that the world owes you your first feature. Here's what I find astounding: I do these workshops, and I stand there in front of a bunch of twenty-somethings, or almost twenty-somethings. They all want to be filmmakers, and they say all the

CHRISTINE VACHON with Mary Clarke

November/December 1998

CHRISTINE: You just never know. Sometimes you have a story that's difficult but incredibly interesting, and you then combine it with actors who are very juicy and cool, and you hope that together it will raise the want-to-see factor.

MARY: How many movies have you produced?

CHRISTINE: Fourteen or fifteen. I'd have to count them up.

MARY: Do you have favorites?

CHRISTINE: At the time I'm making it, every movie is the one I'm the most passionate about. There are some movies I look back on as favorite experiences—like showing *Go Fish* to an all-lesbian audience or doing our concert scenes on *Velvet Goldmine*. In some ways *Safe* is one of the films I'm proudest of, because it was so hard to make. And people didn't embrace it immediately, by any means. A lot of critics who weren't very nice about it when it came out later turned around and embraced it as brilliant, which is great. But it would have helped if they'd done that when it was actually in the theaters for a minute.

MARY: Is it better if you have a low budget and you're forced to be creative? Or does that become tiresome after a while?

CHRISTINE: Of course it does. But a budget is a reality, no matter what your budget is. Thirty million may not be enough if your film is more ambitious than that. Every producer and director comes up against walls that they've got to think of creative ways to circumvent. That's the same

things that kids that age say, basically: "I have something to say." But when you ask, "Who are you saying it for? Who is your audience? Who is this supposed to speak to?" they don't have an answer. There's this sense that anybody who has a story can bring it to celluloid, and the ideas of craft get lost.

MARY: So part of the purpose of your book, *Shooting to Kill*, is to show that there's a lot more to moviemaking than just standing behind the camera?

CHRISTINE: I wanted to give an idea of what real creative production is. Even though I moan, "Oh, there are all these people running around saying, 'I want to make a movie,'" there are not that many great producers. There aren't that many people who have a real sense of how to find material, put it together with the right people, and locomote a project—which in independent film often is 90 percent of what you're doing. I don't think being a producer is as sexy as being a director, of course. Everyone wants to be a director. But I don't.

MARY: Low-budget filmmaking has obviously changed dramatically since you started. Can you predict at all where it's heading?

CHRISTINE: My only big prediction is that independent film is going to be declared dead in the next year.

MARY: So it's cyclical?

CHRISTINE: Something will rise out of the ashes, and we'll be able to get on with it.

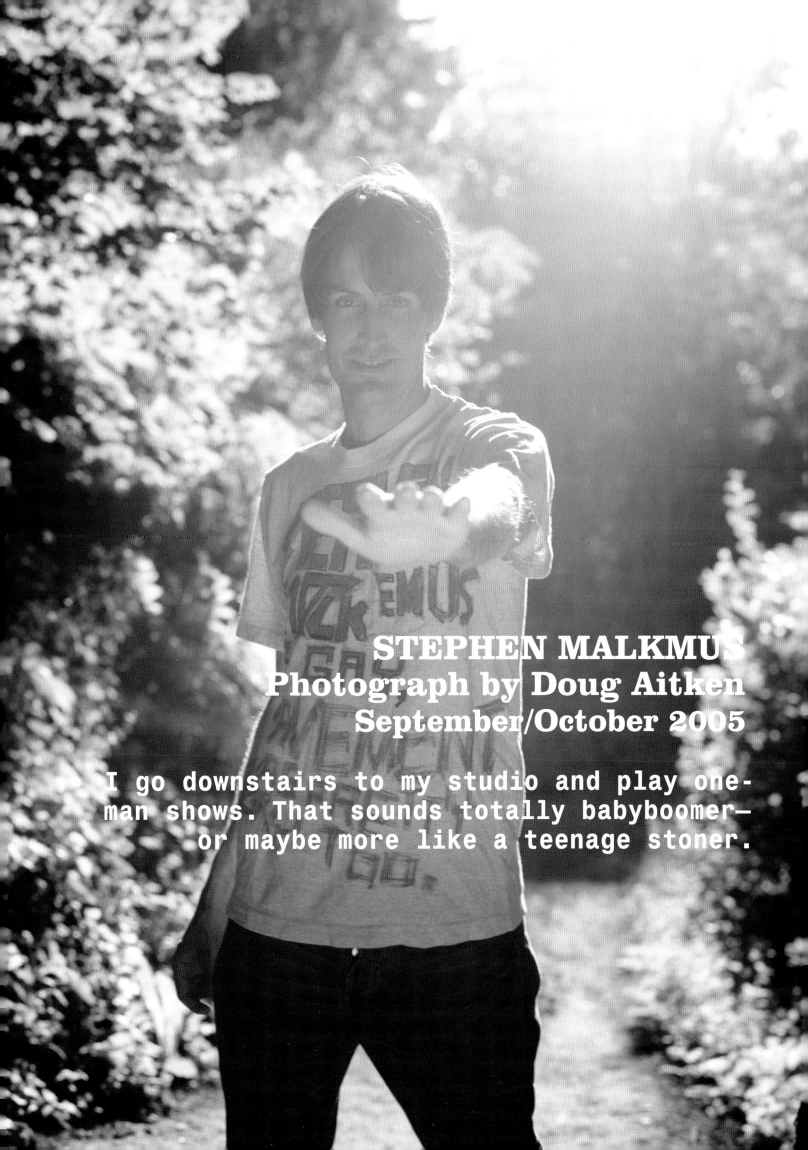

STEPHEN MALKMUS
Photograph by Doug Aitken
September/October 2005

I go downstairs to my studio and play one-
man shows. That sounds totally babyboomer—
or maybe more like a teenage stoner.

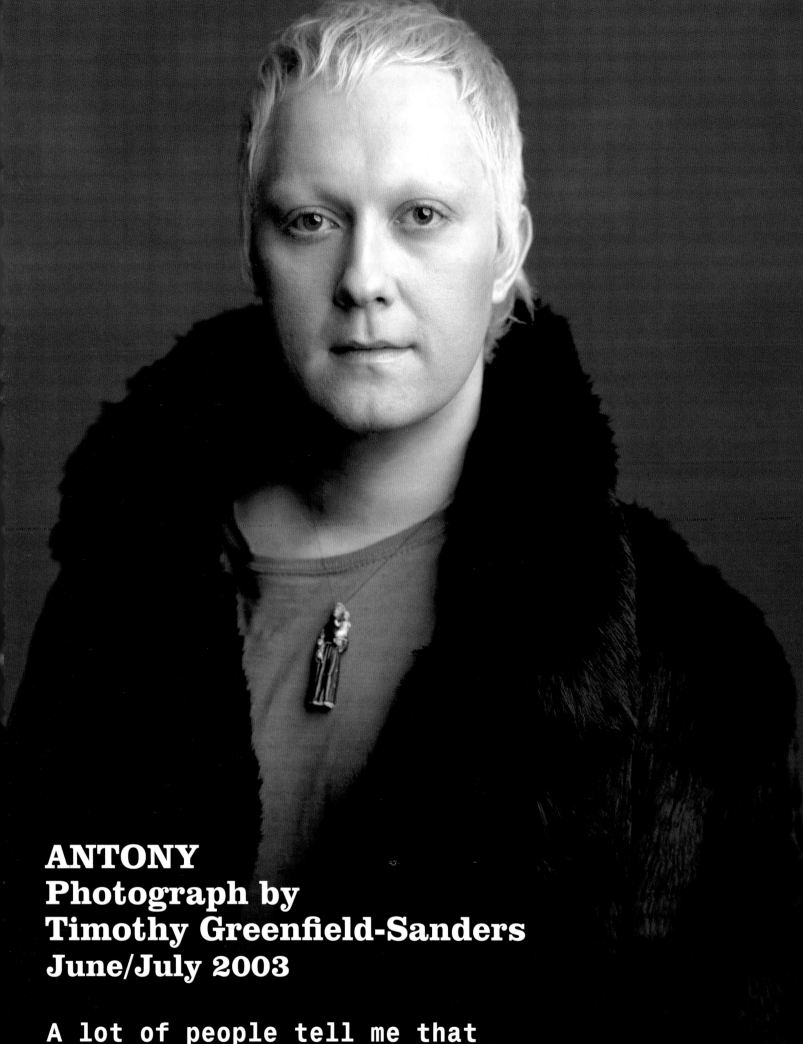

ANTONY
Photograph by
Timothy Greenfield-Sanders
June/July 2003

A lot of people tell me that
my songs are too self-indulgent,
too full of sorrow and grief.

TODD HAYNES
with Stephen Sprott

June/July 1998

STEPHEN: It seems that all the films that you've made play as much with film history as with the history of recent pop culture. All these little film tricks in *Velvet Goldmine* have a nostalgic appeal.

TODD: I remember going to the movies in the late '60s and early '70s, seeing films like *Butch Cassidy* or *The Graduate*, and you never knew what was going to happen. There was no sense of the ready-made genre that we have today, where you just plug in different actors and slightly different scenarios. Back then, it was a feeling almost akin to a drug experience, where you entered into a world you'd never seen before. I definitely wanted to bring that into *Velvet Goldmine.*

STEPHEN: How were you able to do that?

TODD: Throughout the film, there is a real insistence on visual motifs that come from the early '70s, stuff that we haven't seen in a long time, like rampant zoom-ins and zoom-outs, racking focus and swish pans, a whole different kind of camera . . . much more investigation of surface, of the grain of cinema, not the pyrotechnics of tracking and swooping into things physically

STEPHEN: It couldn't look more different than *Safe*.

TODD: With both *Safe* and *Velvet Goldmine*, there were a series of rules played out within each film's universe. *Safe* had a controlled camera that was extremely removed from the subjects, that slid very subtly in space around Carol White, the main character. Whereas *Velvet Goldmine* is full of short, fast shots, zoom-ins, and highly ornate kinds of camera movement. So the films are almost jokes on each other in a funny way, they were so opposite—or jokes on me.

STEPHEN: Did your style evolve from one film to another, or do you think the nature of the story demanded that *Velvet Goldmine* look so crazy?

TODD: There are definitely parallels to my first film, *Poison*, in the messiness of the filmmaking—although I'm not a messy filmmaker. I'm an incredibly over-cognitive filmmaker. But the visual poetry of the two films comes from trying to have images that can take over the narrative machine. Of course, those two films are so much more about sexuality than *Safe*. *Safe* is also about the body, but it's not at all about sexuality. I'm not sure if there are two catagories for the films that I make—with the more intertextual, cut-up films that are often more gay-themed and more sensual and erotic, and then the more cerebral "women's films." [Laughs.] Who knows? Certainly *Poison* had a much stricter, theoretical structure, with its three interwoven stories, making you very aware of the artist's hand manipulating the different parts. Maybe I'll start to see a pattern emerge.

STEPHEN: *Velvet Goldmine* almost has a *Citizen Kane* type of story.

TODD: It does have this sort of fantastical narrative structure that's very classic Hollywood—an investigator unfurling a story that his memories and his past start to mingle into. But it still has a kind of uniform narrative that's not being so completely manipulated.

STEPHEN: Do you feel more grounded when working on a film like *Safe*? Do the multiple texts of *Velvet Goldmine* make it harder to find your place?

TODD: *Velvet Goldmine* was the hardest thing I've ever done. It did not come naturally to me, neither the writing of the script nor the creation of the film. You hear those stories about Tarantino writing his scripts—that the characters just wrote themselves! I probably have never, ever felt that. I think I would be scared of feeling that way. With *Velvet Goldmine*, I tried to incorporate what I consider to be the language and material of Glam rock into a narrative context. And that means that the narrative is essentially artificial and stylized. My challenge as a filmmaker is to have this emotional side that draws you in and that reverberates within you, but with nothing in the material of the actual elements that announces that.

STEPHEN: And the music helped you to that end?

TODD: Completely. That's what's amazing about Roxy Music. The best of their stuff, their early records, are very well thought out tropes, with arch lyrics, the whole pose of the performers with their costumes. Bryan Ferry would snarl his lyrics and trill like a vaudevillian singer. Still, these songs are incredibly moving. They can comment on what they're doing and still be enveloping and resonant. That, to me, is amazing and curious, and it goes against the whole tradition of rock, which had been about authentic expression and a direct depiction of emotion. Glam rock took this strident stance against that. When it works, it's not just a camp joke; it has an emotional side as well. That's what I'm hammering myself to try to put into this film.

STEPHEN: *Velvet Goldmine* is so shockingly about Glam sex and the Glam revolution. But because your camera takes an almost childlike point of view, we see Glam as having more of an unformed relationship to sexuality.

TODD: Despite all the films that have come out about that time and are continuing to come out, it's something that I don't feel has been sufficiently addressed. There was this incredibly progressive optimism, particularly in the early '70s. Despite the fearful state of siege in most Western countries at the end of the 1960s, there was the courage to continue to shock and amuse and play around with sexuality and notions of gender. As the film states, the revolution became a sexual revolution in the early '70s. I love that. I think that the androgyny, the leaning toward bisexuality, even the naïve notion of racial integration that was prevalent around that time, particularly within youth culture, was *radical*. It really was the most culturally progressive period, unlike anything we've seen since—which I miss. I did want to put that in the film.

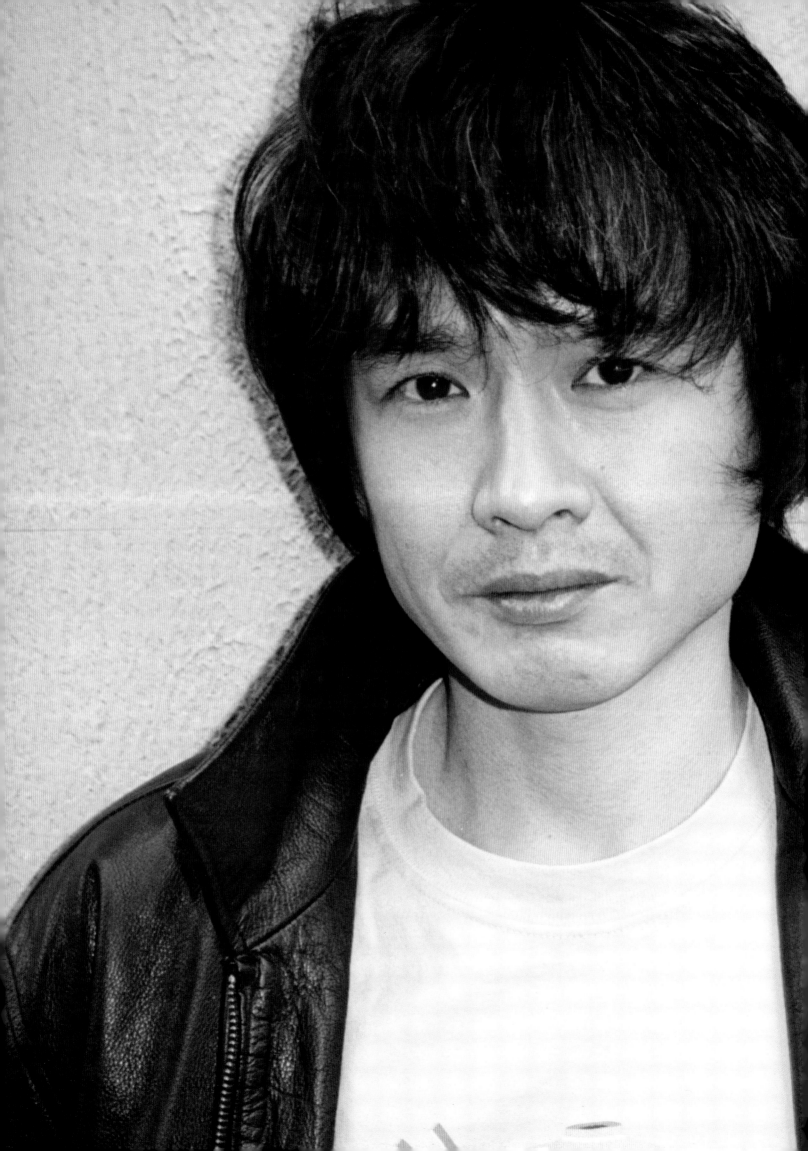

J
Japan

YOSHITOMO NARA IN TOKYO
Photograph by Leeta Harding
February/March 2001

My artwork contains a lot of guilty memories that remind me how bad I've been. I frequently get letters from people who tell me that my paintings show them their own inner darkness.

AKIRA ASADA with Krystian Woznicki

September/October 2001

Asada's first book, *Kozo to Chikara (Structure and Power)*, appeared in 1983 when he was 26 years old. Without any advance publicity, it sold close to 80,000 copies in a matter of weeks. Asada became a bona fide, if unwilling, cultural celeb. His popularity was referred to as the "AA Gensho," the "AA Phenomenon." Now 44, Asada continues to write about a range of cultural issues, from Japanese consumerism to the adulation of pop idols. He is always eloquent and full of passion, whether in his laserlike writings or when he speaks.

KRYSTIAN: Why do you think there was such a voracious consumption of postmodern critical writing during the '80s in Japan?

AKIRA: From 1945 until the early '70s, Japanese culture tried to be very modernist. But in the '80s, partly because of economic growth, and partly because of the importation of postmodern theory, people stopped worrying about modernism. Instead, they began to search for their roots in the premodern period. They synthesized that with postmodern theory. There was a group of people who looked for a historical precedent in the Edo period, a time when everything was communicated through parody and pastiche.

KRYSTIAN: A lot of people cared about this?

AKIRA: In the '80s, one could find the most acute symptoms of Japanese consumer society's avant-garde nature. The managers of department stores read Baudrillard, and they understood his ideas. They didn't believe in the inherent value of merchandise, and they consciously manipulated the consumers' desire by making use of parody in advertising.

KRYSTIAN: Was that the setting in which your book became so popular?

AKIRA: Actually, Japan had been a paradise for translations of European writers for a long time. In the '60s and '70s we already had some translations of Benjamin, Adorno, Deleuze, Derrida, etc. But they were read and discussed only in academic circles. Then in '83 I wrote my first book, which was a summary of French postmodernism. To everyone's astonishment, it became a best seller and made me a sort of cultural hero. I was chased by the media. My case was a symptom of how theory can get consumed and become fashion. I was trying to analyze the very mechanism by which such a thing could happen, but in a postmodern consumer society, the theorization itself was consumed!

KRYSTIAN: Media and culture studies have been very fashionable in the US as well.

AKIRA: But the American situation is different, because the focal point there has been multiculturalism. In college literature departments, you can't simply concentrate on the Western canon anymore. You have to read African literature, Asian literature, etc. You also can't simply concentrate on the heterosexual male writers. You have to read some gay writers, some lesbian writers. I don't want to criticize all these—it's wonderful to rediscover the creations of minorities and marginalized people. The problem is that the motivation can be more politically oriented than spontaneous.

KRYSTIAN: What do you think of virtual reality?

AKIRA: If you want to think about "virtual sex" or "virtual death," problems arise. Death is real. You can imagine a dead person, but you cannot imagine death itself—it escapes from being captured with words or images. It's the Real in the Lacanian sense—that which escapes being mediated by any language.

KRYSTIAN: There's a sort of low-end use of technology that's very important in Japan, like the "girls with cameras" phenomenon of photographers like Hiromix and Yurie Nagashima.

AKIRA: It's true. We do have a general tendency toward infantilization. [Laughs.] There's a divide that goes on in the consumption of technology in Japan. On the one hand there are real techies, and on the other hand there are people who play with gadgets, of which the girls' photography phenomenon is a good example. These polar opposites exist simultaneously. My wish is to overcome that polarization. There is also a divide between young people who are interested in new machines and old people who read philosophical books. Somehow we have to close the gap and open up a space for dialogue.

KRYSTIAN: There seems to be a celebration of amateurism going on, which is promoted by the new consumer media industries. It's that sense of "Anyone can do this."

AKIRA: Of course, Andy Warhol said that everyone can be a star for 15 minutes. That can also be read as, "Everyone can be an artist." But Andy Warhol was Andy Warhol—no one could be him. Art pretends that it belongs to the masses, and the masses pretend to be artists.

KRYSTIAN: Japan was involved in two World Wars in the twentieth century, and the trauma of that still seems to hover in people's minds.

AKIRA: In the '50s Japan was very obsessed with the memory of war, and there was a tendency to cultivate subjectivity around it. There were many survivors of the old regime in Japan, and we had a war criminal as a prime minister. We had fairly conservative regimes in the '50s and '60s, and a lot of people tried to create resistance to that. In the '70s, and especially in the '80s, we pretended to forget what happened in the past while we indulged in the eternal present of a consumer society. Hence, we face a dual task now—we have to continue the critique of the premodern regime, while we also have to continue a critique of modernity as it has been imported from the West. It's a very heavy responsibility.

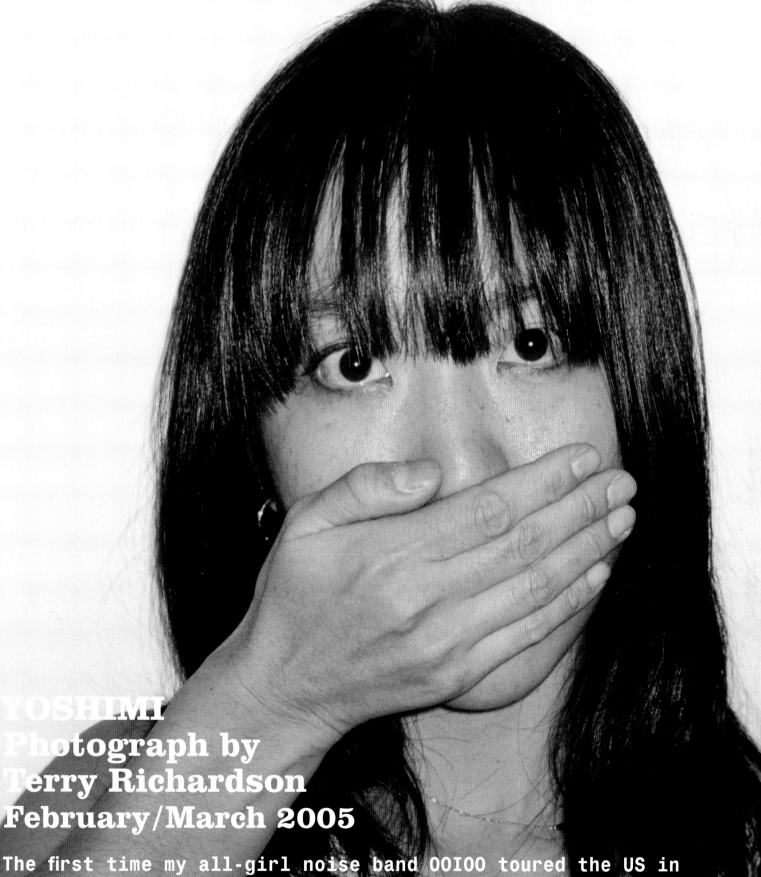

YOSHIMI
Photograph by
Terry Richardson
February/March 2005

The first time my all-girl noise band OOIOO toured the US in
2000, we played the South by Southwest Music Festival in Austin.
The Flaming Lips were recording in Texas and asked me to come
over to the studio to play some trumpet and sing. I didn't hear
anything from them after that. Then one day I walked into the
Rough Trade record store in London while touring with the
Boredoms, and I heard "YOOSSHIIIMMMEEEEEE" blasting from the
speakers. I was so startled! The guy in the store told me it
was a song on the new Flaming Lips album.

I'm standing at the Hachiko crossing in Shibuya, Tokyo. Video screens are broadcasting wholesome images of cute, happy faces high up all around me, accompanied by a din of female voices. But I'm the only one looking up at them. Everyone else is tapping away feverishly at i-Mode phones permanently connected to the Internet. Schoolgirls *completely* aware of their sexual charisma are wearing sailor suits, primly conservative yet perversely provocative. Which is odd, because it's a Sunday.

If, like me, you have a tendency to condemn American-style capitalism for its propensity for homogenizing human culture, it's surprising to see familiar Western brands in Japan doing different—and better—things. Instead of its usual toxic brown syrup, Coca-Cola here sells sugar-free green tea in street-side machines. Häagen-Dazs also adapts to the Japanese market with a delicious green-tea flavor. Colonel Sanders appears outside branches of KFC in the unexpectedly noble guise of a samurai,

JAPPERWOCKY
by MOMUS, SI

Down in the Parco store's book department, boys are flipping through magazines catering to every known enthusiasm. The pages—understated yet popping with detail—are covered with tiny photos and cute little drawings. Everything is laid out for an ideal reader envisioned to be somewhere between curious monkey and style junkie.

I pick up *H* magazine and flip through a fashion feature styled by Sonya S. Park. Girls wear rather formal, childish skirts and blouses marked by striking idiom clashes, pattern incongruities, frills, and ruffs. The girls, flat-chested Japanese Heidis and Alices, stiff and saturnine, Giaconda-pale, look more bookish, less booby and bratty than their snarling counterparts in Western fashion.

I take the elevator to the eighth floor, where, like many Japanese stores, Parco has an art gallery. I'm asked to take my shoes off before entering and handed a plastic bag to carry them in. The gallery is a red cave full of young girls who sprawl on the floor, gazing at big cheerful photos of strawberries and boats taken by other young girls just like them.

Sometimes I think the Japanese have the best of both worlds. They have a society that has largely avoided the traumatic fragmentation of globalization. They have the atelier world of medieval craftspeople on small streets and huge global corporations on the avenues. Big has not destroyed small. New has not destroyed old. Male has not destroyed female. And although the Japanese have access to products from every nation in the world, they have no significant communities from ex-colonies to undermine indigenous customs with nasty things like pluralism and relativism. They have the *café au lait* without the melting pot.

kitted in full military regalia. And in Tokyo, HMV—a record store that in London has little interest in doing anything other than selling Destiny's Child CDs—offers a section called Avant Pop in which, next to records by Bruce Haack and Dragibus, they've placed an Italian futurist lounge magazine called *Il Giaguaro* and a book of the literary interviews of San Diego post-post-modernist writer Larry McCaffery. I open it and read: "One of the good things about capitalism is that it's blind to what it sells. The system isn't really the enemy. All it wants is to replicate and do more things." So I guess it's the flavor of the consumers that dictates the flavor of the capitalist environment. Japanese people have a very distinctive flavor."

Every Friday at 9:00 pm, *TV Tokyo* brings us "Beat Takeshi's Art Battle," a 20-minute section of a program called *Anyone Can Be Picasso*. On this hugely entertaining segment, amateur artists have the opportunity to show their work—big inflatable sculptures, absurd musical instruments, maniac performances—to a panel of judges including comedians, famous artists such as Takashi Homma, or weird musicians such as Maywa Denki. Only one artist can win each week, and if someone wins five times, they get a free trip to New York and a gallery show there. Imagine Devo judging a stream of lunatic art-world hopefuls on a prime-time show hosted by Robert De Niro.

Of course, the irony here is that the ultimate prize for Japanese artists is a chance to escape Japan and see a real art town. At first sight, Tokyo is pretty

underdeveloped, gallery-wise. There's MoTo, for contemporary art, in Saga, and a cluster of Chelsea-style galleries such as Koyama in its orbit. But, as Takashi Murakami realized early in the '90s, in Japan the real action is in the crossover zone between commerce and art. So to see the most interesting visuals in Tokyo, you have to head for stores such as Spiral in Aoyama and Parco in Shibuya, or private cultural centers typically housed in café/bookstore/galleries such as Harajuku's Watarium and Nadiff, or Nakameguro's Organic Depot. In an atmosphere where curating blends seamlessly into shopping, and graphic design is indistinguishable from fine art, these places are remarkably pleasant and civilized examples of Tokyo's talent for

millions of records and playing before thousands in Japan, flying to do shows in little indie clubs in front of two hundred and fifty people somewhere in Texas. Who will tell them that they're wasting their time? The only Japanese artists who can succeed in America, on a modest scale, are obscure arty formalists such as Takako Minekawa and Cornelius, or Nobukazu Takemura. That's the American stereotype of Japan: a weird place, very arty, very formalist, very *otaku*.

Walking around thinking about this, I find the compound genre, Cute Formalism, taking shape in my mind as a way to describe the Japanese aesthetic. Like so many "Engrish" concepts, this is a juxtaposition that would be hard to make in the West. Formalism for us is masculine, dry, adult,

TEMBER / OCTOBER 2001

making shopping exquisite, and the sublime commercial.

Fifteen minutes up the Meguro River by bike from my apartment is the Alpha Spin Building, home of 3D Corporation. On the fifth floor, Cornelius is working on his new album, provisionally entitled *Point*. (Why? "I looked in the dictionary and saw there were many meanings for this word," he explains. "It's ambiguous.") The *Point* sessions have been under way for a year already, though he did take some time off to marry Takako Minekawa and look after their new baby. I sit on a strip-lit orange plastic cloud sofa and listen to the new stuff. It's an exciting moment, for on this record hangs, one could say, the future credibility of Japanese Avant Pop. Can its dilettante formalism hold its own against the class and race strife whose blessed contradictions create so much Western art?

Tokyo is just so playful and pleasant, with everything spread out for discerning consumers and producers. I put it to Cornelius that I wonder if the design Zen doesn't take some of the stroppy, contentious urgency out of the art made here. Cornelius replies that if the recession gets much worse, these "problems of paradise" will disappear, replaced by real pain, stress, and trauma. It's a good point. Japan is a society where dilettantism is poised eternally on the edge of collapse, like the soft-drink vending machines balanced on the crater rim at the top of Mount Fuji.

Japanese pop musicians all want to make it in America. And so you get Dreams Come True and Puffy, accustomed to selling

hard, macho, intellectual, unsentimental, avant-garde. Cute, on the other hand, is feminine, sticky, childish, soft, effete, stupid, sentimental, and kitsch. "Formalist" lives in art galleries, "cute" in department stores. Critic Clement Greenberg declared in 1939 that the alternative to formalism is kitsch, and to this day many Westerners feel you have to choose between them. Not so! In superflat Japan, you can have your kitsch and eat it too. It's okay to play with your food!

I hear Cute Formalism in the friendly sampler experimentation of records by girls like Hirono Nishiyama and Aki Tsuyuko, and I see it all through Japanese visual culture, from Pokemon to Hiropon. I once proposed the idea of Survival of the Cutest—that the future belongs not to musclemen, soldiers, or aggressive businessfolk, but to creatures who can remain childlike and cute all their lives; faux-children, perhaps, replicants, money in kid-guise, brute persuasion morphed into sweet little proprietary characters designed to fascinate and charm us into compliance. Perhaps the menacing little girls in the paintings of Yoshitomo Nara or the spider-eyed gnomes sitting under Takashi Murakami's mushrooms are the new faces of machismo. The voices you hear in Japan are women's voices and children's voices, charming and soothing you with appeals to orderliness and consumption. Who's behind them? Men, probably. Men in big-eyed child-masks, men with helium vocoders. Yeah, cute. Business as usual.

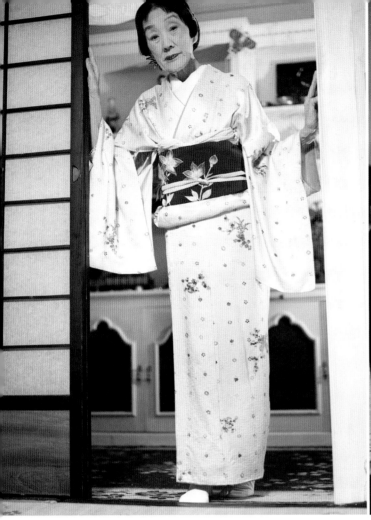
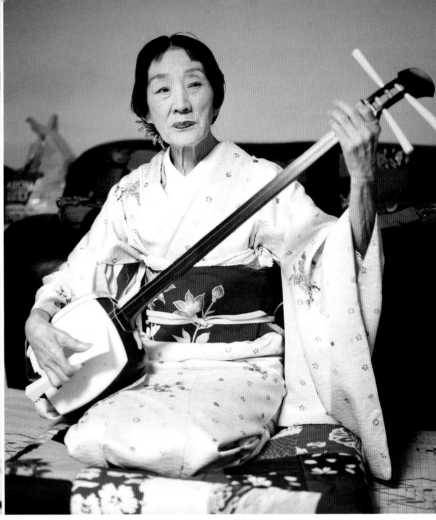

KIHARU NAKAMURA
with Midori Nishizawa

Photographs by Isabel Asha-Penzlien
November/December 1999

Midori Nishizawa, a leading Japanese curator and critic, spoke with the former geisha and author Kiharu Nakamura.

MIDORI: What brought you to the States?
KIHARU: My second marriage—to a photographer who was twelve years younger than I was—turned out to be a disaster. I had a son, but I left him with my mother and grandmother. It was harsh, I know, but at the time I felt I had no choice. I was going to bring him to America after I settled down, but it didn't work out, unfortunately. Anyway, I came to the United States in 1956.

MIDORI: Did you like America?
KIHARU: I loved America! I still do. I thought people were fair and open-minded. They were less judgmental and critical than the Japanese. I wanted to get away from Japan, where people are very inquisitive and nosy about other people's business. After I quit being a geisha, women, especially of a certain class, constantly gossiped behind my back. It was always related to my past work as a geisha, as if I had done something terrible and embarrassing. It was hard to bear. How can you judge people by their previous occupation?

MIDORI: Maybe they were jealous that you got so much attention from men. They forget that being a geisha is a highly sophisticated entertainment and it's a serious profession.
KIHARU: You know, after the Restoration in the late nineteenth century, the first Meiji cabinet members all had wives who were top-ranking geisha. We go through rigorous training, we know the arts, we have sophisticated manners, and we know how to converse with political figures at social events. The traditional Japanese wives didn't do that. Of course, things are changing nowadays in Japan.

MIDORI: How do you find young Japanese women today? Especially the ones living in New York?
KIHARU: Very depressing. Why are they dyeing their beautiful black hair? Why are they not learning the good things about America? Of course, America has gone through big changes too. My problem is that I know the best of times in both Japan and America.

MIDORI: By the way, do you have any comments on President Clinton's sex scandal?
KIHARU: I remember in the 1930s, there was a prime minister, or surely someone very high up in politics, who was accused of having four geisha. In response to the accusation, the man stood up without changing his expression and said, "Well, let me correct you—I have five, not four."

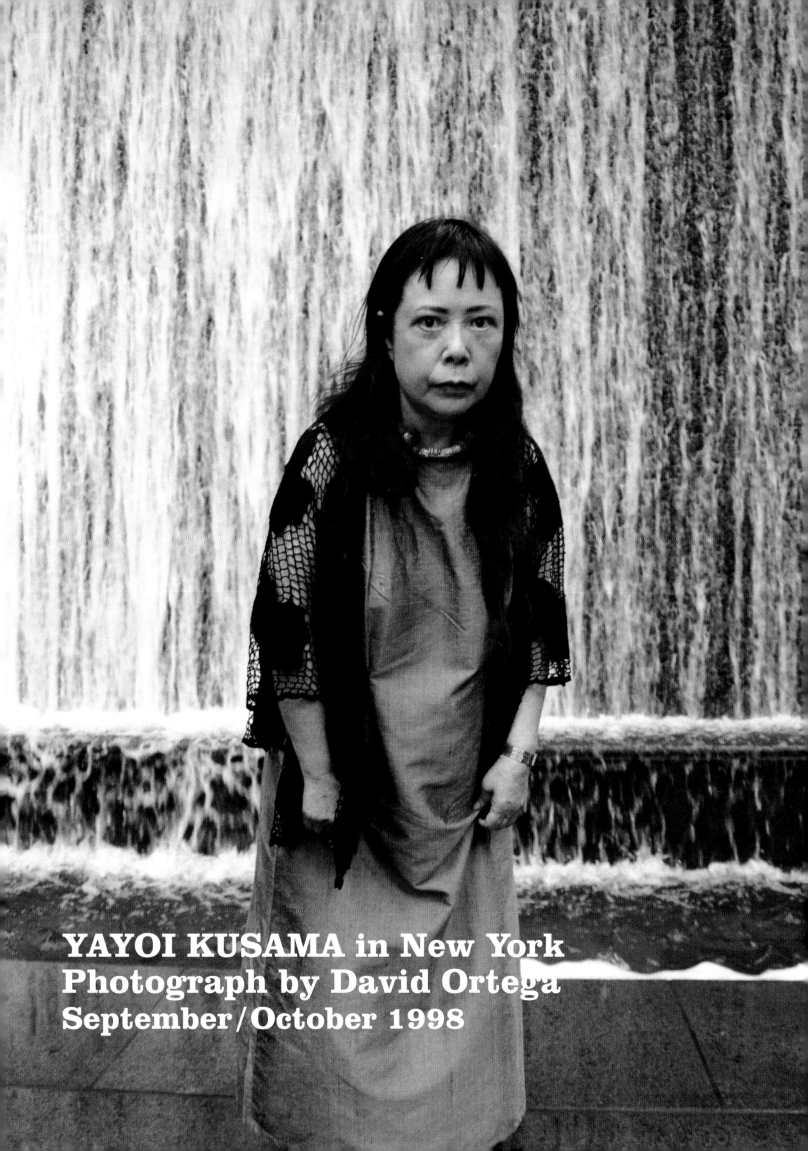

YAYOI KUSAMA in New York
Photograph by David Ortega
September/October 1998

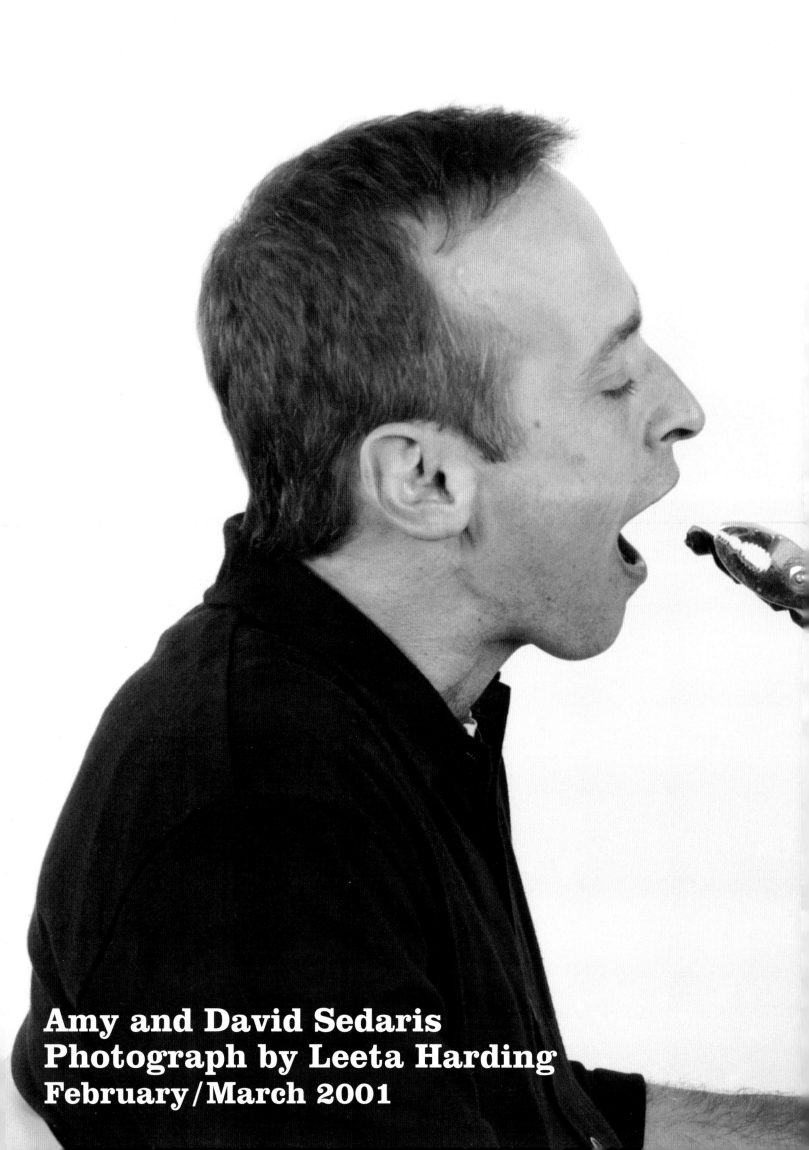

Amy and David Sedaris
Photograph by Leeta Harding
February/March 2001

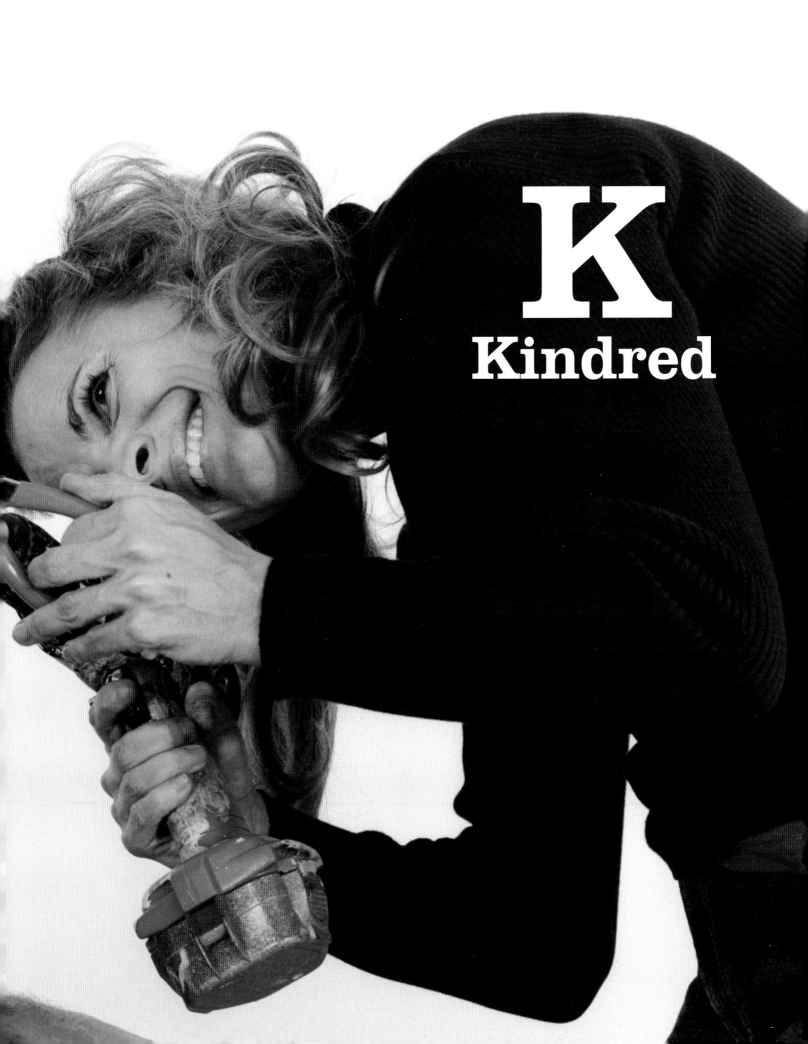

K
Kindred

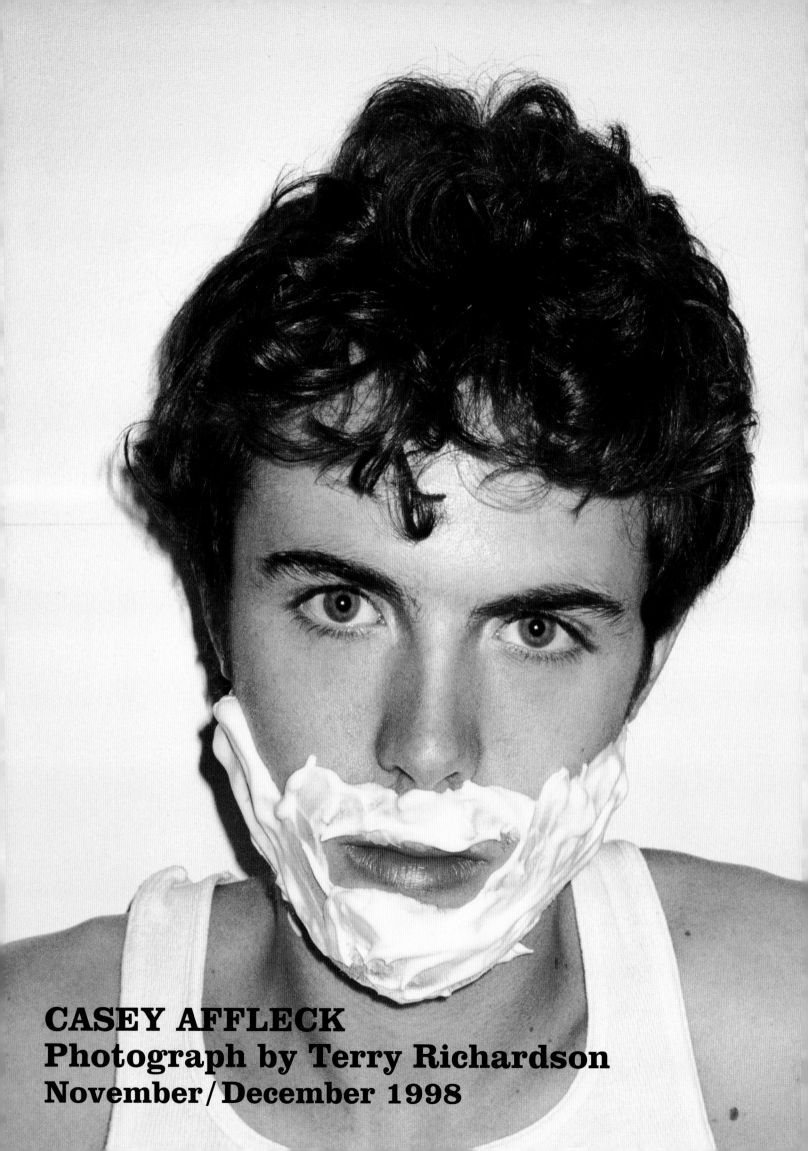

CASEY AFFLECK
Photograph by Terry Richardson
November / December 1998

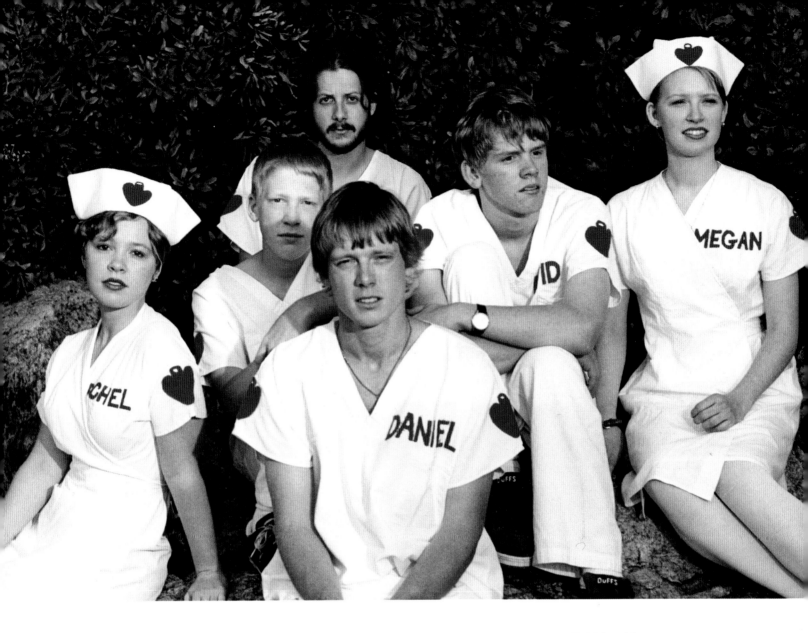

DANIELSON FAMILY with Bob Nickas

Photograph by Tina Barney
November/December 1997

Danielson—Andrew, 14; David, 18; Megan, 21; Rachel, 23; Daniel, 25; and Chris, also 25 (a non-related but "honorary" member of the family)—is a Christian family that sings and plays some of the most wonderful music I've heard in a long time. They've been compared to everyone from the Pixies and the Shaggs to Victoria Williams and Captain Beefheart, but Danielson soars and sails along on a higher plane of their own. And although none of my friends can at first believe how deeply I'm into a group that sings about loving the Lord, once they've seen and heard Danielson play—in all-white doctors' and nurses' outfits!—they, too, become believers. Now, it's not often that I become obsessed with a group, but when I do, I'm a goner. At least with Danielson's totally charming and unbelievably catchy gospel/folk vibe, I can be lost and saved at the same time. Saved. Even me.

PATRICIA ARQUETTE with Rachael Horovitz

Photograph by
Leeta Harding
November/December 2001

RACHAEL: Is *daffy* **a word that describes you?**
PATRICIA: There is a daffy aspect to me. My dad was a comedian. Comedy was a really good survival mechanism in my household. If you wanted to get out of trouble, you could talk intellectually, you could talk spiritually, or you could make people laugh. Those were our options. I think that kind of sculpts you.

ALEXIS ARQUETTE with Chris Lee

Photograph by
Anthony Pearson
March/April 1998

CHRIS: Whenever I read anything about you or your siblings, writers always have to work the word *quirky* **in there. Quirky and zany and . . .**
ALEXIS: OFFBEAT! [Laughs.] You know, we're not quirky, we're not zany. *They're* quirky, *they're* zany. We're normal. We're the most normal people you'll ever meet. We're way more normal than most of Hollywood. We have our shit together. Hollywood's fucked-up. We're not in therapy. We deal with our problems in our family, we confront each other, we don't live in denial.

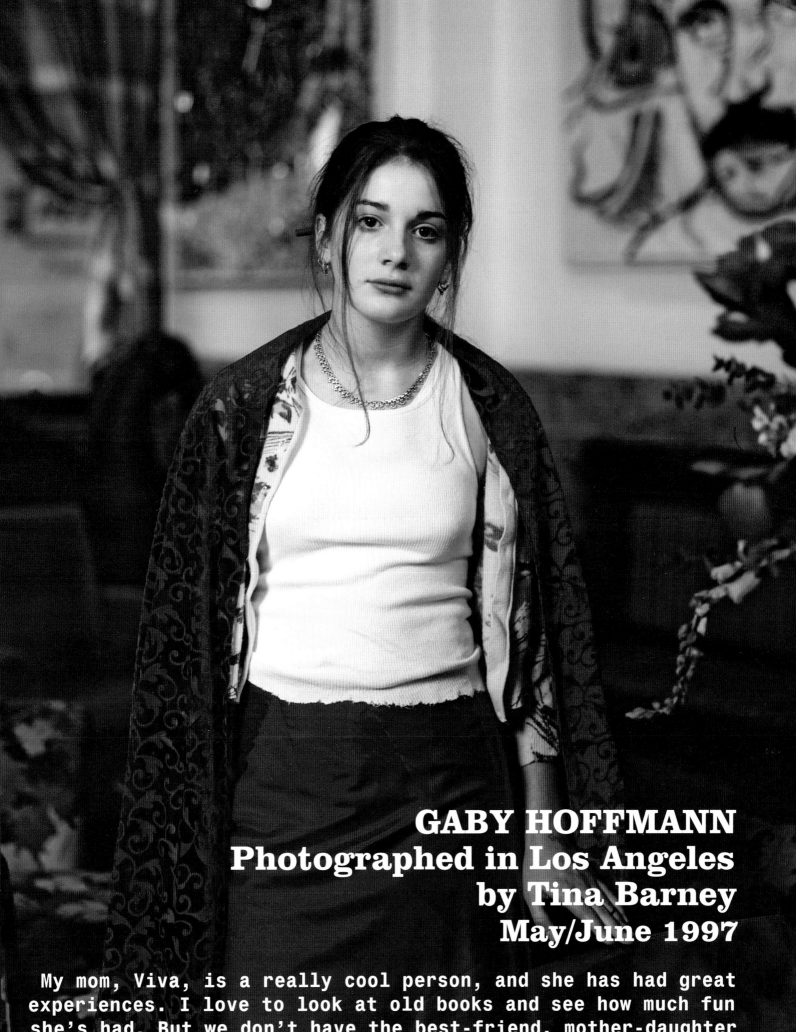

GABY HOFFMANN
Photographed in Los Angeles
by Tina Barney
May/June 1997

My mom, Viva, is a really cool person, and she has had great experiences. I love to look at old books and see how much fun she's had. But we don't have the best-friend, mother-daughter thing where I run home and tell her everything that's going on in my life. I just don't understand that *whatsoever*.

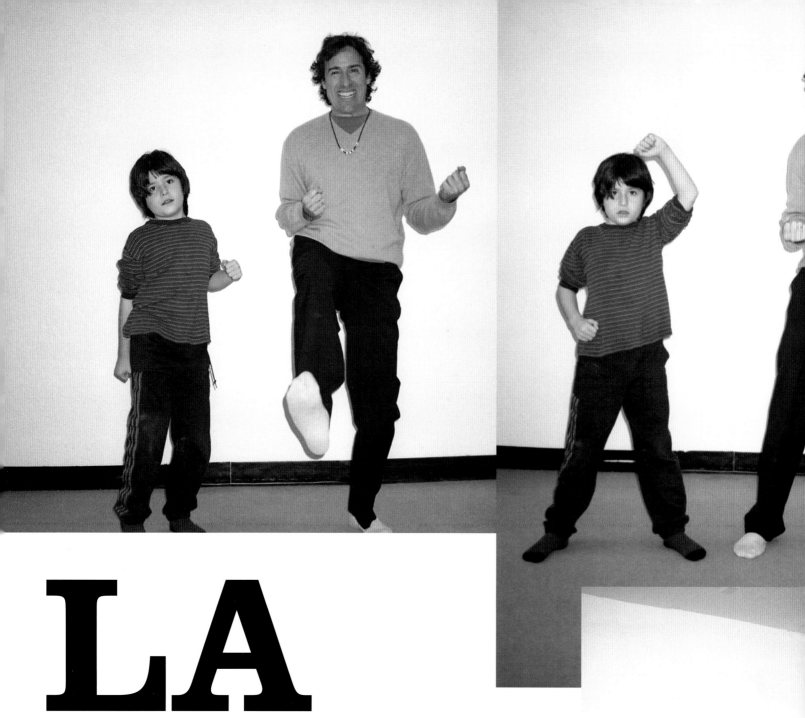

LA
Los Angeles

DAVID O. RUSSELL and Son
Photograph by Alex Hoerner
April/May 2002

Since I'm a father, I probably watch more children's films than grown-up films these days. Right now we're very into *The Bad News Bears*. It's so great to see a film about losers in America.

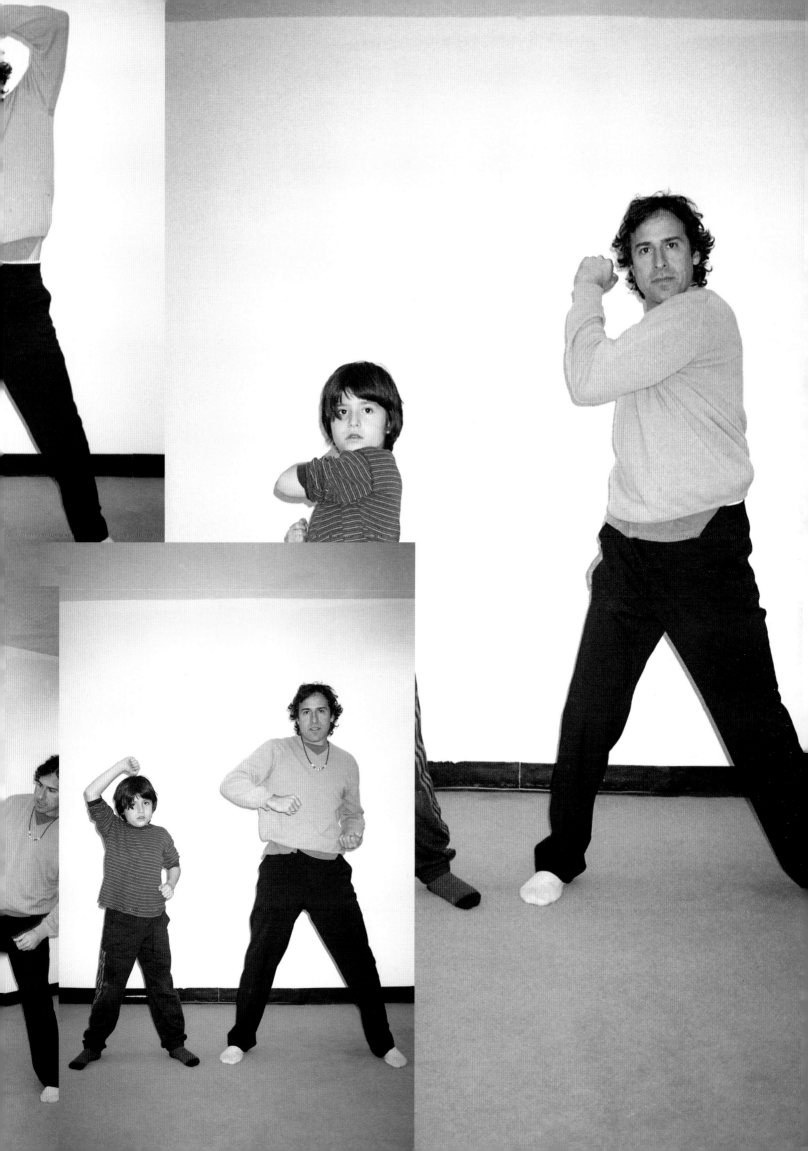

LA CONFIDENTIAL BY RICHARD WANG
MARCH/APRIL 1998

I love to spend the holidays in Los Angeles. I grew up there and was desperate to leave by the end of high school. But during my freshman year of college, they made us watch the film *Less Than Zero* as part of our monthly required peer counseling session. It was supposed to be, like, a cautionary tale, right? But, oh, no! I loved the idea that my friends could become fun-lovin' coke-heads and that I would get to spend my break cruising around in a Corvette and giving blow jobs for pay in Palm Springs! It didn't really happen, but THIS year, with Robert Downey Jr. finally in jail, my niche was opened! Oh, how the coke would burn as I'd toss my head back, giggle, and gush, "Oh, no! Rusty pipes!"

I flew into LAX from Nashville on New Year's Eve. My friend Bryan and his Internet girlfriend from Brazil picked me up, and we went directly to the new airport bar called Encounter. It's inside the giant concrete spaceship thing with legs in the LAX parking lot. Bryan and I have always wanted to go there (well, there and to the famous place down the street called Nudes Nudes Nudes). Anyhow, Encounter recently got re-done as a super faked-out lounge by the Disney imagineers. When you get into the elevator, some space opera music starts playing, and you start to get that tingly feeling of the old Tomorrowland at Disneyland. But once inside . . . hmm. Lots of amoeba shapes and lava lamps. But what's with the a cappella quartet singing golden oldies?! We stayed for one drink, and, of course, the annoying quartet had to stop right in front of us to finish singing "The Lion Sleeps Tonight." I had to act like I was enjoying myself instead of picking up my coat and pushing my way out. People in LA are nice like that!

From there, we drove down to Orange County to go to a party in Sunset Beach. Orange County is skater country, and we were going to a skater party. My sexy Dutch friend Marcel was DJ-ing, and, luckily, I guessed right, and all his friends were hot alternaboys = I had a really good time. I met West Coast shorty Arlo Eisenberg, who is, like, THE voice of modern inline skating. He's famous and junk! He's all little and has a fuzzy shaved head and a tight little body. I was watching the Pamela Anderson/Tommy Lee sex video with him, and while admiring Tommy's nine-inch cock, I began to wonder what kind of extreme feelings Arlo might be having at the moment. Some girl ended up finding out. And by the time midnight rolled by, Tommy had dropped the ball on Pamela, and I had to settle for a Euro-style cheek kiss from Marcel. To top it all off, I had Bryan make an emergency stop on the way home so I could do a fabulous barf session in front of a closed gas station. Rusty esophagus!

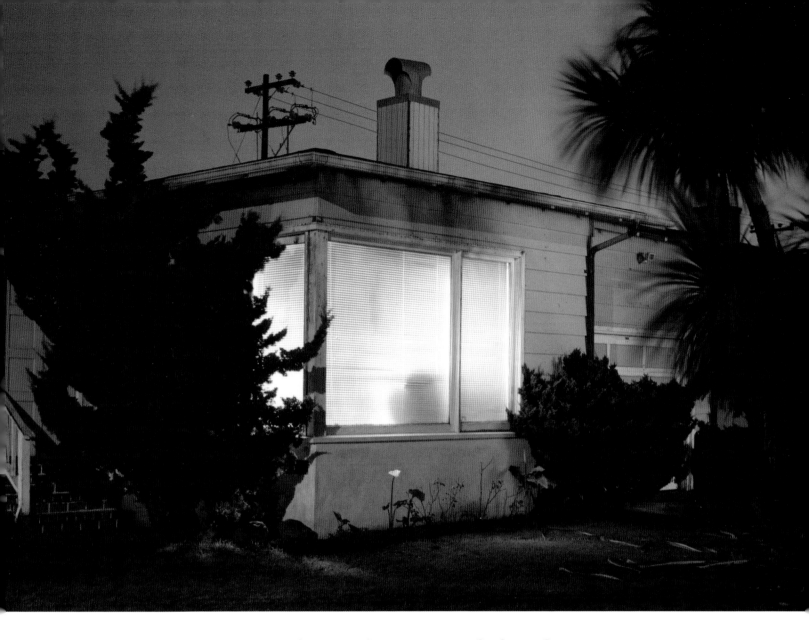

HOW WICKED IS HOLLYWOOD?
BY RACHEL KUSHNER
APRIL/MAY 2005

Photograph by Todd Hido

Occult is chic these days, and Satanism just plain trendy,
an Eastside look and lifestyle. Pentagram-wearing kids,
followers of John Whiteside Parsons, hang around the Jet
Propulsion Laboratory. They've failed astronomy and get all
of their ideas about black magic from Iron Maiden songs.
At the Burgundy Room in Hollywood, they light the bar on fire
when AC/DC's "Hell's Bells" booms from the jukebox. Upstairs
at the Rainbow Room, where it's perpetually 1985, a bloated
Lon Chaney with fangs and a cape leans over and whispers into a
young girl's ear, "Come home with me, and I'll show you
things you've never imagined."

DOES SYD MEAD DREAM OF ELECTRIC SHEEP?

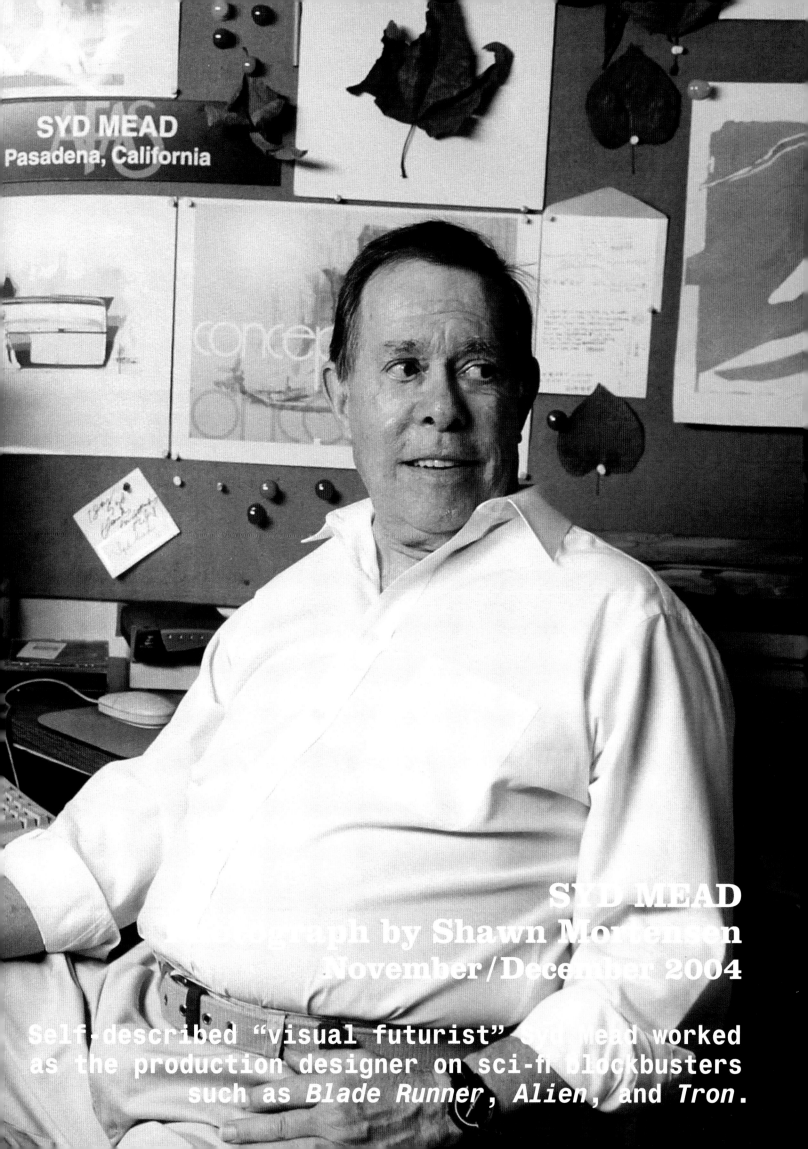

SYD MEAD
Pasadena, California

SYD MEAD
Photograph by Shawn Mortensen
November/December 2004

Self-described "visual futurist" Syd Mead worked
as the production designer on sci-fi blockbusters
such as *Blade Runner*, *Alien*, and *Tron*.

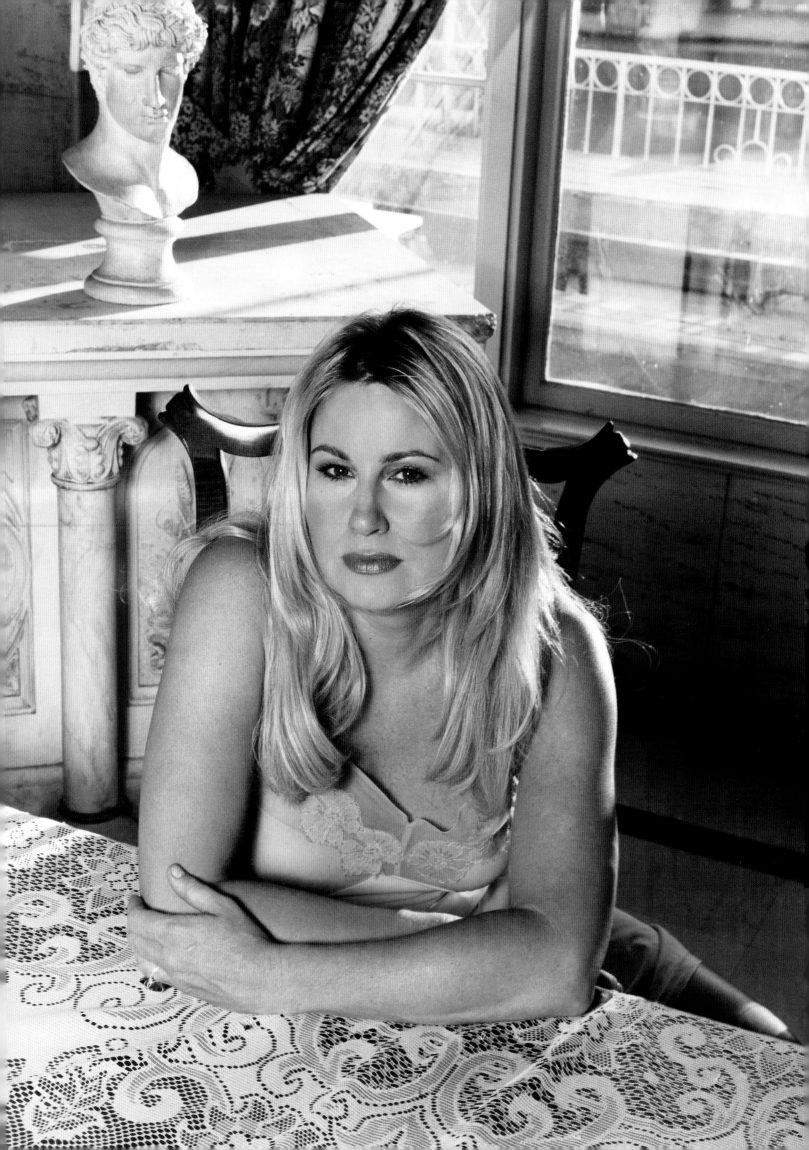

JENNIFER COOLIDGE with Amy Sedaris

Photograph by Richard Kern
November / December 2002

AMY: I fantasized about us doing a cop show together. We're a team. You're so tall and I'm so short. We would be roommates, something like Ren and Stimpy, but we're real. Nobody really knows what our relationship is, but we're pals. Maybe we solve crimes. We'll call it *Pretty Ugly*. It would be fun to do something like that with you. You just ooze sex and trouble.

JENNIFER: Somebody once told me, "You have this really crazy look in your eye, like you could be insane. It's the same thing that Karen Black had." I'll take the sexy thing, but when people start to say you look insane . . .

AMY: Insane is a wild card. But it's always been my choice to play ugly rather than pretty. I'm the one-eyed guy in the lobby. I think that's what my audience is, too—ugly people. My brother did a book tour, and he said, "Amy, I always knew who your fans were, because they would always be the ugliest people."

JENNIFER: I think those one-eyed guys are more interesting in the end.

AMY: Oh, yeah. They're the real diamonds, the geeks.

JENNIFER: Tomorrow I'm going to meet Paul Reubens for lunch.

AMY: Pee-wee Herman?

JENNIFER: We're doing this show on Monday that is a takeoff on bad actor showcases, the kind where everyone makes really bad choices. Paul is playing the blind guy in *Butterflies Are Free*. Of course he doesn't know his lines and has to read them off his hand. He's amazing. I'm playing a Beverly Hills housewife doing *The Glass Menagerie*.

AMY: Whenever I had to bring a monologue into an audition, I would take something from *Our Bodies, Ourselves*. I wasn't going to fucking memorize some boring Shakespeare thing that you'd already heard three times that day. Instead it would be, "I like something small in my anus during lovemaking. No pressure, no movement, just plain there." It's really good. And people learn from it.

JENNIFER: I don't know how actors are able to walk into an audition, win everyone over, and at the same time be aloof enough so that they think you don't quite want the job. It's a really complicated moment. You have to play fifty different things at once.

AMY: You might as well be naked. They're staring at you, and you're, like, "I can't make you laugh right now. I want to know that you're into it too."

JENNIFER: I used to go into auditions and present one hundred different possibilities for one part. I thought that would be interesting to some directors, but that just confuses them. I know this sounds stupid, but the less you give, the better.

AMY: You're right. You have to go in with a solid choice and stick to it.

JENNIFER: Even with one choice, you have to do less than what you set out to do. I can't explain it, but if you really nail it, you don't get the part. You have to leave it where you don't quite give them what they want so they feel like they can give their input. I've never really pulled it off. Christopher Guest doesn't make people audition for his shit.

AMY: *Best in Show*—forget about it—I can't even imagine getting to work with those people. *SCTV* was my favorite show growing up.

JENNIFER: That is such a talented group. They're very cool people who got a dose of fame, but none of them are full of themselves.

AMY: They seem grounded like that. All they want to do is make each other laugh. It was all improvised, right?

JENNIFER: Yeah. All the dialogue was. I didn't really know how *Best in Show* was going to turn out. Christopher has a vision, but it's not really clear until the movie is completed. I got a rough outline that said I'm in a relationship with an old man, and eventually I end up falling in love with my female dog trainer. I had to figure out how I was going to get there, what this character was going to say. Christopher is the genius behind making it all work. He's an incredible editor. There was tons of footage where I knew I wasn't funny. Actually, the stuff I thought was going to be used was sort of darker.

AMY: Everything that came out of your mouth was perfect. I hate to go see improv, but I come from it. I was at Second City, and I still use improvisation as a tool, but I have no desire to get up onstage and say, "Who, What, Where." But, when people are good at it, like everyone in that movie, boy, it's like magic.

JENNIFER: The great thing is that anything that I pre-planned didn't come out well at all—you really can't cheat at improv. All the good shit happens when you're winging it. It was such a fun thing to do. I live in LA, and I was in all these wretched acting classes . . .

AMY: Los Angeles is some weird pretend land. It doesn't seem real to me at all.

JENNIFER: Yeah. There's a girl in my gym, and she had all this weird shit done to her face. I can't take my eyes off her—she doesn't look like any human being I've ever seen. My trainer was saying that her face had been green for about four months. I'm not talking light green. She had a bright green face. It must have been a cheekbone implant that backfired. And there's a guy there who winks at himself and talks to himself in the mirror. It's bizarre. His trainer just stands there and waits for him. He's having a sort of love affair with himself.

AMY: Have you ever lived with a guy before?

JENNIFER: When you live with somebody, you're showing all these incredibly real moments. If I get married, I'm going to live in the house next door.

AMY: I'm the same way.

M
Music

BJÖRK, LONDON, 1995
Photograph by Juergen Teller
June/July 2001

At the moment I have this new
album inside me, which is somehow more
vulnerable than the others that came
before it. It's a lot more emotionally
brave and fragile, and I want to make
sure that the pictures are like that too.

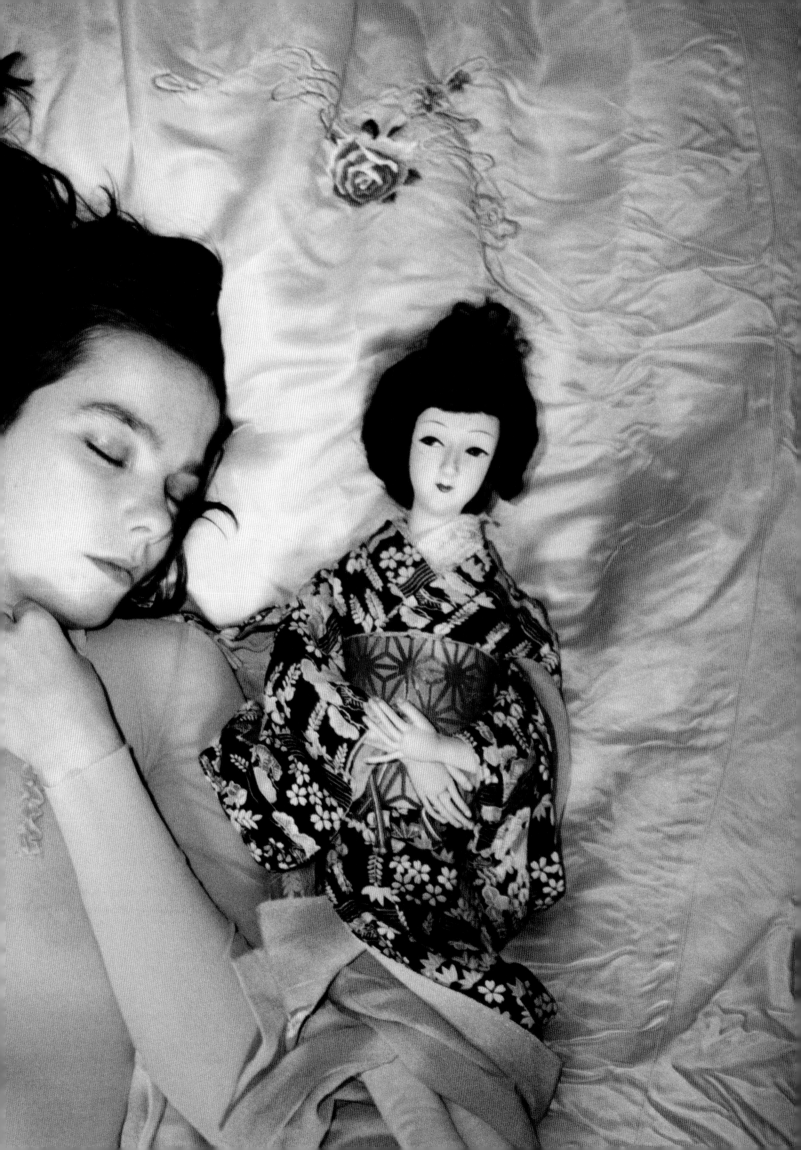

MONICA LYNCH with Steve Lafreniere

Photograph by Lucas Michael
January/February 1999

Monica Lynch, along with co-owner Tom Silverman, has headed up Tommy Boy Records since the label dropped "Planet Rock" on an unsuspecting world in 1982. The tale of a green-eyed, redheaded Irish girl from the Midwest getting all up into New York hip-hop history is a fascinating and, trust me, action-packed one. But to me it's more about the savvy way she kicked up the careers of scads of musicians I've loved: Queen Latifah, Coolio, De La Soul, Stetsasonic, 808 State, Naughty By Nature, Prince Paul, House of Pain, Soulsonic Force, the Jonzun Crew, Digital Undergound, and one RuPaul Andre Charles among them.

STEVE: Okay, let's grind gears a little. Latifah to RuPaul to Coolio—they've all got that *ooomph* factor. It's gotta be fun to groom a pop star.

MONICA: That's why I was happy to see someone like Marilyn Manson become popular a few years ago.

STEVE: Pardon?

MONICA: Just because he's so unabashedly theatrical. I thought that was a welcome respite from all this . . . naturalism. But, yeah, I did take Puff Daddy to his first fashion show. A story I'll be able to tell someone's grandkids someday.

STEVE: The hip-hop rite of passage. Who was it?

MONICA: It was Todd Oldham. But now Puffy has his own fashion shows. You know, one of the interesting facts about rap is that, of all the black music movements in history, it's created the most entrepreneurs. A whole generation of artists, executives, producers, managers, attorneys, you name it, who are basically doing their own thing. That's a significant difference from what you saw prior to this. Over the last twenty years, hip-hop's been this musical revolution, *and* it's been a revolution in marketing, promotion, and equity. Having your own TV shows, owning your own label, your own management company, getting your own film deal . . .

STEVE: So many rappers are making movies. A friend asked me recently which hip-hop group Bokeem Woodbine had been in. She just assumed!

MONICA: Right. And another thing that's significant about the emergence of the rap business is that it's provided great opportunities for women as executives. There wasn't a preexisting hierarchy in hip-hop like there was in rock culture. It started out as such an underground thing that the major labels didn't know if it was coming or going. They weren't investing yet, weren't out to own it all. So a lot of women came up through the ranks. However, for the women artists, it's always been a tougher row to hoe. First there was The Sequence. But it wasn't until Salt-n-Pepa, Roxanne Shante, and J. J. Fad in the mid-'80s . . . and then in the late '80s you had MC Lyte, Latifah, Monie Love, Yo-Yo, although none of them sold as many records as their male counterparts. And the last few years it's been pretty rugged. Either pretty rugged or pretty explicit. But then you've got someone like Missy Elliot doing it on her own terms, and, obviously, the biggest star out there doing it on her own, Lauryn Hill.

STEVE: How do you rank her?

MONICA: I have a lot of respect for Lauryn Hill. First of all, she's amazingly talented, and she's beautiful. But she's a person who also gives a lot back to her community. I remember getting phone calls from her trying to get us enlisted in supporting fund-raising efforts for this thing, that thing, and the other thing. She's really on it. To me, she's got the whole package. I'm looking at the top fifty rap records on urban radio right now, and out of that fifty, the females who appear on the list are . . . Lauryn Hill, who has five records playing at once.

STEVE: Five cuts off one album?

MONICA: Yeah. Which is enormous for any artist, male or female.

STEVE: So what've you been listening to around the house?

MONICA: I've been listening to this album of Terry Callier demos called *First Flight*—a lot of songs that would go on to be produced by Charles Stepney. I should definitely lend it to you. I also just got a Tom Browne compilation, which made me happy, because it's got "Fungi Mama," "Thighs High," and, of course, "Funkin' for Jamaica." He was this funky jazz trumpet player who was mentored by Roy Eldridge. I listened to a three-CD set of Earth, Wind & Fire over the weekend, and it was just so revealing, especially the early things. And then I just got two Rotary Connection albums that have been re-issued.

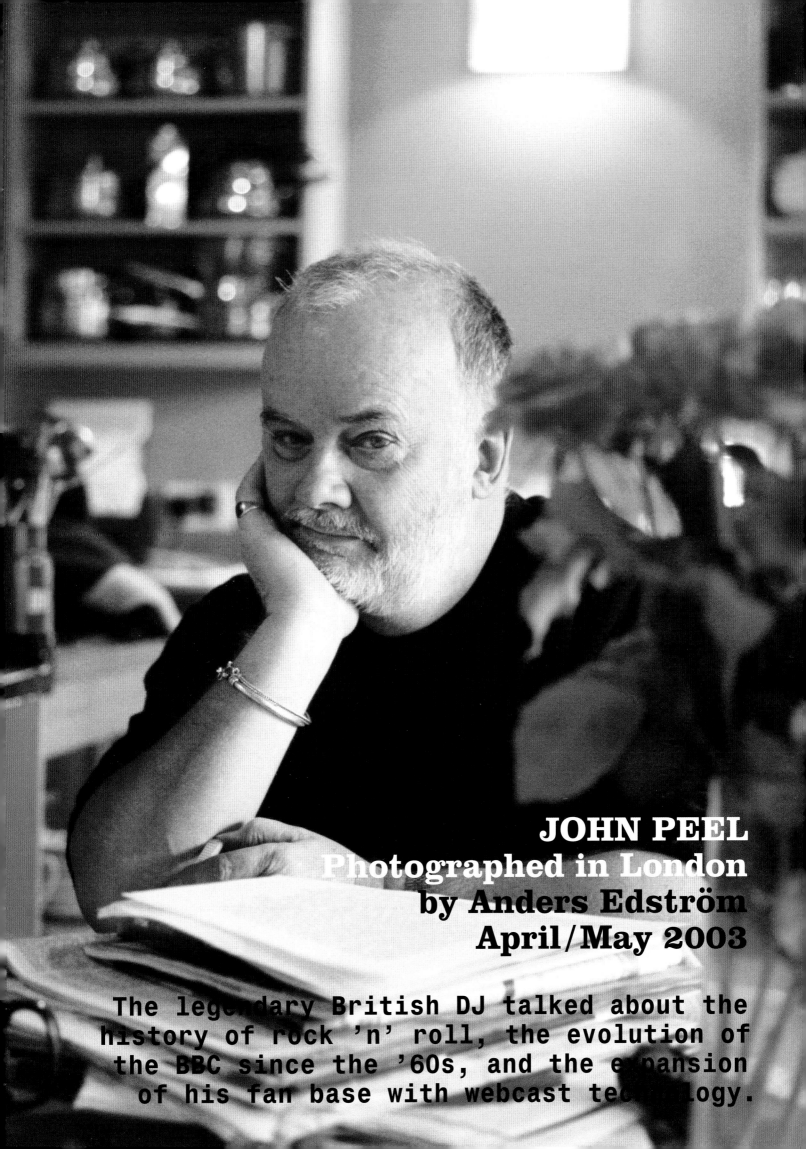

JOHN PEEL
Photographed in London
by Anders Edström
April/May 2003

The legendary British DJ talked about the
history of rock 'n' roll, the evolution of
the BBC since the '60s, and the expansion
of his fan base with webcast technology.

STEPHIN MERRITT with Monica Lynch

Photograph by Leeta Harding
November/December 2000

We've been listening to the Magnetic Fields for quite a while now. Years before the blast-off of their *69 Love Songs* album in 1999, you could have found us dancing around the house to "You're So Technical," or choking up over every gorgeous synth whoosh of "Save a Secret for the Moon." Even with that much awe on our sleeves, though, the idea of actually interviewing the Fields' mastermind, Stephin Merritt, has always left us a little daunted.

One day, we finally hit on the ideal person to interview Stephin for us. WFMU's Monica Lynch hosts a weekly radio show that's as eclectic as Stephin himself. It also couldn't hurt that she's a friend of his. So we asked, and they kindly obliged us by getting together at the Gramercy Park Hotel bar to free-associate on some of their favorite subjects.

MONICA: You're a fan of cowboy music.
STEPHIN: I never built up a collection, though. I liked it all indiscriminately, so one or two records was fine for me. But I'm a sucker for yodeling.

MONICA: You're also a big fan of science-fiction films. I'm curious whether the soundtracks have made an impression on you.
STEPHIN: Only *Forbidden Planet*. I'm always disappointed in the script, though.
MONICA: Do you dance, Stephin?
STEPHIN: I love to dance. I will dance again when I can find the shoes in which to do it. I am very disappointed with my feet. But I took dance in high school.
MONICA: Really? Did you have to wear leotards?
STEPHIN: I don't remember what I wore. But I was liable to be wearing leotards in high school anyway. Or jumpsuits. There was one point when my entire wardrobe was jumpsuits.
MONICA: It was interpretive dance that you took in high school, I suppose.
STEPHIN: Yes, we would invent dance routines to various Bowie songs.
MONICA: Like what? "Ashes to Ashes?"
STEPHIN: Oh, no, no, no. "Moss Garden" from *Heroes*. We were into *Heroes*, and side two of *Low*.
MONICA: What were some of your big moves?
STEPHIN: Actually, I was a minimalist. I didn't make any big moves. I was known for my fingers and toes. I could move my toes well.
MONICA: Did you dance at the new wave clubs?
STEPHIN: I used to dance at Danceteria. I used to do Gothic Whirls, and . . .
MONICA: [Laughs.]
STEPHIN: . . . just before Madonna had twelve-layer clothing, I had twelve-layer clothing. Ripped, torn, interlocking. I would have a shirt full of big, big holes, and another shirt underneath it that would be connected to it with safety pins. Madonna didn't get to that part.

ROCK 'N' ROLL ASTROLOGY
BY IAN SVENONIUS
NOVEMBER/DECEMBER 2000

Before Keith Moon's untimely death, Sonic Youth and The Who shared analogous astrological charts, with one member of each group representing one of the four zodiacal elements. Kim Gordon and Pete Townshend are both earth signs (Taureans); Thurston Moore and Keith Moon, the fire signs (Leos); Lee Ranaldo and John Entwistle, the air signs (Aquarius and Libra); and Steve Shelley and Roger Daltrey, the water signs (Cancer and Pisces respectively). Simple coincidence? Or a startling refutation of our conceits regarding freedom of choice and individual expression? When the group Bikini Kill wrote the song "Thurston Hearts the Who," the parallels were obvious. Indeed, both Sonic Youth and The Who had successfully managed the tricky collusion of high-concept art with bass-beat vulgarity. Was *Goo* just *Tommy* for the '90s? Probably. But while Bikini Kill's pronouncement of Pop art's place in rock 'n' roll was clever and timely, the sentiment held a deeper truth—unknown, perhaps, to the tune's authors.

With free will having been rebuked by the recent craze for genetics and chemical psychology, we can only assume that Sonic Youth, seeming pioneers of noise/pop, had no choice but to elucidate the work of their Who-ish forebears. Primitive feedback forays, flirtations with jazz and art concepts, the idolatry of nihilism, and an obsession with rock history and youth culture were, for both groups, simple destiny owing to their particular zodiacal amalgamations.

Indeed, the similarity among various artists of the same sign and the analogues between their work systematically smash any doubts about our collective enslavement to Fate's great wheel. A glance at the '70s Rolling Stones and their alter ego, Led Zeppelin, lends even more credence to this claim. The parallels between the groups are clear: both bands are synonyms for guiltless excess and together contrived the Classic Rock genre, an ingenious synthesis of bubblegum and Delta blues. Both groups featured guitarists who dabbled in the black arts and defined the early arena era. That respective singers Jagger and Plant are Leos, axmen Taylor and Page are Capricorns, and drummers Bonham and Watts are Geminis should surprise no one.

An examination of the star signs, then, and of the stars trapped within the cell of each sign, is necessary for an appreciation of both our culture and history. But to understand each sign, one must first forego expectations of rigid assignations. Zodiacal signs are not nouns with precise definitions but are more akin to mental illnesses such as schizophrenia or dementia—vague, with blurry edges. The zodiacal cycle stretches from the Aries baby to the eccentric old Pisces, with each sign representing a stage of life and bringing with it that age's attendant strengths and foibles.

SURVIVAL GUIDE: LYN COLLINS WITH AMY KELLNER
MAY/JUNE 1997

Even if you think you don't know who Lyn Collins is, you do. You know her soulful voice, you know her lyrics to "Think (About It)"—"It takes two to make a thing go right, it takes two to make it outta sight." That song has been sampled so much, it's practically ingrained in our unconscious. Lyn Collins, a.k.a. The Female Preacher or The First Lady of The James Brown Revue, is a dynamite singer. Whether it's funk or gospel, she always reaches into a place deep down and sings straight from the soul.

Lyn Collins has been keeping busy, recording with dance hall reggae queen Patra, performing in Europe, and working on some secret new projects. But for those of us who crave the good old days, there's a remastered double CD on Polydor Records called *Message From The Soul Sisters: Original Divas of Funk*, which features Lyn, along with fellow godmothers of soul, Vicki Anderson and Marva Whitney, and all the classic stuff from their James Brown days.

Lyn graciously took time out from her busy schedule to talk to us, and, boy, did she have a story to tell.

AMY: How did you become The Female Preacher?
LYN: That's how I was introduced when we performed "Think (About It)." It was a gospel type of introduction to the song, and it was about my delivery, because I still had that gospel in me.

AMY: Did you like that name?
LYN: It was a novelty. It gave me a title, just like the Godfather of Soul or Soul Brother Number One, or whatever.

AMY: I think it's a wonderful title, not just as a novelty, but as a name that connotes power and respect for a woman.
LYN: Right. And I think I was one of the first women who had that type of title. I was also called The First Lady of the James Brown Revue, but Female Preacher seemed to stick a lot better. Plus, the songs that I had always wanted to sing were songs with a message. Even though I ended up having to do something that didn't have a message, like "Mama Feelgood," which is totally against my personality. But it was the right timing, because it was used in the soundtrack of a movie.

AMY: What soundtrack?
LYN: *Black Caesar*.

AMY: "Mama Feelgood" and "Think (About It)" are such incredibly famous songs. Classics.
LYN: "Think (About It)" was James's idea, because it was the women's lib movement going on during that time. He and Bobby Byrd did the music, and

I wrote the lyrics. This was about two or three o'clock in the morning, after we had done a concert. We were on a charter plane going to Kansas City. I rode on the plane with James. He told me what he wanted, and I wrote from what I was feeling. If you look at the credits, I got no credit for it. It was one of those things. I wasn't able to record any song I wrote unless a part of it was his. That was the only way I could get it recorded, so whatever way I could get it out there, that's how I had to do it.

AMY: I'm surprised that James Brown was interested in the women's lib movement.
LYN: He is interested in any direction that makes money, besides gangsta rap—from what I can see.

AMY: It's ironic that for him it's just about the money, but for you it had real importance.
LYN: It did, very much so, because of the fact that I was raised by a single parent, my mom. I was raised by very strong women. Very strong.

AMY: "Think (About It)" is like an anthem, and it's been sampled so much.
LYN: It really is. I am the most sampled female in rap music.

AMY: Wow.
LYN: And that is an honor in itself. You know, I was angry about it at first, because we had to go through all this trouble to create this, and now they sample it, and they're making millions.

ROYAL TRUX
Photograph by Tina Barney
March 1997

Royal Trux guitarist and vocalist Neil Hegarty
said their album *Sweet Sixteen*, on Virgin Records,
was "not for, like, New York intellectual
scenemakers. It's really for Middle America."

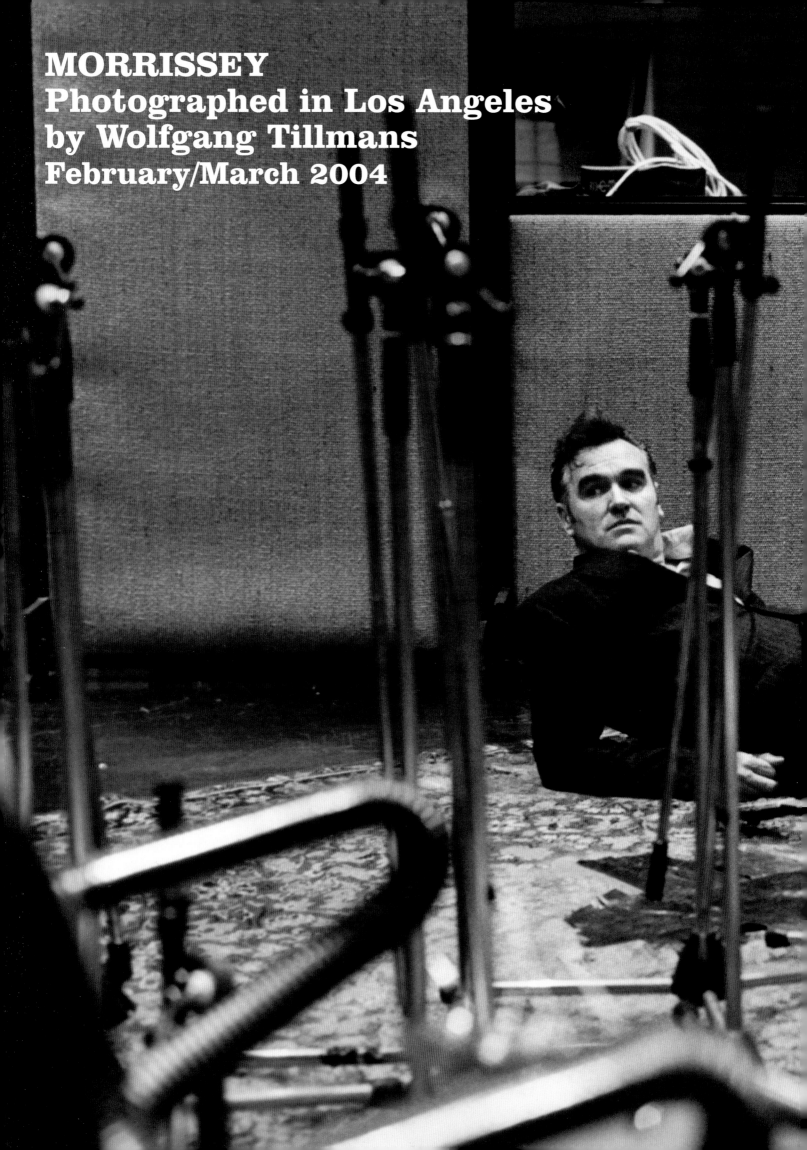

MORRISSEY
Photographed in Los Angeles
by Wolfgang Tillmans
February/March 2004

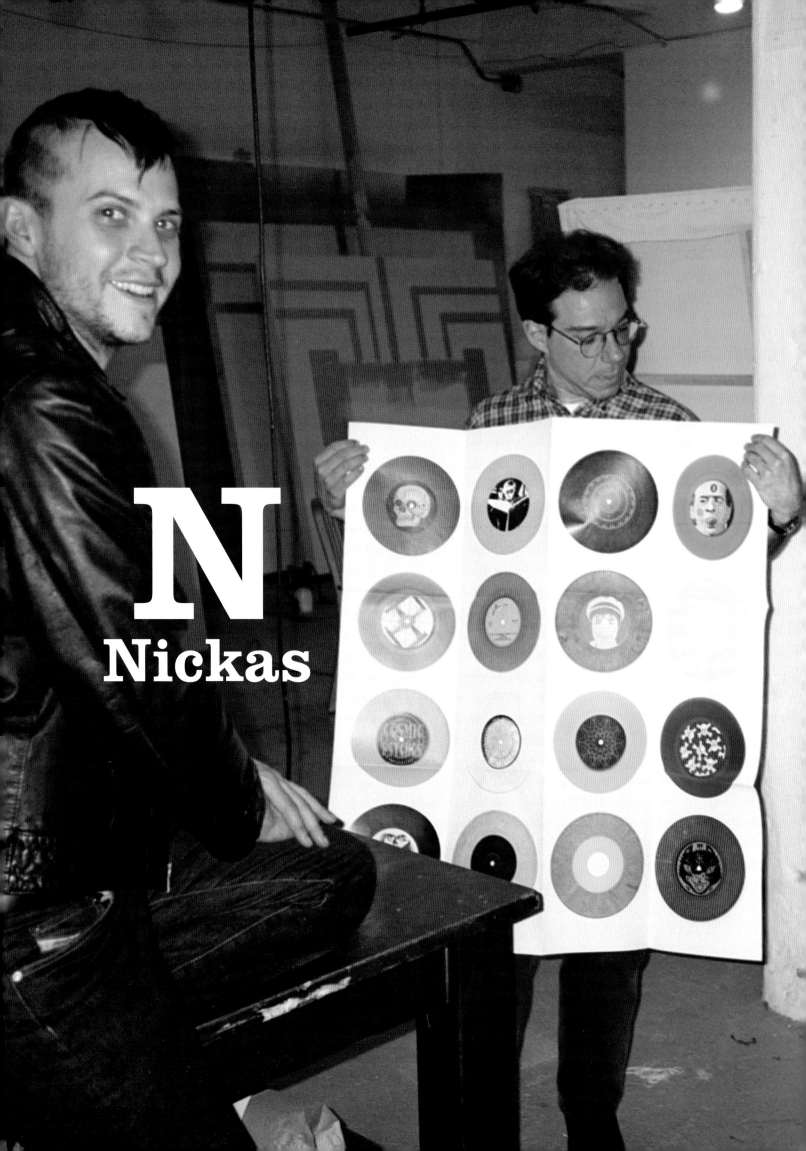

N
Nickas

INTERVIEW
Bob Nickas with Mary Clarke, May 2012

Photograph by
Leeta Harding, 1999

Mary: How did *index* get started?

Bob: *index* was Peter's idea. One of the reasons he wanted to start the magazine was because he thought the art world at that time wasn't as interesting as what was going on in movies and music and design and architecture and fashion. So Peter proposed it. And, you know, I love magazines. I grew up in a house where every morning at breakfast there would be four newspapers, and magazines were delivered every week and every month. When I was old enough, I started getting magazines too. My first subscription was probably in 1970 to *Rolling Stone*. I was thirteen.

Mary: I think my first subscription was to *Calling All Girls*. It was a precursor to *Young Miss*.

Bob: Why don't we do an update of that magazine called *Near Miss*?

Mary: [Laughs] I think I got involved with *index* because David Robbins recommended me to you.

Bob: Did he? I remember we met at a party after a Metro Pictures opening, at Helene Winer's house. We had a very animated conversation about magazines, and I felt a big spark as we were talking. It seemed like it could be real—starting a magazine. And of course, I knew you had been involved with *Sassy*. Nobody at *index* had any experience on a magazine. We were making it up as we went along.

Mary: There was a kind of DIY approach, but so considered. I distinctly remember going to one meeting, you and me and Peter and Steve Lafreniere. It was sort of a concept meeting, but it seemed to be like, "This is what we're not doing. We're not *Paper* and we're not this or that."

Bob: I thought *index* was all about enthusiasm, all about being a fan. In general we talked to people we liked and were interested in. We were very aware that we were focusing our attention on stuff that wouldn't normally get into a magazine, putting people on the cover who might never be on a magazine cover, like Alison Folland, who was on our first cover.

Mary: I suggested her because I had written something for *Allure* that wasn't accepted. It was about her first movie, *All Over Me*. You guys asked me to interview her, but I was too nervous, so I said, "Why don't you get Christina Kelly to do it?"

Bob: There we were, a new magazine, and we had no idea who to put on the cover! We were desperate at times. A little later, we started asking agents about getting people on the cover. We had to pretend we were a real magazine. We would send copies of the magazine to agents and we would never hear from them again!

Mary: Was there anyone you wish you'd interviewed?

Bob: In general I didn't care if we got someone or not. I had only one regret: that we didn't land Yogi Berra, the former Yankees manager. He had so many classic lines, but here's my favorite. The Yankees were having a totally losing season, and when he came onto the field, he looked up into the stands and they were almost empty. This is the philosophy and logic of Yogi Berra. He looks up and says: "If they don't want to come, you can't keep them away." So I thought he would be a great interview for our Sports issue. The publisher of his book just hung up on us. I was devastated.

Mary: Were there a lot of fights in the office?

Bob: Not really. I feel like we let things just happen for a while, and at some point, we wanted to not lose so much money. That's when it had to be more like a normal magazine. It had gotten a certain following for its minimal look and fannishness, but can you make money from that? People may be amused by its oddity, and they might cop some ideas here and there, but you can't convert that into any kind of capital, except for the word-of-mouth around town.

Mary: I remember going for a job interview at Fairchild publications. I got up to a pretty high level, and the guy who was interviewing me saw *index* on my resume and said, "Ooh, *index*." I was sort of surprised that he even knew of it, but I thought, "I've got cred!"

Bob: Do you know the band, the Vaselines? They broke up the week after their first record came out. But Kurt Cobain loved them, and he thought, "If I can get their record reissued, maybe they can get back together and open for Nirvana." And so there was a cachet around them. But they were just kids making it up as they went along, not making money or being taken seriously. And now the record is a collector's item. We weren't the Vaselines. We had more in common with the fan that wanted them to get back together.

Mary: Did you work with writers and editors because you thought, "this person is good with music," or whatever, or was there more of a crossover?

Bob: With certain people you understood what their talents were, so you didn't have to give them direction. They had ideas. Steve Lafreniere had ideas. Bruce LaBruce had ideas. You had them. The people who had ideas and were funny, who were natural writers and would always deliver, you just kept working with them.

Mary: You were such a great editor, too. I mean, you would literally call me and ask, "Is it okay if we put a comma here?" You were so diligent when you really didn't have to be. I don't think I've ever worked with anyone like you. So thank you.

Bob: Thanks to you.

Mary: How did you choose photographers?

Bob: Our first designer, Laura Genninger, recommended a lot of photographers. That was really helpful. I knew Wolfgang Tillmans from the art world. Terry Richardson was someone we probably met through Bruce LaBruce.

Mary: At *index* I didn't really get involved with the photographers, which was the total opposite of the way I had worked at other magazines, where I went on photo shoots. If I interviewed somebody for *index*, they would be photographed later.

Bob: I went to Terry's photo shoot with Brendan Sexton because he was just a kid. Same with the Danielson family, photographed by Tina Barney. At times I was like an adult chaperone.

Mary: Who came up with the name *index*?

Bob: I did. Peter wanted to call the magazine *Pop* and I said no. At home I was using an electric typewriter, and there was a key in the top right corner—I don't know what it was for—that said *INDEX*. So I constantly saw that. I was typing everything and handwriting everything. I didn't have a computer in the beginning.

Mary: When did you get one?

Bob: I don't know! I didn't get one during my time at *index*. I used one at the office. Oh, and *index*'s typewriter font came from my typing all the original manuscripts on a typewriter.

Mary: Who did you think would buy the magazine?

Bob: We thought that we'd grow some sort of audience, but at the beginning we felt like we knew all the people who were reading it. They were mostly our friends. There was a phone number you could call to subscribe, which was answered

during the day by an intern or whoever was there. Sometimes I would stay late because that's when it was quiet and I could work. When the phone rang, I could have just let it go to the answering machine, but usually I would pick up. I would ask people where they were calling from, and they'd say, "I'm in St. Louis, Missouri." I would ask where they had seen the magazine. They would want to know what was coming next. We would talk for a while and then I would take their subscription info. I don't think anyone at the magazine knew I was having these after-hours conversations. I was trying to give it a personal touch, and wondering, "Who are these people out there?" Sometimes we would get a letter from someone who wanted to get involved with the magazine. I remember one English kid sent a picture of himself from a photo booth. He looked very underage, and he wrote, "I want to come to New York. I want to work for the magazine. I would do anything"—and anything was all in caps and underlined—"I would do ANYTHING to work with you." That one got filed away.

Mary: I was recently reading some of Amy Kellner's columns in the back of the magazine. The back section was so great. We could write about these tiny little corners of the world.

Bob: In the back section, we'd try anything.

Mary: Unlike *Sassy*, at *index* there was the freedom to do something like my "Obsessions" column with Andrea Linett. At the time, there weren't fashion stories about obsessing over Wallabees, Birkenstocks, or whatever. Now every magazine says, "We're obsessed!"

Bob: A funny connection between *Sassy* and *index* was . . .

Mary: Kim and Thurston?

Bob: Yeah, Kim Gordon and Thurston Moore. But also Ian Svenonius of The Make-Up, who had been The Sassiest Boy Alive! He was one of our best writers and kept writing for *index* after I left. Whatever he turned in would be smart, funny, really well written and would need almost no editing. My favorite kind of writer.

Mary: The feature interviews were really long.

Bob: So many magazines whittle an interview down to almost nothing. We let them run long. In retrospect, I would go back and cut some of them down. [Laughs.]

Mary: Sometimes people talked for a really long time. When I was on the phone with agnès b., I could not get her to stop talking! Same with Marc Jacobs. I turned over my cassette tape, and he kept going. I think he must have smoked half a pack of cigarettes in two hours.

Bob: You remember the interview with Louise Lasser, the actor from *Mary Hartman, Mary Hartman*? Do you know how long that was? *Three hours*. At one point I had to send the guy to buy more batteries for the recorder, and then back to the office for another blank tape.

Mary: The other great thing was that *index* used a transcriber.

Bob: The only person who did his own transcribing was Steve Lafreniere.

Mary: Didn't he only talk to people on the phone?

Bob: He didn't want to meet them in person. He was one of the only interviewers who would really do his homework before he talked to someone. I think he would even re-watch their movies.

Mary: What gave you the confidence to keep putting this magazine out?

Bob: I don't think we really doubted ourselves. We were doing what we wanted to do. What was great is that Peter was the publisher. There wasn't a company guy who would lower the boom every few issues, saying, "Come on, you guys really have to get it together!" It reminds me of a program I watched when I was a kid, *The Little Rascals*. *index* had a *Little Rascals* aspect to it.

Mary: It seems like there were these unspoken guidelines. There was something very freewheeling, but at the same time there were certain things that you just had to know. For example, there was somebody I wanted to interview—Monti Rock III—but you said, "No. No one will know who he is."

Bob: Sorry!

Mary: He was a really wonderful hairdresser. He was on talk shows, and then he was the DJ in the movie *Saturday Night Fever*. Now I think he's the Reverend Monti Rock III in Las Vegas.

Bob: It was from those sorts of ideas that I developed the Survival Guide, where we would go to people who were usually older and had had really interesting lives in the '50s, '60s, or '70s. Quentin Crisp was the first one. Although they were sometimes more recent. Who's that child actor from *Home Alone*?

Mary: Macaulay Culkin.

Bob: Right. I would say, "Let's do a 'Survival Guide' with Macaulay Culkin!" He had kind of disappeared at twenty-five. That would be a very *index* thing. Bruce LaBruce would interview him, and then we'd get Terry Richardson to do the picture. Or Bruce could do both. We'd save money. Bruce could do the interview and take the picture. So you could just fall back into it in a second, I think, because the spirit of *index* isn't tied to a time. You can always plug people into the sensibility.

Mary: What was that sensibility?

Bob: Thinking back to the contributors and me as the editor, I would say the sensibility was punk, post-punk, homo. And Peter was none of those things, right? But maybe that's why he was the publisher. *index* was also post-*Interview*, because *Interview* wasn't as interesting as it had been when Peter and I were younger. *index* was kind of punk-goes-to-summer-camp, because we had people like Steve Lafreniere, Amy Kellner, Bruce LaBruce, Bruce Hainley, Tina Lyons, David Savage. A certain sensibility also carried over from the '60s, '70s and '80s into that moment in the mid-'90s, and to some extent it's still very much with us. I feel like we could go back and start working on a new issue of the magazine tomorrow morning.

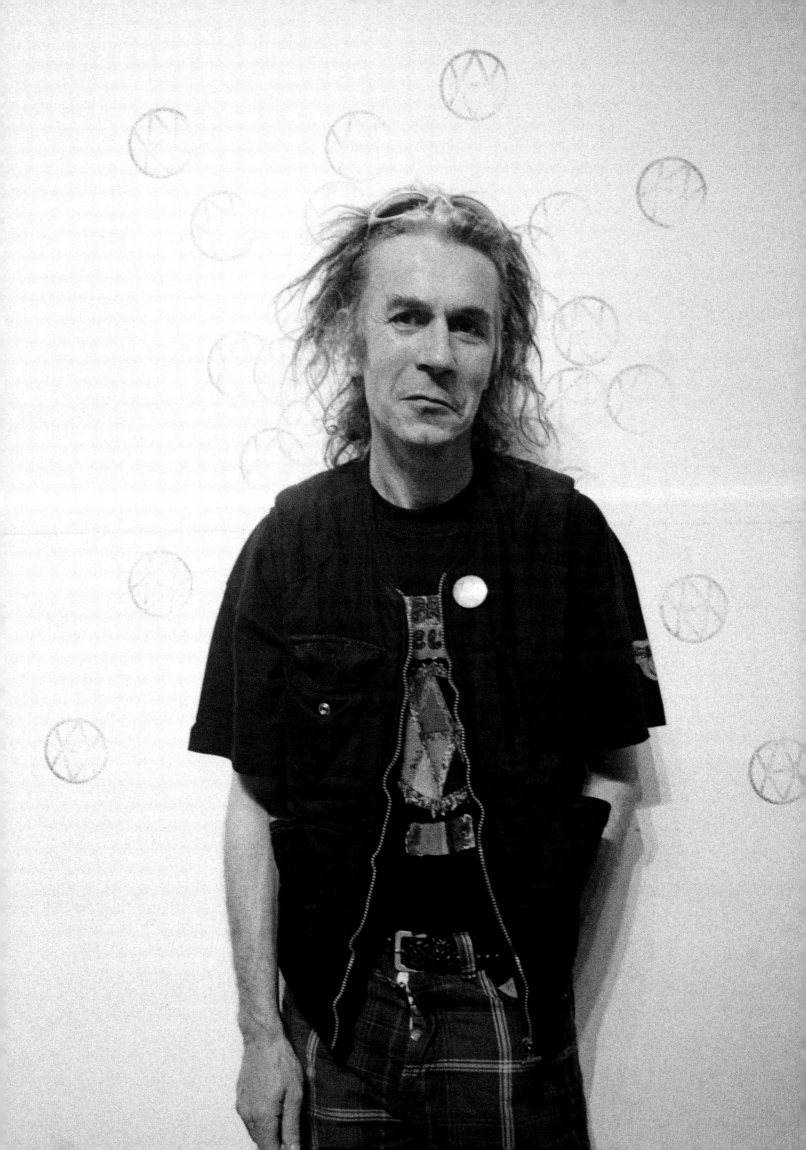

JAMIE REID
with Bob Nickas

Photograph by David Ortega
January/February 1998

Record collectors often buy records because they're attracted to the artwork on the sleeve, and I'm no exception. I bought a big part of my collection between 1976 and 1979, when there was an almost endless, giddy flow of punk singles. At first, the look was deliberately undesigned; predominately black-and-white, it was less the product of art direction than the nearest Xerox machine. The look fit the roughness of the music, but didn't exactly stand out in the racks. The records were all about the anarchic, messy sounds pressed into the vinyl itself, and the sleeves were just something they were slipped into.

But then came Jamie Reid. His work for the Sex Pistols single-handedly defined punk's visual aesthetic and was instantly absorbed. With their ransom-note lettering, acidic fluorescent colors, and cartoonish Pop-barbs, you could see the records a mile away. What Jamie Reid did was give an image to the attitude behind the music that made them inseparable: you could almost hear the song when you saw the sleeve.

Fast-forward to the present, and a Jamie Reid retrospective in New York, and his work is still as compelling as it was nearly twenty years ago. And so is Reid himself.

BOB: Some of your early work reminds me of that great '60s English Pop, artists like Richard Hamilton and Eduardo Paolozzi. You must have been aware of them.
JAMIE: Sure. I mean, some of those people were actually teaching at the time—Bridget Riley was a visiting lecturer, as well as Richard Hamilton.
BOB: You can trace a line from mid-'60s Pop to late '60s radicalism, to the early '70s—with people wondering where to go from there—and on into punk. I mean, nobody knew that punk was coming. But many of the things that you were doing in the years before it hit were going to really define punk, graphically and philosophically.
JAMIE: I can only speak for myself and what influenced me—where I was coming from. The whole Situationist, anarchistic element that's within punk—Suburban Press, the Pistols—it's like a re-evaluation of history. You can look at twentieth-century art, and it's all pretty much recorded both on a spiritual and magic level, but also on a political level. From the Surrealists and the Dadaists, to the Situationists and the whole movement of community agit-prop politics, down into punk, and then into all sorts of things. It's a continuing story.
BOB: Well, let's hope it isn't going to be made into a movie by Oliver Stone.
JAMIE: God forbid. I mean, the move into the punk thing was a disillusionment with the whole over-intellectualization of the Situationist movement and the politics of the '70s. It was an attempt to take those movements into popular culture.
BOB: At the time, I think there was a strong sense of—in quotes—of the "failure" of '68.
JAMIE: Not a failure, a re-interpretation.
BOB: I mean "failure" in the sense that some people really believed they were going to change things quite dramatically, and were later . . . well, "disappointed" probably doesn't begin to describe how they felt.
JAMIE: The odds are stacked against you doing anything—it's amazing that any of these things happened at all.
BOB: Didn't you print posters that were put up anonymously or surreptitiously that said things like, "Keep Warm This Winter—Make Trouble" and "Save Petrol—Burn Cars," the LIES stickers that were pasted over advertisements?
JAMIE: Oh, there was all sorts of stuff. It was a whole group of us in London. You've got to remember that there were community presses all over Britain. People were out doing stuff, sending stuff to each other. Pranksterism was very much a big part of the whole thing, a lot of humor as well.
BOB: And although it's easy to mistake it for vintage punk, this was all done well before punk.
JAMIE: Yeah, this is '69, '70 . . . '73, '74.
BOB: So when did you meet up again with Malcolm McLaren? Was he aware of what you were doing?
JAMIE: Some friends of mine who ran a political press in Notting Hill, who wanted to have an entirely different culture within Britain, decided to get out of the city. And they eventually ended up in the Isles of Hebrides in northern Scotland. This is about '73, '74. And I went there to help them set up a croft, a small farm. It was like going back home in a way, because my family is from the highlands, from Scotland.
BOB: That's really getting out of town.
JAMIE: And I ended up staying there a year. I'd kept contacts with Malcolm and one day got a telegram saying, "Come down, we've got this project in London we want you to work on"—which happened to be the Sex Pistols.
BOB: You really had no idea what was waiting for you in London?
JAMIE: I was living in the middle of mountains and lochs, and, suddenly—boom—I started working with the Pistols.
BOB: And that was in '75?
JAMIE: Yeah. I got a job at a printing press in South London, which was actually a Labor Party printing press. That's where we were doing all the early Pistols stuff.
BOB: What was it like working with the Sex Pistols?
JAMIE: We just went for it. It was like that for four years. An enormous amount of spontaneity. And it was a much more collective situation than probably Malcolm or John Lydon are willing to acknowledge. It was sort of fan-based, about fifty people who were every bit as important a part of it as the band was.

THE INDEX: 99 WAYS TO A BETTER YOU

Give me a buck for every New Year's resolution I've made and broken, and I'd be Anna Nicole Smith. But give me a dime for every bit of good advice I've given to *other people* and I'd be Christina Onassis. So this year I'm going straight into the advisory mode and making "resolutions" for everyone else ... from the top down.

99. Ninety-nine bottles of beer on the wall? If you want to know the real price of a drink, take a good look at Leo's face — and he's not even twenty-five.

98. Be discreet. Your friends will eventually tell you everything.

97. Don't give change to young, able-bodied kids in the street. Suggest ways they might work for it. You'll think of something, or they'll think of something.

96. Read a book every week. The phone book, a cook book, Danielle Steele — it doesn't even matter. Just read something.

95. Walk to a place you would normally drive to.

94. Call your mother.

93. Tell people you love them if you do. Repeat as necessary.

92. Be nice to people who carry guns and expect you to do as you're told. That's the Police Department, not the Polite Department.

91. Sleep with people you're attracted to — even if there's a downside.

90. As Gibby says, it's better to regret something you have done than something you haven't done. And he should know.

89. Never tell someone you were "only joking."

88. If you break up with a boyfriend/girlfriend/President, remember that the only way to get over someone is to get *under* someone.

87. Start rumors about yourself.

86. When confronting a wayward husband or child, the first version of the story bears some relation to reality. Anything after that is what they think you want to hear.

85. Patronize owner-operated businesses to the exclusion of all others.

84. They used to say, No one knows you're stupid until you open your mouth. Today, you need only look at how high someone's rolled up the cuffs on their jeans. Think of this as an IQ Test from the legs down.

83. Charming people master the art of free-loading, but there's really nothing charming about it. Pick up the check once in a while. Treat people.

82. Whenever you're going to buy something, stop for a moment and double the price. If you can't afford it doubled, you probably can't afford it at all.

81. When faced with a choice, do both.

80. Be monogamous with as many people as possible.

79. Stop wearing a watch.

78. Don't be late to meet people. Unless you only have a week to live, your time is not more important than anyone else's.

77. The child/puppy analogy is truer than ever. Yes, they're cute and fun when they're little and you can actually hold them in the palms of your hands. Then it all changes, and not necessarily for the best. Stop having children.

photo: Big Dog, San Diego

76. Sleep with someone older. If older, let someone younger sleep with you.

75. Send postcards even if you're not traveling.

74. Send Valentines.

73. Delete the word "like" from your vocabulary unless you mean to express fondness for someone or something, or to indicate similarity.

72. Go and see someone you would have otherwise called on the phone.

71. Make someone dinner at home.

70. Don't try to dance funky if you don't know how.

69. Don't give directions to tourists. There are just too many of them. So refuse, politely of course. Let them get lost or find their own way. Just because you live somewhere doesn't mean you work for the Visitors Bureau.

68. Rejection isn't always about you. As Yogi Berra once said — as he walked onto the field and saw an almost empty Yankee Stadium — "If they don't want to come, you can't keep them away."

67. Don't go to weddings.

66. Stay out of hospitals.

65. If people work for you, give them the day off — with pay — every once in a while. No explanation is necessary.

64. Try to get through an entire day without speaking to anyone.

63. Drink water instead of soda.

62. Take a bath instead of a shower.

61. Be promiscuous with one person at a time.

60. If you have children, keep them home from school every so often and spend the day with them doing whatever they want to do.

59. Adult men should never wear briefs. These are not merely "little boy pants," they're practically diapers. It's time to grow up down there.

58. Banish the phrases "kind of," "sort of," and "you know." You are guaranteed to feel more articulate with each and every passing day.

57. Avoid excessive "baby talk" with infants. Find times to speak to them slowly and clearly and refrain from making too many "goofy" faces. There's nothing wrong with being a little smarter a little sooner in life.

56. Sit a little while in the sun each day. When you go to a tanning salon, no one really believes that you've been to St. Barths. So don't baste like a turkey; let nature take its course.

55. Civil disobedience is not only a right, but a responsibility you bear for every person you pass in the street.

54. Paint your house any color but white — lime green, lemon yellow, coral blue, candy apple red. As "good taste" sweeps America, and towns have begun to enforce color codes, our fine pioneer spirit is starting to look like a sheep yard.

53. Buy little presents for no other reason than to give them away.

52. Make up stories and see if people believe you.

51. Go to a movie by yourself. See whatever you want. Then get something to eat — whatever you feel like having. Then go home and go to bed. This is called "the perfect date."

50. Don't walk out in the middle of a movie, even a bad movie — and especially not on a plane.

49. Amuse people. Make them laugh. Think of it as community service.

48. Send flowers to someone anonymously.

47. If you have to give a gift to someone who's impossible to shop for, lend them your credit card for the day. Then go home and report it stolen.

46. Eat exactly half of what's put in front of you. And in six months, if you don't look and feel noticeably better, there's probably nothing else you can do.

45. Don't eat standing up — unless you're a horse.

44. Write a long letter to someone far away. Ideally, the length should correspond to the distance.

43. Acknowledge even the smallest kindness. It may come your way again.

42. Don't dress ten years younger than you really are.

41. When faced with a choice, do neither.

40. If you're going to punish children, don't spank them. It's one less thing they'll have to look forward to as they get older.

39. Be yourself at all times. But keep in mind that embarrassment can strike at any moment and without warning.

38. Advice is what other people tell you to do. Life is what you tell yourself to do.

37. And never start what you can't finish.

BOB NICKAS

MAURIZIO CATTELAN with Bob Nickas

Photograph by Anders Edström
September/October 1999

BOB: The first time I ever saw your work was when you had the donkey and the chandelier in the gallery.
MAURIZIO: A failure.
BOB: Well, it was closed by the Board of Health after only a few days. Not many people actually saw that show.
MAURIZIO: But the donkey made such a fantastic noise!
BOB: All that braying is what got it closed down.
MAURIZIO: Did you know that I had a project with barking birds? This was another failure.
BOB: What do you mean by "barking"?
MAURIZIO: I was thinking to have one animal do another, to sound like another animal. For six months I had them with a tape recorder . . .
BOB: Oh, like parrots.
MAURIZIO: Yes.
BOB: You were trying to teach them to bark? And you really thought you could do that?
MAURIZIO: Sure. I have a friend who did this. His birds make the noise of a washing machine. I like when you are in front of something that you know extremely well, but it's not the same. The bird is barking. It's not chirp-chirp.
BOB: If you wanted an even bigger failure, you could have tried to teach a dog to chirp.
MAURIZIO: [Laughs.]
BOB: So the show with the donkey was your first in New York. Was there more pressure, or was it just another show to you?
MAURIZIO: I was extremely excited, but, at the same time, every show you decide to do is important.

BOB: Every show?
MAURIZIO: Yes. If you think that one place is more important than another, you are lost. You are lost.
BOB: When I asked you to come and talk, I said that I wouldn't make you explain your work. But now that you're here . . .
MAURIZIO: I can explain the process. If you asked me, "What does the donkey mean?" I don't know what it means. But I am sure that the process can be interesting.
BOB: But you create these images—an ostrich with its head in the floor, a stuffed horse hanging from the ceiling, a live donkey in a gallery—which you can smell as soon as you walk inside. In fact, there are animals in a lot of your works. You're not choosing things so randomly.
MAURIZIO: That show was the first time that I was visualizing myself. You know, back in school days in Italy, they used to put a hat on your head— this kind of hat with two big ears—and they'd say, "Bronca." So I would think, "My God, I'm like an ass . . . "
BOB: Because?
MAURIZIO: Because I didn't know what to do for that show in New York at Daniel Newburg Gallery. I had the idea only five days before it opened. Everything else I wanted to do was too expensive for the gallery. But I really liked the donkey. I remember strongly this image of Daniel and me and the donkey. This was really a fantastic image.
BOB: Maybe better than the show?
MAURIZIO: For myself, yes, because it was very personal. And then the show was just okay. This elaborate, crystal chandelier with the donkey. I imagined that when the Communists took over in Russia, you would have seen something like this inside the White Palace. So it was like a little story.
BOB: Like your life?
MAURIZIO: You know, it's true that I've taken interviews from other people as my own, and once I completely copied one. People would stop me and

say, "Oh, I didn't know you were born in Corsica and you were a student of Bataille." Which, of course, is Ange Leccia.

BOB: We always see each other in New York, and I know you're traveling a lot of the time. So you're not permanently anywhere.

MAURIZIO: This is the condition of everybody lately.

BOB: And you don't have a studio anywhere?

MAURIZIO: If I didn't have any shows, and there wasn't any interest, I wouldn't do anything.

BOB: If people stopped asking you to be in shows, you wouldn't make anything ever again?

MAURIZIO: No.

BOB: But you're asked a lot nowadays. You must get some satisfaction from making your work.

MAURIZIO: It's a deep orgasm—three hours, if it's a good work, five minutes if it's so-so. But when it's not very good, you might regret it for the next six months.

BOB: Have you regretted some pieces you made?

MAURIZIO: No, because in the end, even if it's a failure—and I've had many—it's something that is part of your experience. Because I don't have a studio, a piece is made just for a show, and what I see is what you are going to see.

BOB: I've always been a fan—long before we met.

MAURIZIO: When people tell me, "I like the work," I say, "Okay, okay." But I can't believe it, because I'm not able to take myself seriously.

BOB: You can't believe that I like your work?

MAURIZIO: I mean, yes, I do. But it's amazing.

BOB: Well, listen, life is really tragic.

MAURIZIO: Yes. [Laughs.]

BOB: So tell me about some of your interesting failures.

MAURIZIO: Oh, Jesus. [Laughs.] You start with an idea, and you think, "I'm going to make at least one object." This is always my goal, to do, let's say, a rhetorical sculpture, and then in the end I'm not able.

BOB: Your goal is to do a rhetorical sculpture?

MAURIZIO: For a long time I had a car in mind. My God, I was so obsessed. It was at least two years. I said, "I want to do a car, a beautiful car." Because it's the end of the century. The last century, it was the end of the horse, and now it's the end of the mechanical century.

BOB: Do you drive?

MAURIZIO: I am really involved with a bicycle, and that's another world. But I do have a car.

BOB: Do you drive well or badly?

MAURIZIO: Mmm . . . I drive slowly.

BOB: Is it a myth that Italians are bad drivers?

MAURIZIO: No, we're pretty good. And we have fantastic—how do you say?—blowers.

BOB: Horns.

MAURIZIO: Here in New York the horn blowers are very soft, but in Italy, Jesus, the level of noise. It's unbelievable.

BOB: So what's the starting point for your work?

MAURIZIO: I say, "*Cazzo, cazzo*, I'd like to do something great . . . "

BOB: What does that mean?

MAURIZIO: "Cazzo" is your dick. [Laughs.] "Cazzo! Cazzo!" It's like, "Fuck, fuck!" So this is the first point . . . to present something like an object or a painting. But when I realize that

it's extremely difficult for me to obtain this result, then I'm hating myself that I grew up and decided to do it, to be in this fucking world.

BOB: Hating yourself?

MAURIZIO: Yeah, sure. To find myself in a situation where I'm not able to say, "No, I can't do that." Because I feel like a professional. When you say, "Yes," you are sure that in the end, good or bad, you're going to end up with something.

BOB: You're a professional . . .

MAURIZIO: Art worker.

BOB: But with you, there's not always an actual work.

MAURIZIO: There was the time I had to go to the police to tell them that someone stole an invisible sculpture from my car.

BOB: I've never heard about this. An invisible piece?

MAURIZIO: I was supposed to have a show at a gallery, and I didn't really have anything for them . . .

BOB: . . . and you didn't know how to tell them?

MAURIZIO: Yes, so I decided to report that a sculpture had been stolen from my car.

BOB: So you'd have a good excuse for the gallery?

MAURIZIO: Exactly. I went to the police station in the early morning, and I was frantic. "Oh, my God . . . "

BOB: And they believed you?

MAURIZIO: Sure. [Laughs.]

BOB: Didn't you once steal someone else's work and then bring it to the place where you were having your show?

MAURIZIO: Yes. This was more about displacement. I thought it was interesting to move one place completely into another.

BOB: So you broke into the gallery?

MAURIZIO: Yes, we broke in at night.

BOB: They didn't have an alarm?

MAURIZIO: No. [Laughs.]

BOB: Whose work did you take?

MAURIZIO: Actually, we took everything from the gallery . . .

BOB: Like the fax machine and all the stuff in the office?

MAURIZIO: Everything. We rented a van and just filled it up.

BOB: This was in Amsterdam?

MAURIZIO: Yes, at de Appel. They wanted me to do a piece in a week. But I'm not used to working so quickly. So I thought the best way to get something that fast was to take the work of someone else.

BOB: That's a new take on the ready-made.

MAURIZIO: Well, when you don't know what to do . . .

BOB: But didn't the people at de Appel ask, "Where did all this stuff come from?"

MAURIZIO: The story finished quickly, because the police came, and there were problems . . .

BOB: Were you arrested?

MAURIZIO: No. That is why I did the piece in Holland.

BOB: [Laughs.] Imagine doing that in New York.

MAURIZIO: It took a while for everyone to calm down, but then we became very good friends, and they even asked me to do a show with them.

BOB: But that's your ultimate punishment—you had to figure something out for another show.

MAURIZIO: Yeah, it's true.

BOB: Crime doesn't pay.

O
On the Set

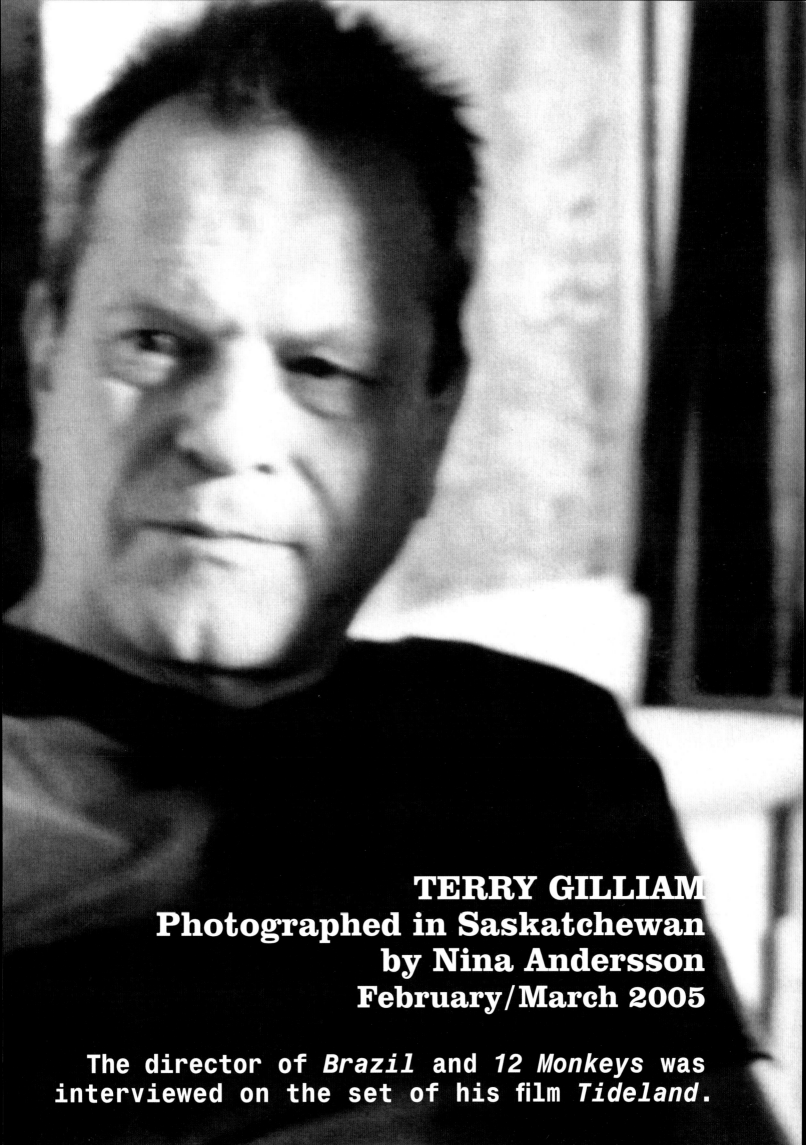

TERRY GILLIAM
Photographed in Saskatchewan
by Nina Andersson
February/March 2005

The director of *Brazil* and *12 Monkeys* was
interviewed on the set of his film *Tideland*.

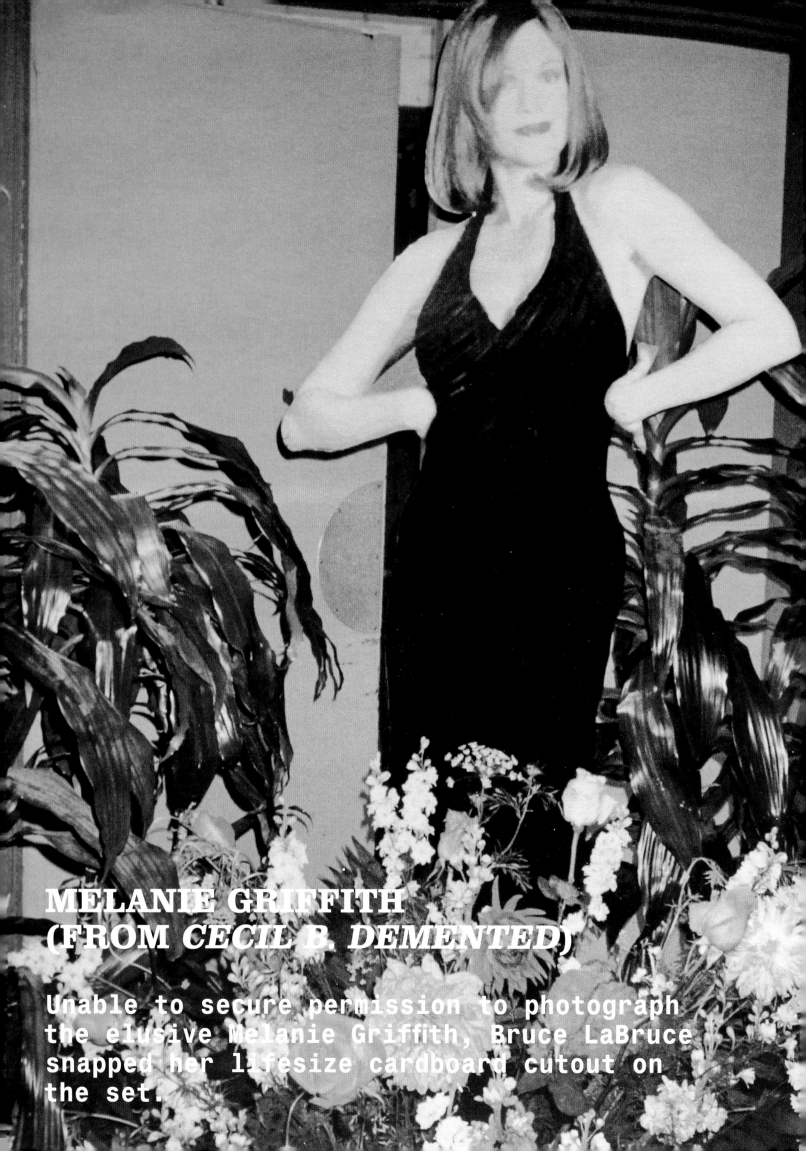

MELANIE GRIFFITH
(FROM *CECIL B. DEMENTED*)

Unable to secure permission to photograph the elusive Melanie Griffith, Bruce LaBruce snapped her lifesize cardboard cutout on the set.

BRUCE LaBRUCE on the Set of John Waters's *Cecil B. Demented*

FEBRUARY/MARCH 2000

If the symptoms of epilepsy include experiencing graphic sexual hallucinations, mood swings, and seizures—and they do—then being subjected to the work of John Waters may be the closest that some of us will ever come to understanding the disease. Now, you must understand that many filmmakers might foolishly construe such an introductory statement as a peach put-down, but in the walleyed world of Mr. Waters—dubbed variously by critics in the past as Cecil B. DeMented and The Prince of Puke, and currently the self-proclaimed Elder Statesman of Filth—an apparent insult can feel like nothing less than a kiss. In fact, if it were discovered tomorrow that John Waters's movies, along with certain Japanese animation and Mary Hart's voice, induce epileptic fits, the Filth Elder would no doubt consider it to be one of his most glowing reviews.

Quite a few reels back, I had the honor of chatting with Mr. Waters, one of my great cinematic and homosexual role models, at a grisly after-party in New York for my own crypto-camp porno movie. He informed me that he would soon be shooting his next feature in—where else?—Baltimore, in the Land of Mary, his hometown, and the location of every one of his 14 previous films. Hedy Lamarr with excitement, I asked the elegant auteur if I might pay a visit to his set under the auspices of *index*, whose cover he once graciously graced. (As he has generously given me props in several interviews over the past couple of years, I figured it was high time for a little mutual log-rolling.) Thus was I invited to the set of *Cecil B. DeMented*, the movie itself named for the man behind the camera. For me, it's a pilgrimage of sorts to Waters' Dreamland, the perverted eastern inversion of Tinseltown, which as a film student gave me profound inspiration by proving that eating dog shit can play between the coasts.

Thirty years later, I finally arrive in Baltimore (better late than never) and grab a cab to the Senator Theater, the very site of all the Waters world premieres, which also happens to be the location of the current shoot for the next four days. Like a tourist, I snap pictures of the names of his various movies—*Female Trouble*, *Hairspray*, *Cry-Baby*—carved into the cement out front, and then of the marquee, which announces the title of the film within the film, *Some Kind of Happiness*, starring Honey Whitlock, a role being essayed by Melanie Griffith. The casting of Miss Griffith is pure Waters, who has a penchant for recuperating stars by allowing them to parody themselves before others less charitable get the chance. I'm thinking of Liz Renay, Traci Lords, Kathleen Turner—sexpots all—whom the director encourages to luxuriate in their own bad-girl personae. (In the *DeMented* script, Honey Whitlock's very first role is identified as that of an ingenue turned vixen in the movie *Good for Nothing*.) Fresh off a couple of ballsy performances for Woody Allen and Larry Clark, Melanie Griffith should be primed for Waters.

Skipping over stout cables, I enter the theater and ask a young gentleman in a baseball cap if he could kindly direct me to the unit publicist. What archery! It's the publicist himself, who proceeds to fill me in on the order of things. After giving me a brief lowdown on the shoot thus far, he gingerly presents me with two rules vis-à-vis access to Miss Griffith: 1) Do not under any circumstances take her picture without asking her permission first, and 2) Do not ask her permission. Catch-22'd already, and we haven't even had lunch yet. Of course, his prohibitions have the opposite effect on me—as the day progresses, my hands, like those of Dr. Orlac, begin to take on a life of their own, clutching my camera, pulling me inexorably toward the inaccessible star. But more on this later . . .

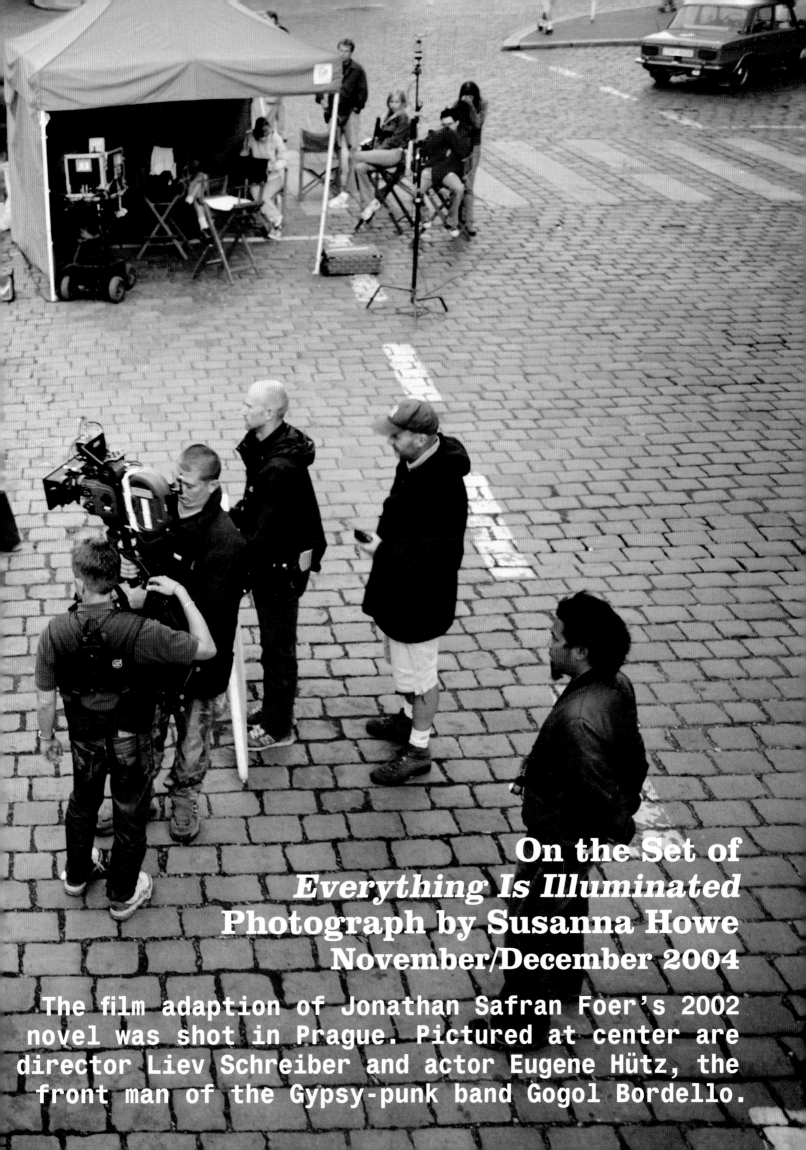

On the Set of *Everything Is Illuminated*
Photograph by Susanna Howe
November/December 2004

The film adaption of Jonathan Safran Foer's 2002 novel was shot in Prague. Pictured at center are director Liev Schreiber and actor Eugene Hütz, the front man of the Gypsy-punk band Gogol Bordello.

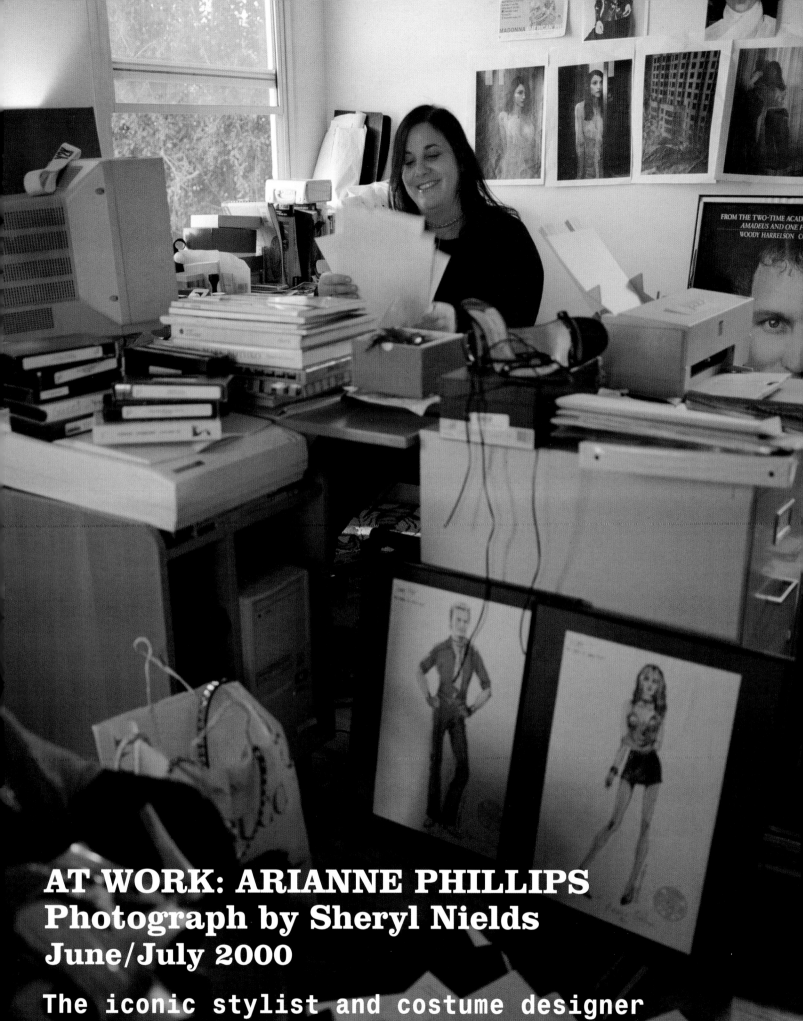

AT WORK: ARIANNE PHILLIPS
Photograph by Sheryl Nields
June/July 2000

The iconic stylist and costume designer
worked for Madonna and Courtney Love. She had
recently designed costumes for the 1999 film
Girl, Interrupted.

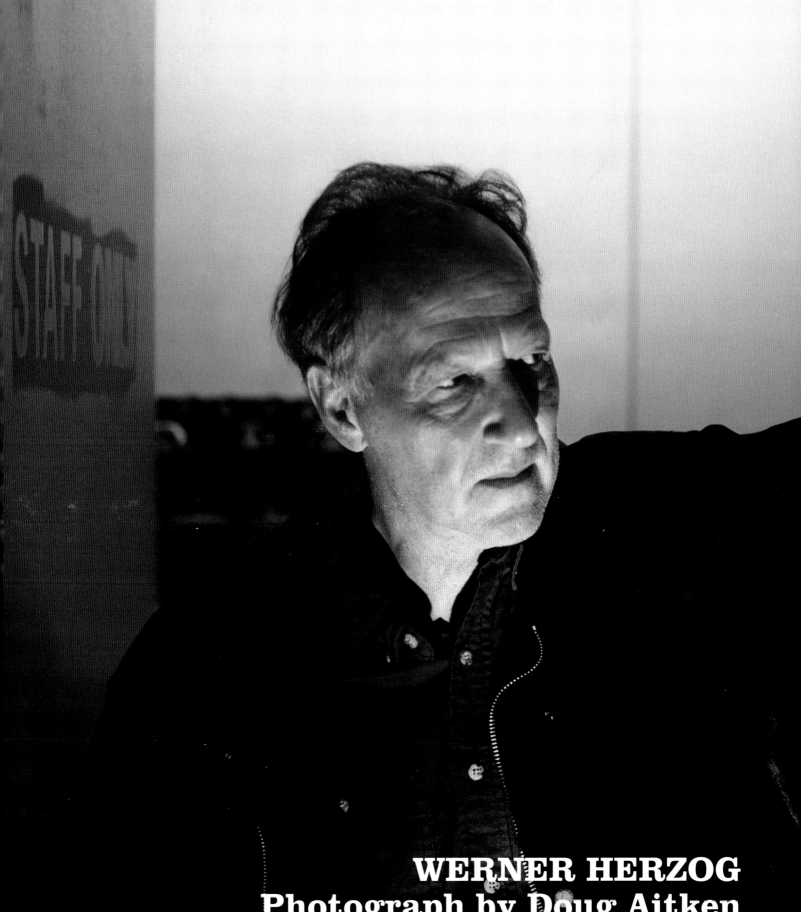

WERNER HERZOG
Photograph by Doug Aitken
November/December 2004

Porno films are movie movies, like Fred Astaire
films are movie movies. I scared my wife
recently by saying that I should be the first
director to make a real porno movie.

WES ANDERSON
and OWEN WILSON
with Marina Isola

February 1996

MARINA: Wes, you just directed *Bottle Rocket* with James Caan. How does a first-time director get to work with someone like him?

WES: We ended up having the same agent, and we kept hearing stories about him that resembled the character, who is very eccentric. We wanted someone like him for Mr. Henry's role.

MARINA: He is thuggish but offbeat.

WES: Right, he's got this Zen thing . . . The Asian guy who played his business manager in the movie is actually Caan's karate master. We hadn't cast that part, but we heard about him and wanted him. He does all sorts of strange things, like pound his own hands and feet with a sledgehammer to build up the bone from the hairline fractures. So they become weapons, like rocks.

MARINA: And Caan is really into martial arts too?

WES: Absolutely. One time he knocked on my hotel door at 11 pm. I was asleep, but he was really up and had these ideas for a scene that we were going to shoot in five days. He wanted to throw the character to the floor and do all this weird karate stuff. So he starts demonstrating. He pulls me in front of the mirror—he is an extremely physical guy—and here I am, in the middle of the room, in the dark, in my bathrobe, and he puts me in all these different holds. And he's throwing me around for about half an hour.

MARINA: Of course, you have to keep your actors happy.

WES: Yeah, but at the same time that it's weird, I'm also totally interested in everything he has to say.

OWEN: When we first met Caan, we wanted to put him at ease, so, next thing you know, he has me demonstrating some karate moves, one of which was to try to strangle him. So he keeps saying, "C'mon, strangle me harder," so I'm pressing on his neck, and then he just knocks my hands away. I thought it was the most obvious thing, if someone is strangling you, to knock his hands away. You don't have to know karate! But everybody was like, "Oh, my God, that's just incredible!"

MARINA: Did he have lots of ideas for the movie?

OWEN: Oh, he had lots of ideas, but no prima-donna stuff. He would invite us to his trailer and tell us stories about working on *The Godfather*.

MARINA: Owen, you basically had no experience, and suddenly you were plunged into the lead role in a big feature—how did you know what you were supposed to do?

OWEN: I had performed a little before, although I have never taken acting classes. I am hesitating to say this, but I don't think there's much to acting. Wait, that sounds horrible. No, it's difficult to be a good actor.

MARINA: Was Dignan's character a big stretch?

OWEN: Dignan is sort of childlike in his enthusiasm and energy. He doesn't censor himself. He has little-boy ideas about what it is to be a criminal.

MARINA: It's not an adult reality. He was into organizing things the way a kid would.

OWEN: Yeah, like in *The Adventures of Huckleberry Finn*, when Tom Sawyer comes to get Jim out, and he can't just open the door. He makes them dig a tunnel under the house and do all this stuff they got from *The Count of Monte Cristo*. So Dignan has the same thing, where it's not just doing it, it's the style you do it in.

MARINA: It's more the idea of the ritual.

OWEN: Right, it's not the amount of money you're getting out of the robbery, it's the process.

MARINA: There are lots of funny parts.

OWEN: So you liked some of the jokes?

MARINA: Yes, like when Anthony gets ready to rob the warehouse, and he goes over these totally ridiculous preparatory, frame-by-frame, flip-book sketches of the character pole-vaulting over the security wall.

OWEN: Oh, good. I'm glad you liked that . . . but did I answer your question?

MARINA: About acting for the first time?

OWEN: Oh, yes, well, it was made easier by the fact that it was a comfortable situation. It was a big crew, but I saw friends and relatives everywhere.

MARINA: What about all the minor oddball characters? Weren't some just friends from home?

WES: Yeah, the Indian safecracker is from Dallas, and he spins plates and juggles, some of which was in the movie but had to be cut.

MARINA: How long did this entire project take?

WES: It took almost five years, including the short.

MARINA: Did producer James L. Brooks ask for a lot of changes from what you had envisioned?

WES: We thought we would just tell him about the movie and then just go and shoot it. [Laughs.] Of course, it was much more complicated. After screening the short at Sundance, we had a reading of the script for Brooks and Polly Platt, who was the producer on location. It was 130 pages printed, but it was in this really tiny typeface, and we realized it was a four-hour movie. The reading went on forever!

MARINA: Were they beginning to look worried?

WES: Not really, or at least they hid it well. Owen and I cut it down at the Sundance labs. Then we went to LA in February '93 and had another reading with actors.

MARINA: When did you move there from Dallas?

WES: Shortly after that. The studio put us up in a hotel for eight months.

MARINA: When a studio is involved to that extent, what kind of agreement do you have—any guarantee?

WES: At that point we had a contract that guaranteed money, but not that the movie would be made.

MARINA: How do two people write a script together? Were you ever at each other's throats?

WES: Actually, it was fairly civilized. But we worked with lots of different producers, and they each had criticisms, so we would end up on the same side—angry at them.

HARMONY KORINE'S
JULIEN
BY BRUCE LABRUCE
MAY/JUNE 1999

Photograph by Bruce LaBruce

The size of the crew and the general atmosphere of the shoot is refreshingly modest for a million—dollar-plus movie—definitely not, thank Christ, the scaled-down, hierarchical Hollywood system needlessly adopted by most American indie productions. As the entire picture is being shot in digi-beta and within the relatively austere restraints of the Dogme 95, the crew has been kept down to a very manageable and mobile 15. Although Harmony speaks of the Dogme "rules" with a certain irreverence, I get the impression that both the director and his DP Dod Mantle take aspects of it quite seriously. When I ask Dod about his lighting for the interiors, he tells me that they really are using only practicals as much as possible, and, indeed, he is loath to move or manipulate even the existing lighting of a location; otherwise, he says, "What would be the point?" I also overhear him complaining about the soundman on another Dogme project who manipulated the sound during a scene, as opposed to the straightforward live sound mix that is being used in the making of *Julien*. Purists they are to a degree, so I mischievously

ask Harmony if he is wearing his Dogme 95 lab coat under his parka. He says he's not but confesses that they have already shot one scene in their skivvies.

Owing to technical difficulties with the sound, the scene is delayed as the sun nudges down below the horizon. "Fuck the sound, let's shoot MOS—we're losing the light," decrees Dod Mantle. The cameras roll, and Ewen Bremner walks somnambulistically toward the fat kid holding one of the turtles, which were transported to the set in a beer cooler half full of water. After a brief conversation, Ewen suddenly grabs the kid and throws him headlong into the mud, flailing at him wildly with both hands. As if the whole city is in collusion, an eerie silence follows— no sirens, no distant voices, a strange lapse of street noises—out of which emerges Ewen's odd laugh, then his cries for deliverance. As the sky offers a brilliant sunset that even Hollywood couldn't contrive, I can't help but think this movie has been blessed.

Afterward, the crew converges in Harmony's grandma's little house, trying to confine its muddy boots to the path of green plastic garbage bags gaffer-taped to the wall-to-wall carpeting. Grandma Joyce sits brightly in a comfortable chair, poodle in her lap, taking it all in. She informs me in broken English and, I assume, Yiddish that Harmony's father gave her the pooch as a present at the cost of $1,000. She proudly shows me childhood pictures of H. and his older brother and younger sister. I snap photos of Harmony with his grandma. I tell him to look suitably demented, but then I say, "Forget it, you already look demented enough."

H. and Ewen and Anthony gather around the portable monitor to look at the day's footage. They peruse the fruits of their labor, discussing it animatedly. In one shot, from the boy's point of view, a huge drip of snot hangs off Ewen's nose, which looks amazing. "I'm good with snot," he remarks proudly.

JUERGEN TELLER
with Cory Reynolds

Photograph by Leeta Harding
November / December 2000

CORY: Why did you go to London?

JUERGEN: My required army duty was getting closer—
I was going to do civilian service. I thought
I'd have to give up photography at twenty-two.
So I just said to my mom, "I'm leaving." She was
heartbroken. And then I just drove off to London.
I came from a place where, like, four thousand
people lived. I didn't speak any English. All I
knew about fashion came from looking at what the
different bands were wearing.

CORY: Were you the kind of photographer who shot a lot
of film for each assignment?

JUERGEN: No. When I started out, I couldn't even
use normal film, because it was too expensive
to process. I started shooting this thirty-five-
millimeter Polaroid film, which came in twelve
and thirty-six exposures. I could only afford the
twelve exposures, so for each job I had twelve
pictures. [Laughs.]

CORY: You must have been very, very careful.

JUERGEN: Yeah, and now it's the opposite. I shoot
a lot because I don't want to create this one
decisive moment. Sometimes I even shoot with two
cameras at once.

CORY: Do you find it nerve-racking to pick out the best
picture?

JUERGEN: It's really tough. I spend a lot of
time editing in my studio. Sometimes it's
heartbreaking.

CORY: And do you re-edit your old work?

JUERGEN: The first time I re-edited was with Nirvana.

CORY: Those are such great pictures. Who asked you to do
them?

JUERGEN: It was for *Details* in 1991. They said,
"There's this band, they're going to be huge in
America. They've got long hair, ripped jeans . . .
they're called Nirvana. Do you want to go on
tour with them in Germany?"

CORY: What did you think of them so close to the
beginning?

JUERGEN: I went with them on the tour bus and
stayed in the same hotels. And there was this
journalist along too. The first time I heard
them play, it really was mind-blowing. But I was
very shy at the time, and Kurt himself was quite
introverted. And I felt so stupid being with that
journalist—he just nagged them, he was always on
top of them. The band had to do interviews with
the local reporters in each city. The photographers
would come in and say, "Do this, stand there . . . "
I just stayed in a corner. By the end, I was
thinking, "Fuck, I haven't done any pictures yet."
[Laughs.] I just felt it wasn't the right thing to
do, with all these aggressive people around. But I
was able to do them at the end.

CORY: And you re-edited those pictures after Kurt died?

JUERGEN: Yeah, with the whole weight of history
behind them.

Stephen Shore, Merced River, Yosemite
National Park, California, August 13, 1979 (top)

Stephen Shore, Country Club Road, Tucson,
Arizona, December 7, 1976(bottom)

STEPHEN SHORE
with Peter Halley

April/May 2000

PETER: I actually briefly met you once in the '70s. A
friend and I were walking down Lexington Avenue, and
you were there handing out leaflets—the leaflet was a
satire on the possibility of a Soviet attack on the US.
STEPHEN: It's possible. [Laughs.] I did a number of
projects at that time like that. In about 1970 I
did a series of postcards in Amarillo. They were
the ten highlights of Amarillo—the main street,
which is Polk Street, the tallest building, the
civic center, the hospital. And then more local
highlights, like Doug's Barbecue, which was the
best place to get barbecued beef. I thought what
the New York art world wanted more than anything
was postcards from Amarillo, Texas. I got
Wittenborn to agree to sell them and had 56,000
printed.
PETER: Do you still have some?
STEPHEN: I still have some.
PETER: Oh, good.
STEPHEN: And I miscalculated, and no one was
interested in them. [Laughs.] But the backs
of the cards didn't give the name of the town.
It just would say "Polk Street" or "Doug's
Barbecue." So when I did all these trips across
the country, I'd go to postcard racks in various
towns and stuff them full of these cards.
PETER: That's fantastic. I do want to go over your early
years. Can you tell me a little bit about growing up in
New York?
STEPHEN: Well, I actually started doing darkroom
work before I was interested in taking pictures.
An uncle of mine gave me a darkroom set for
my sixth birthday. He thought it was something
that a kid might like. I did, and I developed
pictures, just my family's snapshots, in my
bathroom at home.
PETER: The pictures were black-and-white, I'd assume.
STEPHEN: Yes. I immediately fell in love with it
and got my first 35-millimeter camera when I was
eight or nine. Our upstairs neighbor was a very
smart man. For my tenth birthday he gave me a
copy of American Photographs by Walker Evans. So
one of my earliest influences was Walker Evans.
PETER: My great-uncle had a copy of Albers's Interaction
of Color, which I saw when I was about fifteen. I guess
these things can change your life.
STEPHEN: Yes. I mean, I could have gotten anything.
PETER: What about your meeting Edward Steichen?
STEPHEN: I was about fourteen, and I think I just
didn't know any better. I called him up, and I
said, "I'd like to come and show you my work." It

was as simple as that. Maybe if I was older, he
would have hedged a bit.
PETER: What did you take pictures of when you were
fourteen?
STEPHEN: Oh, mostly of people around the city.
They weren't very good. But he got three for the
museum.
PETER: This being the Museum of Modern Art.
STEPHEN: Yes.
PETER: Later on, you ended up photographing Warhol's
Factory. Your parents must have been worried.
STEPHEN: I think they gave up on me by that point.
But I had parties at our house. Andy would come,
and my mother befriended Nico. I think the
combination of giving up on me and at the same
time having these celebrities come to the house
somehow, if it didn't make it okay, made it
acceptable.
PETER: And you were only sixteen or seventeen at the
time?
STEPHEN: Seventeen, yeah. I essentially stopped
going to school my senior year in high school.
PETER: I think more than any photographer of your
generation, you reinvented photography in the '70s. I
mean, in the '80s, we have another kind of photography,
the kind that we see in Cindy Sherman or Richard Prince
or Sherrie Levine. But today in Germany, there's a
whole generation of photographers influenced by your
work. And in the US, there's so much photography based
on the snapshot. You introduced color and pioneered
certain sociological concerns.
STEPHEN: Mm-hmm.
PETER: Some writers have talked about Ed Ruscha being an
influence on your work.
STEPHEN: I guess the first time I saw Ruscha was
when I was laying out my work in the Warhol
Stockholm catalogue. Kasper König was involved
in that, and he said, "I have this incredible
thing to show you," and he stretched out "Sunset
Strip" on the floor. That must have been in '68.
Then I became more and more interested in color.
I had been collecting postcards, collecting
snapshots. Then, as these things happen, a very
stupid, ordinary event occurred. I met a guy
at a party, and he was interested that I was a
photographer and wanted to see my work. I took
him back to my apartment, and when I opened the
box, he said, "Oh, they're black-and-white." And
that just sort of hit me, that here was this guy,
a smart, ordinary, New York human being, who just
expected that my work was going to be in color.
And coupled with my interest in postcards, I just
said, "Okay, this is something I have to pursue."
PETER: It was that simple.
STEPHEN: I got this wonderful little camera called
the Rollei 35, which I guess was the predecessor
of the modern point-and-shoot cameras, and
decided just to get in the car and go across
the country. Within a couple of days I realized
that the ideas I'd had sitting in my apartment
in New York had nothing to do with what I was
encountering, and what I was encountering was
just amazing. So I started photographing every
bed I slept in, every toilet I peed in, every
meal I ate, and every person I met, and then I
photographed streets, buildings . . .

MARK BORTHWICK with Neville Wakefield

September/October 2002

NEVILLE: Your photography flirts with the fashion context, but it's not the whole of your work.

MARK: I still consider myself a fashion photographer. I'm interested in using fashion as an instrument to find another way to create an image.

NEVILLE: When it comes to making new work, what's the motivation?

MARK: Life in general. On the one hand, I'll walk into my office at home and find inspiration among the chaos. Generally, I just thrive on that chaos. But when there's too much stuff going on, I move to an empty space outside.

NEVILLE: Are you seeking order out of chaos?

MARK: Yeah. I enjoy that. I initiate the struggle. I have to find the solitude, the simplicity within the chaos.

NEVILLE: To achieve simplicity, you isolate things—you misplace and displace them.

MARK: I haven't figured out where things belong. I'm dyslexic, so everything really does belong elsewhere. I definitely feel misplaced myself.

NEVILLE: There's a kind of absurdity that you introduce into the mix . . . you photograph clothing draped on a chair, on the floor.

MARK: In a way, that's where clothing belongs. I shoot all the time. I record our lives—my wife, Maria, the kids, the chaos that I live in at home. For practice, I allow myself to take one photograph of my son, Joey, on the way to school and one on the way back. I have all these little rules I give myself . . . unless it's a piece of furniture, and then I'm allowed to do whatever I want with it.

NEVILLE: What do the other parents think, seeing you take a chair for a walk in Brooklyn?

MARK: It gives me a good reason to sit down, order a coffee, and have something to write about. You know, I take what I do quite seriously, yet on the other hand I have to laugh at it.

NEVILLE: This has been your routine for some time now, hasn't it?

MARK: It's a practice I put myself through every day. I really force myself. And I'm allowed to take one photograph of something I've never photographed before. So in the middle of every roll of film there's always a misplaced photograph, something that doesn't belong to me yet. Those are the photographs that help me find where to go next.

NEVILLE: It's the architecture of the prosaic, the unnoticed. You also depend on repetition.

MARK: I've photographed the same windowsill every single day since we've lived on Wyckoff Street in Brooklyn. I take two or three photographs of it, never touching it, just leaving everything as it is—Joey's toys along with other things in accidental layers. It always becomes decorated, because it's right in the corner of our bedroom where we sleep.

NEVILLE: What were you doing when you made the series of advertising proposals for Prada, Armani, and all the rest? You placed the company logos on different photographs of sidewalks that you've taken.

MARK: I was just trying to show how unimportant they've become—that they're all the same. It all comes from the same source. They place so much weight on their image, but they tend to lose their identities anyway. The same photographer who shoots for Gucci this season will shoot for Prada the next.

NEVILLE: Why do you take pictures of displaced clothing?

MARK: It's a reaction to the way magazines try to control the way you apply clothing to your body. But clothing belongs in so many places other than the body.

NEVILLE: Like the washing machine.

MARK: Clothes really do belong in-between. I'm interested in putting things where they don't belong, in hiding things. Say I photograph Joey hidden behind a sofa. I know that Joey's there, but nobody else who looks at the photograph knows that.

NEVILLE: Doesn't it make the image a secret? You're either in on it or you're not.

MARK: I wonder if it's just that life's full of secrets, secrets that you keep from others.

NEVILLE: Are you asking us to look at what's not there?

MARK: I'm inspired by this idea of absence—it could be nothingness or just the idea of stillness. It's about slowing down time. If you hide something in a photograph, you create stillness.

NEVILLE: What was it like photographing Erin O'Connor for *index*? You've worked with her before.

MARK: The most interesting thing happened. I sat her down in a chair I had borrowed, and I started photographing her from behind. I turned around, and there were bits of weeds and little nicely arranged things lying on the pavement. So I started photographing that stuff. Since Erin had her back to me, she didn't see what was going on. I disappeared.

NEVILLE: So you described her absence.

MARK: That's dangerous, isn't it? I'm trying to practice taking everything away. I'd like to just let the image be what it is—not have any references whatsoever.

NEVILLE: Most people's lives are so full of white noise that it's very hard . . . nothingness requires a certain amount of contemplation.

MARK: Yes, but nothingness can give off signals, signals from things we see every day and we ignore.

NEVILLE: Does it matter, then, what you're photographing?

MARK: No. I'm against the idea of giving too much importance to the image. That's why I have a big problem with the idea of showing my work in galleries. Galleries create this monumental idea of the framework and the mounting and the importance of hanging something on the wall. That's fine for them but not for me.

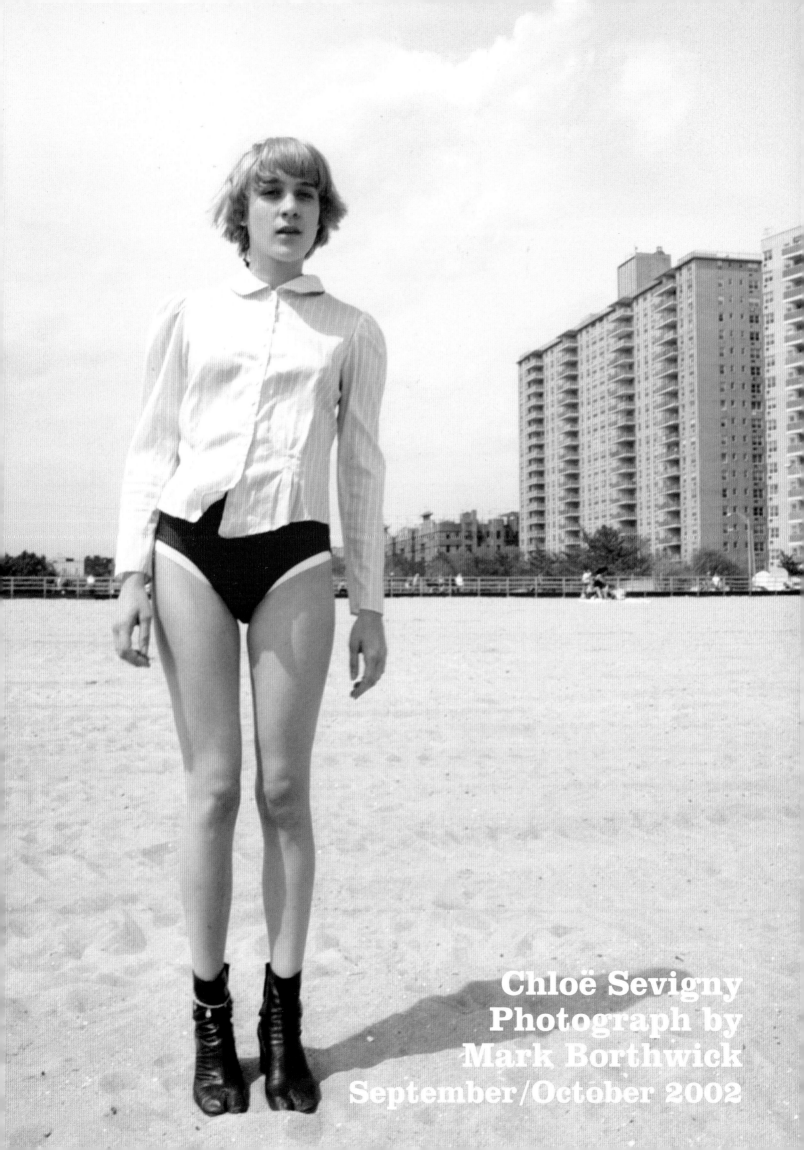

Chloë Sevigny
Photograph by
Mark Borthwick
September/October 2002

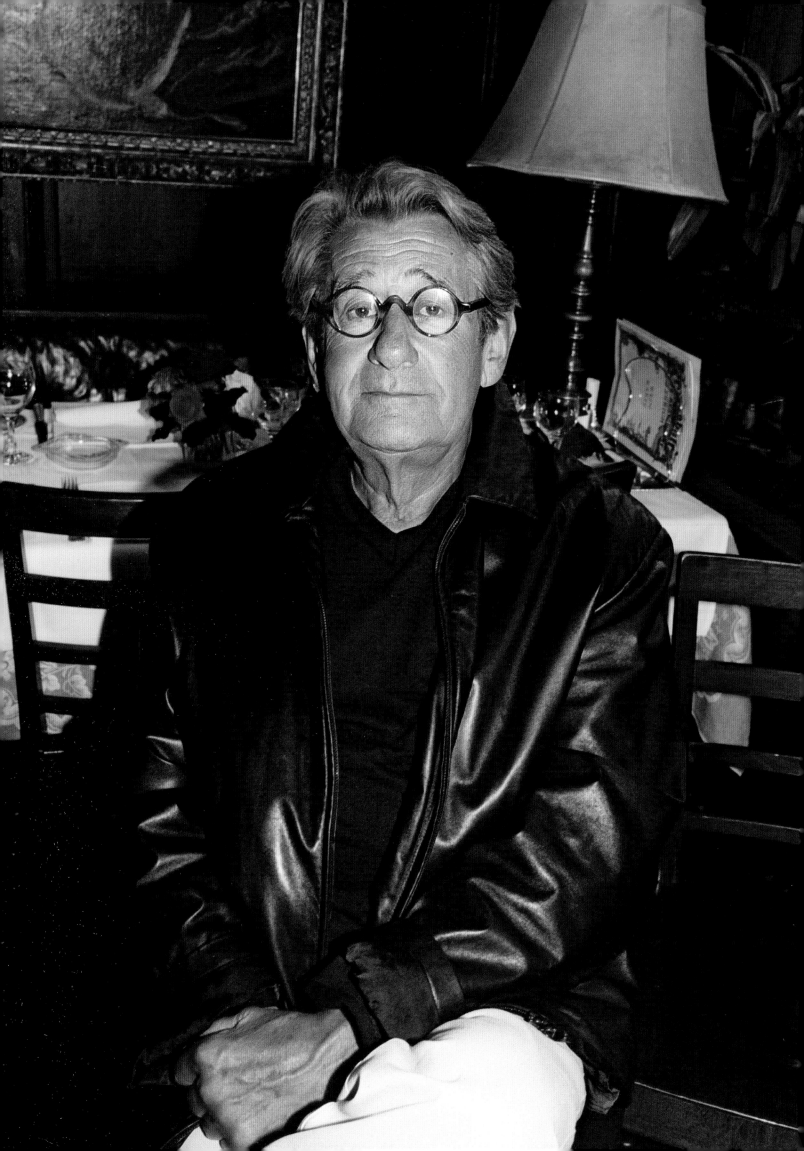

HELMUT NEWTON
with Leeta Harding

**Photographed in Zurich by Leeta Harding
September/October 2001**

LEETA: What's your favorite magazine?

HELMUT: It's called *Housewives in Bondage*. It's a porno magazine that used to be for sale in Los Angeles. I don't know whether it still exists, but it had very good content.

LEETA: Did you shoot for them?

HELMUT: Unfortunately, no.

LEETA: But you did shoot for *Playboy*.

HELMUT: Oh, yes, I was a contributor for nineteen years. Now I think my work may be too kinky for *Playboy*. They're nice people, very generous and understanding. My relationship with them was always quite good. But the man in charge in Chicago once wrote me a very formal letter, saying, "Helmut, you haven't worked for us for such a long time. Do something for us . . . but nothing as kinky as what you do for French *Vogue*."

LEETA: You once wrote that American *Vogue* in the '70s was quite daring to publish your photographs.

HELMUT: Yeah, Alex Liberman was great.

LEETA: He must have been.

HELMUT: Dangerous. We all feared him.

LEETA: Why? Was he a dictator?

HELMUT: The worst was when you were called into his office, and he started off by saying, "Dear friend." Then you knew you were up shit creek without a paddle. He was a great man.

LEETA: Did he always publish everything you sent him?

HELMUT: Oh, no. He would put all the photos up on the board, enough for ten pages. Then he would publish four and a half. I would ask, what happened? And he would say, "You've got to stay flexible, Helmut."

LEETA: Which magazine first published your work?

HELMUT: I started in the early '50s with Australian *Vogue*. Some of that work is in a book called *Pages from the Glossies*, which traces my fashion photography from Australia to the late '90s.

LEETA: Flipping through it, you really get a sense of the consistency in your work—from beginning to end, it's all strong. Do you follow any of the new magazines?

HELMUT: Well, there's the *Purple* thing, and *Dazed & Confused*. They all ask me to contribute, but I just feel that those pages should be filled by young people, not by old geezers like me.

LEETA: And do you like the work of any of these young photographers?

HELMUT: Terry Richardson. I can see what he's after. Some time ago I thought what he did was shocking for shocking's sake. I find that sort of thing a little bit boring. But now I can see he's got a certain handwriting that comes through.

LEETA: I usually feel that there's some sort of narrative going on in your pictures.

HELMUT: Alex Liberman once said something that I liked very much: "Helmut's pictures are like a story that has no beginning, no middle, and no end. You don't know how it fits together, but it's got a story."

LEETA: That's it exactly. Also, the women in your photographs always seem to possess a strong spirit. In a lot of other fashion photography, the models look so out of it and withdrawn.

HELMUT: I don't like using girls who are already very famous. That way they don't have a routine—which I prefer.

LEETA: What do you generally look for when you choose a girl?

HELMUT: It depends—my tastes change with the times. Every decade women's bodies seem to be different. I remember when I first came to Paris in '56 or '57, all the models in the haute couture houses were little. They were five-foot-six… and they were all French. Now you look at a French girl, and she's like an American girl. It has to do with what they eat, working out, going jogging, bicycling. There's an American influence on everything. Everybody looks the same around the world—sneakers and jeans.

LEETA: I don't think that's going to change anytime soon.

HELMUT: Then there was a time, in the early '60s, when women had no waist. Remember the sack and the A-line dress? Before that, when I was in Australia in the '50s, if a girl could wear a dog collar as a belt, that was the ultimate. Then you got the Twiggies. You know who Twiggy is, don't you?

LEETA: Yes, the original waif.

HELMUT: And then the big Swedish, German, and American girls came on the scene in the '80s. They were built like truck drivers, which is a look that I like. It was the heyday of the supermodels like Cindy Crawford—Cindy had a great quality. Then it went back to this kind of zonked-out, anorexic girl in the early '90s.

LEETA: A lot of photographers in the '90s copied your style, using hard flash, hotel rooms, cars, even dogs.

HELMUT: I'll tell you something. I'm touched if I can influence young people. I was influenced by Brassaï, by Erich Salomon—they're the people I admired when I was very young. In fact, I still think there's some Brassaï in my photography—which is a good thing. But what really pisses me off is when famous photographers do it. I'm not mentioning names, but I'm thinking of a Versace campaign. You know the photo of the woman with the garters?

LEETA: You mean Steven Meisel?

HELMUT: Mind you, he's a very good photographer. But it's a dumb way to work. I grew up in the Bauhaus period; I looked at Maholy-Nagy, Cartier-Bresson, and Brassaï. Look, young people have got to start somewhere.

LEETA: The Bauhaus people loved abstract shadows and sharp angles . . .

HELMUT: They all photographed from their balconies, and I still do the same. Which means that you either look down or you look up. And everybody photographed chimney stacks on the diagonal after Rodchenko—I think he was the first to do it.

LEETA: You're really a child of European modernism.

HELMUT: Yeah. The first picture I ever took was of a fountain in Berlin. I was twelve years old. And what did I do? It wasn't straight, it was diagonal, because I had seen all these diagonal pictures!

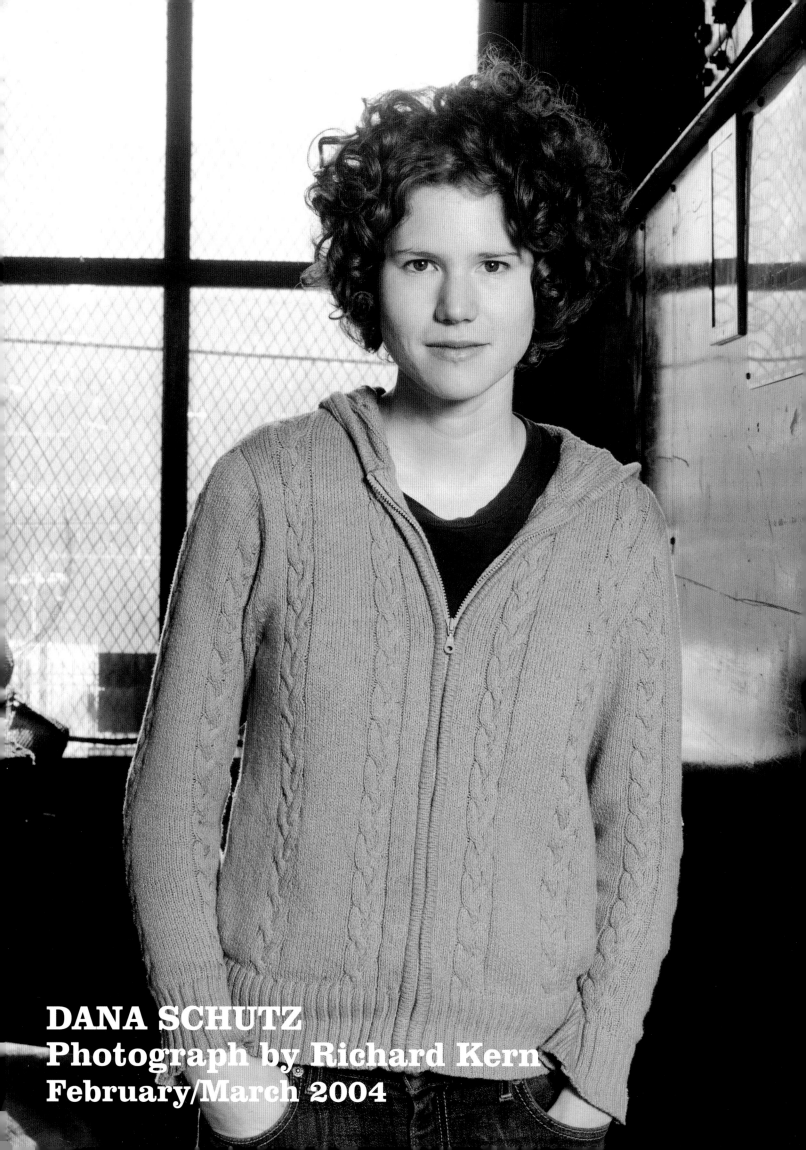

DANA SCHUTZ
Photograph by Richard Kern
February/March 2004

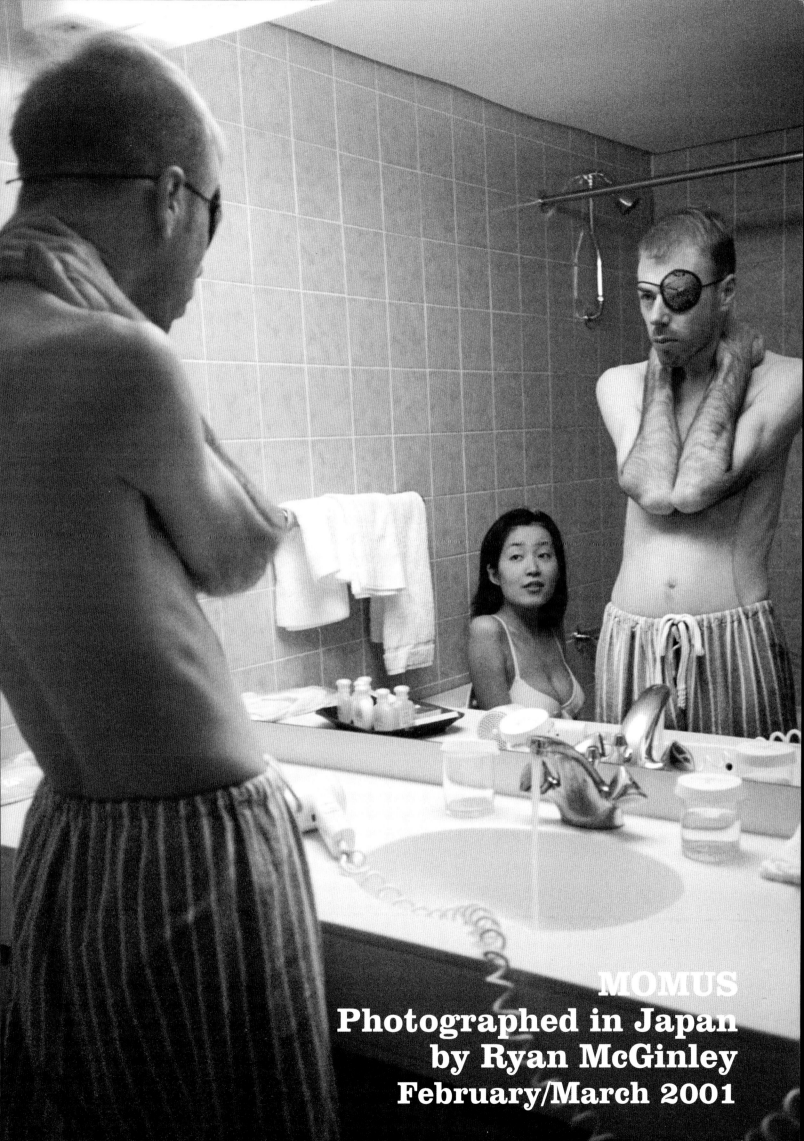

MOMUS
Photographed in Japan
by Ryan McGinley
February/March 2001

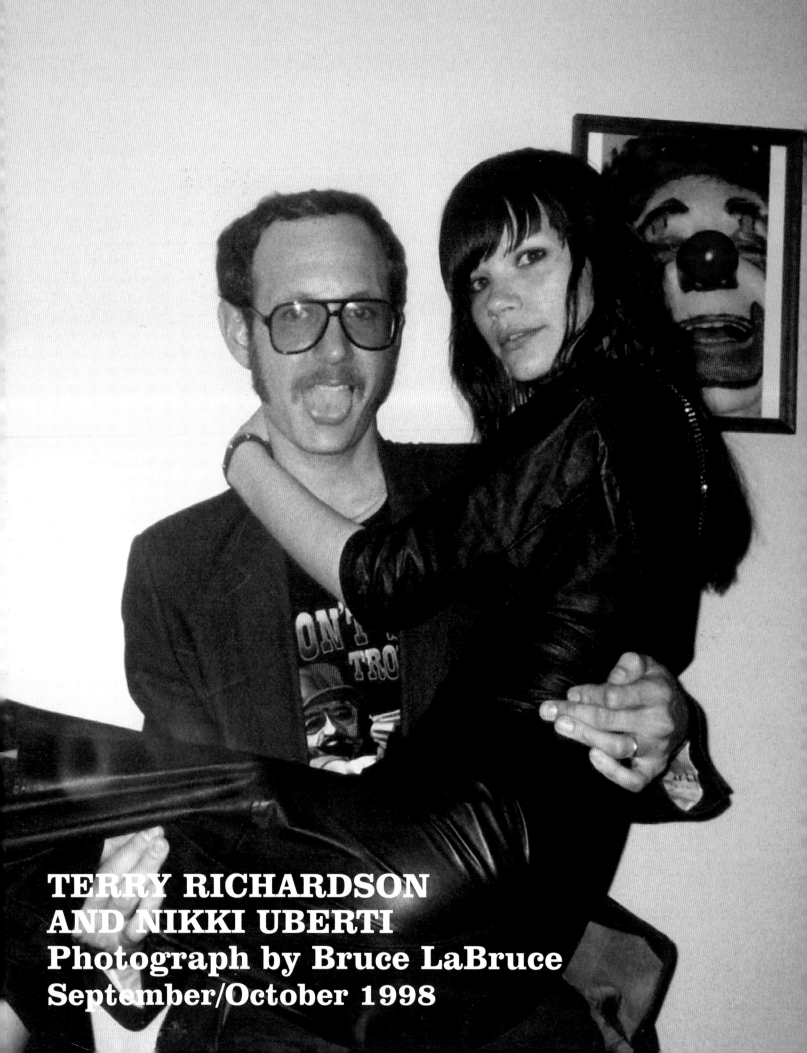

**TERRY RICHARDSON
AND NIKKI UBERTI
Photograph by Bruce LaBruce
September/October 1998**

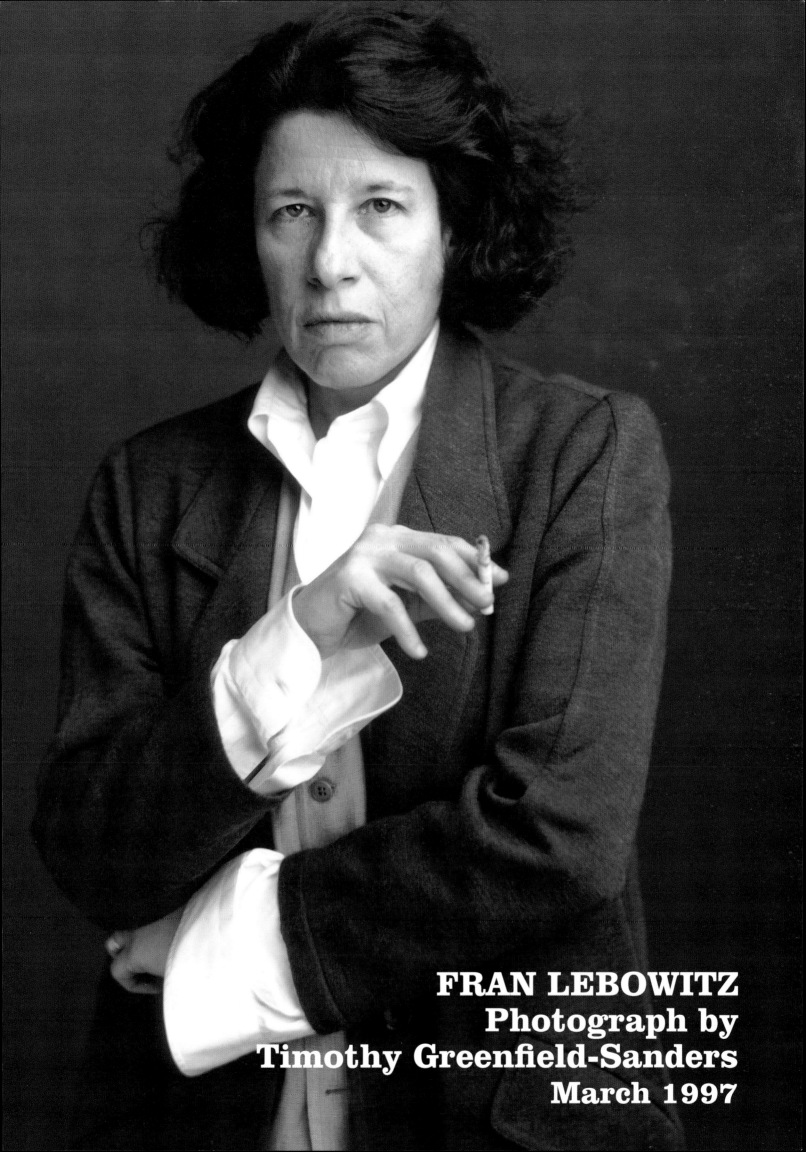

FRAN LEBOWITZ
Photograph by
Timothy Greenfield-Sanders
March 1997

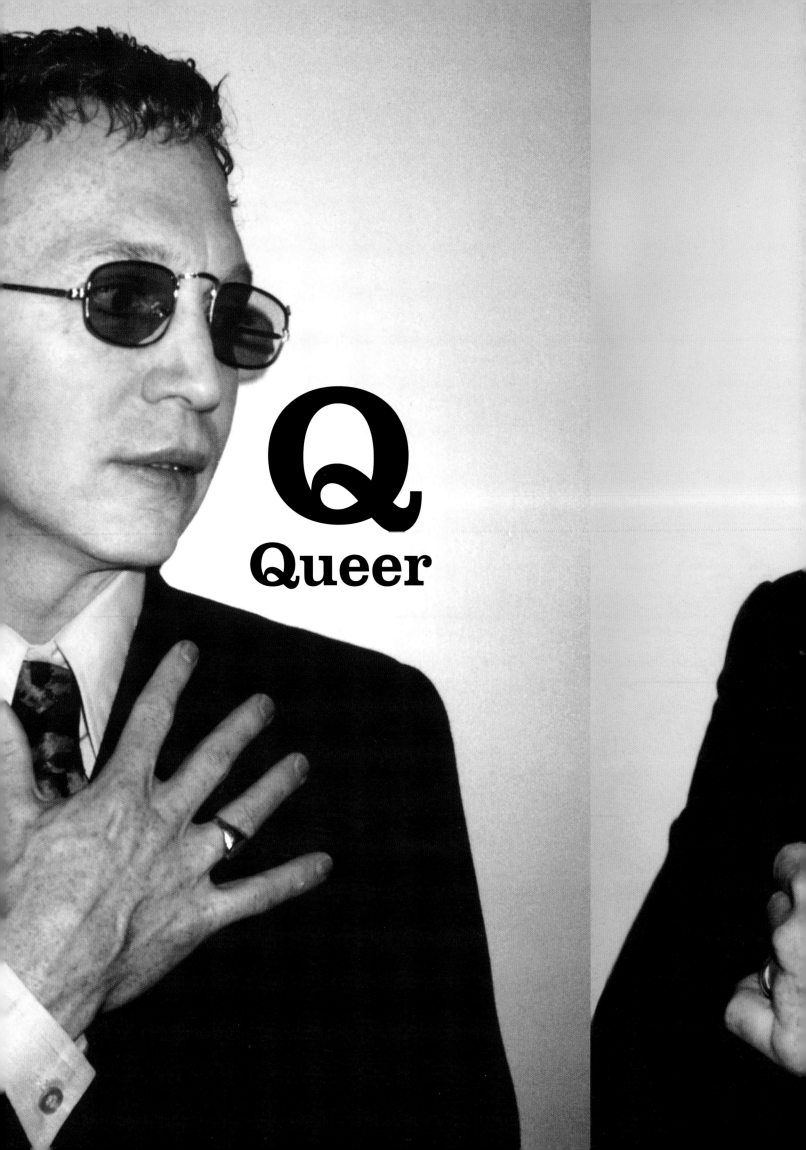

Q
Queer

BRUCE LaBRUCE
with Steve Lafreniere

Photograph by Alan Belcher
May / June 1997

STEVE: I've followed the actor and model Tony Ward since the mid-'80s, when he was in all the homo skin magazines. And then, boom, he's suddenly dating Madonna. What was he like on the set of your film *Hustler White*?

BRUCE: I didn't realize that he was totally junked out the whole time. *Hustler White* was shot in only twelve days, and he was there for eight. I'd only met him the week before, so I didn't know him that well. Actually, the worst problem was the very first day of shooting. We were waiting for him to show up, and he was two hours late or something. We were, like, oh, well, we're not gonna be able to use him; we're gonna have to recast. But it turned out he was just lost. So he was somewhat spaced out getting to locations throughout, but once he was there, he was totally on and engaged and enthusiastic. He got exactly what we were doing.

STEVE: He's cinemagenic for sure. There's something slightly going-to-seed about him that gives him a meatier presence in the film than, say, the porn stars in the cast.

BRUCE: We encouraged him to change his lines and improvise so that he could incorporate his own story. After the film premiered at Sundance, he got a lot of offers. For a Sundance audience, that's obviously what they would get from Tony—potential star material. But I think the amount of exposure and attention was kind of overwhelming for him. It probably drove him further into his drug world. But then he sort of pulled back and realized he would have to get clear if he wanted to take advantage of this. Now he's in AA and NA and whatever other A's there are.

STEVE: Does he ever talk to Madonna?

BRUCE: Um, we got him to ask her for money to finance the film before we shot it. So he gave her copies of my first two movies, plus the script for *Hustler White*.

STEVE: Did you get a response?

BRUCE: She said she liked the movies, thought they were funny, but she couldn't be associated with pornography. This was after her whole re-invention as the boring matron. Later, after she'd seen *Hustler White*, I talked to Tony and asked him what she'd thought about it. She said—about me—that she could tell I was a real egomaniac. And then she called me a twerp.

STEVE: Twerp! You can use that on your next movie poster. I heard Kevin Costner gagged on it too.

BRUCE: Oh, right. The *New York Post* reported an incident where he tried to go see *Bound* at the Sunset Five in Los Angeles, and it was sold out. So he asked the woman at the ticket booth, "What's this other film you're showing, *Hustler White*?" and she said, "It's an underground gay hard-core art film." And he said, "Oh, that sounds interesting." He went in and apparently was making loud comments all the way through and left before it was over, saying, "This is too hard-core for me!"

RUSSELL: When you began making photographic portraits, were you consciously setting out to represent a gay and lesbian community?

CATHERINE: My investment in the community is very important to my work. In fact, I probably wouldn't have done the work if I hadn't felt that I didn't like the way my community was being represented in the world. I grew up in Sandusky, Ohio, and when I was thirteen moved to Rancho Bernardo in California, which is a master-planned community. I left there at eighteen to go to San Francisco. The underlying basis of all my work has been the structure of urban and suburban space, and how communities begin to form. I'm curious about the way family begins to be defined within community. In a suburban community, the family is defined by the individual house. In the gay and lesbian SM community, family is defined by people who get together on holidays and who are close friends. My work is always close to home. It's always about my surroundings and the way that I wander through the world.

themselves that I end up capturing.

RUSSELL: Is the usual reaction very positive?

CATHERINE: Yeah. I mean, with Mike and Sky—the fact that the Whitney Museum owns their portrait blows them away. Mike and Sky are, like, "Can we go to the Whitney, and can we ask to see our portrait?" They were among the first in the community to start taking hormones to become men, so they're really important icons. It means a lot to them that their likeness has been recorded and that they are in a museum.

RUSSELL: That seems to echo your own double interest in formal issues and documentation. On one hand, there's the formal beauty of the portrait, but at the same time it has a broader representative value because it's in this New York museum, representing not just them but a community as well.

CATHERINE: Yeah, they think of it as very valuable. It's something that has been a really great thing for the community. There's also a certain pride that I'm one of the first out leather people to make it into the mainstream art world. But some

CATHERINE OPIE with Russell Ferguson April 1996

RUSSELL: On one level, your standardized portrait formats evoke early twentieth-century social survey photographers like August Sander. But because your portraits all have brightly colored backgrounds, you don't have the environmental clues in the background. It's a much more iconic presentation.

CATHERINE: To photograph the people in their own environments would have been too much like documentary photography for me. I was thinking about Hans Holbein and the way that he used color behind his subjects. Formally, it can bring out all these different shapes within the body, to make them pop. It is a way to take the people out of their environments and isolate them, because the art is really what they're doing with their bodies. It also makes the focus really on the person. I was also getting really tired of how the various magazines that were coming out were dealing with body modification. Nobody cared about the people, and nobody had any formal concerns. It was all just to document it in very basic ways, like the nipple with the ring going through it and the penis with whatever. The representation was just all fragmented. It was all about the body, but I wanted it to be about the person as well.

RUSSELL: Do you give your subjects a lot of latitude in how they present themselves in the portraits?

CATHERINE: With the clothing, a lot of latitude. They wear whatever. Unless it's a drag queen, and then we talk about the outfit. Once they are in the studio, though, they are completely manipulated by me. Even though I don't believe that there is a true essence of a person, I do believe there is something they see within

of my friends can't live with the portraits I do of them. They're too intense. First of all, they've never seen a sixteen-by-twenty color photograph of themselves. A lot of my friends have never even been into a museum. I was the one who left the community. I chose not to be a full-time leather dyke like most of them did, so there are a lot of different dialogues that go on. I make the work that I want to make, but I think that, to a certain extent, the community is still not part of the dialogue of what happens to the work. After it's made, it takes on a life of its own. I have had to have very intensive talks with some of my dyke friends about what it means for a heterosexual man who works for Disney to own photographs of them. We've had a lot of dialogue about that. And I've had to think about it as well. I think it's a great thing. The way that it has opened up is really incredible. But the community is so self-protective, for obvious reasons.

RUSSELL: I want to ask about the self-portraits.

CATHERINE: I thought it was important, if I was going to document my community, to document myself within that community. But I didn't ever want to just do a portrait of me as Cathy, because it just wasn't what I was interested in, just sitting in front of the camera. The first one was really out of losing a relationship, of breaking up after I finally thought I was going to have a home. I had really desired that, and that's where the cutting on my back of the two stick-figure girls came from, and also the child-like drawing. I had kind of a great childhood, but also a really awful childhood. I drew that cartoon for about a year before I made the photograph. It says a lot of different things. One of them is that I have my back to you. And in *Pervert*, my head is covered.

D.C. STRIPPERS
BY RICHARD WANG
February/March 2004

Photograph by Richard Kern

There are two main gay strip bars in D.C. One is called La Cage, where my friend Charles told me the guys are naked with hard-ons and they jerk off and finger their butt holes on occasion. Our friend Danny confirmed the fingering rumor and claimed that the last time he was there, you could even SMELL the butt hole in the atmosphere. The other choice was Wet, which was noted for its "college nite," and the fact that it has a mirrored-shower tableau at the end of its horseshoe-shaped bar/stage. We decided to go to Wet, because I wasn't quite ready for the smell of butt holes.

Wet is in an old warehouse district, next to D.C.'s most popular gay club, Nation. I thought there would be a lot of old men in suits leering, like in the opening sequence of *Faster, Pussycat! Kill! Kill!* but there were just a few. Mostly there were bland, college-type guys standing on the sidelines nursing Rolling Rocks. There were even a couple of girls! As for the "stripping," it turned out to be a total fake-out! Some of the so-called strippers came out nude from the very beginning! The first thing I saw was some naked guy—whom we would later dub Flopsy Mopsy due to his flaccid penis—swinging from a bar screwed into the ceiling. Flopsy took a big backswing and, like a trapeze artist, straightened out his legs *en pointe* for the swing forward, then BAM! He ended up kicking a patron in the head! Suddenly all my fears were gone—this was FUN! The guy moved away from the bar after getting kicked (even though I saw the bartender comp him a drink), and I took his place at the end of the horseshoe.

I had a few drinks and was having a real good time! We each chose our stripper boyfriends. Mine was Red Hat, because that's all he was wearing. Red Hat's thing was that he was a tease, smiled a lot, and played games with you. While Flopsy was flopping himself on John Sanchez's head, I had my intimate encounter with Red. He swung out on the bar and didn't kick me in the head but landed his sweat-socked foot on my shoulder. When he got both feet planted back on the bar, I reached to stuff a well-earned dollar bill into his sock, but he pulled away! Each time I reached, he moved

his leg somewhere else in a playful tease. Obviously, it was a sign. He wouldn't even take my money, which equals true love! Then he leaned in and whispered, "I'll be back!" I swooned as I watched Red run to the other side of the horseshoe and shake it for some screaming girls. Except, hey! What about me?! I even noticed him getting a boner over there, so I decided to exercise my rights over my new stripper boyfriend and reel him in. Literally! Never in a million years could I have imagined myself using an invisible fishing rod to cast across the bar and snag a nude dancer. He played along and wriggled and fought as I mimed the cranking of the reel to get him back. And then the bubble burst, because I saw that he had lost his boner! What a fake! And to think we almost had it all . . .

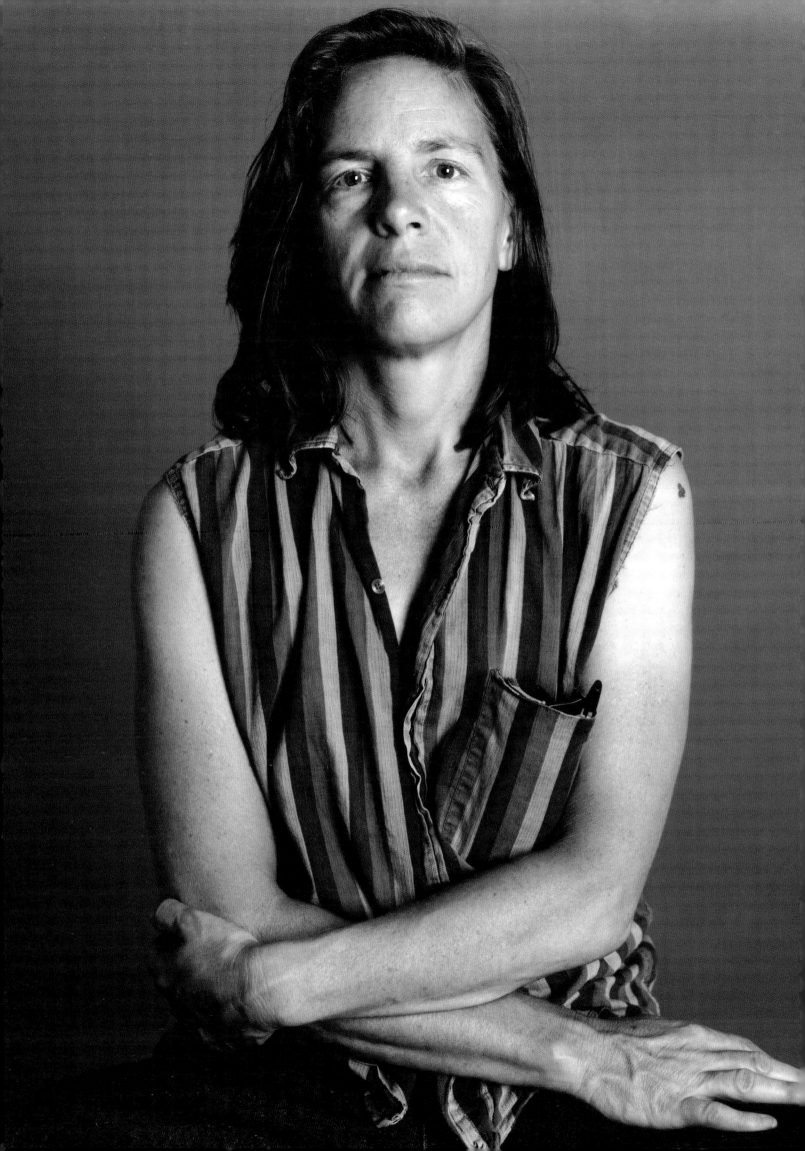

EILEEN MYLES
with Amy Kellner

Photograph by Catherine Opie
January/February 1998

AMY: Social class is a big thing for you.
EILEEN: I come from an Irish-working-class-townie-in-greater-Boston reality. I went to the University of Massachusetts Boston, and we were constantly reminded during our education there that we were unique students for these teachers to be teaching, because they all went to Harvard, and we hadn't read James Joyce in high school. So we were very exciting because we knew so little.

AMY: That's not very encouraging!
EILEEN: It's how I learned about class. I went to college in the late '60s, and there was lot of political activity going on, but not at my school. We all worked in Filene's Basement, and there were a lot of Vietnam vets around. There was already a very checkered class worldview when I started to wake up and write and be more me.

AMY: And then you came to New York, where it's considered cool to be lower class.
EILEEN: Well, you get to New York, and you try to figure out who you could be. And I certainly figured out quickly that I could be an Irish working-class alcoholic who is a poet, which is what I was. But with more awareness. So there was no point in losing my Boston accent.

AMY: You do have a thick accent.
EILEEN: Once in a review of a performance in New York, it said that I had an "outer-borough" accent. Boston is quite an "outer borough."

AMY: Oh, sure. Boston, Queens—what's the difference?
EILEEN: They didn't hear the region; all they heard was the class. There's so much fantasy about class. I wrote this Kennedy poem, which starts out with this confessional mode, where this poor poet is suddenly coming out with her upper-class Boston background, and then slowly she reveals that she's a Kennedy. But what she uses that identity to do is to write a really political poem about homelessness and AIDS. I'd never taken on stuff like that in my poetry, because I just don't do that, but, as a Kennedy, I did. It was exciting to realize that, with a little bit of privilege, I could have a whole different position on politics. Since then I've been trying to figure out different ways that I could regain that privilege. And one of them was running for president.

AMY: Your running for president in 1992 began with that poem?
EILEEN: Yeah, I was moved by my own words. I recited that poem all over the place—and I thought how great it is to make a speech. I thought about speeches a lot. I had gotten into watching videotapes of demagogues, like Hitler, Mussolini, and Huey Long, and that lost art of speech making. There are all sorts of visual cues and dramatic pacing. One of the ways that Hitler gained power making speeches was that he would be really boring and be reciting details endlessly, then suddenly he would go into this staccato shrieking rage. You never knew when he was going to do that, and that's how he held the audience. So I wanted to figure out a way that I could give more speeches. Then, during the Gulf War in 1991, I went to India for a month, and I found myself in this odd situation of talking about what America was doing, and it was as if I was supposed to speak for America. So I came back to New York, and that's when Bush was making those talks about freedom of speech and blah, blah, blah. So I got this brilliant idea that I could keep doing the talking that I was doing and shape it completely politically, and be a poet making speeches and just colonize the political campaign—as a woman, as a lesbian, as a low-income artist, as a working-class American, as all the things I was—as representation, because there are many of us. So it was kind of a desire to be a hero, but in a pluralist way.

AMY: Like an anti-hero?
EILEEN: Mini-hero, serial-hero, big vulnerable, sloppy, masochistic hero.

AMY: You're a Sagittarius, which is the crusader for the underdog.
EILEEN: That is really true. Also, I'm a middle child, and we're always more likely to lead a rebellion than lead a country. There's something about me that's kind of empty or average, or at least that's what I was taught to think. So even in my grandiosity, it's an average grandiosity. I ran for president from that position.

AMY: I can see that in your writing too.
EILEEN: Yeah, even writing about sex. It's so much more fun to write about awkward, funny sex. A lot of lesbian erotic writing is just, like, we're these slick fish, so it's great to show a warped, funky kind of sex.

AMY: Are you part of any scene?
EILEEN: When I think about my life, it's not a dyke talking to a dyke talking to a dyke; it's more like a dyke talking to a fag talking to an older straight guy talking to a child. It's stronger for me that way. Like, if you wanted all your friends to be famous artists, that would be dazzling, but it would also be a disturbing, constant performance of all these egos flapping their wings.

AMY: You seem to like the young dyke punks, like Sister Spit.
EILEEN: There's a whole generation of girls that I am so blown away by. Sometimes I feel like it's my generation; it's just that they finally came around.

AMY: Well, we had role models like you.
EILEEN: Heh, heh, thank you.

AMY: You're moving to Provincetown. What's it like there?
EILEEN: Its mostly, like, dykes you don't want to meet, like with that short-side-long-back kind of hair.

AMY: Oh, yes. The Billy Ray Cyrus hairdo.
EILEEN: Yeah, it's swamped with all sorts of weird-looking homosexuals from all over America in the summer, but in the winter it's so great. It's got four million shades of gray; it just feels like a little Irish village. It's moody, and there's the water. It's beautiful if you like gray. I like gray a lot . . .

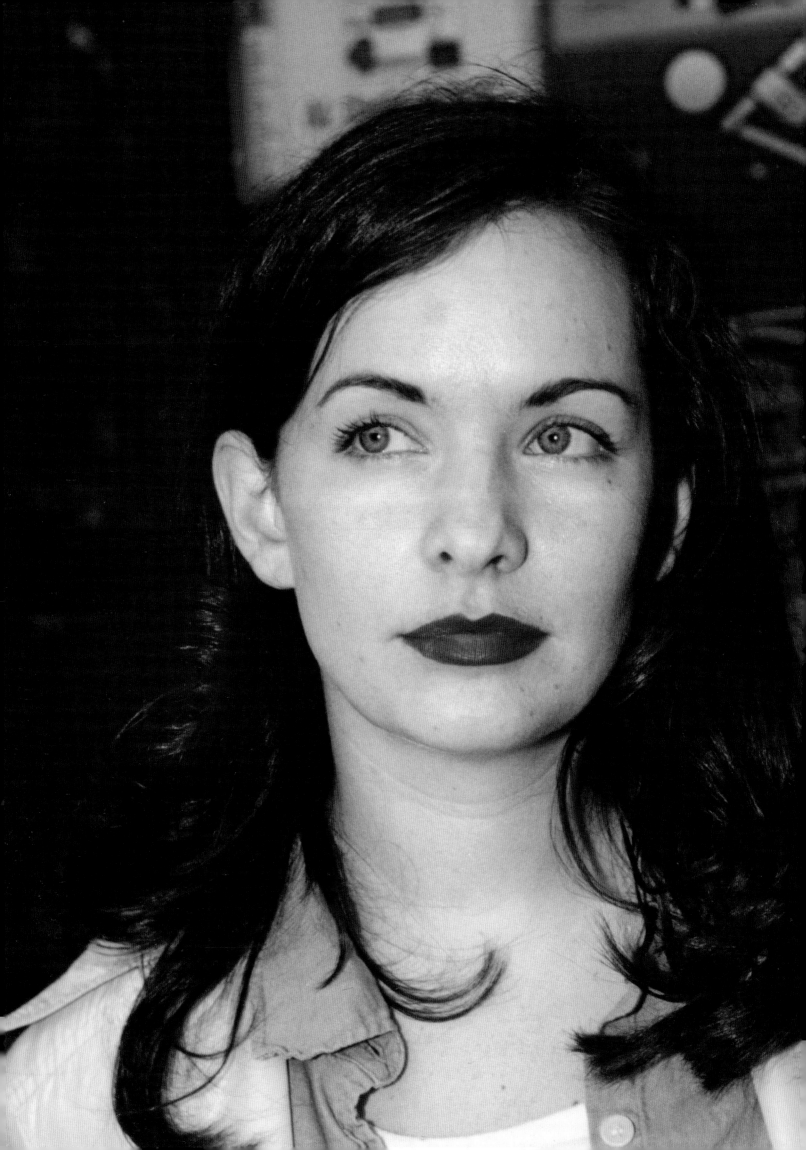

GUINEVERE TURNER with Ari Gold

Photograph by Tina Barney
September / October 1997

ARI: Do you have anything you want to say about your new movie, *Chasing Amy*?

GUIN: One of the interesting things about *Chasing Amy* is that it came out at the same time as the movie *All Over Me*. To me, *All Over Me*, while not a flawless movie, does capture something so real about being so young and queer and about being outside whatever is around you and trying to understand that and get power from it, and being strong enough to accept it and stand up with it and for it. And at the same time, *Chasing Amy* comes out, which is—no matter what else you want to say about it—one heterosexual man's idea of what lesbian sexuality is. And it's so ironic, but the world has embraced *Chasing Amy* as emotional truth.

ARI: Yeah, the reviews are all, like, "the most truthful romantic comedy of the '90s!" I'm so glad you're saying this, because I'm upset that *Chasing Amy* is doing so much better, money-wise, than *All Over Me*.

GUIN: Janet Maslin in the *New York Times* compared them and said that *All Over Me* was self-indulgent, emotional tripe and that *Chasing Amy* really gets somewhere, like, how people interact with each other in emotions and relationships. It's just unfair to compare the movies. Call me angry and PC, but nobody even brings up the fact that *All Over Me* is a movie in which a lesbian is representing lesbians. And *Chasing Amy* is a straight man representing lesbians. Another thing about *Chasing Amy* that's tricky is that a lot of lesbians like it. Lesbians whose opinions I respect. I think that the relationship that actually does ring true in *Chasing Amy* is the relationship between the two men. It's very daring in the way that it shows two really good male friends—one being jealous of the other one who has a girlfriend. That's really gone unrepresented in film.

ARI: Yeah, I wanted to know how you felt about being used to publicize *Chasing Amy*. You're a friend of director Kevin Smith, and your movie *Go Fish* is cited as one of the filmmakers' influences.

GUIN: I don't even need to fully blame them for the way my name always comes up. People just know that I know them. But people have asked me if I had an affair with one of them. And I'm, like, "I am a slut, but I am actually a lesbian too!"

ARI: The main character finds it very easy to just give up her sexual identity for a man.

GUIN: But my defense to anyone who would say, "How could you be in that movie" is . . . have you ever not had a dime to your name, walk to the set of a movie, and have someone say, do you want to get paid to say this monologue? And what are you going to say? There are ongoing moral/political dilemmas that one faces being an actor, and, honestly, I've auditioned for way more offensive parts than that tiny part in *Chasing Amy*.

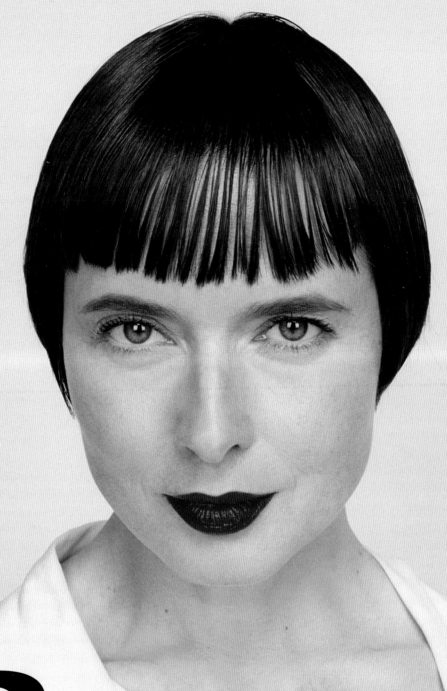

R
Royalty

ISABELLA ROSSELLINI with Peter Halley

Photograph by Terry Richardson
November/December 1999

PETER: I love your autobiography, *Some of Me.*

ISABELLA: Oh, really? Oh, thanks. That's very nice—especially from you.

PETER: So what was your starting point?

ISABELLA: Although it seems very random, the core of the book is the conflict of styles. For example, in talking about my parents, it isn't about how to be a good mother or a bad mother; it's more about what an actress does . . . what kinds of movies. Should they be commercial, or should they be artistic? And so I started writing down all the questions that I'm always asked and cannot answer. Because among those questions, the biggest ones are: What is beauty? What is style? [Laughs.]

PETER: Both your parents are European, and you grew up in Rome until you were nineteen. But since you've lived here for so long, I also consider you a New Yorker.

ISABELLA: I came here in '71. Can you imagine?

PETER: But reading *Some of Me*, it almost surprised me that you don't live in Paris or London. Why did you come here?

ISABELLA: To study English. Every European child is obsessed with learning English. So I came here, and I stayed. I think I like the American way. It's just as simple as that. Well, maybe I like the New York way.

PETER: When you arrived in '71, was it more the hippie New York or the glam New York?

ISABELLA: No, it was glam. It was that time. But I wasn't really part of that scene, because I was young and I felt foreign. It took me ten years to decide to stay. I kept on coming back and taking a little job, and then I would be nostalgic for Europe. So it took a long time to really commit. And what ultimately made me commit was my marriage to Martin Scorsese. In a way, when you marry, we girls think, this is home.

PETER: And what year was that?

ISABELLA: '79.

PETER: And you lived in Tribeca?

ISABELLA: Yes.

PETER: The reason I ask is that I live in Tribeca too. And maybe about seven years ago—did you have a dachshund?

ISABELLA: Yeah, I do. Ziggy. She's still alive.

PETER: Well, I also had a dachshund. And your housekeeper was out with your dachshund, and my housekeeper was out with mine, and your housekeeper propositioned my dachshund.

ISABELLA: [Laughs.] Oh, really?

PETER: It seems she felt that your dachshund wanted to have babies and wanted to know if Henry might be available. [Both laugh.] So then we called the vet and the vet said no, because he was afraid it would be bad for Henry's back.

ISABELLA: The poor thing. A missed opportunity.

PETER: So what's your favorite period in New York, culturally speaking?

ISABELLA: You know, I think I like this present time a lot.

PETER: It is kind of nice, isn't it?

ISABELLA: Yeah. Because in the '70s I was still integrating and coming in, and all the drug scenes out there at the time scared the hell out of me. I never really, thank God, fell for it—but just out of luck. Because I thought, like most people, that it was good for you to take some drugs. But I couldn't—I got sick.

PETER: You're one of those super-sensitive people.

ISABELLA: I'm just lucky. Now we all know that drugs are ultimately bad, but at the time it was not that clear. And I don't know if it was because I was young—Marty was ten years older than I, so I was around people who were older. And when you're twenty-six, twenty-seven and trying to be cool, you always feel your shortcomings.

PETER: There are some people who just don't like drugs, because they like reality the way it is.

ISABELLA: Whatever it was, it scared me. But then when I started modeling, it was pretty wonderful to discover New York . . . Nothing like a job to make you own a city.

PETER: And that's starting around '82 with *Vogue*?

ISABELLA: Yes. When I started with *Vogue*, the photographers became my friends, as well as the stylists and other models. All of a sudden, it wasn't my Italian friends who lived here, or Martin's friends; the fashion people were my own people. And that really rooted me.

PETER: I love how in tune you are with all your photographers over the years. So I was really excited about the opportunity to bring you together with Terry.

ISABELLA: But you know, Terry, I've been trying for so long . . . I'm so pleased.

PETER: Where have you seen his work?

ISABELLA: In magazines. I recognize people's work. I have a love for photographers, maybe the same as my love for directors. I can look at any magazine and tell you who's the photographer. It's like handwriting for me.

PETER: There's something else I think you just have to tell us about, which is your childhood back operation. You were in a painful cast for two years?

ISABELLA: Two years. Starting when I was eleven.

PETER: That must have affected you so much.

ISABELLA: It was a major thing in my life.

PETER: You had scoliosis. And the treatment was a painful body cast.

ISABELLA: First, a body cast to correct scoliosis. And then they took a bone from my leg, and they put it in my back, so I'm completely rigid. That's why I got the role of the queen in *The Impostors*—because of my posture. [Laughs.]

PETER: So that's your secret.

ISABELLA: That's the secret.

PETER: Spinal fusion leads to good posture.

ISABELLA: I get all these roles like the queen, as the one with dignity . . . [Laughs.]

WEDDING BELLS FOR JFK JR.
BY TINA LYONS
FEBRUARY 1996

I've always thought that once you reach, say, the age of twenty-eight, it's inappropriate—well, frankly, downright tacky—for a woman to insist upon a huge, expensive wedding. It's embarrassing. Half a dozen bridesmaids. An "antique" white Rolls or some such vehicle to ferry the couple. And perhaps the worst sin of bad taste: the ubiquitous, post-Diana, cathedral-length train. Ugh!

Now, I'll admit, I was only seventeen when Charles and Diana were married, and it was a moment of disillusionment in my life that ranks right up there with the resignation of Nixon. I would never be the queen; I was an Irish-Croatian-American Roman Catholic and, well, not a virgin. It wasn't that I was a Royalist. Indeed, I much preferred the Sex Pistols' version of "God Save the Queen" as a new wave teen. I think it's just a deep-seated thing for a lot of girls to want to be a princess. For me, I thought that if I were to become a princess, then maybe my mother would love me.

As the years passed and twenty-eight approached, I found I had absolutely no desire for a lavish wedding. My need to be the center of attention was being satisfied elsewhere. My two older sisters had already had their nuptials, and I promised my parents that if I were ever to marry, I planned on eloping to Las Vegas. Easier on them—and much more romantic. The impromptu plane flight, a bridal suite at Caesar's Palace, strolling through the casino in a hastily purchased dress. The sign at the Stardust (unfortunately, now ruined) twinkling in the distance. The only exception to this elopement would be if I were to marry John F. Kennedy Jr. After all, he's the American Catholic girl's version of a prince.

Mind you, I was raised with such impossibly high moral standards that my parents look down their noses at the Kennedy clan. It occurred to me that the Kennedys of Massachusetts, rich and famous as they are, might benefit from an association with the Lyonses of Connecticut, even if I am, perhaps, their most scandalous member. My family is old-fashioned, churchgoing, dirt-free, perfectly respectable. My paternal grandfather, with an eighth-grade education, invented some things and started a family business, for which his five sons have worked. He wasn't an ambassador, but he was not a bootlegger, either. Indeed, my grandfather was a teetotaler. My mother's father's first language was Serbo-Croatian, and he worked in a factory. My parents were Depression kids who had a slew of Baby Boomers. I was the fifth of six. I was in my mother's womb when John's father was assassinated.

I've spent my entire life preparing to live in the public eye, though I've never known what it was that would put me there. I reckoned I'd just be "a personality."

Well, I'm older now, and I have more altruistic desires. Friends have died of AIDS; I've survived brain cancer, and I've seen children dying of it. A few months ago, right around the time of the launching of *George*, there was a brouhaha about John's proposal to that girlfriend of his, Carolyn Whatever-her-name-was. I heard from an "insider" that he had indeed proposed, and she had turned him down. And I thought: how selfish! Okay, maybe watching paint dry is more stimulating than a conversation with John. Okay, you have to watch your back for paparazzi. Okay, chances are he'd cheat. So what! Think about what you could do for the disadvantaged with that money and that name. Poor as I am now, I give what I can, like most people, and I always thought that if I were in the world of the rich, I'd give silently, anonymously. But if I were a Kennedy, I'd use the name to its greatest advantage. I mean, that's the point of the whole gig right there; that interests me more than snagging "the sexiest man alive"—a sobriquet I find debatable anyway. I think that people who complain about how awful it is being famous should stop whining and do something useful. And when you're a Kennedy, you don't have to worry about the career maneuverings required of rock stars or aging actresses. You can concentrate on raising the kids—hey, John, I'll have as many as time will allow!—and working for the sick and the needy. Unlike that foolish Diana, I'd realize it's a job, not a fairy tale. I've sown enough wild oats. And although I would prefer not to be openly humiliated, I don't view infidelity as the end of the world. I would simply argue that discretion is key. All of this could be straightened out in the pre-nup.

Besides, I've always known how to throw a damn good party, if I may say so myself, and throwing a Kennedy wedding presents an amusing challenge. Aesthetically, it would have to be fairly timeless and understated. Nothing pretentious or trendy. Keep it light—after all, aren't big Irish weddings just another excuse for a drink or two? At the same time, the event could celebrate the establishment of the Lyons Kennedy Center for Pediatric Oncology at Memorial Sloan-Kettering. What in heaven's name would we need wedding gifts for? Sterling silver tea services just don't mean anything to me.

When: Fourth of July weekend, early evening. I've always preferred autumn weddings, but summer weather will hopefully allow for all those family boat races and tennis tournaments. My family is equally as sportif—and we outnumber them.

Besides, can't you just picture John in a white dinner jacket?

Where: The ceremony will take place at the Roman Catholic church in East Hampton, Most Holy Trinity. (John's maternal grandparents, "Black Jack" and Janet Lee Bouvier, were also married there.) A completely traditional ceremony with nothing remotely New Age or "personalized."

The Dress: Sleeveless, floor-length, with a bateau or scoop neckline, in a non-shiny, simple fabric such as linen with Celtic embroidery at the neckline. Opera-length cotton gloves with matching embroidery. No tulle, no ruffles, no Venetian lace, no sequins or beading. Something fresh and summery. I'd like to work on a custom dress with someone young, like Todd Oldham, Cynthia Rowley, or Badgley Mischka. But it must be simple and pretty; this is not a time for fashion "wit." Shoulder-length veil with Irish carrickmacross lace or fine Kenmare needlepoint edging. Hair by Frankie Payne of Los Angeles.

Something Blue: A note from John's late mother on her trademark blue stationery, tucked somewhere in the dress.

Who: This one's tricky. Our families combined could probably fill the church, and a "family only" policy makes things a bit easier. But I would've stuck my head in an oven long ago if it weren't for my friends. And the bottom line is, it's my wedding, so I guess we'd have to negotiate his family's guest list. My list gets priority.

Flowers: Montauk daisies, poppies for remembrance, violets for faithfulness, and lilies-of-the-valley (favorite flower of both our mothers). John will wear a sprig of lilies-of-the-valley in his jacket.

Reception: Since the marriage will take place in East Hampton, perhaps either John's Aunt Lee or sister, Caroline, will offer us her home (preferably whichever has the most beachfront). If this isn't possible, the Maidstone Club. Damask tablecloths, Waterford crystal (Lismore pattern), Wedgwood Napoleon Ivy china. Centerpieces of wild strawberry and blueberry plants, and beach plums—no flowers—created by Walter Barnett. Nautical flags at the entrance.

Security: I'll leave that up to them—after all, they know what's required. But I'll need a crash course as soon as possible.

Rings: A classic round solitaire engagement ring set in platinum from Tiffany & Co. (And I mean it when I say size isn't important to me.) As for the wedding bands, I wouldn't be insulted if John chose not to wear a band. Some guys don't like to wear rings. No biggie.

Maid/Matron of Honor: Quite honestly, I would prefer a Best Man—my brother Tom. Maybe John and

I could do a little gender switcheroo and have Tom and Caroline stand up for us.

Bridesmaids: I can't imagine anyone subjecting grown women to this—but it's fun for little girls. Our nieces would be perfect: Rose and Tatiana Schlossberg, Elizabeth and Michelle Serio, and Margaret Lyons. Little ballerina-length party dresses in red and white gingham taffeta with patent leather flats. Nosegays of daisies.

Groomsmen: Because they actually have a job to do (ushering), adults are needed here. John's domain. Boutonnieres: sprigs of green ivy.

Outside the Church: For my mother, the Stony Creek Connecticut Fife and Drum Corps. Mom loves them, and it adds a real Yankee Fourth of July touch.

Food: I know I want a casual summer buffet with a menu that incorporates local fish and produce, but beyond that, I put all culinary matters into the hands of my friend Susie Lish, private cook extraordinaire.

Music: Since I imagine Hole won't go over too well, I suppose we'll have to get one of those society bands, like Peter Duchin's, for the dinner segment of the evening. But once the cake is cut, DJ Dean Chachere of Houston is the only person I trust to spin for those of us who would rather not foxtrot the night away.

The Agreement Bottle: A bottle of whiskey or mead shared by the immediate families, an ancient Celtic tradition. A dry bargain was thought to be not as binding as a wet one.

The Cake: Again, this assignment goes to Susie. But we might as well make the most of the berry season.

My Gift to John: A traditional Irish gift—a pair of bracelets fashioned from my own hair. (I'll have to remember to get a good dye job.)

Gifts to Ushers: CML/JFK nautical-flag monogrammed cufflinks from Tiffany's.

Gifts to Bridesmaids: Antique claddagh rings from Galway.

Photographer: Albert Watson for the formal portraits; Ellen von Unwerth for the candids. The whole event should look like a staged fashion shoot, which, essentially, it is.

Honeymoon: First, a week of relaxation in Ireland, visiting his aunt, Ambassador Jean Smith. Then a couple of weeks working in Bosnian refugee camps in Croatia (would paparazzi really want to follow us there?). Finally, a few days in Cap d'Antibes. And upon returning, I plan on spending a good portion of my time in the Hamptons. Day-to-day city life interests me less as I've gotten older. And I'd prefer to raise kids in the country.

PRINCESS MARIANNE with Peter Halley

Photographed in Salzburg by Leeta Harding
September/October 2001

Princess Marianne Fürstin zu Sayn-Wittgenstein-Sayn—or Manni, as she usually prefers to be called—is an extraordinary woman. At eighty-two, she is still slim and elegant, with an impressive mane of natural silver-gray hair that she has always styled herself. She is thrifty and self-reliant, but many of her friends are the wealthiest, most colorful and creative figures on two continents. She is a respected pillar of Salzburg's summer society, yet everywhere she goes, she brings her camera, with which, for fifty years, she has taken photographs full of mischief, sensuality, and spontaneity.

Manni is blessed with boundless energy and an effervescent personality that would seem to be the result of having lived a charmed life. But she has also overcome adversity. She has been marked by the devastation of World War II and its aftermath. Later, she bore the weight of raising five children alone when her husband died suddenly in the early '60s. Manni was just forty-three.

Before I traveled to Salzburg to talk with her, I asked a variety of Europeans what they knew about Manni. Some of the young people I spoke to considered her only a haughty aristocrat. But another perspective came from a distinguished European scholar who delightedly relayed how, prior to her marriage, Manni had been involved with a Hungarian avant-garde poet who fled to the Soviet Union before the War.

Over the last five decades, Manni has created a personal history of European high society through her photographs of the people she has known. Although she chronicles the jet set, Manni's pictures shouldn't be compared to those of a paparazzo. She is too much a part of the scene, and her photos are just too good. Manni's subjects range from her five children, their children, and their children's children, to famed musicians, heads of state, titans of industry, and just about everyone else who has made their mark in the world.

On the day of our interview, Manni arrived to pick me up slightly late but very apologetic. We sped off in her little Ford station wagon, which she handled with an astonishing agility. It struck me that I was going to be speaking with a much more multifaceted person than I had imagined . . .

PETER: How did your summer luncheons start?

MARIANNE: I don't remember. I do it because I just love meeting people. Everyone interests me.

PETER: What impressed me about being here last year was that there were many different types of guests—opera singers, artists, politicians, your old friends, and their children.

MARIANNE: And Thomas, the farmer from around the way who makes the best goat cheese. I adore him.

PETER: And Margaret Thatcher came to one of your parties as well?

MARIANNE: Oh, yes, I met her one morning nearby in Saint Gilgen. I said, "I live right over the hill, and I have a little shooting lodge. I'm having a luncheon today, and I would be delighted if you could come." She thanked me but said it was impossible because of her schedule. Then, as an afterthought, I said, "How sad—I believe Sean Connery will be coming." She said, "You mean James Bond?"

PETER: What British prime minister wouldn't want to meet 007?

MARIANNE: I drove back home, where I already had 30 guests waiting for me! Eventually, this black limousine pulled up, and Mrs. Thatcher's bodyguards swarmed out into the woods—they were everywhere. She had a great time, of course.

PETER: Manni, the desire to photograph every day, or over so many years, is very much the impulse of an artist. Do you know why you've been drawn to it?

MARIANNE: I want to keep the memory of a certain face, an expression, a lovely landscape. Also, after my husband died, the thing I missed most was being able to say to him, "Darling, look. How interesting." Maybe that's why I started to focus on taking pictures—so I could share them with my children and friends.

PETER: You've met so many people who've played roles in changing history. King Juan Carlos of Spain, for example. If you were to choose a word to describe him, what would it be?

MARIANNE: Maybe that he's so human. He's down-to-earth.

PETER: A Spanish friend once told me a story about the time a friend of his got a flat tire in the countryside in Spain. A man rode up on a motorcycle and stopped to help him change the tire. It took this guy a few minutes to realize that it was the king!

MARIANNE: That's typical. I still remember my first professional appointment photographing him.

PETER: Was that when you were working for *Bunte*, the German magazine?

MARIANNE: Yes. They asked if I would like to go to Spain and photograph the king and queen. I didn't want to tell them that I knew Juan Carlos and his wife, Sofia, from all sorts of weddings and events. So the magazine went ahead and organized the trip to Madrid. I was so ignorant—I thought I would be the only member of the press there, because my editor had said, "You have an appointment on Tuesday at five o'clock." I went to the palace, and there were 50 photographers and five television crews! We were all squeezed together waiting for the king and queen. And I was in the back row, because I was one of the tallest.

PETER: So it was just a photo opportunity.

MARIANNE: Then the king and queen arrived and were formally introduced. Suddenly Juan Carlos looked up and said, "Manni, what are you doing here?" I went to the front and curtsied—with all my cameras dangling—and told him that I was on assignment. He called over to the queen and said, "Sofi, come see, Manni is a professional!" It was so amusing.

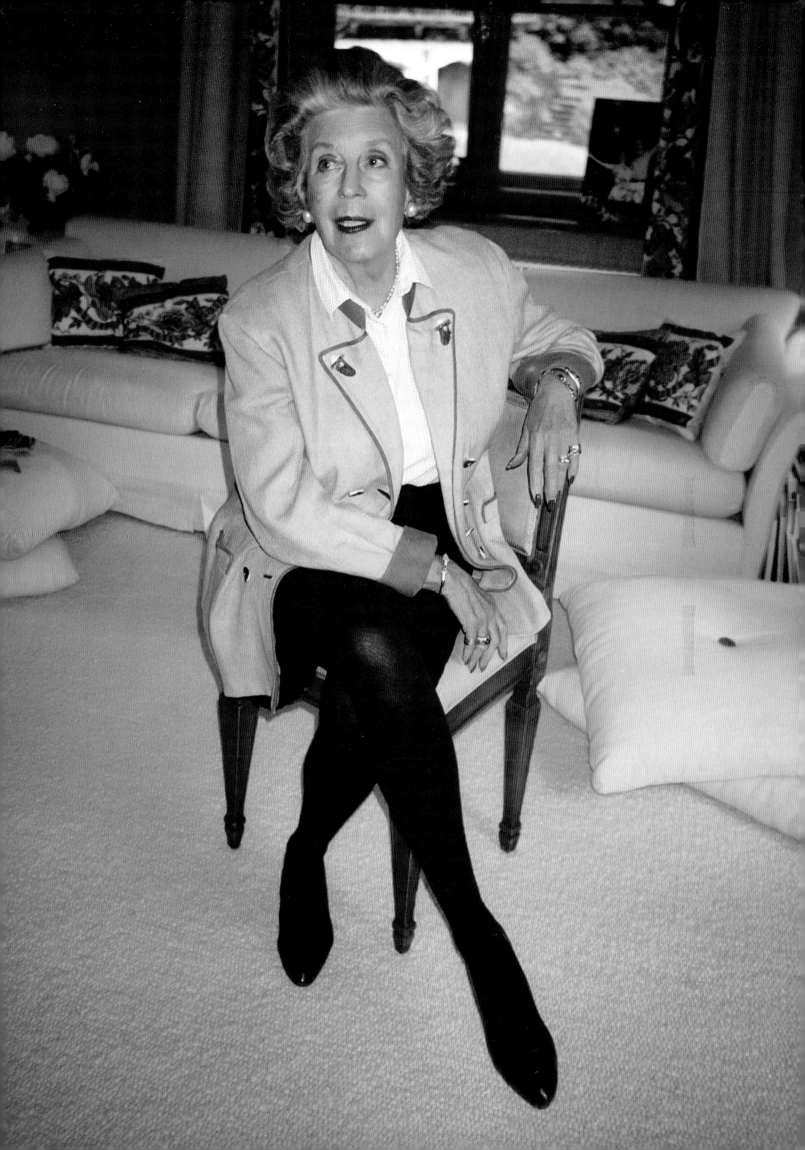

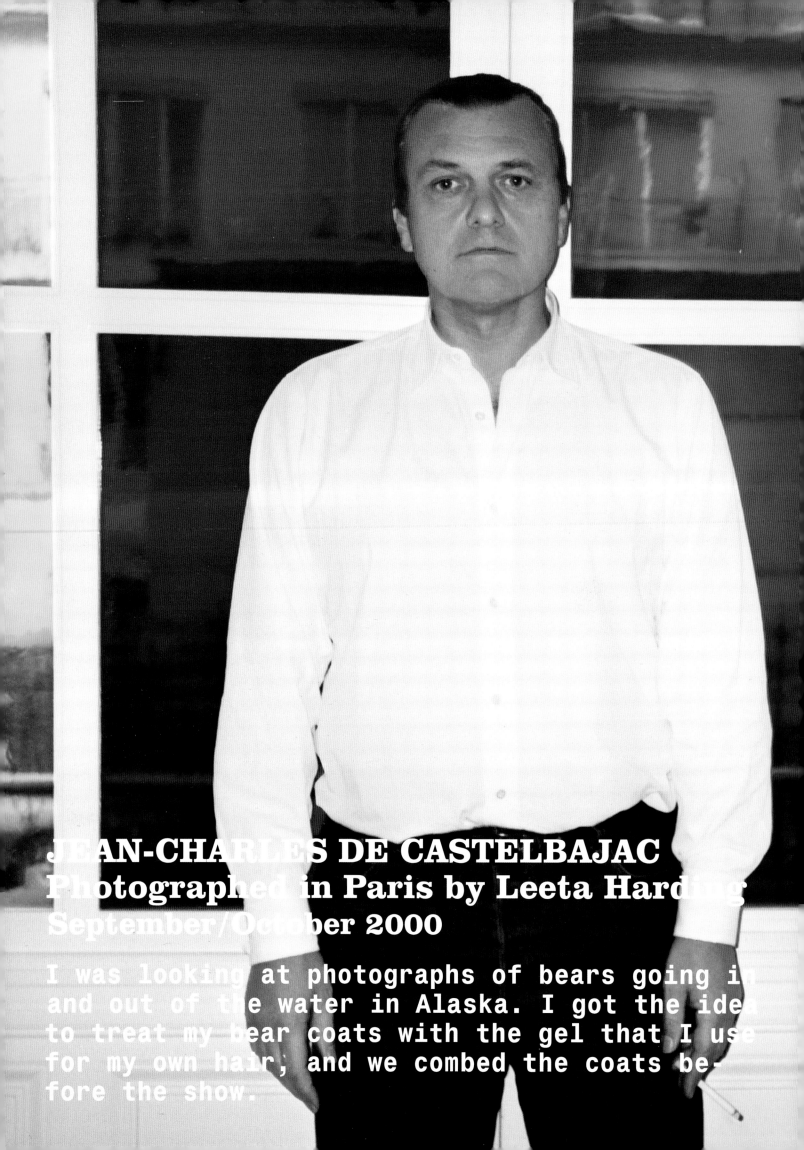

JEAN-CHARLES DE CASTELBAJAC
Photographed in Paris by Leeta Harding
September/October 2000

I was looking at photographs of bears going in and out of the water in Alaska. I got the idea to treat my bear coats with the gel that I use for my own hair, and we combed the coats before the show.

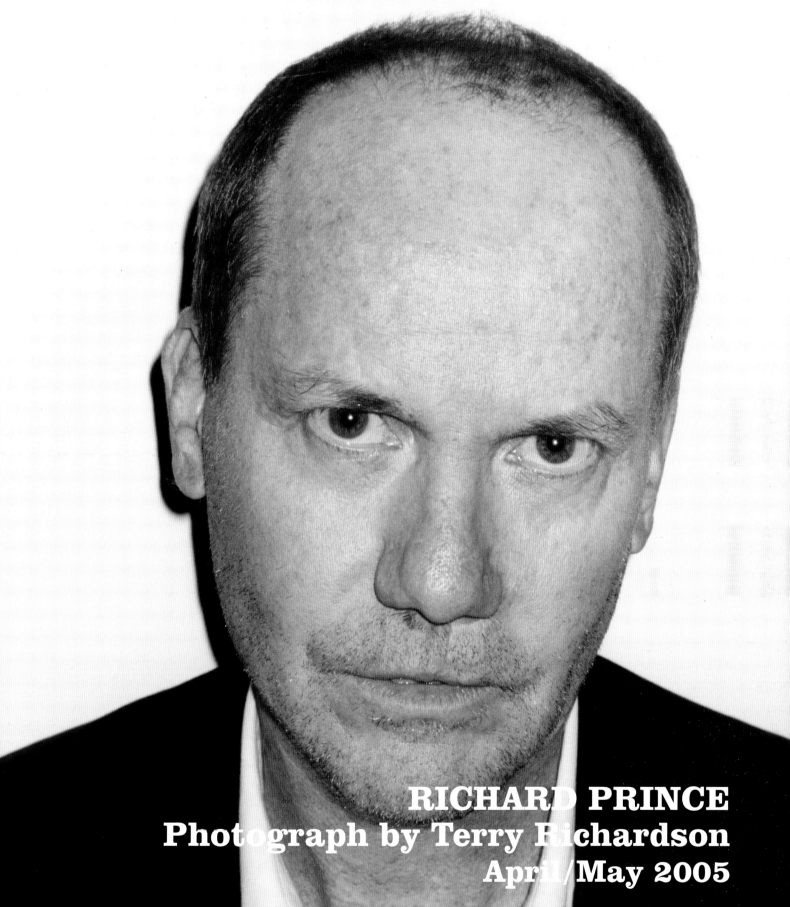

RICHARD PRINCE
Photograph by Terry Richardson
April/May 2005

As a child, I used to pore over *LIFE* magazine.
But I was very suspect of photographs that were
trying to tell you the truth. I never believed
those editorialized photographs.

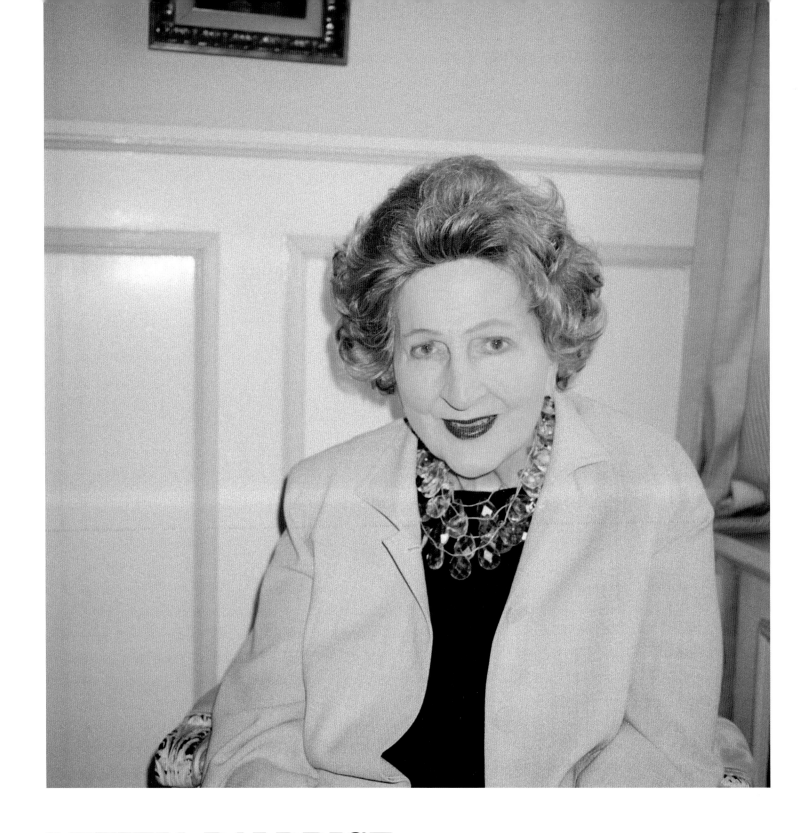

LETITIA BALDRIGE
with David Savage

Photograph by Leeta Harding
April / May 2005

As Jacqueline Kennedy's Chief of Staff, my major contribution was to gather as much information as possible on visiting ambassadors and heads of state. I had to learn the protocol that was expected in their countries. It was a well-run administration. The Kennedys wanted everything to be beautiful and just right. And Jackie had such style.

Television's Xena Warrior Princess doesn't say much at all. If she's in a good mood, she'll make a deadpan joke. To the man who unfortunately landed between her legs in battle, she growled, "I hate uninvited guests"—then promptly slaughtered him with her thighs. (We can only ponder what happens to guests who are *invited* to that hottest of all spots.) Xena never changes her clothes, and she never laughs. On one show she almost laughed during a fight with a trained assassin over the nectar of the gods. He had her pinned to the ground with his sword to her throat. She looked into his eyes and seemed to laugh with merriment but killed him nevertheless.

FIGHTS!
XENA WARRIOR PRINCESS

BY LISA CARVER
SEPTEMBER / OCTOBER 1997

The battles are as inventive and imaginative as the ones happening on the movie screens in Chinatown in San Francisco. Villagers drive off marauders with exploding seltzer water and flying corks. A Machiavellian plotter describes the war between the Amazon women and the centaurs as "a battle between the hooves and the harlots." On another occasion, Xena holds off a dozen ninjas with one pot and one frying pan. Disguised as a goody-two-shoes princess, she pins a castle traitor to the wall with arrows flown, impromptu, out of a harp.

Why does Xena fight so much? For justice. For honor. For truth and for freedom. For the little guy. And to try to make up for her bad past, when she was the greatest scourge of the land, flying from village to village on her chariot, accompanied by her own dreadful army, squeezing humans like sacks of blood wherever she went.

And now, in the time of computers, bureaucracy, and unhappy people, a land in which boredom cries out for a hero. She is Xena, a mighty princess, filmed in the blackest of leather. The power, the legs, the sound effects. Her courage will galvanize our lives.

You might notice I don't mention Xena's sidekick. That's because I feel she's all wrong for the part. I have someone else in mind: me.

S
Superstars

DANIEL DAY-LEWIS
Photograph by Terry Richardson
November/December 2002

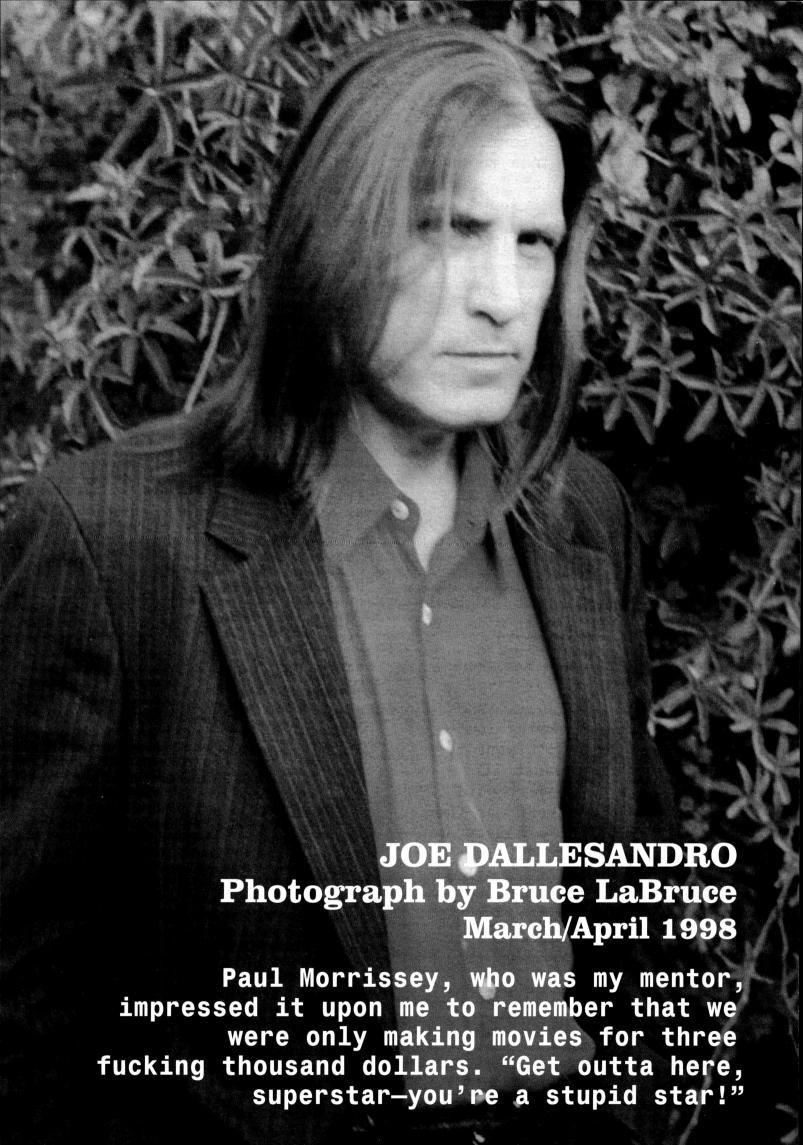

JOE DALLESANDRO
Photograph by Bruce LaBruce
March/April 1998

Paul Morrissey, who was my mentor,
impressed it upon me to remember that we
were only making movies for three
fucking thousand dollars. "Get outta here,
superstar—you're a stupid star!"

CHARLOTTE RAMPLING
with Juergen Teller

Photograph by Juergen Teller
November/December 2002

JUERGEN: Do you feel like you have to be careful when you do interviews?

CHARLOTTE: No. I decided a long time ago that it's easier to spontaneously say what you think. Quite often you can get to know yourself a bit. It's almost like you're with your therapist. [Laughs.] But you're not paying someone to listen to you.

JUERGEN: You seem to pick your projects quite carefully, mostly French films. Have you ever wanted to live in Hollywood and make American films?

CHARLOTTE: I've always understood that Hollywood doesn't have too much to do with me. I preferred acting in European films right from the start of my career. European films were what it was about for me—the sensations I needed, the depth, the storytelling, the characters, the directors, and the freedom that you can't really find in American films. Film is an extraordinary way for us to know each other. A film based on a jolly good John Grisham book is fine, but I like to get a bit under the skin. Like *Under the Sand*, my last movie with director François Ozon.

JUERGEN: Do you watch your own movies?

CHARLOTTE: I've never wanted to be diverted by the image I give off. I don't want to get caught in a narcissistic trap.

JUERGEN: A lot of actors say that. But somehow you've got to be able to judge what you've done.

CHARLOTTE: You can never really judge your work, because once it's done, it's done. Yeah, you could go to see the rushes after a certain shot. A lot of young actors will do a scene and then run off and look at themselves. I don't believe in that at all.

JUERGEN: What about the end product, the finished film?

CHARLOTTE: You can't even know much about that. *Under the Sand*, for example, is very beautiful. As usual, I only saw it once. Then it was released, and people really liked it, so I asked François if I could have a tape. I watched it again, which I'd never done before. I just observed what actually happens. It was quite interesting.

JUERGEN: It's incredible how much work and energy you put into a project that you don't even watch.

CHARLOTTE: Doing cinema is not about watching yourself. There are lots of other films. [Laughs.] You don't have to watch your own.

JUERGEN: Not even in a non-narcissistic way?

CHARLOTTE: It can only be narcissistic. You cannot watch yourself dispassionately. I defy anybody to say different. If you're very beautiful and also a very good actress, you're going to start to become very fond of yourself.

JUERGEN: So what drives you to act, if you can never judge the results?

CHARLOTTE: Desperation, probably. I'm terrified that I can't do anything else.

JUERGEN: That surprises me.

CHARLOTTE: I think that most actors don't have very good opinions of themselves. I don't know anyone in this world who's particularly happy. I'm in my fifties now, and I've been in the business quite a long time. I've stopped many times because I just couldn't handle it.

JUERGEN: Actresses tend to get passed over once they turn a certain age. You've managed to do fantastic films throughout your life.

CHARLOTTE: Yeah, you don't realize what youth is until you don't have it. And in my pride I've sometimes said, "I'm going to stop before they stop me." I don't want anyone to have one over me—I prefer to have one over on them. [Laughs.]

JUERGEN: Do you ever feel pressure to earn money?

CHARLOTTE: I've always earned just about enough, and I've been with men who've helped me. I've always had helpers. And I know how to live with very, very little. I hardly need anything. If I can live in great houses, I will. But I've been prepared to lose everything for something that I know I have to do. I think if you are prepared to do that, then another door will open.

JUERGEN: There are so many actors these days, especially in America, who are willing to be merchandised. I'm astonished by those Gap ads—they convinced so many actors and other notable people to be models and participate. Have you ever done anything like that?

CHARLOTTE: No. I've been asked many times. I've never wanted to be a product. Sometimes one thinks, "Well, maybe they really need the money," and that's another thing. Often I haven't been very well off, and I've carried on. But I really, really couldn't hack selling my name like that.

JUERGEN: How do you decide which films you'll make?

CHARLOTTE: It's the director that counts. He is the person that you're going to have to answer to. He's the one that you're going to give your soul or your heart to, your talent, your smile, your tears, everything.

JUERGEN: I was surprised when I heard you were in *Spy Games*. How did that come about?

CHARLOTTE: I did that film just so I could kiss Robert Redford. He's a very kissable man, and I thought, "Maybe I'll never get another chance." It's really just a cameo, but it intrigued people. Now I can bill myself as having starred with Redford.

JUERGEN: I wonder how actors can take on a role and then discard it when the shoot is over. Do your characters stay with you?

CHARLOTTE: More and more so as I get older. When I was younger, I didn't think too much about it—I did things with a gut instinct. Then, little by little, the roles start to creep up on you. I can't just brush things off anymore.

JUERGEN: I've experienced that as well. It's kind of frightening.

CHARLOTTE: I've also found that I need a period of rest after a shoot. The film experience is quite devastating. Everything happens so quickly and so intensely. You don't have long rehearsals like you do in the theater—it's absolutely about being now. Only when it's over can you try to come to terms with what actually happened.

DAME DARCY READS THE PALM OF CINDY SHERMAN
JANUARY/FEBRUARY 1998

DD: You know, I never knew what you looked like, even though I've seen your image hundreds of times . . . there's a chameleon sort of appeal. Are you a Gemini?

Cindy: No, I'm a Capricorn.

DD: Oh, I was wondering, because you do this multi-faceted work.

Cindy: Yeah.

DD: So do you have any particular questions before I start reading your palm?

Cindy: Well, can you tell me if I'm going to make another film? Or if my work will change in some direction? I don't know if you can see that.

DD: Maybe.

Cindy: Do you have enough light?

DD: No, that's fine. Okay, so are you right or left-handed?

Cindy: I'm right-handed.

DD: Okay, you have a very complex life line. In fact, your life line splits into two different lines. When you were younger, if you'd gone in a certain direction with your life, you would not have ended up as happy and successful as you are now. There's a point, maybe around ten, when you were a child, when some crucial decision that you made really changed your whole life.

Cindy: Wow.

DD: You seem to have an old presence or spirit. Your subconscious guides you a lot, which your work also shows. A lot of it's like dream and nightmare imagery. And that shows up a lot in your palm. Maybe even ideas and things that are coming from another place—other people or ghosts, not just necessarily from your own experience. You seem to be a divining rod, a little bit. You work very hard, and you'll always work really hard. But that doesn't necessarily mean it's something you don't want.

Cindy: Right.

DD: You give really good advice to people, and you have a very nurturing, generous nature. You've always tried to help people, and people have always tried to help you in return. You're going to live a long time.

Cindy: That's good.

DD: You'll live a really long time.

Cindy: Oh, good!

DD: Maybe into your mid-nineties or late nineties.

Cindy: Fantastic, wow, that's good.

DD: You have fairly good health. If you ever have bad health, it's directly related to your psychology. Like, if you get a migraine or something, or if you have an upset stomach or a cold, a lot of the times it's having to do with what's going on around you, not just a physical thing. You have a great capacity for love. It's easy for you to fall in love. You get your heart broken fairly easily. You have in the past, because you give so much right away, and so easily. You have a lot of people in your love line—more people than usual. You had several chances for love when you were younger. Some of them were sometimes in your mind. Friends and loves are sort of about the same thing. Sometimes friendships for you are just so intense that it is like love, so that's why they would show up . . . Do you have any questions pertaining to your work?

Cindy: Somebody was trying to read my palm once and was curious because of these two x's at the end, like, right here. And they didn't know what it meant.

DD: Well, it's sort of a crossover. All of your lines are interconnected with other lines. It's like a web. In your world, love and traveling and your life, your past, your present, your future, and what's going on in your mind and your heart are all integrated. They aren't separate from each other. Like, some people have their life, and then they have their travel.

Cindy: Right, right.

DD: They have their family, and then they have their lover. And in your world it's all very, very connected. And I think that that's what these x's are. They're just connecting it all.

Cindy: Right, right. And that same person was wondering . . . I guess this is probably what you were talking about . . .

DD: Your other life.

Cindy: Yeah, I've always wondered, what is that, because my private self is so different from the artist self?

DD: Well, in your case, it may appear different to other people. It may appear very separate. But it's not. You are who you are, and what you do is what you're thinking and how you feel—exactly.

Cindy: Right.

DD: And maybe to other people it comes up as this disjointed imagery, but it's not. This is, like, from when you were a child. There was a point in time where, if you decided to not learn photography or not pursue making what's in your subconscious, if you decided to just take the straight path and get a job, I think you would have been a lot less happy. But that was an option at one point.

Cindy: Yeah, funny.

DD: But it's no longer there. You were more predestined to go the way you did.

Cindy: So can you tell if I am going to make another film? Or will I pretty much stay just making art? It's not like I want to go out and make another film. I'm just curious.

DD: Your career seems to be very integrated with your life. And I see that your life is going fine. And I think that if it was going to devastate you that you didn't make another film, then . . . no, I don't see that. But I can tell that you'll probably continue doing . . .

Cindy: Just what I'm doing.

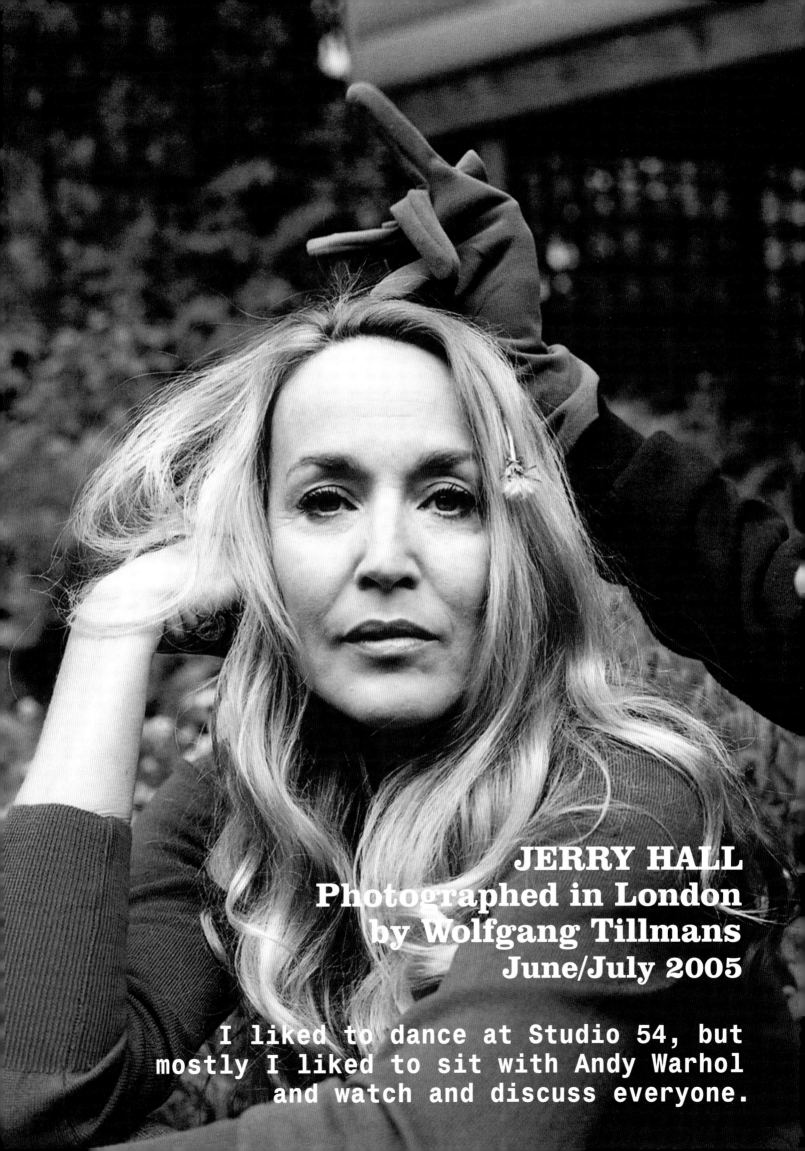

JERRY HALL
Photographed in London
by Wolfgang Tillmans
June/July 2005

I liked to dance at Studio 54, but
mostly I liked to sit with Andy Warhol
and watch and discuss everyone.

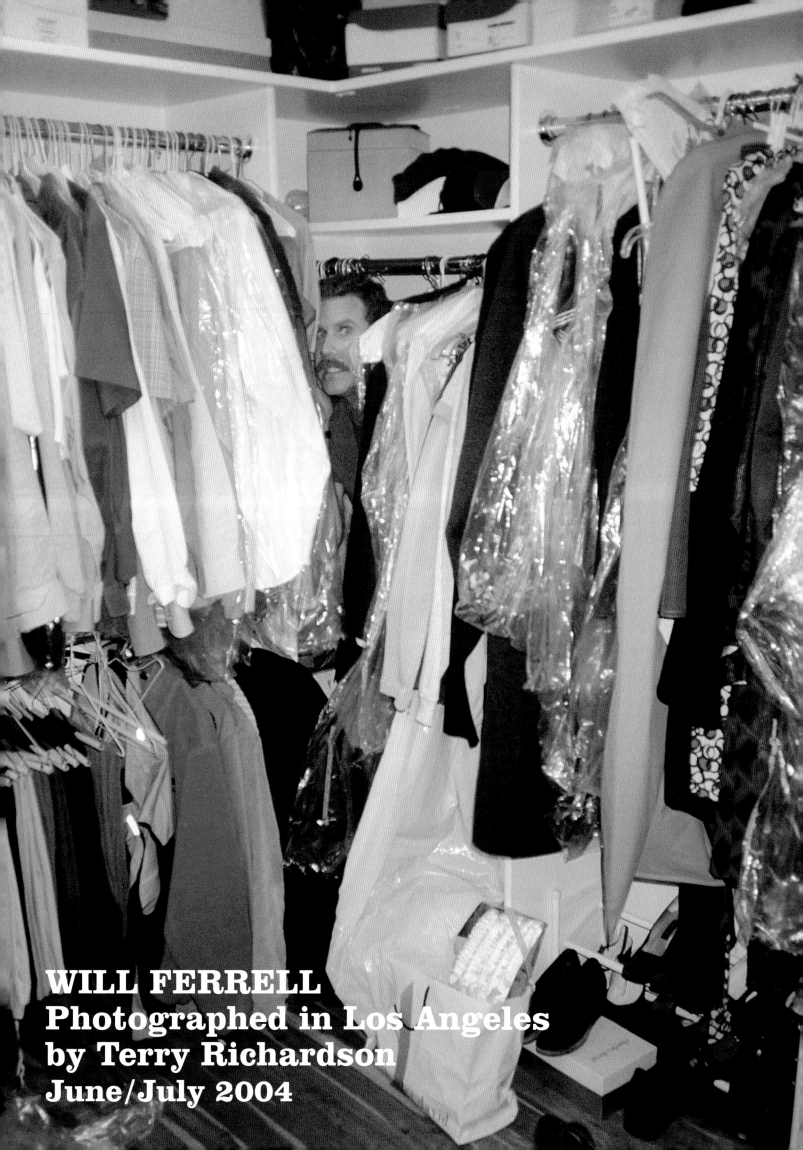

WILL FERRELL
Photographed in Los Angeles
by Terry Richardson
June/July 2004

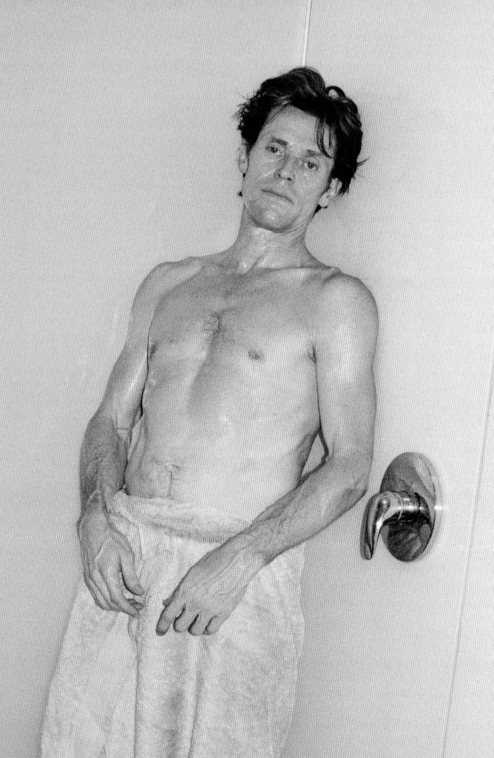

WILLEM DAFOE, London, 2003
Photograph by Juergen Teller
November/December 2003

Most of the preparation work happens when you're on the set. It's like going to a cocktail party—you know who's going to be there, you have certain expectations about the topics of conversation and the social dynamic . . . but sometimes the most important thing is just having a good costume.

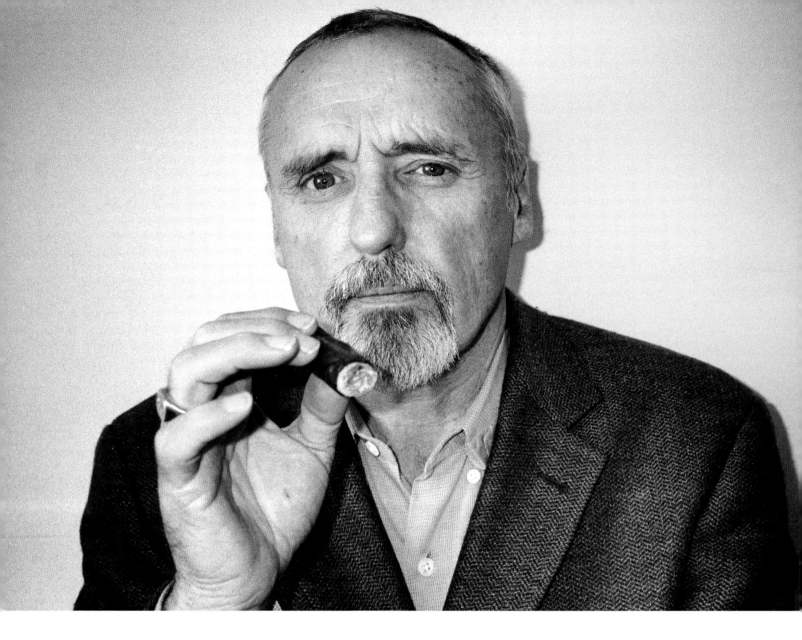

DENNIS HOPPER with Tony Shafrazi

Photograph by Terry Richardson
May/June 1999

Most people know him for the indelible characters he's invented as an actor for more than 40 years. What's not widely known about Dennis is that he's also a photographer. And he's been taking pictures since the early '60s, documenting the art scenes in New York and LA, urban streets and Hollywood sets, rock 'n' roll bands, bikers, and civil rights marches. He's made definitive portraits of everyone from Brian Jones to Jasper Johns. Dennis always managed to be in the right place at the right time, and, with movies very much in his mind, his photographs show that he can also direct a picture with a still camera.

Until now, only two books of Dennis's photographs have been published. But thanks to the curator Walter Hopps, who held on to nearly 300 contact sheets that Dennis himself hadn't seen since the late '60s, a new book is expected by the end of this year. Along with his old friend, the art dealer Tony Shafrazi, Dennis has been poring over thousands of images to assemble a comprehensive collection.

TONY: So, what are you doing these days?

DENNIS: Well, I've been going through the proof sheets.

TONY: Great. I did also, and they look wonderful.

DENNIS: Well, it's a hard process for me, because there are so many people who are dead—Roy Lichtenstein and Andy and so on. I have so many memories.

TONY: Are you moving ahead and choosing good images?

DENNIS: I'm still going through them. I didn't use a light meter; I just read the light off my hands. So the light varies, and there are some dark images. Also, I'm sort of a nervous person with the camera, so I will just shoot arbitrarily until I can focus and compose something, and then I make a shot. So generally, in those proof sheets, there are only three or four really concentrated efforts to take a photograph. It's not like a professional kind of person who sets it up so every photograph looks really cool.

TONY: Oh, I think a lot of it looks really cool. And now, after many years of talking to you, and many years of talking to Walter Hopps, we've finally managed to get hold of all the contact sheets, at least the 500-odd sheets that survived, that, luckily, Walter Hopps kept all this time.

DENNIS: That I literally haven't seen since the '60s.

TONY: And other than the 100 or so prints that we showed in Europe in '88, we never really looked at all of them carefully.

DENNIS: You know the one photograph I picked of Andy with the flower—the one where he's not smiling and looking sort of straight at the camera? That's the one that's become a very famous picture of Andy. But there are two more, another one of him with the flower, but he's now smiling, because he's seen me. And there's one with, I think, Barbara Rose's arm reaching for a cigarette. It's a longer shot of him, and he's so handsome, so young. It's 1962 or '63, he's in a suit and tie, and he looks really wonderful. And I've never even printed those. Those have never been seen before. And I have so many great photographs of Ed Ruscha that have never been printed.

TONY: I told Ed that we are trying to do a big book of your photographs, and he said, "You should do a big book! There are so many great pictures. Just tell Dennis you should print all of them, man."

DENNIS: [Laughs.]

TONY: Well, he's right! You can still have your 200-odd pages of single pictures, and have many others in contact form. It could be the way we're looking at them, slightly more enlarged, maybe. I was just looking at some incredible photos of Jane Fonda . . .

DENNIS: Oh, some terrific shots of Jane. With the bow and arrow and the bikini.

TONY: And the photos of Phil Spector, who looks like a young Mozart.

DENNIS: He was.

TONY: So, there's a lot of stuff there. I think we can play with it, and it will read more like a film.

DENNIS: You know, the history of California art doesn't start until about 1961, and that's when these photographs start. I mean, we have no history out here. So that's the beginning. I have so many photographs of Ed Kienholz, of Wallace Berman, Llyn Foulkes, George Herms, Bruce Conner.

TONY: And you were one of the first patrons; you were collecting art. There's a picture of you in your living room, and Ed Ruscha's big gas-station painting is hanging there.

DENNIS: Right. There's a big 12-foot Standard station—that was the first one. It's a great painting. One of his best.

TONY: When Andy had his first one-man show in LA at Ferris, which was the Campbell's Soup paintings, you ended up buying one. And they only sold two, I think.

DENNIS: No, no. Everybody's confused. My whole written history is one big lie! [Laughs.] I mean, I can't even believe my history. But I did have the first Campbell's Soup painting. It was in the office at Virginia Dwan's gallery, and I bought it for $75. This is '62 or '63.

TONY: I think that in planning this book, we have to find a way to keep a bit of the narrative that's there. You were around all the time with the camera. And you can see that in these pictures.

DENNIS: You have all the Happenings. There's Claes Oldenburg—that Auto Bodies Happening that I photographed—and then Rauschenberg and John Cage, roller-skating with the parachutes, and those big plastic tunnels that were filled with air.

TONY: And Allan Kaprow . . .

DENNIS: With what I call The Ice Palace. He built these great ice cubicles and then lit torches inside them and let them melt all over Los Angeles. There are wonderful photographs of that.

TONY: When I look at your pictures, I think of the kind of thing that we all did in the early '60s—where we'd take a camera and shoot from the television set, like all the Kennedy pictures you took.

DENNIS: Hmmm.

TONY: In a way, your pictures are like a cinema verité of the whole time. I see a lot of this as an almost naïve or cleaner or purer image of the feeling I get when I see *Easy Rider*. You're traveling across this wonderful time and space. Your photos give that feeling to me. This isn't just the work of a photographer, but of someone telling a story.

DENNIS: Yeah.

TONY: Now, I guess everybody knows your history in the '50s, after making the great movies with James Dean . . .

DENNIS: I went under contract to Warner Brothers on January 7, 1955, and I did *Rebel Without a Cause* that year, and *Giant*, I believe, was maybe the beginning of '56. They were made back-to-back, actually.

TONY: You met James Dean in '55.

DENNIS: Right.

TONY: And he had a real passion for art also and encouraged you to take photographs?

DENNIS: Oh, yeah. He said, "I know you want to be a director someday, so you should start learning how to compose pictures through your camera without cropping them." Because the idea in those days, everybody took photographs and cropped them.

TONY: So he liked painting and sculpture . . .

DENNIS: Absolutely.

TONY: I remember, as a kid, seeing pictures of James Dean sort of fooling around . . .

DENNIS: Oh, he painted.

TONY: He did?

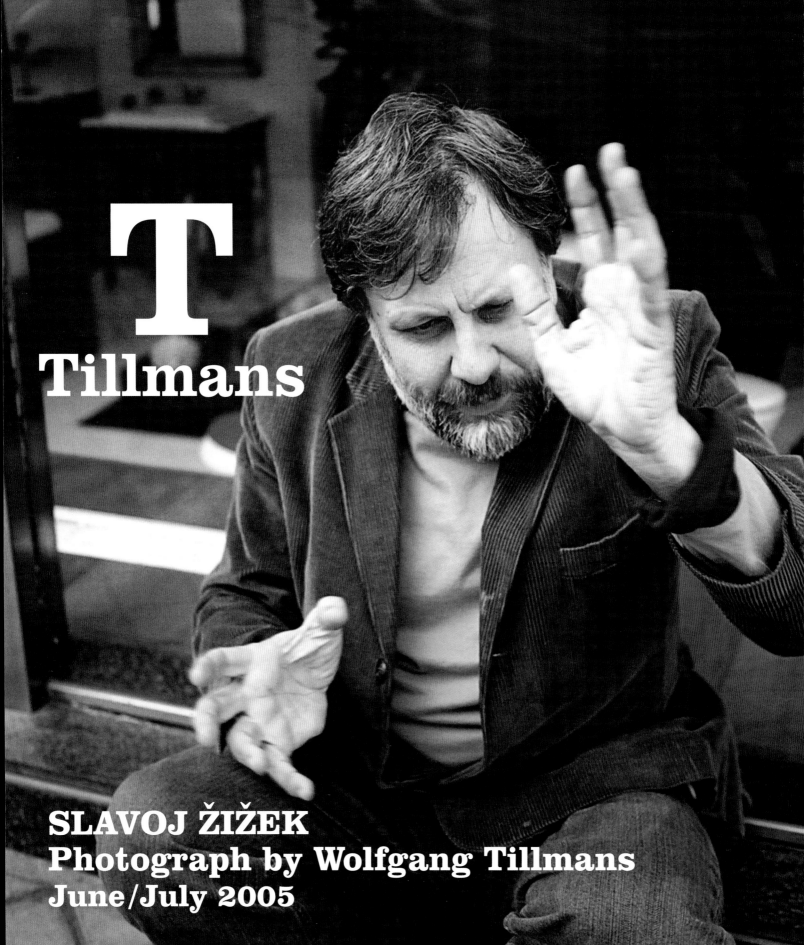

WOLFGANG: What are your vanities?
SLAVOJ: My vanities are my secret narcissisms.
I love owning all my books. I'll open one and
think, "Oh, my God, look what I've written!"
It's absolutely disgusting self-satisfaction.

T
Tillmans

SLAVOJ ŽIŽEK
Photograph by Wolfgang Tillmans
June/July 2005

WOLFGANG TILLMANS
with Peter Halley and Bob Nickas

March 1997

PETER: What gets me about your photographs—what separates you from other photographers today—is that you seem to connect with people rather than look at them cynically. And in your pictures, life looks very worth living, you might say. It's hard for me to express.

WOLFGANG: It's also difficult for me, without sounding corny, I guess. But, of course, I love life, and I have a positive outlook on things. I have idealistic intentions with my work. And I want to put some image of my vision of humanity into the medium. And I find that basically that is a political kind of work.

PETER: And you really are not a snob about people being young outsiders or famous and beautiful. It's, like, you want to take it all in.

WOLFGANG: Yeah, without actually pretending that I'm . . . that there is a big family or anything like that. There are certain misconceptions, and one of them is that I only photograph my friends and my family, and it probably arises because they [my subjects] all look like friends.

PETER: I actually thought that was only a small portion of your work.

WOLFGANG: Yeah.

PETER: I imagined you going on trips and maybe meeting people, or them being sort of random situations.

WOLFGANG: No, I hardly ever pick people off the streets or in clubs . . . almost never, really.

BOB: I'm thinking of the word "democratic," because when I started looking at more of your photographs, I couldn't always tell the difference between what were personal pictures and what was commercial work. And I realized there's a kind of blurring between them. In other words, with some photographers, their commercial work looks like it's what they were hired to do. And the other work is personal. But in yours, they kind of flow into each other much more.

WOLFGANG: I just make my work, and there's only one kind of work that I do. But then, I put it out into the world, and it instantly starts to travel. People start to claim it for whatever field they think it sits in. So I actually don't control the framework in which my work circulates. My staged work looks so real that people actually take it for documentary. But, in fact, that is my intention, to disguise the manufacturedness of it. Half of my work, or probably more than that, is staged.

PETER: This is contradictory to what you were saying at first, that you went into shoots without expectations.

WOLFGANG: That's the thing. I go into an *index* cover shoot without expectations because there is nothing I can expect, because I don't know who I'm meeting. But there are a lot of themes and images that I have in my head that I stage with people, with models. And then, in order to distribute them into the world, I use fashion channels. So I use the fashion magazine as my platform to publish my storyboards. I inject my personal visions into the world by making them look real or like a club shot or like a fashion shot. But, actually, what I do is, I enact situations with my models or friends so I can see what they look like. There's the photo of those people sitting in the trees, or those people lying on the beach. The woman with her hands wrapped around her head. All those were planned images.

PETER: But by "staged," you just mean you move people around a bit?

WOLFGANG: No, I tell them what to do, and I choose the clothes, I choose the location, and I set them up in their positions.

BOB: It sounds a bit like a little scene from a movie . . .

WOLFGANG: Yeah, but it's a kind of post-art photography. It's no longer about, "Look how much of an artist I am, how controlled it is." I'm confident enough to use photography to its fullest extent without constantly pointing at how I'm controlling the whole process.

PETER: Do you identify strongly with the *cinema verité* tradition, or the street photography tradition?

WOLFGANG: No, I'm actually not very interested in finding, in collecting these moments. I'm looking for the one definitive picture of a person or a situation.

PETER: I always get the impression that you started taking pictures when you were, like, six years old. You seem to have that kind of natural relationship . . .

WOLFGANG: It's pretty much the opposite. I tried all sorts of things, but the last was photography. Maybe because my family was such a keen amateur-photographer family . . . we were forced to view slide shows by my father. It was really the only medium that I didn't experiment with. But in '87 the first black-and-white laser copier from Canon came into town, and I discovered its power to enlarge copies to 400 percent, not with mirrors but with a digital process. So I started photocopying things, dissolving photographs though the pixilation and the high-magnification of the Canon machine. Then I needed more photos after I had done a few little shows with that work, so I bought a camera.

BOB: When did you buy your first camera?

WOLFGANG: In '88. I was 20. And then, after a while of continuing to work on the copier, I realized that the photographs were better than the manipulations. Since I started with manipulating photographs, I never really went into making the process visible.

PETER: When you do an exhibition, you still are very much an installation artist who uses photographs.

WOLFGANG: Yeah, but it's not so much about remodeling a teenager's bedroom or an art director's clipboard, which people sometimes think it is.

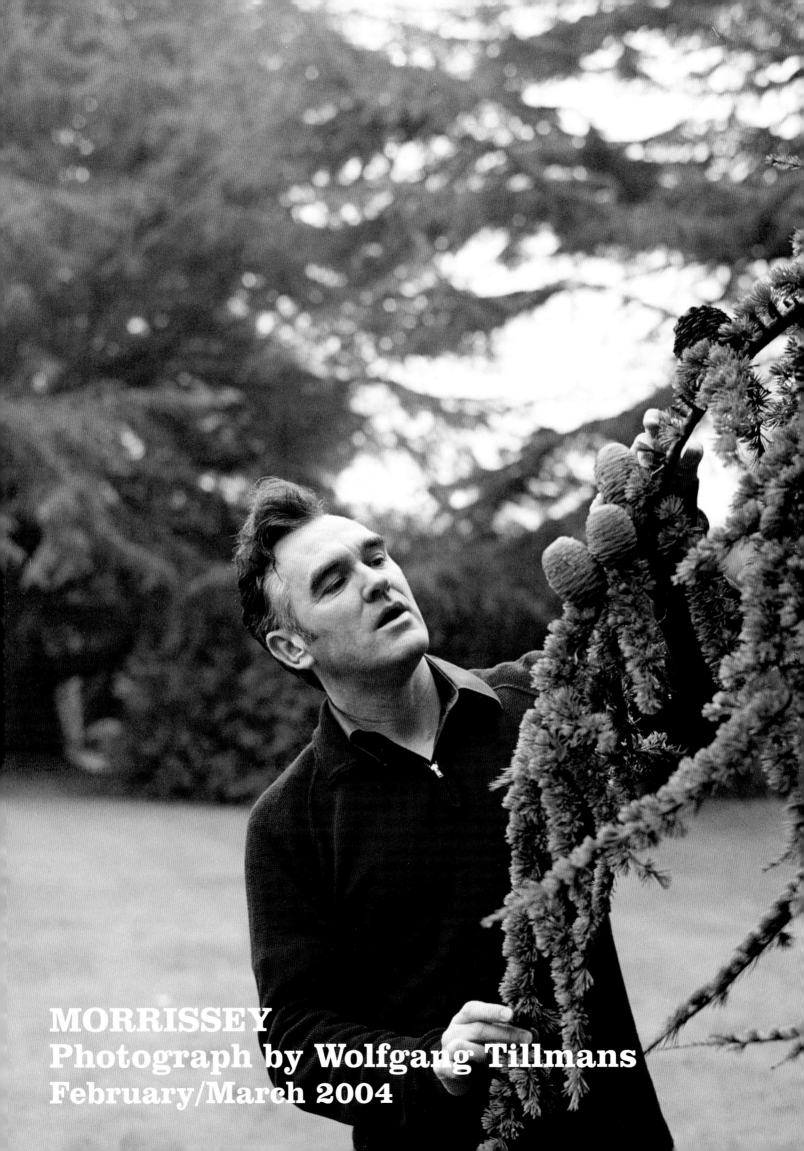

MORRISSEY
Photograph by Wolfgang Tillmans
February/March 2004

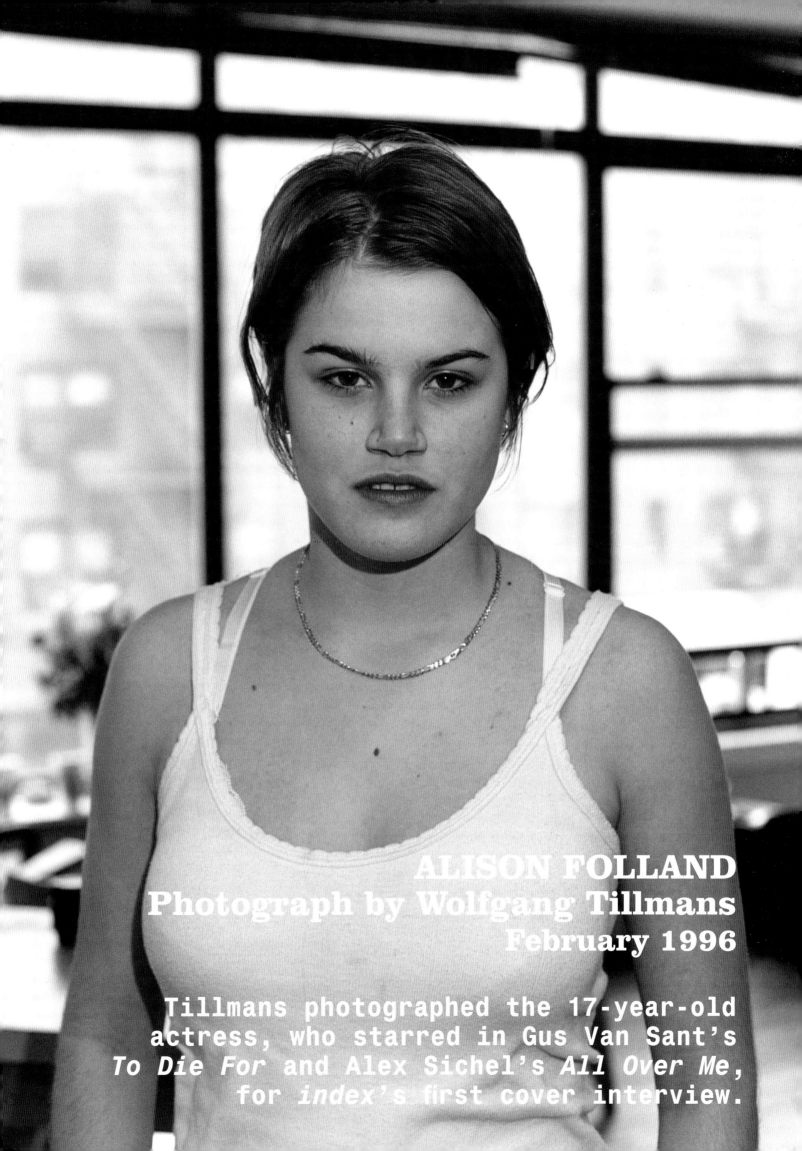

ALISON FOLLAND
Photograph by Wolfgang Tillmans
February 1996

Tillmans photographed the 17-year-old
actress, who starred in Gus Van Sant's
To Die For and Alex Sichel's *All Over Me*,
for *index*'s first cover interview.

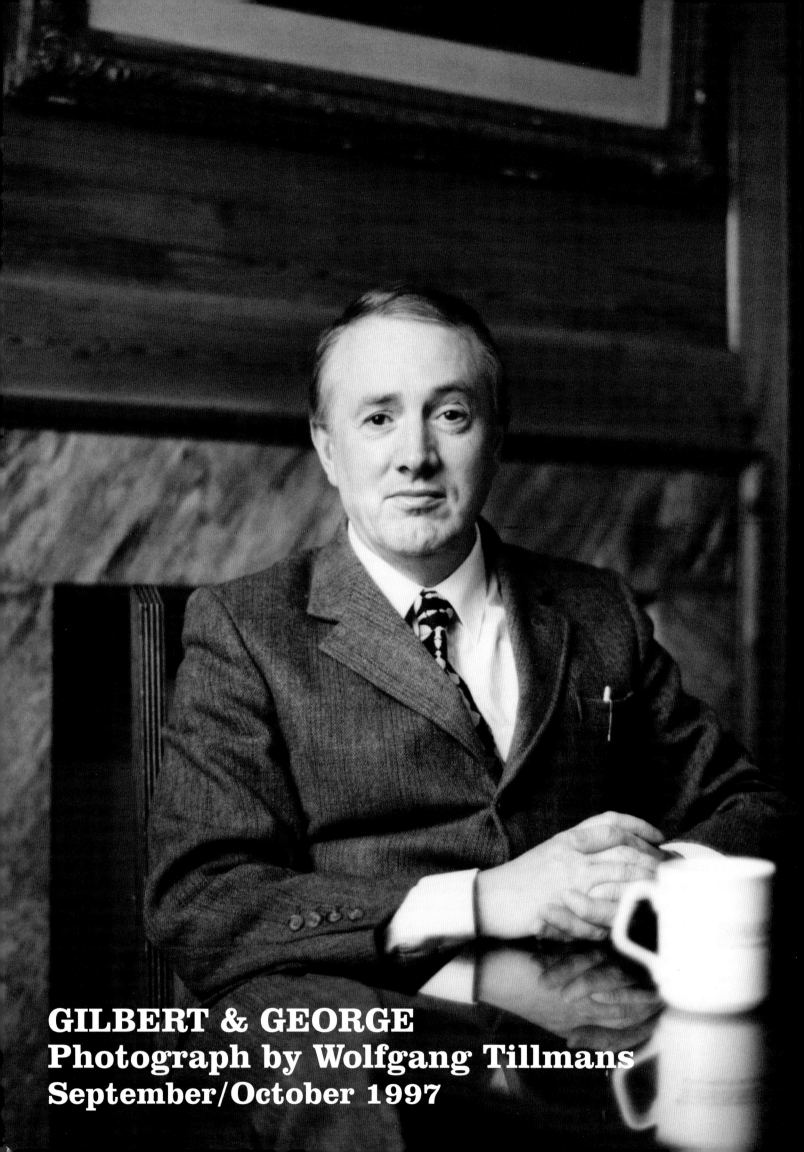

GILBERT & GEORGE
Photograph by Wolfgang Tillmans
September/October 1997

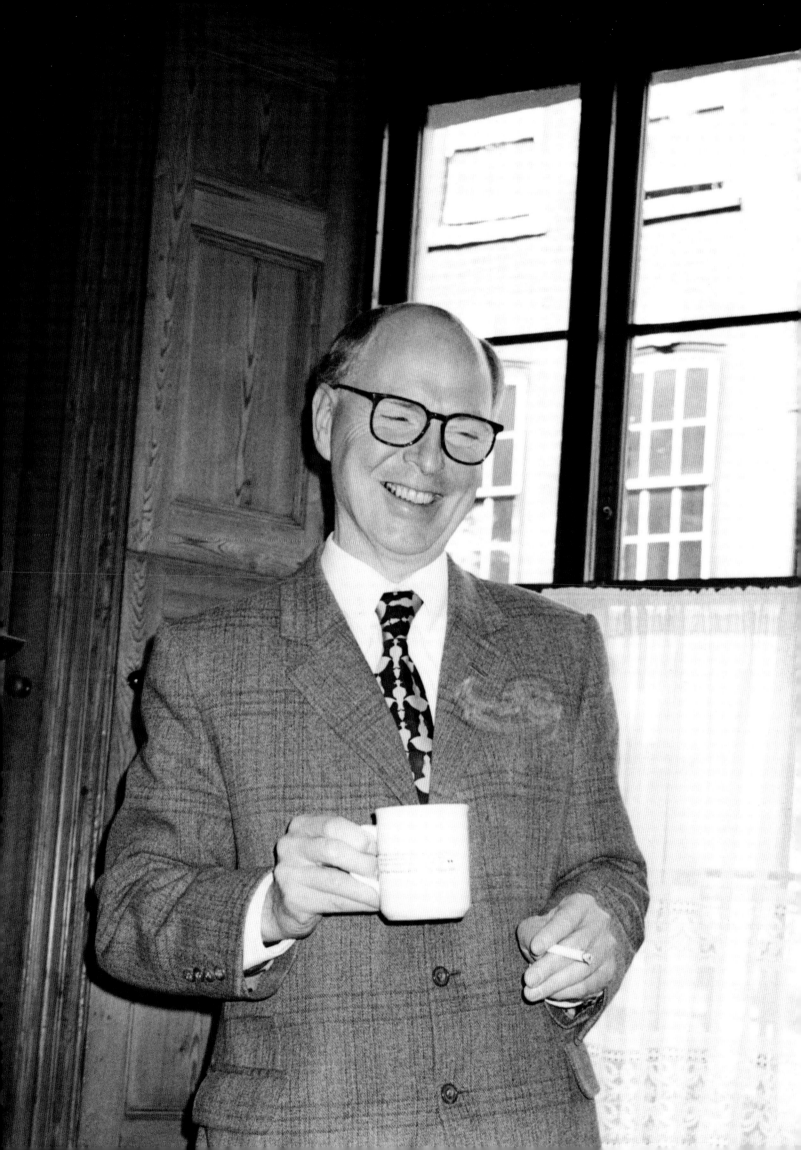

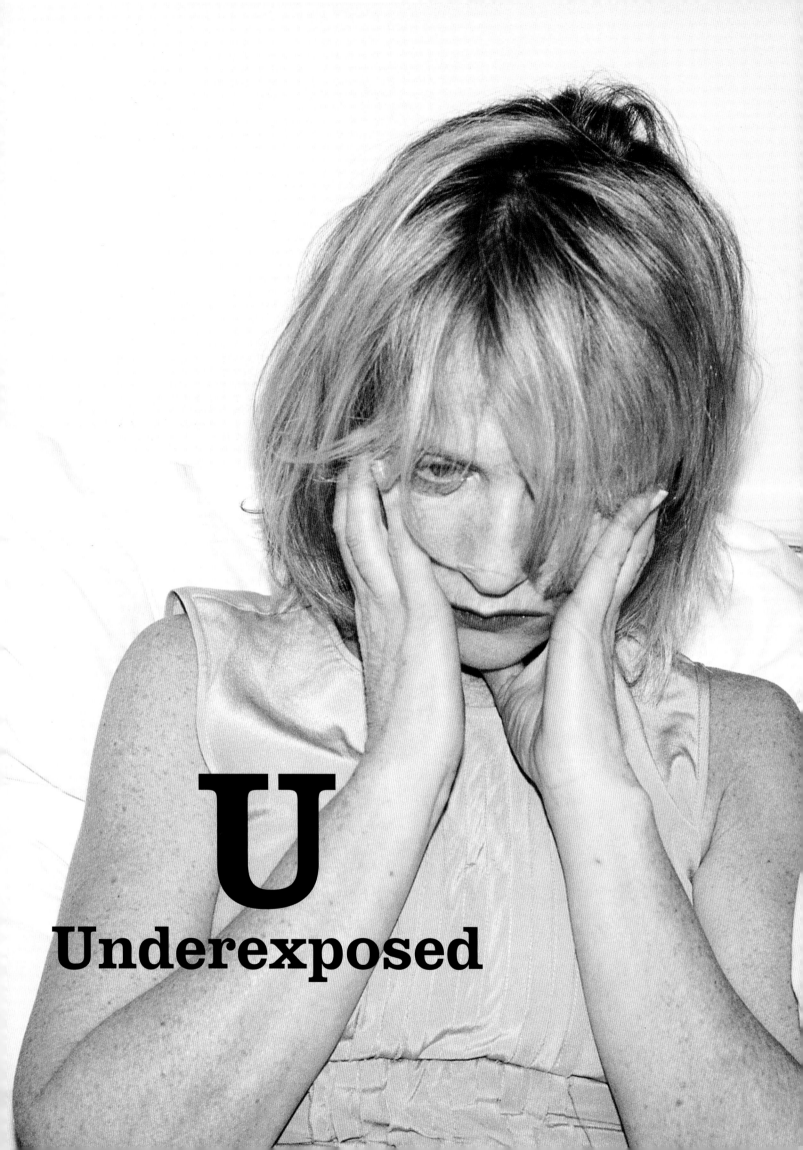

U
Underexposed

ISABELLE HUPPERT
with Cory Reynolds

Photograph by Juergen Teller
June/July 2002

CORY: How do you approach your roles? Do you have a consistent method?

ISABELLE: I wouldn't say I have a method, but I'm quite attached to the idea of trying to get as close as possible to the truth. Very often, actors want to idealize their characters, or they want to be as fascinating as possible to the audience. That has never been my concern. I'd rather focus on what I think reality is, with all its ambiguities and complexities and shadows. A little bit of good and bad—that's a human being, you know?

CORY: Even so, you're known for choosing particularly edgy roles.

ISABELLE: I never play entirely sympathetic characters. But the great thing about film today is that the line between good and bad is more blurred than it was thirty or forty years ago. So in some ways, I'm just reflecting the spirit of our time, when it's so difficult to determine who is normal and who is insane.

CORY: For example, Erika, the character you play in Michael Haneke's *The Piano Teacher*.

ISABELLE: A lot people have talked about her as being insane or abnormal, and, of course, I never entertained the idea that she was not normal. I mean, for me, she's quite normal. Or if she's not normal, then nobody is.

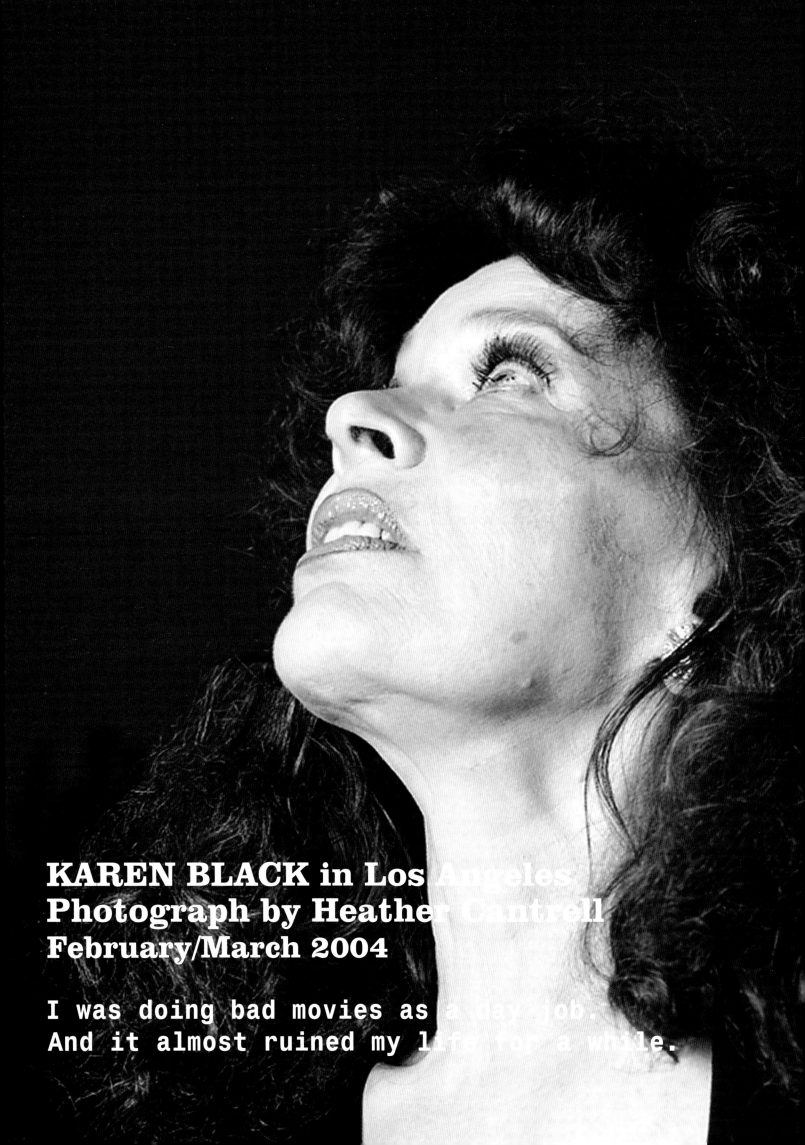

KAREN BLACK in Los Angeles
Photograph by Heather Cantrell
February/March 2004

I was doing bad movies as a day job.
And it almost ruined my life for a while.

DAME DARCY READS THE PALM OF RICHARD FOREMAN

MAY/JUNE 1999

RICHARD: I'm interested in very esoteric stuff, in art and so forth, and yet I'm pretty unhappy about the world around me, and I always have been. That's why I escaped to France for many years. But I'm an American. I have to be here in America. And I really can't decide how much I should push toward making more accessible work or work that's going to speak only to the happy few. Because that's what I did for many years. I'm always torn between those two options. The play that I'm doing now, *Paradise Hotel*, represents for me the most populist thing that I've done, the biggest crowd-pleaser ever. But in the context of this society, should I continue operating that way? Or should I do something that is really esoteric, and a lot of people are just not going to know what to make of it?

DD: Maybe you could do both.

RICHARD: I bounce back and forth. I have sort of alternated in certain ways for many years doing one kind of thing, then doing the other. But it still remains problematic for me, very problematic

DD: I think it's really wonderful that you're questioning things. Even though you're not a kid, you're still questioning things like a kid.

RICHARD: Oh, I am like a kid. I'm very adolescent. I think all Americans are pretty adolescent. But I'm one of them. And I'm well aware of the fact that it shows up in my work.

DD: That's not bad.

RICHARD: Oh, I don't care.

DD: Who influenced you to be this way and to work like you do?

RICHARD: Now, literary influences are one thing. For many years, people like Bertolt Brecht and Gertrude Stein—neither of whom interest me that much anymore. But there are two people who really changed my life, and one was Jonas Mekas. He's the head of what was called the underground film movement in the '70s, and now he runs the Anthology Film Archives. Jonas was a totally selfless person, a moral example, a kind of St. Francis of the artistic movement that was independent film in America. He opened me and many others to the realization that really wonderful art was being made by young people who were starting to make movies all by themselves, which was unheard of . . .

DD: In the '70s, this was?

RICHARD: Yeah. And they were not ashamed of the awkwardness of their efforts, which had a certain beauty. That was profoundly important to me. I had gone to the Yale Drama School to be a playwright, and I spent many years trying to write my plays so that I did not hear my mother's voice in them. My mother used to read stories to me and my sister at night. And when I would write a play, as I'd

read it back to myself, I would hear my mother's voice reading it. And I thought: "Oh, my God, I've got to sound like Sartre or Tennessee Williams. I can't sound like my mother." So I'd rewrite and rewrite. But through the influence of Jonas and the work of all the filmmakers around him, I finally realized: "You know, if I'm going to sound like my mother, I'm going to sound like my mother. That's me." So it was very important.

DD: That's actually really touching.

RICHARD: My other big spiritual influence was George Maciunas, who started the Fluxus movement—and who started SoHo. George set up the first artists' co-ops in SoHo. He would get artists together, buy a building, and make a co-op. This was in the days when it was illegal to live here. This building that we're in now, where I live—one day I went to George and said, "Well, I've screwed my courage to the sticking point. I, too, want to move down to SoHo."

DD: When was this?

RICHARD: It was 1970. In those days, it cost $10,000 to buy this space.

DD: Oh, my God.

RICHARD: Well, it wasn't like this. It was a doll factory.

DD: A doll factory? Wow.

RICHARD: So George had armies of starving artists who at dirt-cheap rates would come—and I helped too, of course—and build these lofts. He was such a selfless, crazy person . . . the head of Fluxus, which was a kind of neo-Dadaist movement in New York. And the example of George, just killing himself for his totally wacky visions about all kinds of things, was the other big influence in my life. So these were my gurus, really—both Lithuanians who came here after the war.

DD: So how were those films an influence?

RICHARD: They were totally personal, idiosyncratic visions, really personal visions. These filmmakers were doing something that spoke to me, and theater did not.

DD: What made you interested in theater in the first place?

RICHARD: When I was in the second grade, we had a Christmas play. Everybody was given a line, and my line was, "Here comes the Yule log." But I was so shy that I couldn't say it loud enough, and they took my line away from me. So I said, "I'm going to show them." And when I was about fourteen, I was still shy, but I started putting on my own plays with my schoolmates, because that was a way in which I could relate to people—in the context of doing these plays.

DD: Just like now.

RICHARD: Yeah. And although I soon began to realize that things in other arts were much more interesting, the theater was what I knew, and I thought it was a challenge—if you could do serious art in the theater, of all places, that was a better achievement.

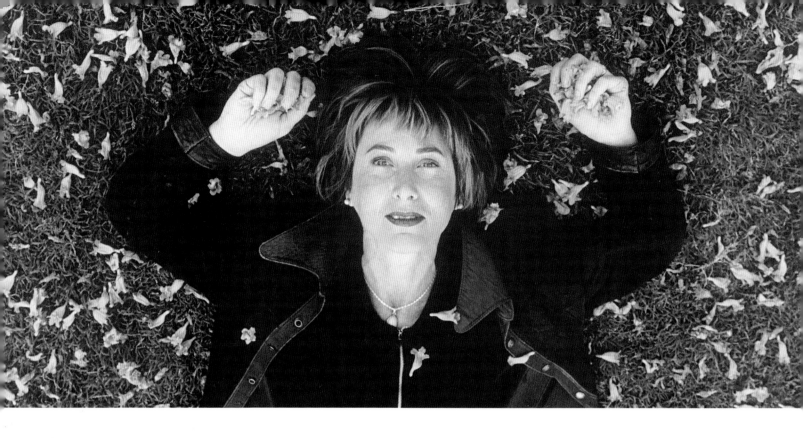

CHRIS KRAUS with Jean Rasenberger

**Photographed in Los Angeles by John Dunne
September/October 2000**

Kraus's books are unsparing, provocative, and, in their own way, beautiful. Both are part of the Native Agents fiction series—which Kraus herself also edits—published by the independent press Semiotext(e). Established in the late '70s as a series on contemporary philosophy and theory, Semiotext(e) is the brainchild of Kraus's husband, author and critic Sylvère Lotringer. Since the inception of Native Agents ten years ago, some of the most subversive voices in contemporary fiction have been included in the series: Kathy Acker, Eileen Myles, Michelle Tea, and Lynne Tillman, to name just a few.

JEAN: In some ways the Native Agents series was exactly what was missing from Semiotext(e).

CHRIS: Exactly. That was the genesis of it—a way of thinking about subjectivity outside of psychoanalysis, outside of impersonal theory. So the Native Agents books really aimed to be a radical practice of subjectivity.

JEAN: Because the writing is of a personal "I" nature. Not that it's necessarily diaristic or journalistic, but it's an "I" speaking.

CHRIS: Right. And that's so easily, and still so often, misread. The whole idea that "I" could really be conceptual, that it could appear in many ways through different masks, is lost on a lot of people. It's read as true confessions. What groups our books together is a very polemical "I," and the outcome of the narrator's story isn't necessarily central to the action of the book. They're very robust adventures, and they're

funny books. I don't think that we've ever published anybody who's been through a creative-writing program. [Laughs.]

JEAN: They're action books.

CHRIS: They're adventure books, which are still so lacking in female writing. Female writing is still kind of small, closed, domestic—such a micro-micro picture. And these are great big adventure books.

JEAN: I admire your ability to take to task what I refer to as "The Academy of Boy-Dominant Theory."

CHRIS: Part of what I've hoped to do with the series was to help create a girl-underground culture. With my generation—growing up around the underground—it was so hard to find your place in it as a girl, because nearly everyone you admired was a boy. And where did that leave you?

JEAN: Longing for daddy still. [Both laugh.]

CHRIS: I definitely see the books that I publish as presenting this underground female adventure hero. I really want a female adventure hero. And in my own books, because I've been so close to this male avant-garde theory and rhetoric, and it's so much a part of how I see the world, I need to work through it and find a way of claiming bits of it as mine, and reject and redefine other bits of it. Like, when I talk about chance in my book *Aliens & Anorexia*—is there a female chance? And how would the female chance be different from the male?

JEAN: And what do you see as the difference between female and male chance?

CHRIS: It started to seem to me, just from my own experience and little stories that I tell in my book, that female chance is so much more defenseless and wild. Male chance somehow had to be engineered and arrived at. But for a female to cut herself loose in the world is to open herself up to chance.

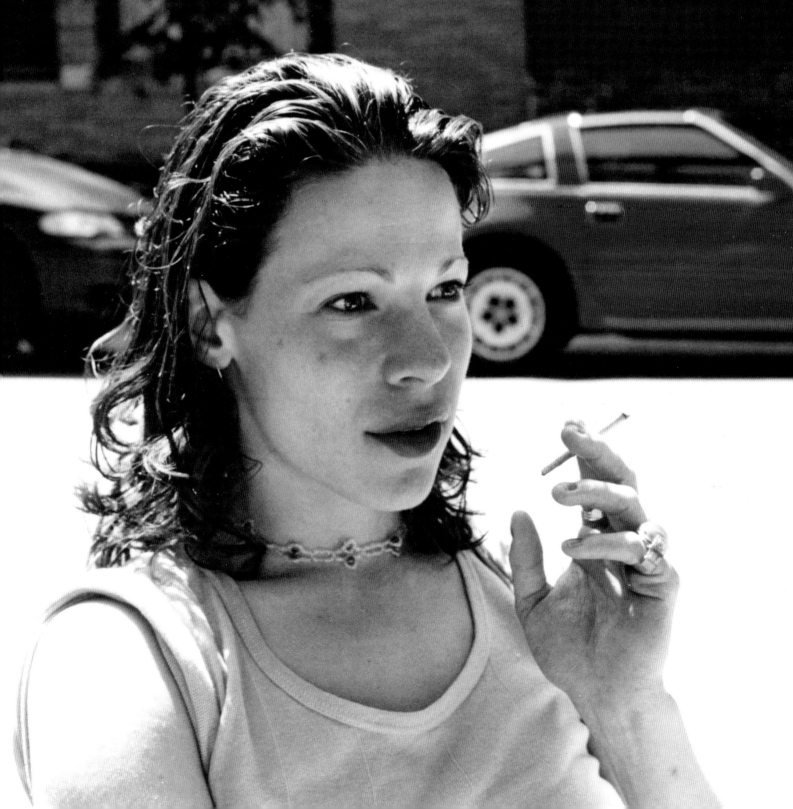

LILI TAYLOR with Steve Lafreniere
Photograph by Lucas Michael
September/October 1998

STEVE: I keep thinking how ... unbelligerent you seem considering all the
things arrayed against you.
LILI: The weird thing about this business—and I'm sure this operates in many
other areas, but it's very present and acute in this business—is that a lot
of people don't realize that they have power. Particularly actors. There's
a bizarre illusion of helplessness. That you have to take things that you
don't want to do, that you have to play by certain rules. And those rules ...
I kept thinking, "Who made these rules up? I don't believe in these rules."

JEAN TOUITOU
with Mary Clarke

Photograph by Lucas Michael
March 1997

MARY: So when you first started A.P.C. back in 1987, did you have to do a lot of explaining?

JEAN: Yes, people were saying, "Oh, you're doing basics." And I just hate that word. Because for me, a basic is when you're starving and you grab anything to cover your body against the cold or against the heat. That's a basic for me. So I had to explain that I put my hysteria into trying *not to be* exceptional. I put my hysteria into trying to be normal. And that takes a while to explain. Because that's totally hysterical, to work that much, to do something that just looks invisible.

MARY: Is it true you'd like to do only one collection a year?

JEAN: Yes, maybe one and a half a year would be right. We have to create a new year that will have fifteen months. Because this rhythm of producing something every six months is just insane. It's just too fast. You're just finishing one collection, and you enter the next one. It's too quick.

MARY: Is it harder to design for winter or summer?

JEAN: Summer is very hard for me because I love heavy, military pieces. Basically that's what I love. People don't follow me too much in my choices for summer, but I'm pretty satisfied with this particular collection, because I sort of hated the winter I did before. I think I went out of control. I did too much.

MARY: You're talking about the winter stuff that's in the stores right now?

JEAN: Yes. Now I have such a good team, one morning I could say, "I want to do this printed wool thing," and then they go, "Jean wants to do printed wool." So they run everywhere, and all the information is on my table two days later. So now, whatever I say gets done. And that's a catastrophe, because it's impossible for a store to look good with so many styles, even if one by one they are nice.

MARY: We're sitting here in the press room surrounded by spring samples. Do you also do runway shows?

JEAN: No, I just stopped, I just stopped. At one time I did a few little shows in some strange places, but I just think it's impossible to show clothes in the proper fashion. One has eighty-five shows and everybody is exhausted and everybody is fabulous: "Where am I seated, what should I wear today?" And those gimmicks are so pathetic. The only thing amusing about the shows I did was that there was no specific seating. The chairs were not in line, and there were no names on the chairs. So it was interesting to see who was going to sit where.

MARY: Are there people you think about when you design?

JEAN: Yes, of course, sometimes . . . but less and less. I have fewer and fewer heroes. I keep getting older.

MARY: Didn't you once mention Brian Jones?

JEAN: Yes, because Brian Jones was a prototype of this mixture of a horrible person who could look like an aristocrat. I mean, he had terrible respect with his personality, but he was also an incredible musician and would look really good. He had a very good style. I was also watching not only musicians like Ray Davies and Brian Jones, but also a lot of Samuel Beckett. His attitude with clothes, I totally appreciated. Because he was at the same time very austere and very, very elegant.

MARY: A lot of what you do reminds me of stuff Bob Dylan wore in the mid-'60s "Don't Look Back" era.

JEAN: Sure, it's true. But it's more than that. I mean, I was an adolescent during the '60s, and that's when it hits you. So, yes, it's always there. People say, "Oh, a '60s revival," but I've always thought that was the last elegant period in fashion.

MARY: In addition to your team, you collaborate with other designers sometimes, right?

JEAN: Yes, yes, yes. Because I'm very jealous of the music world, where people record something and send it to another artist, who basically is also a competitor. They say, "Why don't you mess around with my tape?" They're competitors, but also there is a community thing. And through my mail-order catalogue, every season I invite a designer to use me as a producer, as a publisher. I say, here's my fabrics, please give me your colors and your design, and we'll cut the pattern, and we'll make the samples, and we'll give you a very decent royalty. I did it with X-Girl, Anna Sui, Martine Sibon, Xuly Bet, and with Milk Fed too. And I really like working this way.

MARY: How is the catalogue doing?

JEAN: I'm really happy with the way it started in America. You know, I'm not an industry person. I don't get high on big figures and stuff. I'm totally satisfied. It's only a five-digit figure for this year. But I'm very happy. It's soon going to be a six-digit figure. I don't think it's fun to have a huge catalogue with zillions of girls on the front, so it's doing fine. In France, it's the same. And then in Japan, it's extremely big . . .

MCDERMOTT & MCGOUGH
Photograph by Brian Berman
April/May 2002

If you try to understand new ideas through the framework of the past, you can see them for what they really are. Sometimes you can get to a place that nobody else can get to at all.

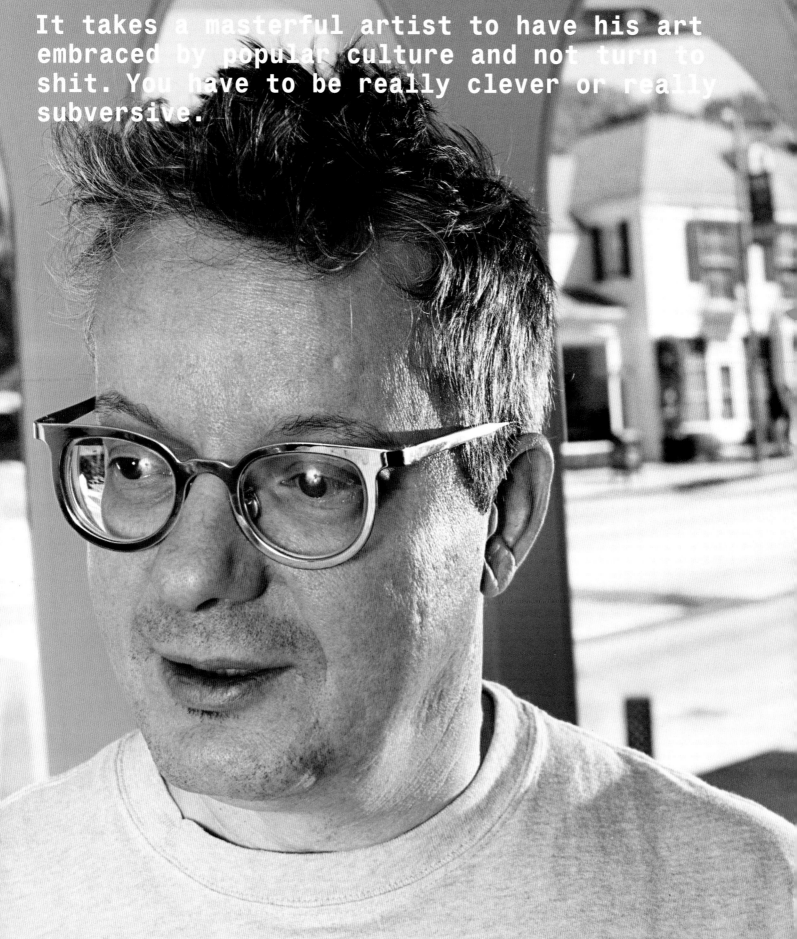

MARK MOTHERSBAUGH
Photograph by Richard Kern
November/December 2002

It takes a masterful artist to have his art
embraced by popular culture and not turn to
shit. You have to be really clever or really
subversive.

SURVIVAL GUIDE: ALLEN TOUSSAINT BY JEANNE P. NATHAN
JUNE 1996

Allen Toussaint is a seminal American songwriter, arranger, producer, singer, and pianist whose music is infused with the sensuality, tenacious originality, and funkiness that is New Orleans. He is best known for writing and producing hits over four decades, from Al Hirt's "Java" and Herb Alpert's "Whipped Cream," to '60s classics such as "Working in the Coal Mine," "Lipstick Traces," and "Mother-in-Law," to the '70s hits "Southern Nights" and "Lady Marmalade."

A soft-spoken, highly private man, he moves as slowly as New Orleans, yet has a magnetism that has captured the hearts and imaginations of many. As a legendary producer, he has worked with everyone from Lee Dorsey, Irma Thomas, and Dr. John to Patti LaBelle, Joe Cocker, and Elvis Costello.

Allen Toussaint continues to offer the musical gems and spirit of New Orleans with *Connected*, his first full-length album in almost twenty years. And he shares his profoundly philosophical relationship to life with us here today.

PRODUCING
In the early days I was playing with artists others sent to me, or those I had chosen. I would look for uniqueness . . . not what is better; that doesn't apply in the art world. But outstandingly unique. Everyone is unique, even if bad. I chose people convinced about what they were doing. People who came across in a good way. When I began to produce things, I was listening and paying attention to the artist, hearing the highlights . . . vocally and spiritually. As a producer, I hire musicians, do rhythms, songs, and words an artist would feel good saying, believable words . . . so they can believe in it themselves.

THE VOICE
I didn't have much time for the luxury of getting to know them. I needed to hear something about the voice, sheer voice, and not much about the person. But I would get to know the voice when it touched the right place in the ear or the spinal cord. I write for the voice itself.

SONGWRITING
It's according to how it comes. Some are totally inspired and stay with you, help you, hug you. Others are a quick plot. Now that the plot has come, you have an assignment to do. Sometimes it's like listening to what it would say next rather than forcing it . . . Words are pretty general—been around for thousands of years. It's the distinction of what the words meant when the inspiration came that is important.

STYLE
We all have a signature, a spiritual penmanship. We simply are who we are, moving about. I couldn't imitate me. When someone else describes me, I can recognize me.

SEEING
However it all translates . . . I still take in my immediate environment. I take nothing for granted. I ride around in the middle of the night and look at New Orleans, its shotgun houses, streets I haven't been down before. When a building is missing, I know what was there before, because I took it in. I really care about and love it, so it impresses me, and I miss it when it's gone.

NEW ORLEANS
I take in New Orleans all the time. It's reflected in everything I do. New Orleans is all about charm itself. Old World charm. The pace is slower in every way, getting to the next block . . . getting to the next decade. There is a price, but if you stay right there in it, you don't know any different. Even our hearts beat a little slower, the pace is so relaxed. The music reflects it too. It is something so strong that it can't be destroyed. New Orleans will always influence New Orleans, just as Chicago influences Chicago, and New York, New York.

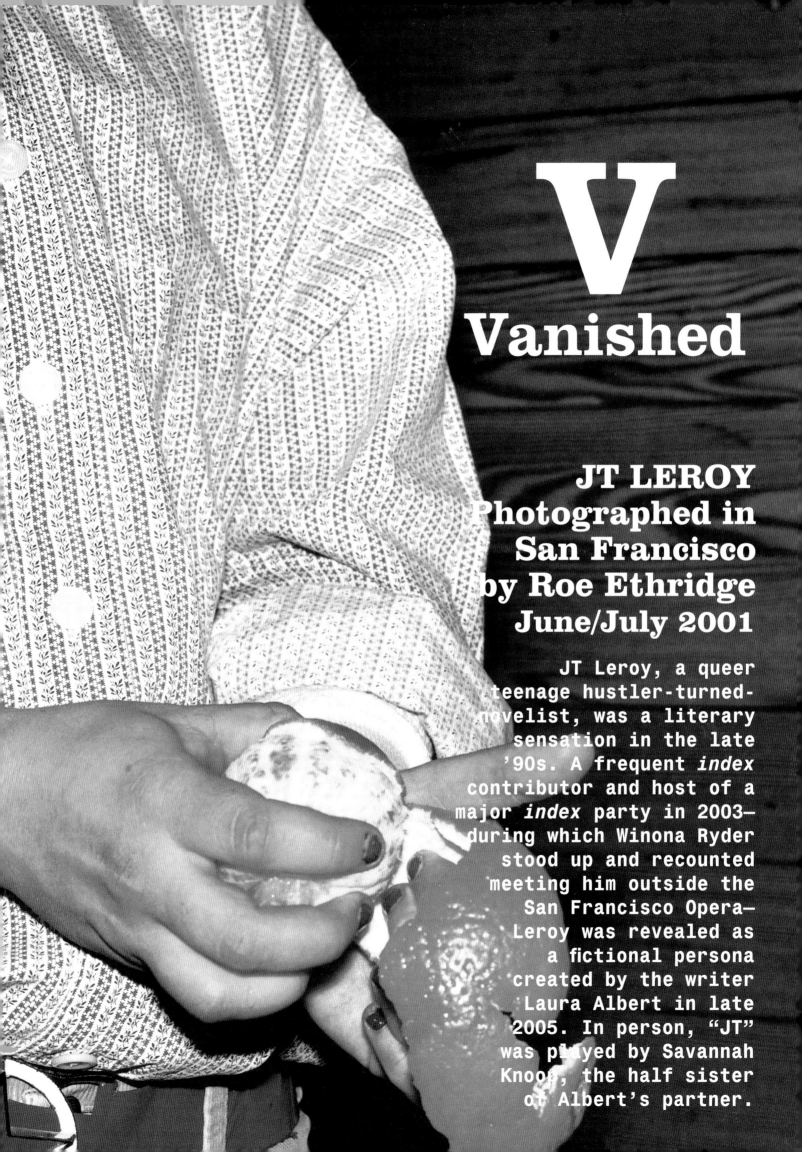

V
Vanished

**JT LEROY
Photographed in
San Francisco
by Roe Ethridge
June/July 2001**

JT Leroy, a queer
teenage hustler-turned-
novelist, was a literary
sensation in the late
'90s. A frequent *index*
contributor and host of a
major *index* party in 2003—
during which Winona Ryder
stood up and recounted
meeting him outside the
San Francisco Opera—
Leroy was revealed as
a fictional persona
created by the writer
Laura Albert in late
2005. In person, "JT"
was played by Savannah
Knoop, the half sister
of Albert's partner.

JT LEROY with Bruce Benderson

June/July 2001

BRUCE: You recently mentioned that I might not know the new you. What did you mean by that?

JT: Well, here's an example. I recently sent a thank-you gift to the first editor that my shrink, Terry Owens, sent my work to.

BRUCE: So the change is from a scamming street hustler to a legitimate author and a genuine communicator?

JT: Well, I'm not saying that side is completely gone! [Both laugh.] But I was a really different person when I was on the street and on drugs.

BRUCE: When you were sixteen, you seemed fragmented and unpredictable, and I never knew whether you might be in trouble. I rarely worry about that anymore.

JT: I still have some of those problems, but they're not as out of control. I used to feel like a car just careening, with no one driving. A lot of the time I still feel that way—but that's not the reality.

BRUCE: I'm wondering how you discovered the craft of writing.

JT: Early on, when I lived in Seattle, I was attempting to steal a copy of *Try*, by Dennis Cooper, from a bookstore. And a guy was following me around the store, because I didn't look like someone who was shopping. And I just thought, fuck, because I had the book in my hands. So finally the guy asks if he can help me, and I think maybe he wants to trick, so I kind of respond. And now he's really about to get gnarly. So I ask, "Do you know where I can find transgressive fiction?" I'd just learned that term, and I felt like a bad-ass bandying it about. I held up the book. And all of a sudden, he changed his attitude. It was like pressing buttons on a robot. He was like, "Transgressive fiction, must help." I turned from a suspect into a person he had to assist. And then he gave me several books, including Mary Gaitskill's *Two Girls: One Fat, One Thin*. I actually felt like I had to buy them at that point to hold his respect. So I bought them, plus the copy of *Try* that I'd been hoping to stuff into my bag while he wasn't looking.

BRUCE: That's when you started thinking about writing as an art?

JT: That's the thing. One book was about a guy who was in prison, who'd had this horrific childhood. But I realized I didn't give a shit about his story, because it was written so badly. It had no beauty; it did not engage me. And then I read Mary Gaitskill's book, and it was beautiful. She wrote about characters that I would not have cared about normally, and I cared. That's how I learned the power of craft. Before that, I was just addicted to having people respond when I wrote for my therapist's class.

BRUCE: So writing began as a therapeutic tool, and then you thought of it as a way to communicate with others, and then finally you got involved in the craft.

JT: Right. But I first became aware of good storytelling when I lived with my grandparents. We had to write biblical scenes. Like, "Moses meets Jesus: write a scene." I learned that if I could write a powerful, emotional story that was beautiful as well, I got more response. Otherwise, there weren't many pats on the back.

BRUCE: You wrote for positive attention.

JT: I was really starved for it. I was used to getting attention for my body, or for sex, or for bad behavior. But not for something like this.

BRUCE: You've made no secret of how you survived on the street. Some of it had to do with prostitution. I wonder if there's any parallel between the activity of prostitution and the activity of writing?

JT: Big-time.

BRUCE: You've written about how you created characters for yourself when you were tricking. You fulfilled other people's fantasies by pretending to be who they wanted you to be, making up false names and stories about yourself . . .

JT: Yeah.

BRUCE: Maybe that's hard to talk about.

JT: It is. Someone once told me I'm "a very baitable worm"—meaning I have a lot of bait parts that the media would be interested in. When *Sarah* first came out, I made a pact with Dennis Cooper that I wouldn't talk too much about certain things—because opening up to an interviewer can give me the feeling of sitting down with a trick who wants to get a lot out of me. Not with you—you're a friend. But, you know . . .

BRUCE: Well, the autobiographical nature of your writing makes you especially vulnerable to the media.

JT: The thing is, I always want to become friends with the interviewer. I find myself wanting that attention, that connection, especially if they're cool. It's very hard when I feel they want something from me or have expectations. It's hard for me to hold on to what I want to say and what I want to give. Like, some interviewers only want to talk about prostitution, and I don't want to talk about that. One article was all about how the interview took two hours because I kept hanging up. That interview really upset me. Because people can worm in on me—I'm not good at boundaries. I tend to say stuff that I don't want to say.

BRUCE: Well, let's talk about something different but related. I have never encountered another writer who has, in such a dynamic and enthusiastic way, sought out so many of the creative artists who have been inspirational to him. You've become friends with most of the people you've sought out. What do you get out of contacting these people?

JT: It makes me feel like a real person. When I read a work that impresses me, I want to consume the book. I want to memorize it. I feel a desire to connect with that person.

BRUCE: Once you connect, what's it like?

JT: Often it's really amazing. Like, I read Mary Karr's book, *The Liars' Club*, years ago. It really changed how I wrote. So I contacted her, and now we've become really good friends. Mary Gaitskill and Dorothy Allison too. They all educate me, steer me towards books, offer wisdom. I feel like a hungry fucking sponge—I'm in awe

of these people. And besides that, they all have experience with the industry. Like, I went through this period where I had to figure out how to work with an agent. In A.A. they call that a "high-class problem," but it was very upsetting. So I was able to call Michael Chabon and Tobias Wolff and some other people and ask, "What do I do, what do I do?"

BRUCE: Your most intimate friendship with a writer is with Dennis Cooper. How did you find him?

JT: I went to the library, and I asked, "If you wanted to write to an author, what would you do?" The librarian looked in a book, wrote down the agent's number, and I just called. I was so scared. I had stolen—well, borrowed—a calling card.

BRUCE: You just called Ira Silverberg?

JT: Yeah. He told me to fax in a request. And so I went to Kinko's and all that. Later that night I spoke to Dennis, and we just connected. His novel *Try* meant everything to me. At that time I was still tricking, using the name Ziggy—which is the main character's name in *Try*. And then later, Dennis sent me your book, *User*. And I experienced that strong feeling of wanting to know what you knew.

BRUCE: I'll never forget the first time you called me. Your voice sounds incredibly young, so when you told me you liked *User*, which was about Times Square hustlers and crackheads, I thought, "My God, this kid in junior high is telling me he likes my X-rated book. Could I get arrested for discussing it with him?" But that was just the beginning of a very deep relationship for me. Because the more I heard about your life, and the more I saw of your work, and the more I talked to you, the more I realized that you were influencing *me* in a really meaningful way.

JT: It was amazing for me to have that kind of connection with you, as a writer. It was powerful that you cared about me without it having to do with, like . . .

BRUCE: Sex.

JT: Right. You were, like, my Jewish mother. [Laughs.] And I'd never had one of those, so that was really an experience.

BRUCE: Well, I know I fit the bill physically. [Both laugh.]

JT: But, seriously, I never had the experience of going to school and having classmates to ask, "What do you think of this thing I'm working on?" So I'd wait for you to wake up in the morning, or I'd call late at night. I'd read to you, because I really needed permission. I'd write a paragraph and need permission to go on.

BRUCE: The prose in *The Heart Is Deceitful* is very different from the extremely constructed, sophisticated, musical prose in *Sarah*. In a way, *Sarah* can be read as entertainment. It's about an underage boy who dresses as a girl and is a truck-stop hooker— yet you come out of it entertained and amused. The new book leaves you with your mouth gaping, devastated.

JT: I think people also come out of *Sarah* pretty devastated. I've gotten a lot of E-mail from people—I put my E-mail address in both books because I really wanted to make myself available— and the response has been mostly a combination of devastation and hope.

BRUCE: *Sarah*'s a very fanciful book, and it's got lots of satire and funny scenes.

JT: Yeah. That's one thing that reading Mary Karr and Frank McCourt has taught me—humor makes the story more powerful. You reach a saturation point with pain. Like, how many stories can you read in *The Heart Is Deceitful*? If you have humor, you can take people further with you on your journey. You won't trip their wires.

BRUCE: Do you feel that the public and the press understood what you were trying to do with *Sarah*?

JT: Yeah, I've learned a lot from the press. I got, maybe, five bad reviews for *Sarah*. Otherwise, I've gotten all these amazing, analytical reviews. And people talk about these new stories being so structurally well-crafted too. But the truth is, when I sit down, I have only a vague idea where I'm going. When I wrote *Sarah*, I really didn't have it plotted out.

BRUCE: That relates to what we were saying before: your sense of craft is intact, but on an unconscious level.

JT: Having a story inside is not something I enjoy. With *Sarah*, I felt like a dog had a hold on my throat and was shaking the hell out of me. All I wanted was for it to be done, but the story kept saying, "No, you have to go here." I was driving in thick fog—I couldn't see far ahead.

BRUCE: You know so many high-profile people, and yet you've kept fairly anonymous. There are very few pictures of you. You don't do public readings. You rarely give live interviews.

JT: There have been all these rumors about who really wrote *Sarah*. I like the idea that people think Dennis Cooper actually wrote my books . . .

BRUCE: But that's different. Why do you stay incognito?

JT: I keep my life very controlled. I don't leave the house that much. When I was on the street and doing drugs, my life was outside. That was how I functioned out there. So now I keep my world really small, because I'm still learning. I went from doing drugs to being out of control, to being in a parental situation and having a book come out, to dealing with the media and the press, all in a really short time. And that's pretty fucking heavy to deal with.

BRUCE: Even though you love and need attention, you just don't want to be recognized.

JT: I have such mixed feelings. I really don't want people to come up to me on the street or in the outside world. I don't like being looked at physically. When people look at me, I think they're thinking really horrible things. I take medications that help, but, oh, my God, if I had to do a reading and have people look at me, and hear what they were thinking . . . I mean, I'm still figuring out who I am on so many levels. If I were out there getting all this attention, and people were telling me, "Oh, you're wonderful, you're great," I'd be back on drugs so fucking fast, it wouldn't be funny.

BRUCE: So instead you circulate misinformation about yourself.

JT: Yeah, I really like the idea that if I need to escape, there are lots of people who will come forward to claim that they wrote *Sarah*, that they wrote everything. I've laid the trail.

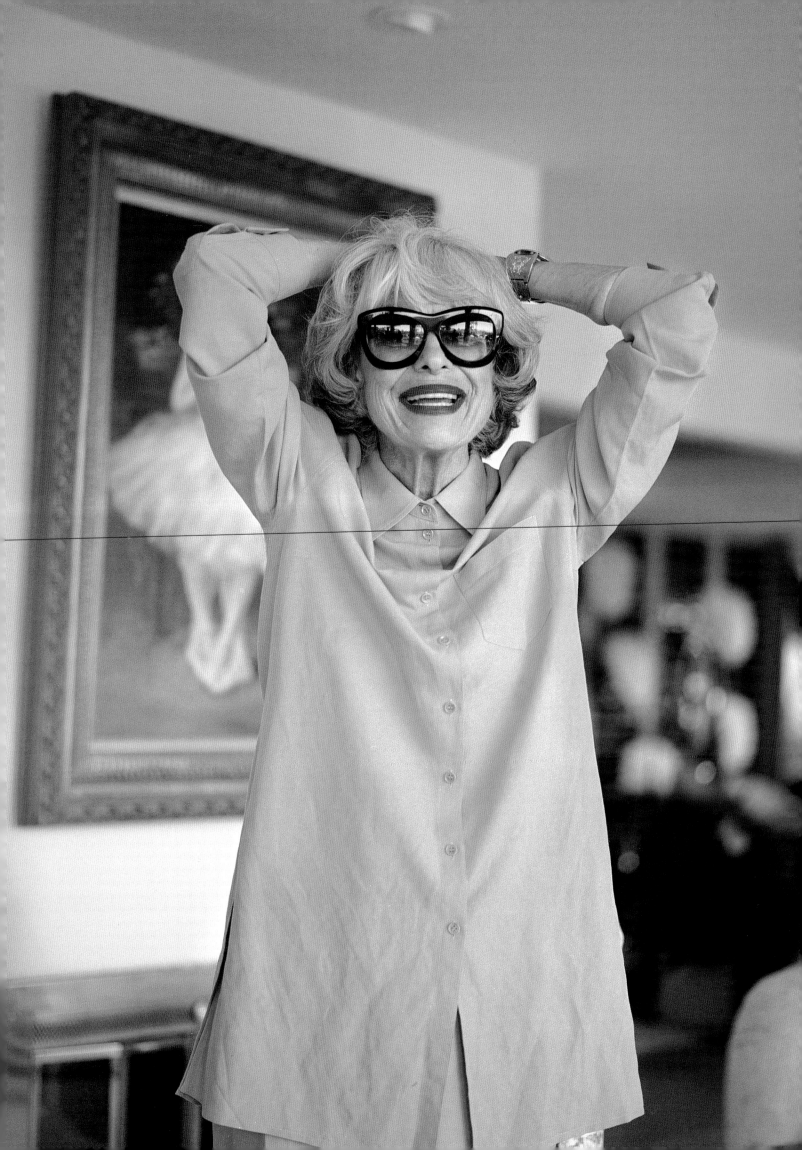

DAME DARCY READS THE PALM OF CAROL CHANNING
FEBRUARY/MARCH 2000

Photograph by Sheryl Nields

DD: You've got an incredibly long life line. And you get stronger as you get older. You'll keep going forever.

CAROL: Well, people are living to one hundred now as a normal thing.

DD: You might be one of them.

CAROL: Yeah, but how ugly you get when you're beyond a hundred.

DD: People have a lot more character when they get older. And I think character is always better than beauty in the end.

CAROL: Oh, I agree. But now everybody's getting plastic surgery. All the society ladies . . . I keep wondering who I'm talking to.

DD: [Laughs.]

CAROL: Someone who was great all the way to the end was Marlene Dietrich.

DD: I love her in *The Blue Angel*. I wish all of life could look like that—that stage with the seagulls being pulled up and down with string during the nautical sequence.

CAROL: Wasn't she fabulous? To me, that's a true talent, to be able to create yourself that way.

DD: She made herself into an idol.

CAROL: Dietrich's daughter, Maria Riva, lives right down the road from here. We've always been friends. She's a writer. She wrote *Marlene*, the book about her mother. It's a work of art. It really is. And, oh, God, the things she's told me about her mother . . .

DD: For instance?

CAROL: Well, she could never get John Wayne into bed with her. Maria told me that it drove her crazy, not getting him into bed. That's the only person she couldn't get. She got everybody she ever worked with!! And sex wasn't even such a driving force. It was just ego. That scene when she looked at John Wayne—"What I could do with you if I had you alone"—that wonderful look on her face. Oh! And you adore her.

DD: Of course.

CAROL: You get the whole quality of her glamour and also her arrogance. And she was bisexual, so she could say, "If you don't like me, John Wayne, I can go elsewhere." That's her attitude! [Laughs.] You can't grab ahold of her. She's not constant. That's part of her fascination. I just think she's great. And she's probably the opposite of me. I'm a Girl Scout, you know. And she just tries EVERYBODY out!

DD: Did you ever work with her?

CAROL: No. But I knew her. Maria and I were always friends. To think of Dietrich now, it's funny—in this age of emancipated women, all we have are such little-bitty sex kittens.

DD: I know. I don't like the new Hollywood trend . . .

CAROL: Now, if I live as long as you say, am I going to have to play little old ladies?

DD: You won't have to do anything you don't want to do. Everything is looking great.

CAROL: Is it comedy mostly, I hope?

DD: Yes.

CAROL: Good. I never had to do anything I didn't want to do. Every part I had, I was madly in love with it. So many people, when they're under contract, like the movie stars used to be, they're always stuck with the same parts. But I always got to do just what I wanted.

DD: That is lucky.

CAROL: Well, I notice it usually sells tickets too, if a person is doing just what he wants. Also, the response tells me what the times are. The audience tells me what's exciting now. They always do. An audience doesn't hear anything but what they relate to.

DD: Did you go to the theater when you were a little kid?

CAROL: I used to deliver *Christian Science Monitors* backstage at the Curran Theater. There was a stage door on the alley, and I could barely move the bolt on the door, so I must have been very little. My mother lifted it for me, and I went in. I thought, I'm on holy ground. It was overwhelming. This is a mosque, this is a temple, it's a church, a mother church. And then I saw the stage. I had never seen a show before, and I wondered, "What happens on that stage?"

DD: What was the first show you went to?

CAROL: I was seven, and I said, "I've got to go see Ethel Waters." I'd saved my allowance, and I got a ticket and sat down. The lady said, "You can't possibly see; do you want to sit on my lap?" I didn't think anything of it. I wanted to see Ethel Waters, so I just sat on her lap. A total stranger! [Laughs.] Then, when Ethel Waters came out! BANG! She was dynamite. And it was FUNK. It was purely funk. I had never heard funk before.

DD: Wow.

CAROL: She stood there, and she was towering over me. There was a silhouette of a man hanging from a tree with his head and his feet still but dangling. My father was a newspaperman, and they were not allowed to speak of lynching at that time. They could not do it; they wouldn't allow them. And here was this song, written by Moss Hart and Irving Berlin, no less—the two greatest. They said, "This is the woman's going to do it." And she did. She sang about a lynching. [Carol begins to sing] "Supper-time. I should set the table 'cause it's supper-time. Somehow I'm not able, 'cause that man of mine ain't come. Children will be yellin' for their supper-time. How will I keep from tellin' that that man of mine ain't comin' home no more?" And he's hanging there, right behind her in a silhouette on the stage. He's just hanging there.

DD: My God!

CAROL: At the intermission, the people were looking through their programs and stretching their legs, and I thought, "They don't know!" But I was just like . . . Wow! It was blood curdling. And she was monumental. All I thought was, "When I grow up, I want to be Ethel Waters."

SURVIVAL GUIDE: J.G. BALLARD WITH PETER HALLEY AND BOB NICKAS
NOVEMBER 1996

THE FUTURE

Does the future still have a future? That's what I want to know. Is it what it used to be? No, I think the future is about to die on us, actually. I think it may have died a few years ago. I think we are living in the present. We theme-parked the future just as we theme-park everything. We theme-parked the past. We theme-parked the future and visit it only when we feel we want some sort of glittery gimmick. But maybe I'm a bit jaundiced, having reached the age of sixty-five.

AUDIENCE

It's very difficult for a writer to know who his readers are . . . I have never seen anyone reading one of my books. Unlike the painter who goes to a gallery or museum that is holding an exhibition of his work and sees other people looking at his work, or a choreographer, or a film director, or an actor, the writer has no direct line of contact to his readership.

SCIENCE FICTION

I haven't actually written any science fiction for a very long time. People still think of me as a science fiction writer. Or some people do. Of course, to people inside the science fiction world, they are in no doubts whatsoever; they are convinced that I am not a science fiction writer. I'm some kind of housebreaker who has climbed into the ghetto at night and stolen away all of their priceless little heirlooms, their little sacred vases. I made off with them and set up a rival camp outside the wall of the ghetto. They detest me for all the obvious reasons.

THE LITERATURE OF OUR AGE

I always believed, and I have said so countless times, that I think science fiction is the authentic literature of the twentieth century. Sadly, it's largely being written by the wrong people. But, in principle, I think it is the literature of our age. Most of the mainstream novelists we now regard as holding center stage will vanish into oblivion. They won't be remembered fifty years from now. Whereas science fiction in its present form may well be unique to the twentieth century and will be seen to be the only form of imaginative fiction responding to change. We live in a century driven by change, and the main engine of that change has, of course, been technology and, behind that, science.

REASSURANCE

The great bulk of people who read fiction are reading, really, for entertainment, but they are also reading for reassurance. They are reading for confirmation of their sense of what the world is about. I'm absolutely opposed to reassuring any potential audience I have. I am trying to, in a sense, unsettle and provoke. I think the readership I have is happy with that arrangement. They are not offended by the lack of sentimental endings. My sort of maverick world does seem to appeal, fortunately, to a few people.

SUCCESS AND INTEGRITY

Integrity . . . I have none whatsoever. I have always followed my own obsessions, and I have always had a slightly schoolboy urge to shock and scandalize. Actually, that's probably not true. I have always been able to write what I wanted to write. I might not have been able to do it, say, living in New York. I think the professional landscape here is sympathetic to writers. The standard of living in Britain is low, so you don't need to make so much money to keep going. And I, for the most part, lived modestly.

DEATH

Almost anything you predict will come true. It may be that the thought of death, any mention of it, probably will be banished in the future. I think people realize more and more that they are living in an awfully meaningless universe. Religions have died. The great sustaining themes that helped mankind over the awkward fact that life is finite—those great sustaining visions gave birth to all the messiahs who have given hope of another life. All that has ended, really. People realized that their lives are largely meaningless. They look at their designer kitchens and then realize, those polyps in my colon may have other plans for me. And it's impossible to attribute any real meaning to the consumer-driven society in which we live. So the simplest way out is to just shut one's eyes.

SURVIVAL

All you can do is cling to your own obsessions. All of them, to the end. Be honest with them. Identify them. Construct your own personal mythology out of them, and follow that mythology, follow those obsessions like stepping stones in front of a sleepwalker. I think if you compromise with your own obsessions, that way lies disaster.

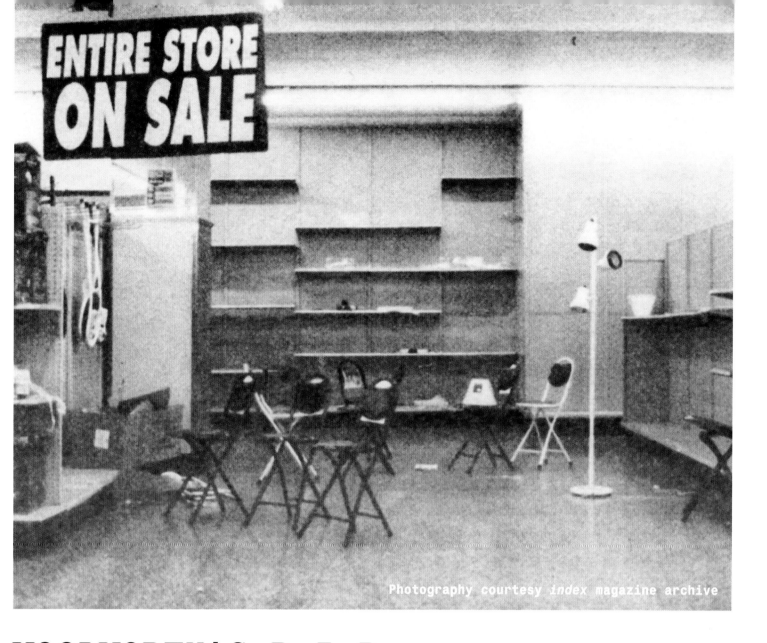

ENTIRE STORE ON SALE

WOOLWORTH'S R.I.P.
BY MARY CLARKE AND CHRISTINA KELLY
November/December 1997

CHRISTINA: Going to the Woolworth's going-out-of-business sale, didn't you feel like you were looting during a blackout?

MARY: I felt bad going in there. Like I'd stayed away too long—which I had. Before my final visit, the last time I bought something there was in 1993—a light blue undershirt for around six dollars. I saw the exact same one in Urban Outfitters for twelve dollars. So what were your final purchases?

CHRISTINA: Well, my Timex watch, with the silver bracelet, which was twenty-seven dollars—originally thirty-four. It's so pretty and classic, unlike those tacky, nouveau-riche Rolexes. I also bought garters that look like big white ponytail holders. I've never seen such things before, and I'm sure I'll never see them again. So I figured I'd better buy them in case I should ever need them. When I went to the 34th Street Store, I just got too sad for words. The café was already closed, and it was so beautiful, I almost started weeping, and the signs were so lovely, like at the candy counter. I think I'm so upset because I fear change. Woolworth's gave one a feeling of continuity with the past, to quote the man in *Breakfast at Tiffany's*. He was talking about prizes in Cracker Jacks boxes, though.

MARY: But the cool thing about Woolworth's is that it was always there to meet your changing needs. Think about all the different Woolworth's phases in your life: candy and banana splits when you're little . . . the photo booth, which was a big part of teenage after-school fun. Then, in art school, I'd take pictures of the displays in the Providence Woolworth's. I didn't have a car to get to the scenic areas, so I'd go downtown and shoot inside the store. Everyone at RISD wore those canvas crisscross-strap wedgies from Woolworth's. They were really cheap and stylish. I don't know why I was surprised to see them still available after all these years, but there were tons at the 8th Street branch, so I bought a pair. Getting them seemed like the perfect final shopping gesture. I don't really want to go back anymore. It's too depressing.

CHRISTINA: I feel guilty, like I'm somehow responsible. If I had just shopped there a little more often.

JED JOHNSON
by Peter Halley
and Stuart Parr

**Photograph by Timothy Greenfield-Sanders
February 1997**

When TWA Flight 800 mysteriously crashed in the
waters off Long Island this past July, with no
survivors, an immediate shock and disbelief
registered all along the nearby beaches where
many New Yorkers decamp every summer. The interior
designer Jed Johnson was not among them. He had
been on the plane bound for Paris.

 We didn't know Jed Johnson personally but had
followed him in his path from Andy Warhol's
Factory to establishing himself as one of the most
important and influential designers working today.
We asked design aficionado Stuart Parr to tell us
about the Jed Johnson he had known.

STUART: If you met Jed, he spoke incredibly softly. It
 was difficult to hear him at times. You had to listen.
 Jed did not raise his voice. And if you didn't know
 him, it was tough at first. But when you got to know
 him, you found out he was just very funny. And very,
 very witty. Jed is probably one of the few people I've
 ever met who was not into gossip. He would listen to
 things, but he was one of the few people you would
 never, ever hear talk badly about somebody he knew.
PETER: And the basis of Jed's talent . . .
STUART: It's quite simply that Jed was comfortable with
 his own tastes and his own decisions, and this is a
 rarity. It's just so rare.
PETER: Let's say he was looking for a chair or
 something. Did he decide right away, or would he
 come back four times?
STUART: He would certainly try a few things out, but
 actually I don't remember him ever taking anything that
 he didn't purchase.
PETER: And his personal and professional partner
 was Alan Wanzenberg. How did they work together?
STUART: Well, Alan did the architecture, and Jed did
 the decoration side of it. It's an amazing thing for
 two people to work together really well, no matter what
 they're doing, and to live together on top of it.
PETER: And how long did they work together?
STUART: About fifteen years.
PETER: That long?
STUART: Yeah. Jed and Alan would get on a plane and go
 fly somewhere to look at a house, which is something
 very unusual. And they both had a major interest in
 knowing what they were talking about and in learning
 how things were made, how things were manufactured.
 They had so much in common in terms of their pursuit of
 knowledge.
PETER: From what I've seen of their work and
 their reputation, their things must have been
 incredibly well-made.
STUART: Well-made? Unbelievable.

W
Writers

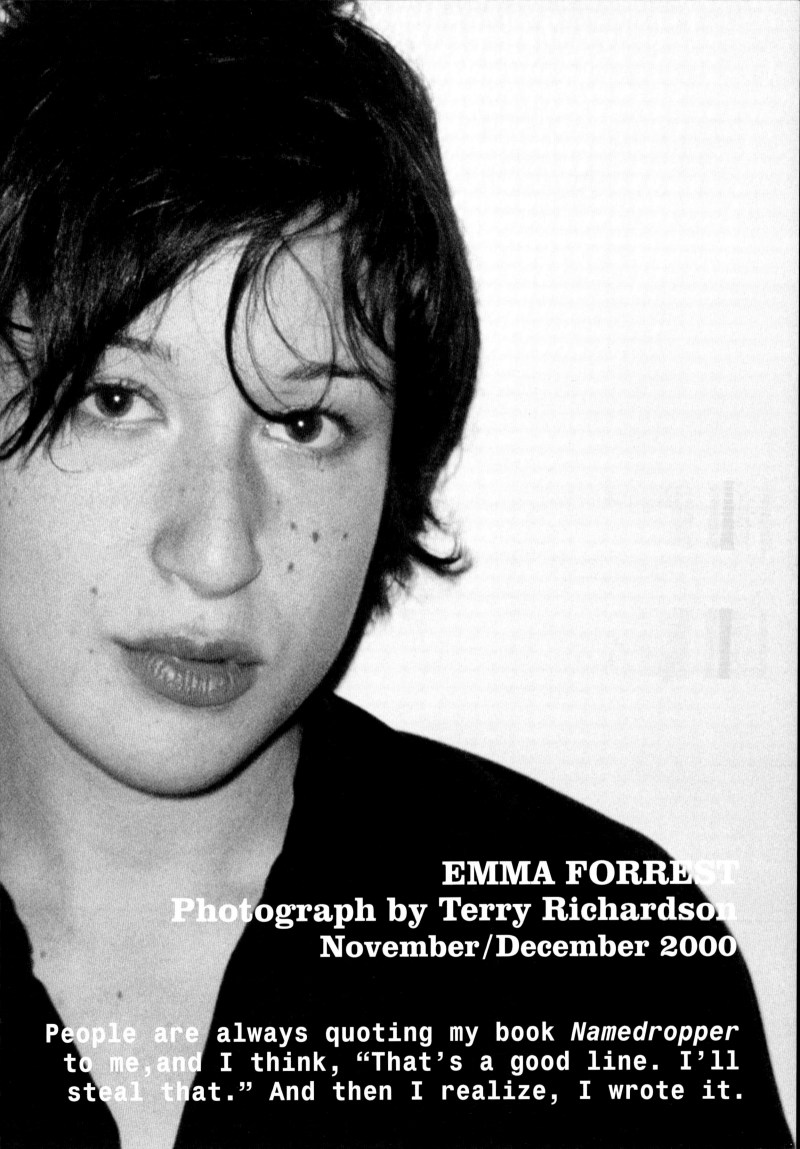

EMMA FORREST
Photograph by Terry Richardson
November/December 2000

People are always quoting my book *Namedropper* to me, and I think, "That's a good line. I'll steal that." And then I realize, I wrote it.

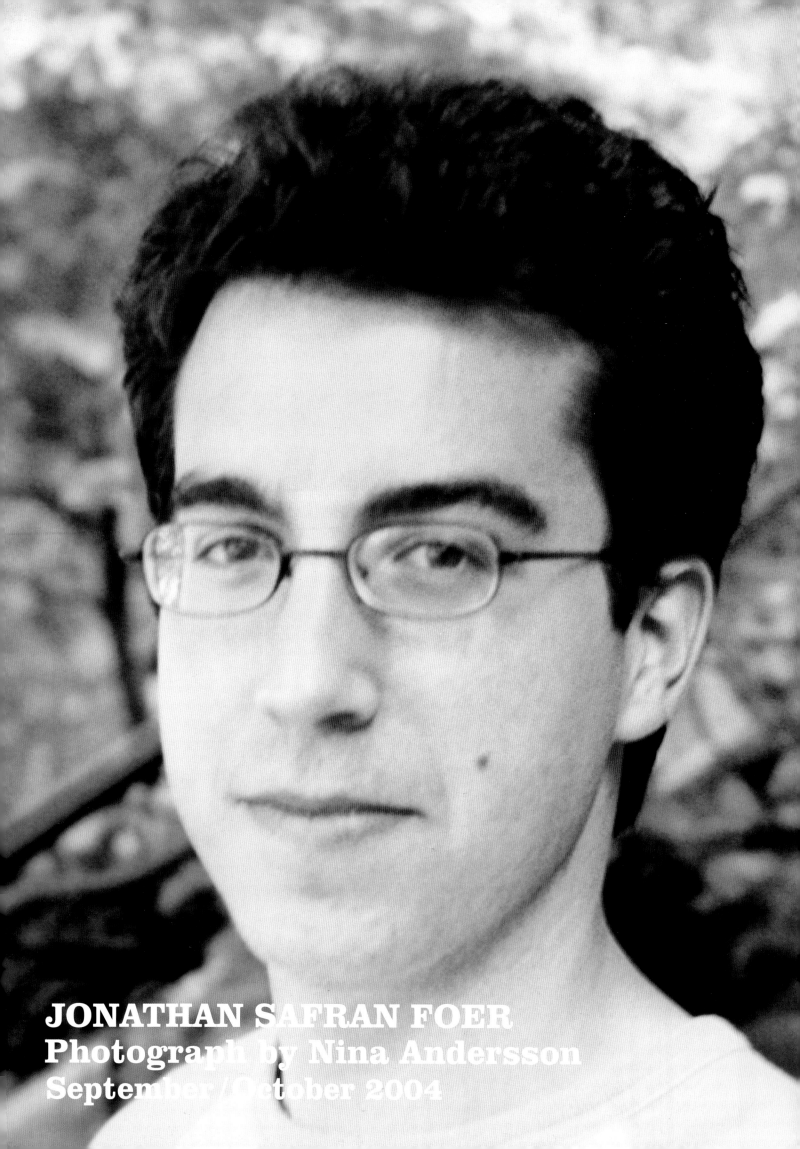

JONATHAN SAFRAN FOER
Photograph by Nina Andersson
September/October 2004

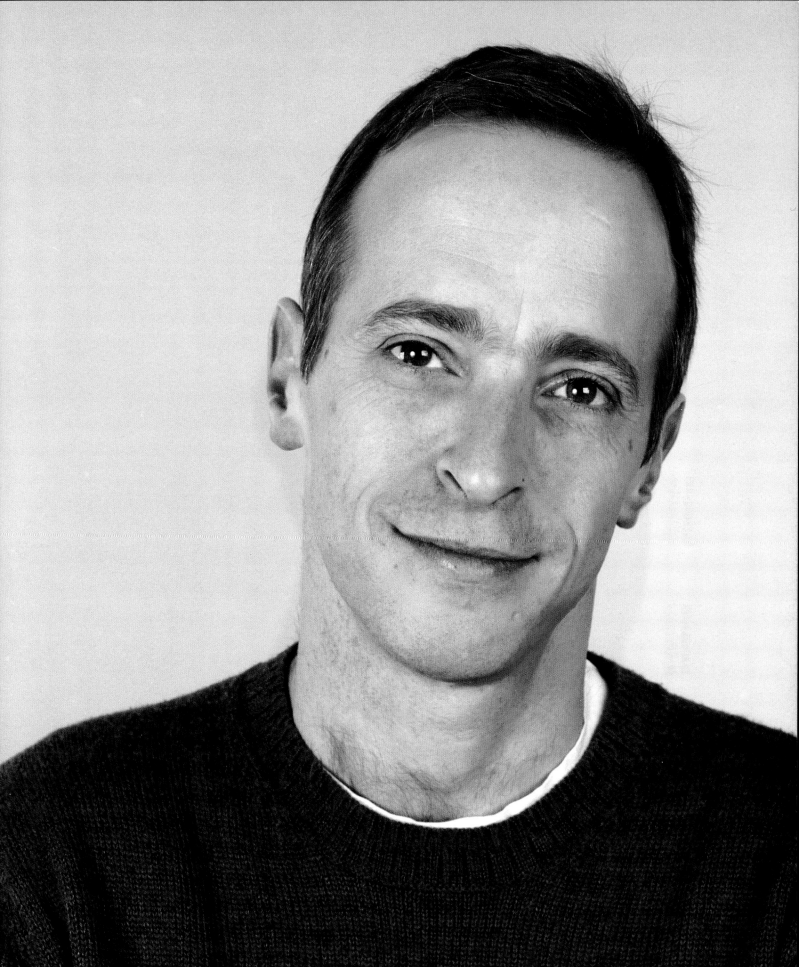

DAVID SEDARIS
Photograph by Leeta Harding
May/June 1997

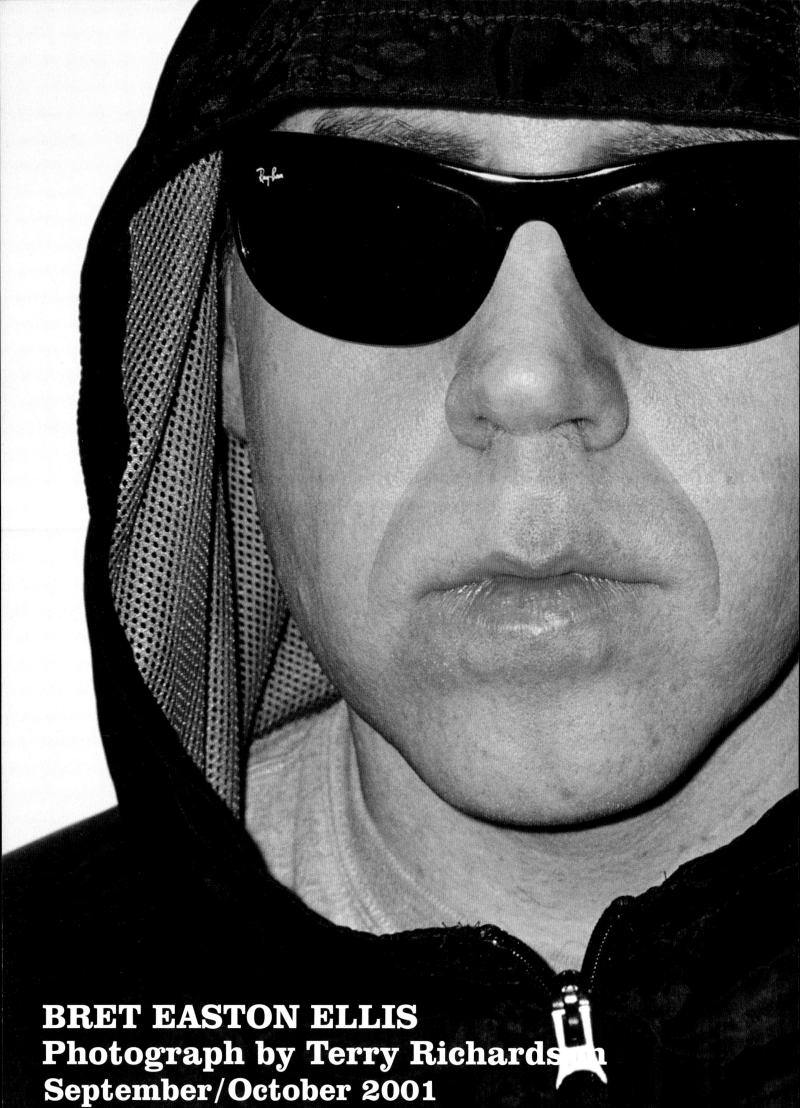

BRET EASTON ELLIS
Photograph by Terry Richardson
September/October 2001

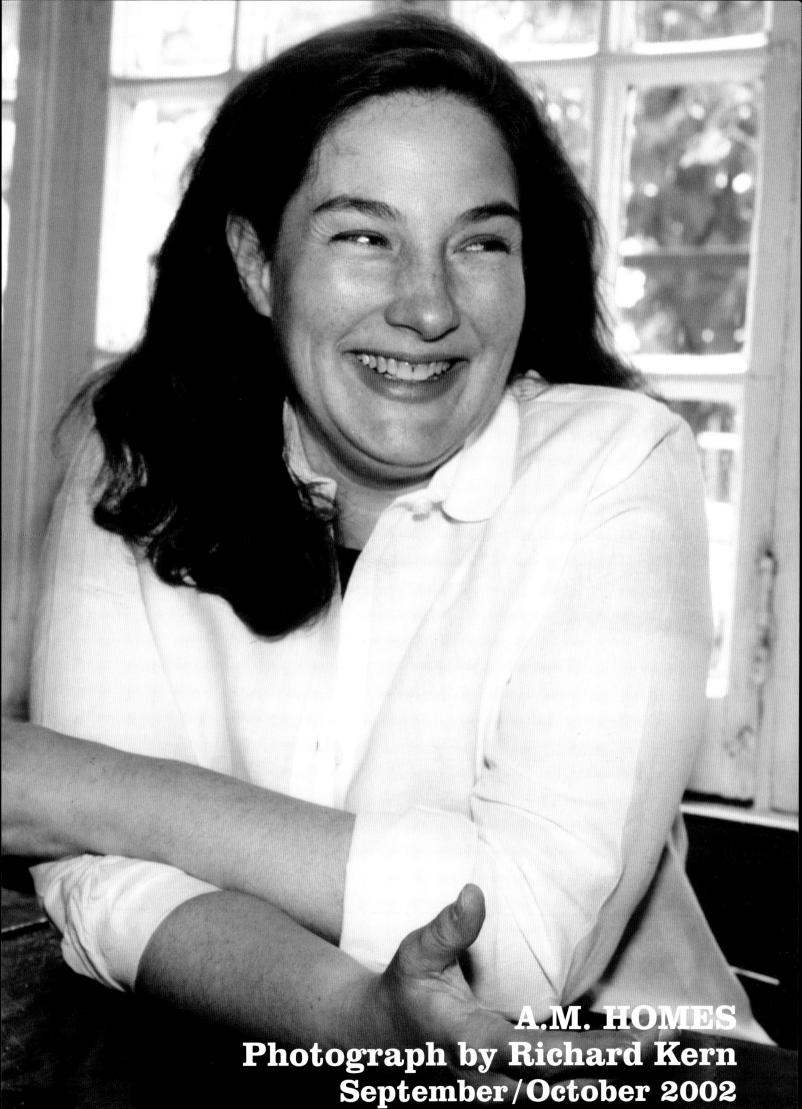

A.M. HOMES
Photograph by Richard Kern
September/October 2002

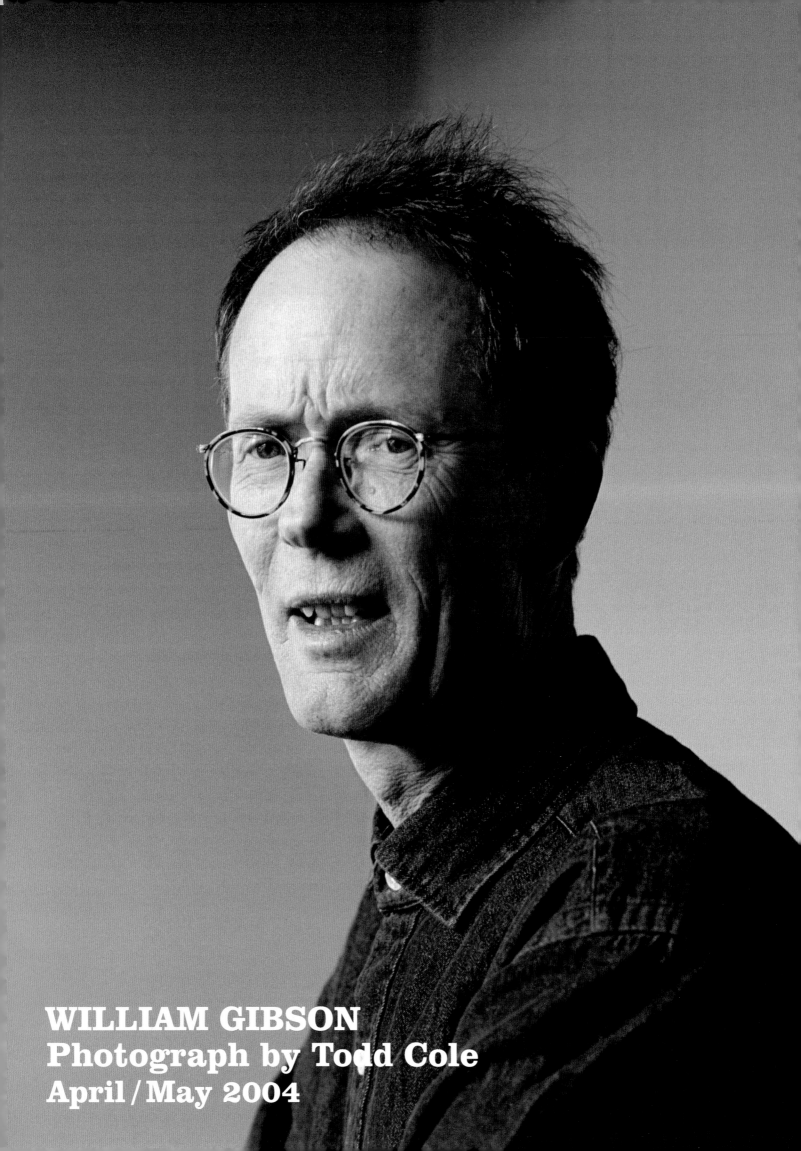

WILLIAM GIBSON
Photograph by Todd Cole
April / May 2004

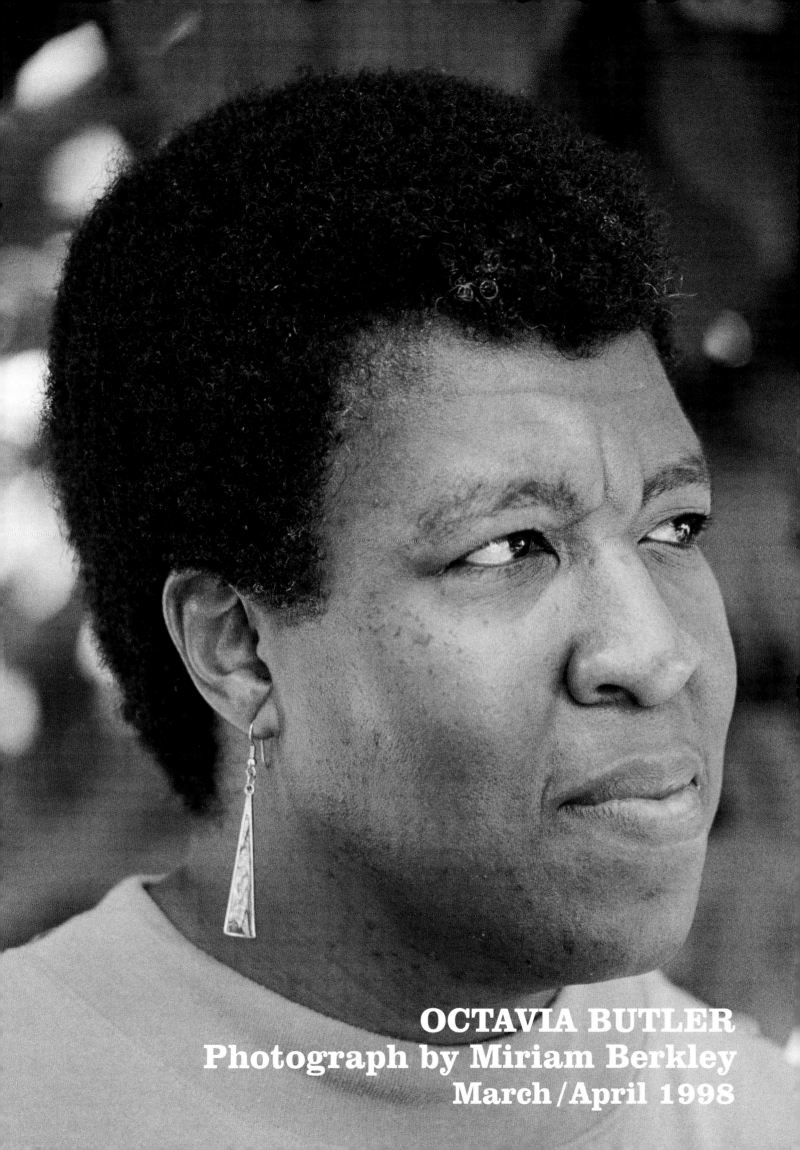

OCTAVIA BUTLER
Photograph by Miriam Berkley
March/April 1998

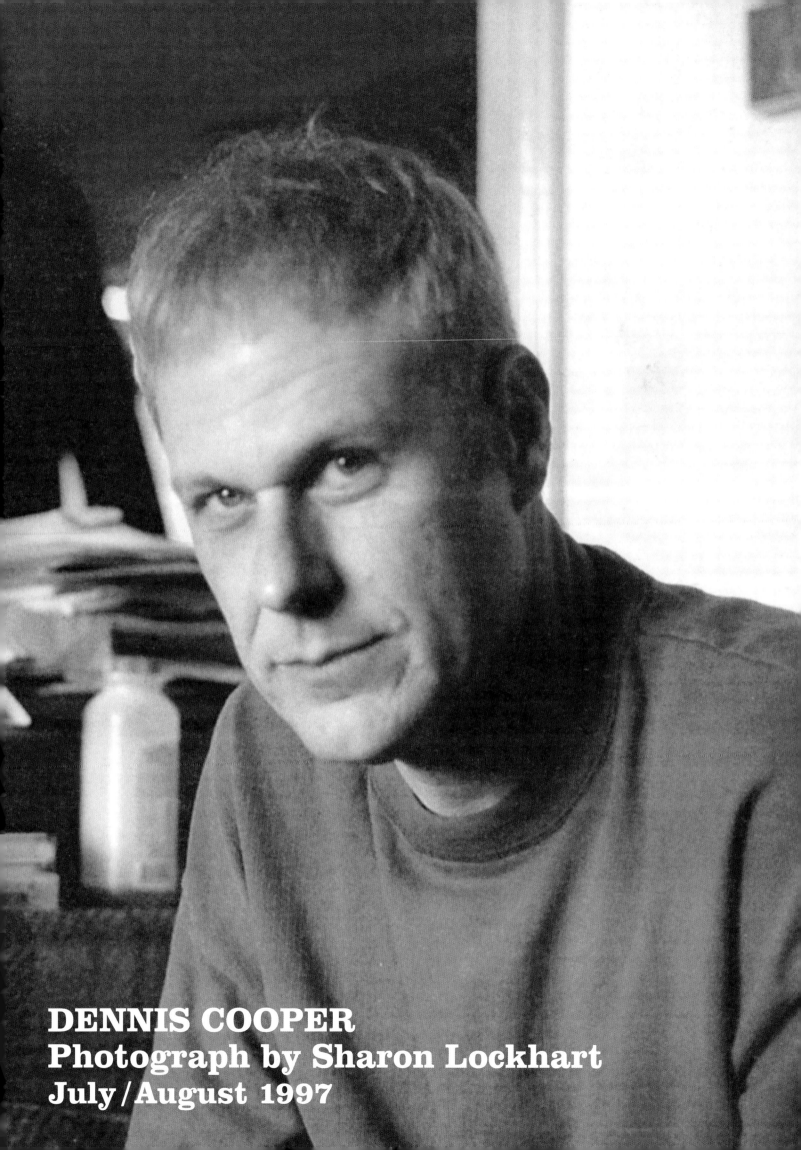

DENNIS COOPER
Photograph by Sharon Lockhart
July/August 1997

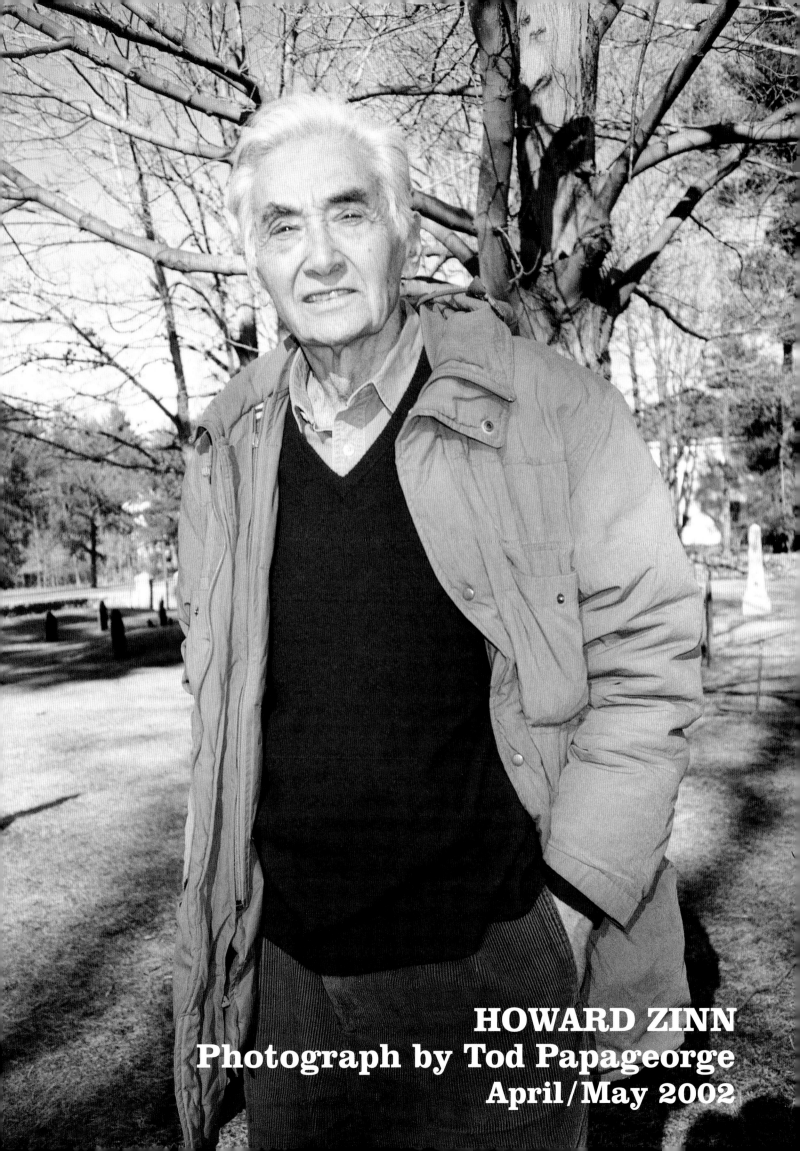

HOWARD ZINN
Photograph by Tod Papageorge
April/May 2002

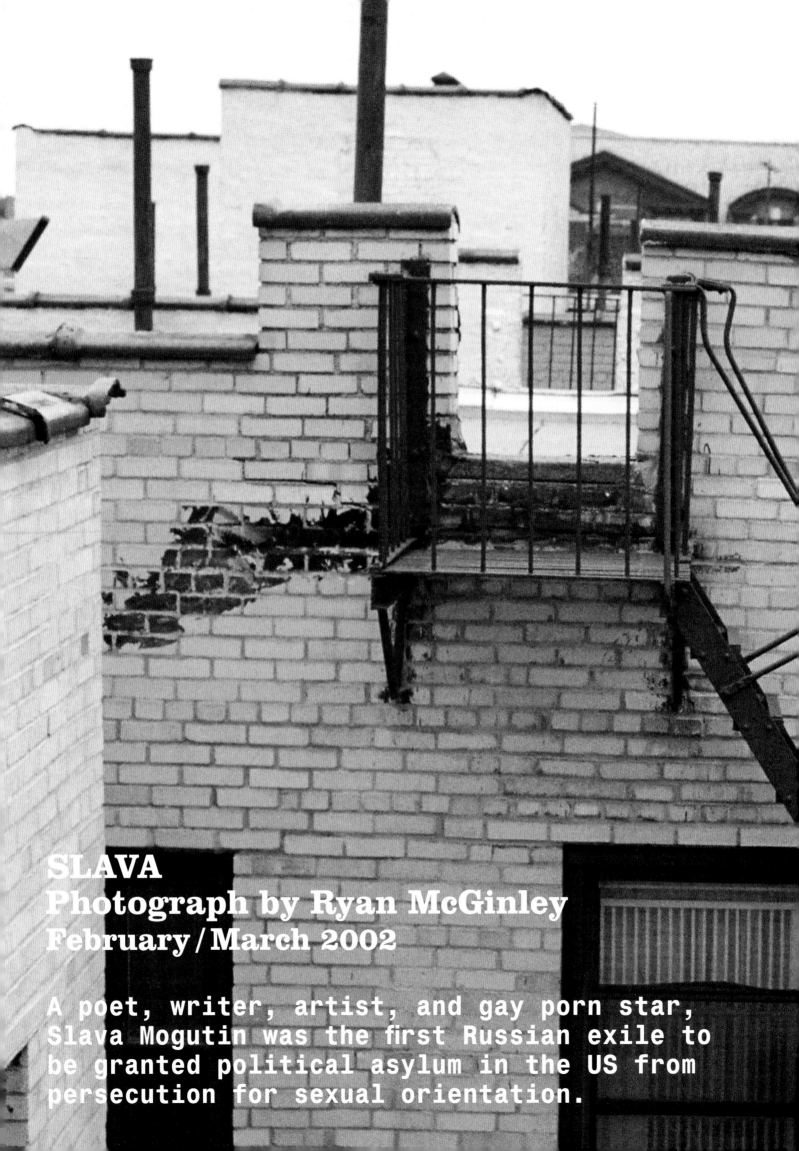

SLAVA
Photograph by Ryan McGinley
February/March 2002

A poet, writer, artist, and gay porn star, Slava Mogutin was the first Russian exile to be granted political asylum in the US from persecution for sexual orientation.

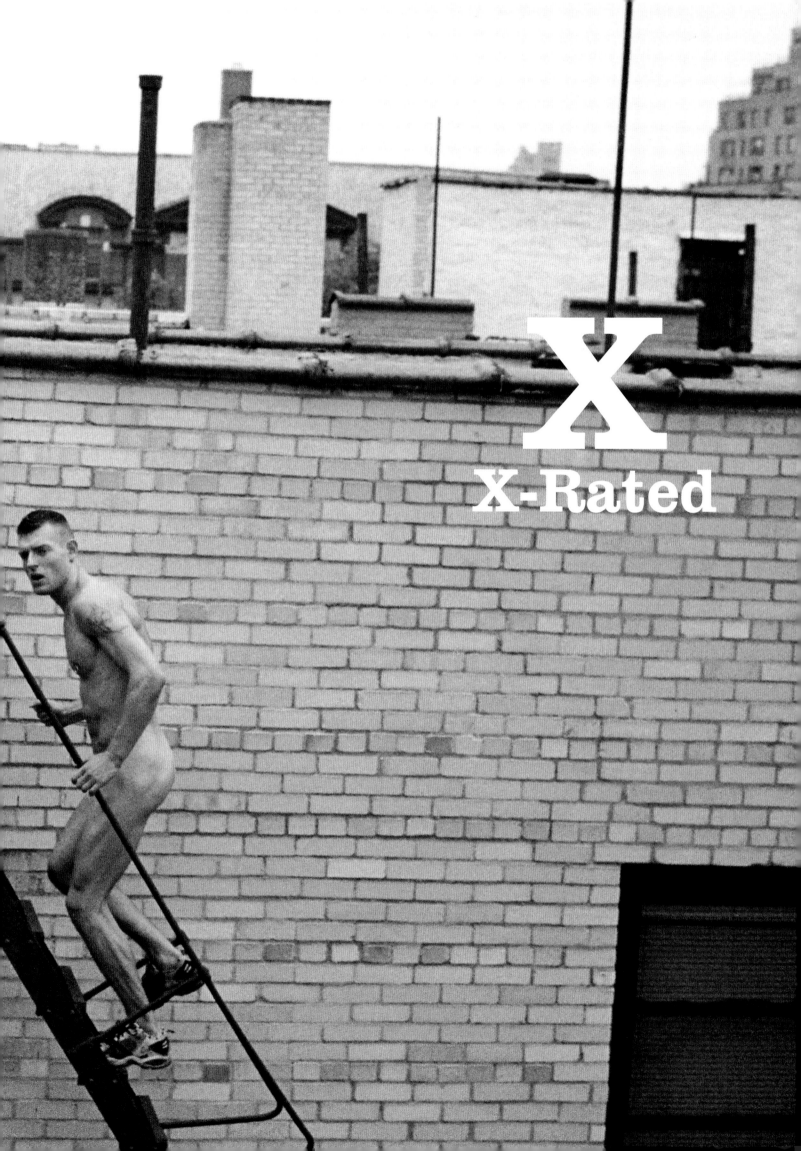

X
X-Rated

SHANE
Photograph by Catherine Opie
January/February 1999

My movies are kind of like a spin-off of *MTV's Real World*—except with hard-core sex.

DIAN HANSON with Michelle Golden

Photograph by Kevin Hatt
June / July 2002

MICHELLE: After twenty-five years of working on publications about butts, breasts, bikes, and legs, have you ever thought about starting your own magazine?

DIAN: It's not as if there's one perfect magazine that I've always wanted to do. I just love the challenge of taking a difficult subject, figuring out the psychology, and managing to get exactly the right tuning and material so that every single person who is attracted to that subject buys that magazine. That's what made *Leg Show* such a great project for me.

MICHELLE: I know *Leg Show* and *Juggs* were floundering when you got there. You must have had your work cut out for you.

DIAN: Both of those magazines were published by MMG, which put out the majority of the gay magazines in America in the mid '80s. *Juggs* and *Leg Show* were put together by an all-gay staff who didn't really care about them but had lots of fun doing them. You could hear the hoots of laughter and derision. I thought, "Oh, these poor orphan magazines deserve more attention." I really understood the potential for *Leg Show* once I read the letters that came in. I saw how seriously the men took this subject and how literate they were. I begged to be allowed to try my hand, and I increased the sales immediately.

MICHELLE: So how did you get a handle on the psychology of the *Leg Show* readers and know what to put in the magazine?

DIAN: I'd always been interested in sexual, psychological peculiarities. My father was a naturopath, a sort of weird, holistic doctor, so we always had lots of medical and religious books around the house when I was growing up. In *Leg Show*, I recognized an obsessive readership who would actually guide me in making the magazine. I really put myself in there, photographing myself and writing directly to the readers. They were the perfect audience for that approach—men who were at least fifty percent submissive, eager to be explained to themselves, and absolutely ready to be led by a woman.

MICHELLE: What kinds of things did you write about?

DIAN: My columns were serious. Quite often I'd talk about the roots of fetishism, and I'd explain the different varieties. I was drawing from scholarly writing as well as my own conclusions, which had been drawn by reading their letters.

MICHELLE: It's interesting that you went so far as to psychoanalyze your own readers in the magazine. Did you see yourself as providing a special kind of service to your audience?

DIAN: Oh, always. I was so deeply touched by their plight, by their self-hatred, their fear, confusion, and isolation. So many people wrote in that they had spent years in therapy trying to rid themselves of their fetish, that they had attempted suicide, or that they had never dared to tell their wives. They said they had denied themselves sexual pleasure because they thought their sexuality was unacceptable. And a lot of them felt that they were the only one. So that was a service that I wanted *Leg Show* to provide—to let these people know how many others there were. What the readers really wanted was to know that there was a sympathetic woman out there who wasn't sneering at them. That was the purpose the models served—they eroticized contempt. So for my part, I gave them love. Because they wanted it, it made them loyal readers, and it made me feel good.

MICHELLE: And how did you determine what sorts of images the *Leg Show* readers were looking for?

DIAN: The magazine dealt with multiple fixations. But I started from the standpoint that the readers had at least some obsessive-compulsive component. That meant the stockings should never be wrinkled, and the seams should never be crooked. The shoes always had to be exactly the right size, the panties fitted just so around the buttocks. The poses had to be precise. You couldn't have sloppiness because the O.C. personality needs everything absolutely right, or he's not going to be able to masturbate. Even the proofreading had to be perfect!

MICHELLE: And what about your other magazine? How was the *Juggs* reader different?

DIAN: The *Juggs* guy, it doesn't matter. "Aw, wrinkled stockings, so what. Look at her big breasts. They may not be the kind of breasts I usually like, but they're breasts. And they're big!"

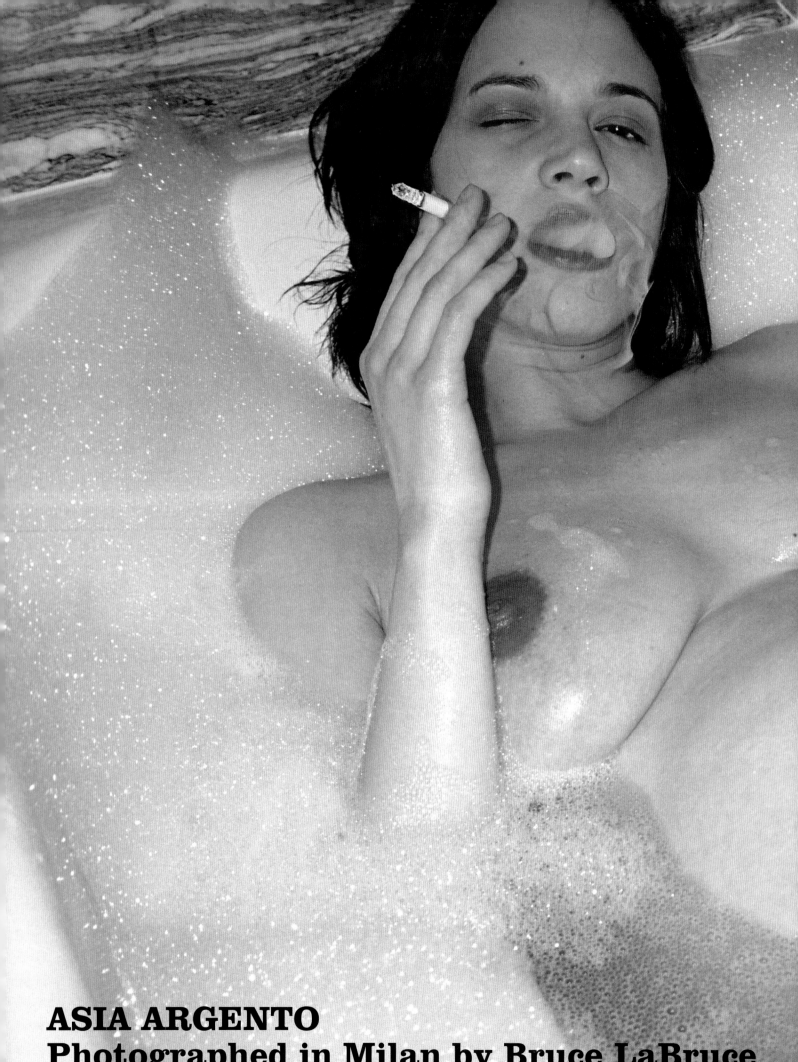

ASIA ARGENTO
Photographed in Milan by Bruce LaBruce
September/October 2001

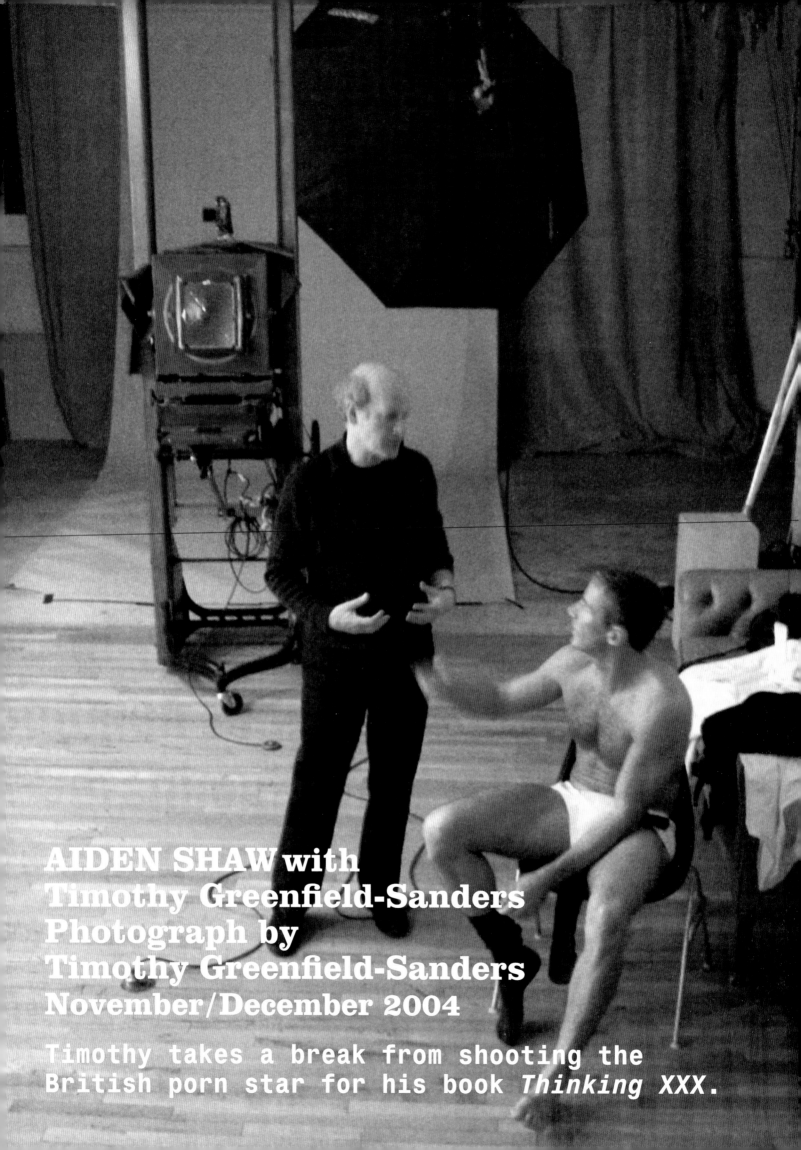

AIDEN SHAW with Timothy Greenfield-Sanders Photograph by Timothy Greenfield-Sanders November/December 2004

Timothy takes a break from shooting the British porn star for his book *Thinking XXX*.

EAST MEETS WEST
BY MICHAEL BULLOCK
September/October 2002

I first heard about the party through friends. They told me that I had to go, that something special was taking shape, that New York's circumstances after 9/11 were giving birth to a new sexual freedom. At Triple X, an intriguing group of thrill seekers was taking the place of the usual backroom crowds with their lecherous, has-been bottom-feeders. New York's gay community was coming together to explore a new form of male bonding, to comfort and be comforted—and to have wild public sex.

After six short weeks, Triple X got busted. I had missed my opportunity to experience a legendary event. Luckily, the new demand for public sex prevailed, and by early March, promoter Johnny McGovern and his cohorts were back at it. The party, now dubbed Magnum, moved to the posh restaurant The Park on Sunday nights. Magnum made use of The Park's opulent top three floors—its three bars, two terraces, hot tub, cabanas, and outdoor recreation area.

At the Park, after a few hellos, I moved out to the hot-tub area on the terrace. There were people I'd met from every walk of life over my four years in New York—investment bankers and artists, hipsters and muscleheads, celebrities and hustlers. Other than the fact that there wasn't a single woman in sight, I imagined it was the kind of mixed crowd that had defined the legendary Studio 54. Still, it was a bit forced. It felt like a big gay prom—all the different cliques had shown up to see and be seen.

By the hot tub, three naked Magnum men watched the crowd watch them. They weren't touching each other or dancing, but observing. Next to the tub were strategically placed cabanas where partygoers could "change into swim trunks." These semiprivate booths had been co-opted for other purposes.

After a while the drunken crowd started to get frisky, and the once-aloof hot-tubbers began to let people give them blow jobs. Somehow, it all felt very polite. A guy would be standing by the tub, talking to his friends, sipping his apple martini. Then, when conversation lulled, he'd just turn his head and start servicing. The whole exchange came off as casual and understated.

Feeling a little adventurous, I headed up to the third-floor roofdeck. To get there, I had to climb a stairway and pass through a long, dark hallway. It was twenty degrees hotter there, and the air was humid with sweat. In that dark corridor, all pretense of politeness had been stripped away. The crowd hadn't paired off—it had simply merged, like one giant, writhing organism. As I pushed my way through, groping hands attempted to pull me into the fold. I noticed a friend-of-a-friend grappling desperately with one-half of a very well-known fashion duo.

Finally, I made it out to the tiny roof. Around the perimeter, a makeshift wooden safety wall had been set up to shield the neighbors from the debauchery. I took a few steps and saw what was easily the main event of the evening. In a well-lit spot, a cheering group was tightly huddled around three attractive men. The man in the middle was naked, bent over, and passionately servicing a banker-type in his early thirties, while simultaneously being sodomized by a fully-clothed muscle queen who was slapping his ass and smiling. The crowd was wild with testosterone. People were cheering as if at a football game. "Next show at 2:30," one guy yelled out sarcastically.

Y
Youth

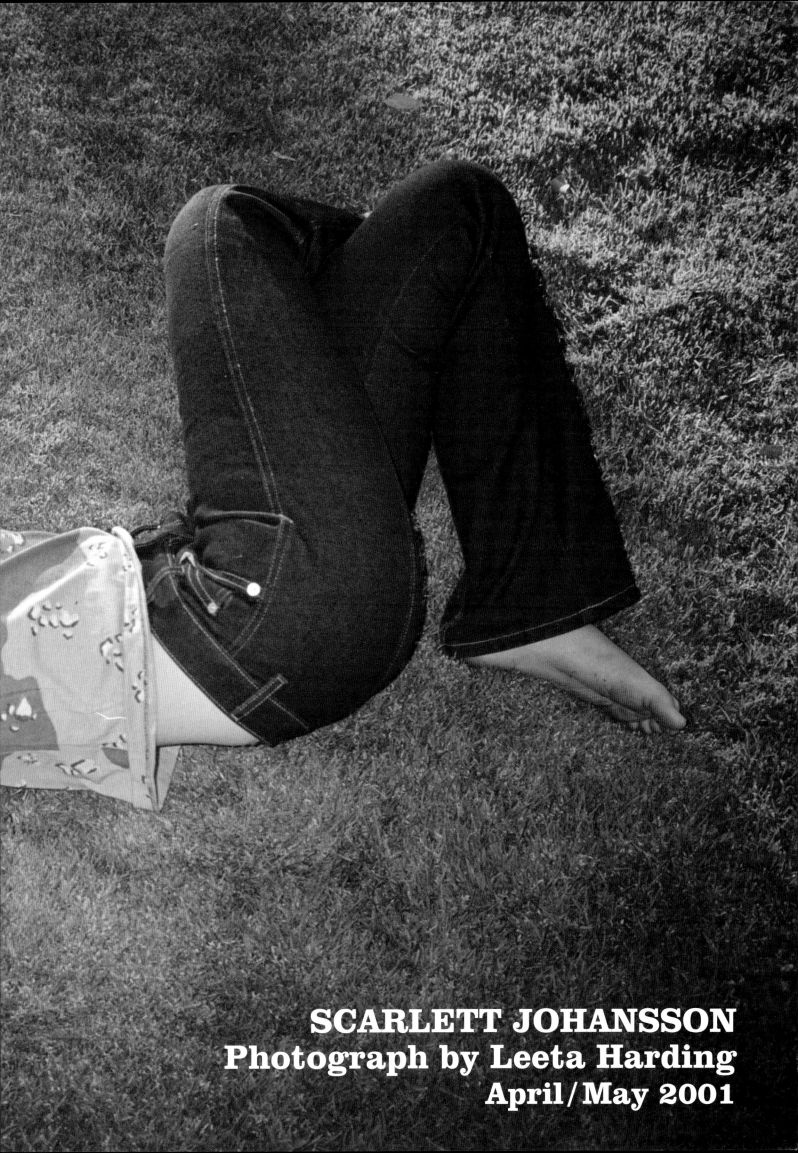

SCARLETT JOHANSSON
Photograph by Leeta Harding
April / May 2001

JENA MALONE
Photograph by Richard Kern
February/March 2003

Now that I'm 18 I can buy cigarettes and lottery tickets.
But I've been emancipated for a while so it's sort of strange.
My friends took me to a strip club for my birthday. That's
another thing you can do legally when you're 18— see naked
women and men.

LEO FITZPATRICK
with Bruce LaBruce

Photograph by Ryan McGinley
November / December 2001

BRUCE: I want to go back a little and talk about *Kids***. It was your first movie. How did you get involved with it?**

LEO: I've known Larry Clark since I was fourteen. I've always skateboarded in Manhattan. Larry got into the scene in the early '90s, taking pictures and skating with us. Then one day he was, like, "I just got the money for this movie I've been talking about for the past two years. Do you want to come in and audition?" I said, "Sure." I had nothing better to do.

BRUCE: Who was conducting the auditions?

LEO: It was Larry, Harmony Korine, and the casting director. I didn't really know Harmony at that point, but I'd seen him around because we traveled in the same circles. Back then, skateboarding was far from cool. It was like the geeks of the geeks. Skateboarders were genuine losers. Most of them came from fucked-up families, so skateboarding gave them this new family of friends.

BRUCE: I just read that BMW has come out with a skateboard that costs five hundred dollars.

LEO: Skateboarding has been so gentrified by big companies. I don't like to say that I'm a skateboarder anymore. But even though it seems really lame now, I still have love for it. It's been a huge influence on me creatively. Like lots of people, it's given me a mental independence I might not have found without it.

BRUCE: You weren't at Sundance for *Kids***, were you? That's where I met Harmony, but I didn't see you.**

LEO: I think that was part of the distributor's scheme. Miramax didn't introduce the actors at any of the screenings. That's why a lot of people thought *Kids* was a documentary. I still meet people who think it was real.

BRUCE: It's seen as a landmark movie, a defining moment, the voice of a generation, blah, blah, blah.

LEO: After I made *Kids*, I went back to working at a skate shop, just living life as a stupid skateboarder. But people would call the store and say, "I know you're that guy from *Kids*. I'm going to come down there and kick your ass." I would say, "Calm down, it was only a movie."

BRUCE: I think Larry Clark's *Bully* **is even harsher than** *Kids***, because all the characters in it are so fucked up—just totally wired on LSD and stuff. It's hard to watch.**

LEO: The actors in *Bully* were pretty much as crazy as their characters.

BRUCE: I know. I've hung out with Bijou Phillips, Brad Renfro, and Mike Pitt. You must have been, like, the adult on the set.

LEO: I felt older. I wasn't fucking around. I wasn't going to the set fucked up and not knowing my lines.

BIJOU PHILLIPS
with Bruce LaBruce

Photograph by Terry Richardson
April/May 2000

BRUCE: Okay. So tell me about your *Playboy* shoot.

BIJOU: They contacted me, we went out to dinner, I had all these conditions, and we figured everything out.

BRUCE: What were your conditions?

BIJOU: That Ellen von Unwerth would shoot it, and that I would have control over the article and the pictures, pick where the shoot would be, what happens in the shoot, the clothing . . .

BRUCE: Or lack thereof.

BIJOU: And that it's a cover.

BRUCE: Now, did Hef come in during the shoot in his bathrobe?

BIJOU: Yeah, he did. We did some pictures together. That was fun.

BRUCE: What about your family? Did you consult with them about *Playboy*?

BIJOU: Yeah, they said, "Great, just make sure you have control."

BRUCE: I guess there's nothing shocking about it anymore.

BIJOU: It's just tits. No big deal.

BRUCE: Did they ask you for split beaver?

BIJOU: No! Ellen has tons of those of me, from photographing me years ago, but she would never release them. She's taken some nutty pictures of me, but we're friends, so she wouldn't publish any of them.

BRUCE: Now, I wanted to ask you, having read in *Celebrity Sleuth*, my main source of information, about those Calvin Klein ads.

BIJOU: The kiddie porn ads.

BRUCE: I'd forgotten you were in those.

BIJOU: It was kind of scary, because they had this guy . . .

BRUCE: Steven Meisel.

BIJOU: No, Steven directed it, but then there was this porn guy.

BRUCE: Off-camera. A real porn guy. I think it was Ron Jeremy.

BIJOU: And he was wearing these pants, and it was just a nightmare.

BRUCE: What do you mean—wearing these pants?

BIJOU: These weird leather pants, and he had a cowboy hat on, and he was just sitting there.

BRUCE: So he looked all leathery? Like a leather daddy?

BIJOU: Yeah, and he was asking these questions, like, [in a creepy voice], "What do you like about your Calvin Kleins? How do they make you feel?"

BRUCE: Now, you were born on April Fool's Day, and in *Papa John* it says that your mother was on heroin when she was pregnant with you, and that you were born premature and almost died.

BIJOU: Yeah. I'm a crack baby. Word.

BRUCE: That's not a very nice way to come into the world. You must carry some anger about that, or did you just let it all go?

BIJOU: I have so much anger.

BRUCE: Does it freak you out that everybody knows all these details? The book's out of print, by the way.

BIJOU: At the time, it was huge, when it came out in '87.

BRUCE: When you were only seven.

BIJOU: The book's a bunch of lies—that's what my sister says.

BRUCE: Mackenzie?

BIJOU: Yeah. Everything in it's all bullshit . . .

BRUCE: It says in the book that Mick Jagger and Jerry Hall were babysitting you once when your parents were going through heroin withdrawal, and Mick and Jerry wouldn't give you back to them because they were too fucked up. And then your father tried to burn down his own house. Do you remember that?

BIJOU: No. I was only three. My dad went to jail at the time, and no one would give my mom money.

BRUCE: But she had lots of rich, celebrity friends.

BIJOU: My parents fucked so many people over that no one wanted to talk to either of them. Me and my mom ended up sleeping on the street.

BRUCE: You weren't sleeping on the street!

BIJOU: Yeah, we slept on the street a couple of nights, in doorways. And we had to steal food.

BRUCE: I read that your dad was a real grifter.

BIJOU: At one point, he bought a drugstore so he wouldn't have to cop on the street anymore.

BRUCE: And before he became famous, he was a mailman, but he was too lazy to deliver the mail, so he'd just throw it away.

BIJOU: He's just dumb.

BRUCE: In *Celebrity Sleuth* it says you have a "Daddy" tattoo on your butt, and there's a picture of it.

BIJOU: Yeah.

BRUCE: It's funny how you can know a person and not know they have "Daddy" tattooed on their butt.

BIJOU: That was during a time when I was a pretty sick puppy. I went and got it with my friend David Blaine. I was eighteen.

BRUCE: *Celebrity Sleuth* once mentioned an urban myth about you cutting off some guy's little finger in a cigar cutter?

BIJOU: Look, some jerk was coming on to me all night, grabbing my ass while I was dancing with my friends.

BRUCE: Where was it?

BIJOU: At Spy. We were all smoking cigars, and there was a cigar cutter. I dared my friends to put their fingers in it, and they're like, "Yeah, Bijou. Whatever. Go away." And then I saw that jerk who was bothering me, and I thought, "Oh, that guy, he'll do it." So I said, "I dare you to stick your finger in there." And he goes, "Well, what does it do?" I mean, if he's dumb enough to stick his finger in the fucking cigar cutter in the first place, then he deserves a little nick. I gave him a little nick, and that was it.

BRUCE: So how does that turn into an urban legend?

BIJOU: Because a lot of people were there that night, like Leo and all those guys. Everyone was like, "She cut the fuckin' finger off, man, the finger was on the floor, she picked it up, it was horrible. I don't know, dude, she's fuckin' nuts."

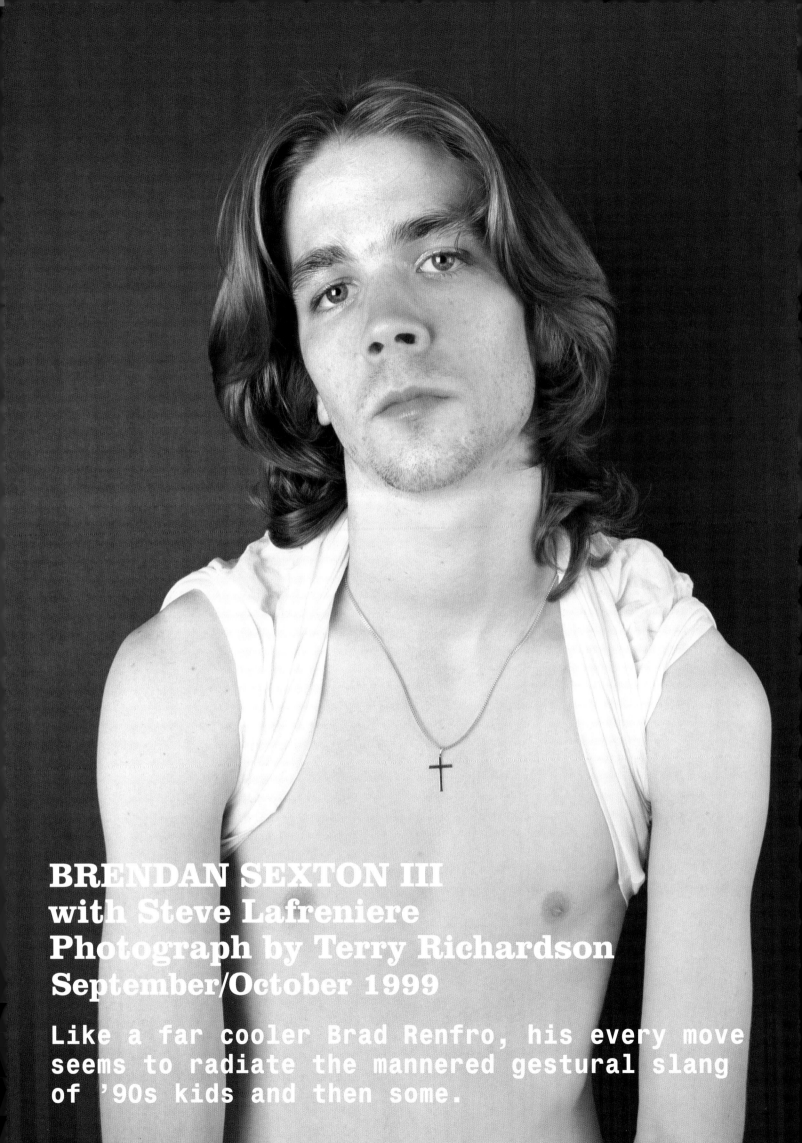

BRENDAN SEXTON III
with Steve Lafreniere
Photograph by Terry Richardson
September/October 1999

Like a far cooler Brad Renfro, his every move
seems to radiate the mannered gestural slang
of '90s kids and then some.

DON'T CALL ME MA'AM
BY CHRISTINA KELLY
MARCH 1997

I am not the only woman who finds this offensive. Four out of five women polled agree. "I'd rather be called 'Miss'," says Amy, age twenty-seven. "I like that 'ma'am' is old school, but it's too old lady." Maureen, age twenty-five, was first called "ma'am" when she was a mere twenty. "I thought, I'm not that old yet," she says. "'Ma'am' connotes old ladies with cardigans buttoned all the way up." Obviously, the term hits a nerve in women with issues about aging and maturity, which includes every woman I know, except for my mother and grandmother. "What's even worse than 'ma'am' is being called 'madam'," says Mary, whose age has remained a mystery in the almost ten years I have known her. "That just sounds like you're in your eighties." Valerie, age forty-two, was quite eloquent on the subject: "When people call me 'ma'am' I feel like there's an assumption that I've left something behind that I haven't left behind," she says. "It's like you've taken on an identity that's more middle-aged, less energetic, not going out as much. Personally, I still have a lot of my inner child alive; there's a lot of the Ms. and Miss left in me. That said, it doesn't bother me as much as it used to. Now I occasionally get a kick out of being called 'ma'am'."

While we're on the subject, why is "ma'am" so much more insulting than its masculine equivalent, "sir"? I'll tell you why: It's because "sir" implies respect; "ma'am" connotes condescension. I don't think my male contemporaries would be offended if they were called "sir" by a cab driver or a dry cleaner. Just surprised and a little confused. In fact, once when I was eating at a hamburger joint in Midtown with a twenty-five-year-old (male) friend of mine, the sixty-five-year-old, blue-eye-shadowed waitress called him "sir," and we both became hysterical with laughter. My friend is no "sir." When you think of a "sir," you picture either a dude wearing Brooks Brothers with the *Wall Street Journal* under his arm, or an elderly professorial type with, like, a pipe. You do not imagine some tiny hipster in a vintage button-down.

The only people who are allowed to call me "ma'am" are Southerners. Preferably some boy from Tennessee. Southerners are weirdly polite; it's part of their odd culture of hospitality. When they call you "ma'am," they don't mean it as an insult, so you shouldn't take it the wrong way. It's actually sort of endearing. It's like when you're in London and the cab driver calls you "love." You just want to pat him on the head.

Z
Zeitgeist

"An *index* magazine evening with JT Leroy and friends," April 17, 2003. Famed writer "JT" organized the benefit, hosted by *index* and Motorola, for the McAuley Psychiatric Treatment Program for adolescents in San Francisco. Top row, left to right: Vanessa Carlton, Gaby Hoffmann, Shirley Manson, Deborah Harry, Winona Ryder; bottom row, left to right: Tatum O'Neal, "Speedie," Rosario Dawson, Asia Argento, Savannah Knoop as JT Leroy

Top row: Bob Nickas (standing) with Peter Halley in Halley's Chelsea studio that served as *index*'s headquarters, 1999; Olympic figure skater turned actress Oksana Baiul at Terry Richardson's TERRYWORLD after party, 2004; Leeta Harding and Famke Janssen; *index* Summer 1999 compilation CD; The crowd at the TERRYWORLD after party at the Maritime Hotel, September 10, 2004.

Middle row: Peter Halley with photographer Timothy Greenfield-Sanders at the book launch of Greenfield-Sanders' *XXX: 30 Porn-Star Portraits*, October 30, 2004; Editor Cory Reynolds at the *index* office in front of Andy Warhol's *Electric Chair* prints, c. 2001; Lady Bunny and friend with *index* cover star Slava at Timothy Greenfield-Sanders' *XXX* party, 2004; Associate Editor Stephen Sprott (left) and Assistant Editor Jesse Pearson. Bottom row: The view from the *index* office, c. 2000; Advertising Director Michael Bullock and Ricky Clifton at the *index* party in honor of Miranda July, Tribeca Grand Hotel, June 2005; Ryan McGinley in 2001 at Indochine by Leeta Harding.

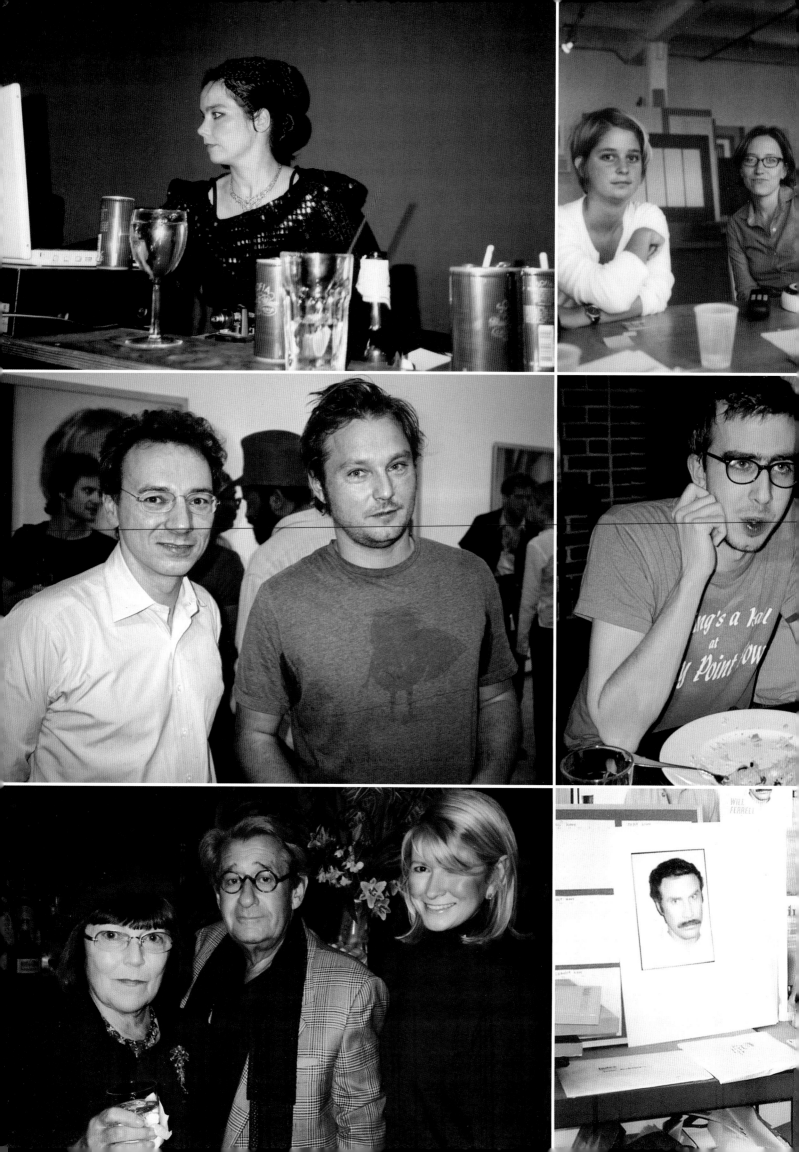

Top row: Björk DJ'ing at the launch of *index*'s June 2004 issue at a Lower East Side club; Editor Ariana Speyer (right) and Assistant Editor Jenny Grant in the office, 1999; Glenn O'Brien, Michael Bullock, Gina Nanni, and friend; Savannah Knoop, in the role of JT Leroy, with friends at the *index* benefit event at the Public Theater, 2003. Middle row: Peter Halley and photographer Juergen Teller at Teller's Lehmann Maupin Gallery opening in Chelsea, 2000; Editors Jesse Pearson, Amy Kellner, and Cory Reynolds at the May/June 2000 issue launch dinner; Toronto filmmaker Bruce LaBruce and Peter Halley at *index*'s fifth anniversary party at The Park, 2001. Bottom row: June Newton, Helmut Newton, and Martha Stewart at Indochine, 2001; Features Editor Zoë Bruns at the office, 2004.

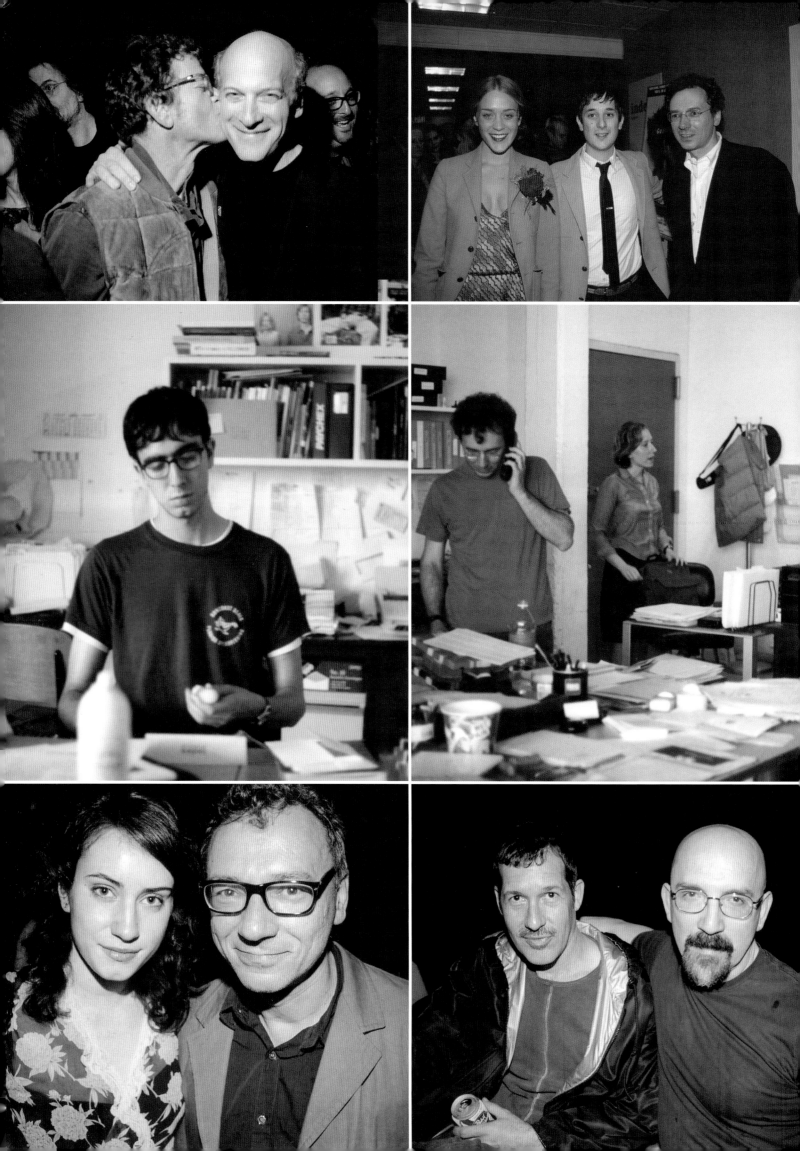

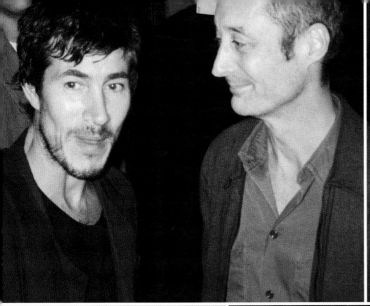
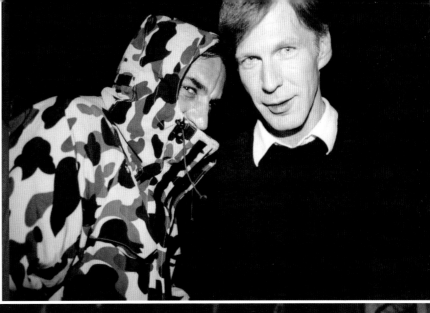

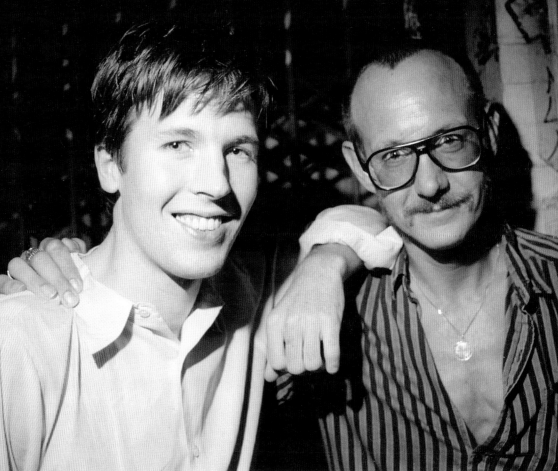

Top row: Lou Reed gives Timothy Greenfield-Sanders a congratulatory smooch, 2004; Chloë Sevigny, Harmony Korine, and Peter Halley at the *Gummo* premiere, October 15, 1997; Photographer Mark Borthwick (left) and friend; Jim Walrod (right) and friend at the Zaldy fashion show after party cohosted by Misshapes and *index*, February 11, 2005. Middle row: Jesse Pearson; Peter Halley with Ariana Speyer and Cory Reynolds, 1999; Photographers Ryan McGinley and Terry Richardson. Bottom row: Peter Halley with daughter Isabel Halley at the 2005 Miranda July party; Contributing Editor Steve Lafreniere (right) and a friend, June 2005; John Waters and friends at Greenfield-Sanders' *XXX* party, 2004.

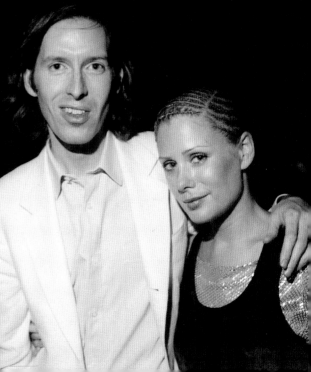

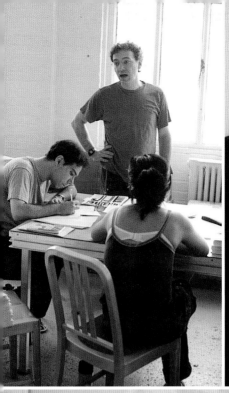

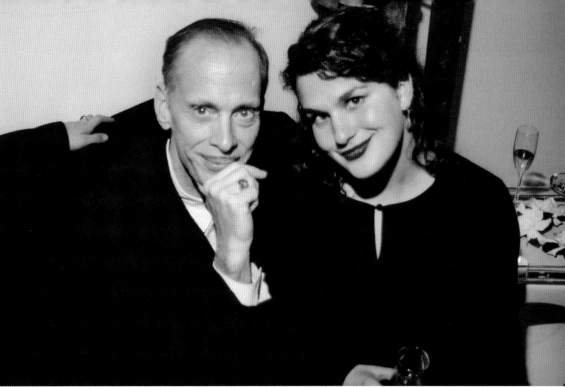

Top row: Editor Cory Reynolds and Peter Halley in front of Halley's paintings, 1999; Writer Emma Forrest at a dinner celebrating Juergen Teller; A day at the *index* office, 1999; John Waters with Associate Publisher Melinda Rose Silva, 2004. Middle row: A pensive Jesse Pearson; Ariana Speyer and filmmaker Bruce LaBruce; Cory Reynolds; Parker Posey with Peter Halley at the *Gummo* after party, 1997. Bottom row: Interns with the door list at an *index* party circa 2004; Director Wes Anderson and fashion designer Tara Subkoff at the TERRYWORLD after party, 2004; Revelers in Terry Richardson glasses at the TERRYWORLD party, 2004.

Top row: Richard Kern at an *index* issue launch; Fischerspooner photoshoot for the February/March 2000 issue cover; Cory Reynolds, Jenny Grant, and Peter Halley; Harmony Korine and Chloë Sevigny at the *index* two-year anniversary party at Barmacy, 1998. Middle Row: Mark Borthwick by Leeta Harding; Darren Aronofsky, Timothy Greenfield-Sanders, and Rachel Weisz at Greenfield-Sanders' party, October 2004; John Waters at Timothy Greenfield-Sanders' *XXX* party, 2004; Ryan McGinley at the opening of his Whitney Museum exhibition, "The Kids Are Alright," in 2003. Bottom Row: Ariana Speyer and Peter Halley, 1999; Peter Halley with Lady Bunny and porn star Aiden Shaw, 2004; The crowd at the June/July 2004 issue launch, featuring French pop band Phoenix.

WANG

219 MOTT ST NEW YORK 10002 T: 212 941 6134 F: 212 941 6961